Concrete Case Studies in Conservation Practice

CONSERVING MODERN ARCHITECTURE

The Conserving Modern Architecture Initiative
(CMAI) is a comprehensive, long-term, and
international program of the Getty Conservation
Institute (GCI). The goal of the CMAI is to
advance the practice of conserving twentieth-
century heritage, with a focus on modern archi-
tecture, through research and investigation,
the development of practical conservation
solutions, and the creation and distribution
of information through training programs and
publications. The CMAI works with inter-
national and local partners, including profes-
sional and organizational networks focused
on modern architecture conservation, to expand
the existing knowledge base.

 The Getty Conservation Institute

CONSERVING MODERN HERITAGE

Concrete
Case Studies in Conservation Practice

Edited by Catherine Croft and Susan Macdonald
with Gail Ostergren

The Getty Conservation Institute, Los Angeles

CONTENTS

Projects

FOREWORD

In 2011, the Getty Conservation Institute launched the Conserving Modern Architecture Initiative with the aim of advancing international practice in this emerging area of interest through research and investigation, the development of practical conservation solutions, and the creation and distribution of information through training programs and publications. Early in our work, the GCI identified the need for good information on appropriate approaches and methods to conserve modern heritage and more technical information on ways to address the material conservation problems typical of modern buildings. In response to this need, the GCI has developed a new publication series, Conserving Modern Heritage, that will bring together case studies that demonstrate suitable approaches and solutions to some of the conservation challenges specific to modern heritage.

I am delighted to introduce the first book in this new series, *Concrete: Case Studies in Conservation Practice*, which will help to bridge the information gap and contribute to the development of a cohort of practitioners across the world who are well equipped to meet the challenges of conserving the twentieth century's most ubiquitous building material, concrete. The book presents twelve large and two smaller conservation projects undertaken over the last ten years that demonstrate approaches to the conservation of significant concrete buildings and structures.

It takes a skilled team to conceptualize and produce a volume such as this. I would like to thank the editors, Catherine Croft, director of the Twentieth Century Society, and Susan Macdonald, head, Buildings and Sites, GCI, who worked to assemble these case studies and craft the book. Thanks are also due to all of the case study authors and to the GCI staff members who assisted with the editing and production of this publication. We hope this series will provide practical and useful information to those involved in the conservation of modern heritage. The second volume, *Energy and Climate Management: Case Studies in Conservation Practice*, is already in preparation. We look forward to expanding this series to meet the field's needs.

Timothy P. Whalen
John E. and Louise Bryson Director
Getty Conservation Institute

PREFACE AND ACKNOWLEDGMENTS

The Getty Conservation Institute's Conserving Modern Architecture Initiative was inaugurated in 2011 with the objective of advancing the practice of conserving twentieth-century heritage. In order to direct the initiative's work, the GCI convened a colloquium in 2013, bringing together some sixty international experts to discuss the current challenges and needs of the field. A number of recommendations emerged from this colloquium, including the need for research into material conservation issues and the need for published case studies that illustrate some of the recurring technical and material challenges specific to the conservation of modern heritage (Normandin and Macdonald 2013, 6, 9, 11, 20). Concrete was specifically identified as a key material and critical conservation challenge. A follow-up meeting of international experts on conserving concrete, held by the GCI in May 2014, reaffirmed this need, and resulted in a specific recommendation that development of a case study publication on concrete conservation be a priority (Custance-Baker and Macdonald 2015, 13–14, 17, 25). In 2017, the GCI established the Concrete Conservation Project. Through a targeted program of research, fieldwork, publications, and training, the GCI will contribute to developing a community of practice and advance this area of conservation practice.

Concrete is the most important construction material of the modern age. Since the pioneering developments in reinforced concrete in the late nineteenth century, its use as a construction material has steadily increased. By the end of the twentieth century, it had become one of the most common building materials on the planet, and architects and engineers of the modern era exploited its potential in myriad innovative ways, leaving a legacy of extraordinary structures that span the twentieth century. Today we are grappling with the new conservation challenges that concrete has provoked, and while a growing number of good conservation projects have been undertaken in the last twenty years or so, there are still many unknowns. We have not reached consensus on how to repair concrete; we lack common and well-established approaches and techniques; and the community of practitioners who are well versed in its conservation is small.

The GCI's new publication series, Conserving Modern Heritage, aims to provide access to information on how different practitioners have applied a conservation approach to many of the challenges specific to modern heritage. *Concrete: Case Studies*

in Conservation Practice is the first book in this series. It tackles the increasingly common challenge of conserving historic concrete buildings and structures. Future volumes will address technical issues related to other specific materials, as well as broader subjects such as climate and energy management, adaptive reuse, and general conservation planning.

The intent of the book is to share practical approaches to conserving concrete heritage so we can learn from these experiences and identify specific challenges where further research and practical work can advance our field. Through the process of researching and preparing this publication, the GCI honed its own research program and identified specific training needs and future publication topics that we hope will further this effort.

Our sincere appreciation goes to all the authors of the case studies in this volume. The work described herein illustrates the often pioneering approaches of dedicated professionals from many corners of the world, and we are grateful that they are willing to share so openly the successes and challenges of their projects. The buildings, which are of varied typologies, represent different periods in the development of concrete across the twentieth century. They demonstrate the material's structural and artistic potential, as well as the creativity of the engineers and architects who sought to exploit this potential. All the case studies center on recognized heritage places with specific challenges, and they share a common aim: to conserve the significance of these structures in ways that also address the complex and difficult technical problems that arise due to their material characteristics.

Sadly, during the development of the book, in August 2017 we lost our colleague Professor Sergio Poretti, who coauthored the case study on the Magliana Pavilion. Professor Poretti's contribution to scholarship on the history of construction and structural engineering of the modern era is significant, and we are honored to include his work here.

The editors would also like to thank the GCI's Gail Ostergren, who undertook much of the supporting editing work to bring the book to fruition; Sara Powers, for her logistical support in the production of the book; Stefania Landi, for assistance in sourcing case studies; Ana Paula Arato Gonçalves, for assistance with finalizing some of the case studies; and Cynthia Godlewski, who shepherds the GCI's publications through to completion. In Getty Publications, we thank Rachel Barth, Jeffrey Cohen, Nina Damavandi, Michelle Woo Deemer, and Ruth Evans Lane.

Susan Macdonald and Catherine Croft

WORKS CITED

Custance-Baker, Alice, and Susan Macdonald. 2015. *Conserving Concrete Heritage Experts Meeting: The Getty Center, Los Angeles, California, June 9–11, 2014.* Los Angeles: Getty Conservation Institute. http://hdl.handle .net/10020/gci_pubs/conserving_concrete_heritage.

Normandin, Kyle, and Susan Macdonald. 2013. *A Colloquium to Advance the Practice of Conserving Modern Heritage: The Getty Center, Los Angeles, California, March 6–7, 2013.* Los Angeles: Getty Conservation Institute. http://hdl.handle.net/10020/gci_pubs/colloquium_report.

A Note on Measurements

Metric measurements are provided throughout the case studies in this volume. In instances where authors supplied measurements in imperial or United States customary units and those measurements reflect the system in which the building or project was originally conceived and constructed, they have been retained and metric conversions added in parentheses.

INTRODUCTION

Concrete Conservation:
An Emerging Area of Practice

I am particularly fond of concrete, symbol of the construction progress of a whole century, submissive and strong as an elephant, monumental like stone, humble like brick.

—Carlos Villanueva, 1955

Concrete is one of the most ubiquitous materials of the twentieth century; therefore, anyone involved in conserving modern heritage needs some understanding of the material, its deterioration, and its effective repair. Some 150 years of development of reinforced concrete has produced an extraordinary legacy of structures and buildings. In recognition of their historic, architectural, and technical importance, a small number of reinforced concrete structures were protected as early as the 1960s. Auguste Perret's Notre-Dame du Raincy (1923), for example, was listed in 1966 (Albani 2015). Beginning in the 1970s, government heritage agencies in England, France, and Germany began to systematically protect a number of 1930s concrete buildings.

In Europe, many pioneering reinforced concrete structures, such as the Bauhaus (Walter Gropius, 1925–26), the Villa Tugendhat (Ludwig Mies van der Rohe, 1929–30), and Le Corbusier's housing at Cité Frugès, Pessac (1924), underwent repair following damage inflicted as part of the large-scale devastation of World War II. Those buildings that survived the war intact started to demand attention shortly thereafter. By the 1960s, a number of buildings from the pioneering period of twentieth-century architecture, such as Notre-Dame du Raincy and Unity Temple (Frank Lloyd Wright, 1909), were cited as being in poor condition and in need of attention to address some of the material challenges. These were often the result of original design flaws inherent in groundbreaking new technologies, such as lack of sufficient concrete cover to reinforcement, and the issues in most cases had been significantly exacerbated by a lack of maintenance. A few buildings had started to undergo conservation work that recognized the need to preserve the historic significance of the concrete, but too often the concrete itself was not seen as having sufficient intrinsic interest to merit a conservation approach. Unfortunately, there is scant literature documenting these early conservation efforts.

In the late 1980s, more comprehensive strategic programs for identifying and protecting modern structures and buildings, including those made of concrete, began to be undertaken by heritage agencies, predominantly in Europe and North America. The formation of Docomomo International (the International Committee for Documentation and Conservation of Buildings, Sites, and Neighborhoods of the Modern Movement) in 1988 was catalyzed by the dire state of Jan Duiker's Zonnestraal Sanatorium (1931) in the Netherlands. An early protagonist of thin-wall reinforced concrete, this case did much to focus attention on the architectural legacy of the modern era. In response to the threats to modern heritage and the subsequent formation of such organizations, a small but active community of practice began to form, consisting of professionals interested in concrete conservation. The interest in protecting these buildings also brought recognition that there were a number of specific problems associated with the undertaking, including technical challenges, that sometimes raised conflicts between a desire to reinstate the architect's pristine original intention, and the more typical conservation approach that aimed for minimal intervention.

Conservation does not seem to have lagged too far behind the general interest in utilitarian concrete repair, although the scale of activity was clearly minuscule in comparison. The concrete repair industry was still relatively undeveloped at the time of the early heritage listings and little published information on concrete repair was available until the 1980s. Industry-based organizations dedicated to sharing and increasing knowledge about concrete, however, were established early in concrete's history. The American Concrete Institute, for instance, was established in 1904, and the British Cement and Concrete Association founded its own research station at Wexham Springs in Buckinghamshire in 1947, specifically to demonstrate that concrete could be used imaginatively and artistically. By the 1970s, concrete repair had become a major issue. Dedicated repair organizations, some independent and some industry-based, began forming, recognizing the potentially enormous specialist market for products and repair methods to address the increasingly evident technical deficiencies, as well as some of the negative perceptions about the material and its aesthetics. Research institutes such as the Building Research Establishment in the United Kingdom commenced major research programs addressing concrete problems and repair needs in the last few decades of the twentieth century. Over the last thirty years, concrete repair has grown into a multibillion-dollar international sector and there are now numerous research institutions, industry groups, and university programs dedicated to research on concrete and its repair. Concrete *conservation*, however, is a much smaller, niche market, and there has not yet been the hoped-for response by industry to develop repair approaches and materials that meet specific conservation needs.

Historical accounts of the development of concrete began to be produced early in the twentieth century. Concrete pioneer Ernest Leslie Ransome's text *Reinforced Concrete Buildings: A Treatise on the History, Patents, Design and Erection of the Principal Parts Entering into a Modern Reinforced Concrete Building* dates from 1912 (Ransome and Saurbrey 1912). By the mid-twentieth century, texts on the history and the repair of concrete were being published more regularly, with additional writings

emerging through the 1970s and 1980s. More followed, and by the 1990s and early 2000s there was a growing interest in the subject, resulting in a modest body of literature in some parts of the world on the historical development of concrete in all its forms. Today there are huge quantities of literature on both the history and the repair of concrete that are enhancing understanding of the material, and numerous related events are held around the world annually (Custance-Baker et al. 2015).

Challenges of Conserving Concrete

The challenges of conserving historic concrete are no different than those of repairing concrete buildings generally, but there are additional considerations and difficulties that can differentiate the approach and may demand more careful repair solutions. The nature of reinforced concrete decay, where the advance of the carbonation front toward the embedded reinforcing steel and the subsequent corrosion triggers cracking and spalling, has a potentially significant impact on the structural integrity of the building and on its appearance. When a building or structure has been identified as having heritage significance, specific cultural values will have been identified that articulate why it is important, which elements contribute to its significance, and how the structure may be sensitive to change overall. Managing typical concrete decay and achieving sympathetic repairs creates challenges in conservation terms, specifically with regard to the principles of aiming for maximum retention of historic fabric and reversibility.

Conservation introduces the principle of doing as little as possible and only as much as necessary to sustain the building for its use and preserve its cultural significance. Concrete repair can be an invasive process in terms of investigation, diagnostics, and the repair itself. Structure and skin may be one and the same in a reinforced concrete building. As a composite material, concrete's structural integrity relies on the ongoing and functioning interrelationship between itself and steel. Unpainted concrete, and instances where the material itself is valuable, may mean that the concrete is vulnerable to current repair and diagnostic methods, which can affect the appearance of the building and can also result in the loss of large amounts of original material. Where heritage significance relates to appearance and materiality, conservation relies on retaining material integrity; therefore, there is a conflict with current repair methods. The fact that reinforced concrete is a structural material means that doing nothing may jeopardize structural integrity. One of the challenges is to be able to accurately predict the ongoing threats to a reinforced concrete structure and how it will respond to these threats, and then to determine what level of intervention is really necessary.

Early efforts in conserving historic concrete focused on a strategy of repairing deterioration with proprietary repair mortars that were then covered with an opaque coating applied to all visible concrete, which hid the repair work and slowed down carbonation. Owners and contractors were often reluctant to attempt patch repairs that matched and integrated well with existing concrete due to knowledge limitations and cost factors generally, as well as an unwillingness to embark on more comprehensive works, including overall cleaning strategies. This approach was also influenced

by product manufacturers' warranties and the fact that repair projects were often led by product manufacturers rather than architects or engineers.

Pioneering concrete conservation projects in Europe utilized realkalization and chloride extraction techniques; cathodic protection systems were also attempted. These treatments respond to the fact that corrosion is an electrochemical process. Penetrating corrosion inhibitors were also discussed and some trials undertaken as a potential solution to the challenges. However, data on the efficacy of these products was largely provided by the manufacturers, and thus there were questions as to their long-term impact and apprehension about their application on historic buildings. Some of these early approaches have been examined for their sustainability by the French Laboratoire de recherche des monuments historiques, whose research suggests that these techniques indeed may not prove effective in the long term (for example, Marie-Victoire and Texier 2003; Tong et al. 2012; Sahal et al. 2011).

Many conservation projects have attempted to tackle these challenges, but only a limited number have been documented. Today there has been a move away from realkalization and chloride extraction due to questions about their long-term efficacy, development of a more judicious approach to the use of migrating corrosion inhibitors, and a greater emphasis on developing better patch repairs in terms of material and aesthetic compatibility.

There are instances in which the role of corrosion assessment and monitoring has been recognized as a tool in developing conservation approaches, although there appear to be limited examples of this being implemented. Being able to predict ongoing levels of deterioration through continuous monitoring and as a result take a more strategic approach to repair and preventive conservation will clearly improve outcomes and is a potential conservation approach that warrants more attention.

Over the last twenty years, considerable, although perhaps inconsistent, effort and activity has produced a burgeoning body of knowledge, skills, and experience in the conservation of concrete in various locations internationally. The information, however, is not easy to find or access, it is often place specific, and conservation methodologies are not well developed or presented. This is due to a range of factors, including large knowledge gaps in the long-term performance of a number of the repair techniques, the limited number of published case studies of projects that have been completed, and the dispersed locations and professional disciplines of the people involved. There is not yet, for example, a critical mass of those with the requisite knowledge, skills, and experience in the subject of concrete conservation, and there have been few strategic initiatives that seek to advance the subject outside of a small group in northern Europe and the United States. Lack of government leadership, coinciding with a period of decline in funding for many technical divisions of heritage agencies where such work has traditionally occurred, has meant that this subject has not gained enough momentum for there to have been major advancements in practice. Concrete was one of the first truly global materials. Although the material itself and the ways in which it has been used are infinitely varied, many of its problems are universal.

Currently there is justifiable caution about all methods of repair other than traditional patch repairs. The unproven nature of systems and products makes conservation practitioners understandably nervous about experimenting on historic buildings. There also remains a lack of widespread knowledge of how to effectively undertake traditional repairs, and a lack of information on their potential longevity. Practitioners are anxious to ensure that their work does not compromise buildings further, through either lack of action or the wrong action, which may be irreversible.

Clearly there is a need for the conservation sector to engage with the broader field in a useful and meaningful way to help address the known challenges. Despite the increasing number of concrete buildings that are being identified as culturally significant, they will always be a tiny proportion of the repair sector's work, so it has been difficult to gain support for industry investment in this area of concrete repair.

Lessons from the Case Studies

The projects presented in this book demonstrate a range of different problems and solutions from recent practice from different parts of the world. They exemplify a desire to adopt sound practice and follow a rigorous methodology, but they are also pragmatic in their approaches and tempered to the context and various logistical and cost constraints.

The projects selected represent a range of building typologies, building uses, and project sizes, from the high-rise housing blocks of Le Corbusier's Unité d'Habitation and public buildings such as London's National Theatre, to small monuments such as the structures at Dudley Zoological Gardens and a sculpture by Donald Judd. The projects also represent a range of environmental and economic contexts. Some benefit from high levels of heritage protection and access to funding, while others have had to balance conservation with stringent cost limitations.

The case studies are organized in chronological order by original building date, illustrating the evolution of the use of reinforced concrete from the 1920s to the early 1990s. There has been an effort to include case studies from different periods of history and thus phases of the development of reinforced concrete. The Listening Mirrors project illustrates the most utilitarian use of concrete for defense purposes from the 1920s. The Halles du Boulingrin represents the work of one of the pioneering engineers in reinforced concrete of the early twentieth century, Eugène Freyssinet. The Magliana Pavilion is one of Italian engineer Pier Luigi Nervi's concrete experiments, and Oscar Niemeyer's groundbreaking work in Brazil is exemplified in the São Francisco de Assis Church. The optimism and raw aesthetic of the concrete of the postwar era and the conservation challenges this architectural language brings are demonstrated in the projects of the Unité d'Habitation, the First Christian Lower Technical School Patrimonium, the National Theatre, Morse and Ezra Stiles Colleges, and Brion Cemetery.

The case studies follow a standard template that mirrors the conservation process and emphasizes the need for thorough, well-targeted investigation, diagnostic, and analytical phases of work, the need for trials and mock-ups, and the role of rigorous site supervision and ongoing maintenance. The cases include information on practical

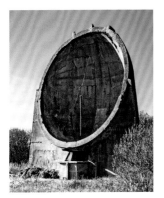

The Listening Mirrors
Denge, Kent, England | 1928–30

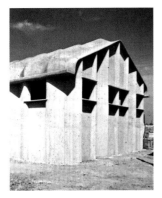

Magliana Pavilion
Rome | 1945

considerations about end use, budget, and access to resources that can influence the project. The Gänsehäufel Swimming Facility, for example, has much higher use demands than the sculpture by Donald Judd, which enabled the sculpture project to adopt a much more conservative approach. The cases will also attempt to provide a level of technical detail that is missing from existing journal articles on the subject.

The case studies share a number of common characteristics. They all demonstrate how the specific nature of concrete and its historical context relates to a building's distinct material and structural characteristics, resulting behavior, and subsequent deterioration. Many of the case study buildings were revolutionary at the time of construction and served as contemporary catalysts in the evolution of reinforced concrete's development as an architectural material. The structures at Dudley Zoological Gardens, the Halles du Boulingrin, and São Francisco de Assis Church, for example, all pushed the boundaries of knowledge and the behaviors of the material. All the case studies share a dedicated effort to follow a rigorous conservation approach that entails a process of investigation and diagnosis to identify causes and target repairs, then balance these with conservation requirements to preserve significance.

In selecting the case studies, we were open to showcasing a broad range of conservation solutions, and had expected electrochemical methods to figure more promi-

Villa Girasole
Verona, Italy | 1929–35

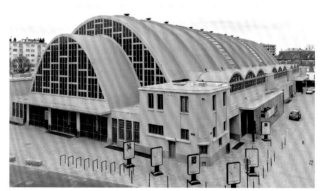

Halles du Boulingrin
Reims, France | 1929

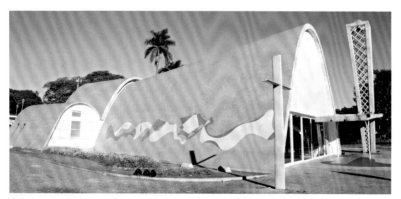

São Francisco de Assis Church
Belo Horizonte, Brazil | 1943

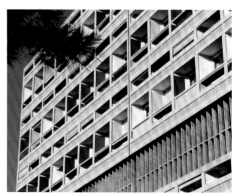

Unité d'Habitation
Marseille, France | 1952

nently. However, most of the projects follow fairly straightforward approaches to concrete repair using traditional patch repair systems, albeit carefully designed to match as closely as possible the parent concrete in order to minimize immediate and ongoing aesthetic impact. Only the Listening Mirrors and the Halles du Boulingrin involve impressed current cathodic protection, and in the latter project it is limited to one part of the structure. Most cases emphasize the role of maintenance in ensuring the efficacy of the repairs and as an active conservation method. Despite the great potential of electrochemical techniques, such as cathodic protection, to address the core of the problem for reinforced concrete structures, there still have been very few instances of its development and application on historic buildings. The need for highly skilled specialists and the bespoke nature of the installation, potential loss of original surface material, and ongoing maintenance have been a barrier. However, it is hoped that these methods will continue to evolve and that there will be opportunities to further advance the potential of this method.

Regardless of the building typology or construction date, the decay mechanism common to all the projects comes down to the basic issue of the steady progress of carbonation that leads to the eventual corrosion of the reinforcement. The rate of carbonation is affected by factors such as the depth of cover to reinforcement, poor

Dudley Zoological Gardens
Dudley, England | 1937

Gänsehäufel Swimming Facility
Vienna | 1950

Morse and Ezra Stiles Colleges, Yale University
New Haven, Connecticut, USA | 1958–62

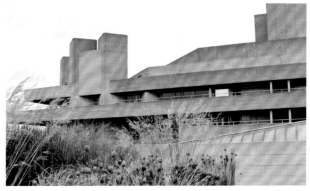

National Theatre
London | 1976

workmanship, and low cement content, sometimes in combination, in each case influenced by the environmental conditions arising from the location. Lack of maintenance or deferred maintenance has been a factor in many of the studies, and poor-quality prior repairs have often exacerbated the problems. Built-in construction deficiencies such as minimal cover to reinforcement are illustrated in a number of cases, including the New York Hall of Science. Other cases illustrate challenges arising from use, such as the Gänsehäufel Swimming Facility, or environment, as at Unité d'Habitation. Problems that have arisen as a result of changes introduced during or subsequent to original construction are evident at São Francisco de Assis Church, where the planned expansion joints were not executed, and at Villa Girasole, where the design was modified so the building would rotate a full 360 degrees. All of these instances point to the need for pragmatic approaches to repair in terms of balancing what is needed to prevent ongoing decay, what is feasible, and the impact on heritage significance.

All the projects undertook trials and mock-up phases of work, and the authors emphasize the need to adequately plan and budget for this prior to project commencement. The Unité d'Habitation's extensive use of trial and mock-ups before undertaking such a large project demonstrates a real willingness to develop the best possible approach for the long term.

The challenges of achieving repairs that are aesthetically well matched to the parent concrete is also common across most of the projects. This has generally necessitated initial cleaning and the development of a palette of repair mixes, as the original concrete is rarely totally uniform.

Many of the cases include proposals for regular maintenance and monitoring as part of the conservation approach. However, only the Listening Mirrors, Dudley Zoological Gardens, and Gänsehäufel Swimming Facility projects have formal monitoring work programmed into the ongoing maintenance of the structures, made possible by involvement of the government heritage agencies. Ultimately, all the projects need ongoing monitoring of some sort to determine the efficacy of the repairs undertaken, but as yet the field has not fully embraced a culture of continual maintenance as a conservation strategy. Realistically, monitoring can be challenging for building owners to resource and effect, despite the long-term potential for this investment to offset inefficient and ultimately costly future repair programs.

We are grateful for the willingness of the case study authors to discuss some of the technical and logistical challenges of their projects. All the projects in this volume had skilled teams of professionals involved in the necessary stages, including architects, engineers, testing institutions, and, in some cases, conservators. Unfortunately, not all building owners are willing to engage the requisite professionals and undertake an adequate level of investigation and preliminary work, and too often repairs perform poorly and are potentially damaging to the building. Many cases cite the difficulties of managing the tender or bid process and/or securing appropriately skilled contractors for the work. Nonetheless, nearly all the projects found ways to address some of the challenges that can be encountered in ensuring that the appropriate contractors are

First Christian Lower Technical School Patrimonium
Amsterdam | 1956

New York Hall of Science
New York | 1964

engaged to undertake the repair work. The São Francisco de Assis Church case specifically demonstrates what can go wrong when this cannot be rigorously managed and the resulting impact of poor execution.

Conclusion

Despite the ever-expanding number of concrete buildings being protected and repaired, identifying suitable case studies for this book proved more difficult than anticipated. This highlights the fact that there still is not widespread knowledge on how to undertake good concrete conservation work or confidence that given work is of a high standard. The concrete industry continues to push standardized repair approaches, materials, and systems, and the fact that conservation is such a small market means that it is difficult to demand more bespoke products.

The process of searching for case studies to include underscored the need for more information on best practices for undertaking concrete conservation. To that end, this book concludes with a short bibliography of key references. Among them is the GCI's *Conserving Concrete Heritage: An Annotated Bibliography* (Custance-Baker et al. 2015), which seeks to provide comprehensive coverage of the available literature specific to concrete conservation. This bibliography, which is available online, will be updated periodically.

The conservation of historic concrete is a critical and growing field of specialization. It is hoped that the experiences and examples presented in this collection will assist in advancing practice in this area. As an ever-increasing number of concrete buildings begin to approach repair with conservation as an objective, the GCI hopes it will be possible to convene further volumes on this subject.

WORKS CITED

Albani, Francesca. 2015. "The Durability of Restoration of Exposed Concrete: Case Histories Compared." In *American Concrete Institute, ACI Special Publication*. Special Publication 305: 3.1–3.10.

Custance-Baker, Alice, Gina Crevello, Susan Macdonald, and Kyle C. Normandin, eds. 2015. *Conserving Concrete Heritage: An Annotated Bibliography*. Los Angeles: Getty Conservation Institute. http://hdl.handle .net/10020/gci_pubs/concrete_biblio.

Marie-Victoire, Élisabeth, and Annick Texier. 2003. "Realkalisation and Corrosion Inhibitors, a Conservation Method for Ancient Buildings?" In *Sixth CANMET/ACI International Conference on Durability of Concrete: Supplementary Papers*, edited by Nabil Bouzoubaâ, 615–29. Farmington Hills, MI: American Concrete Institute.

Ransome, Ernest L., and Alexis Saurbrey. 1912. *Reinforced Concrete Buildings: A Treatise on the History, Patents, Design and Erection of the Principal Parts Entering into a Modern Reinforced Concrete Building*. New York: McGraw-Hill.

Sahal, Mohamed, Yun Yun Tong, Beatriz Sanz Merino, Véronique Bouteiller, Élisabeth Marie-Victoire, and Suzanne Joiret. 2011. "Durability of Impressed Current Realkalization Treatment Applied on Reinforced Concrete Slabs after 5 Years." In *XII International Conference on Durability of Building Materials and Components, 12–15 April 2011, Porto, Portugal*, vol. 3, edited by Vasco Peixoto de Freitas, 1505–13. Porto: FEUP Edições.

Tong, Yun Yun, Véronique Bouteiller, Élisabeth Marie-Victoire, and Suzanne Joiret. 2012. "Efficiency Investigations of Electrochemical Realkalisation Treatment Applied to Carbonated Reinforced Concrete, Part 1: Sacrificial Anode Process." *Cement and Concrete Research* 42 (1): 84–94.

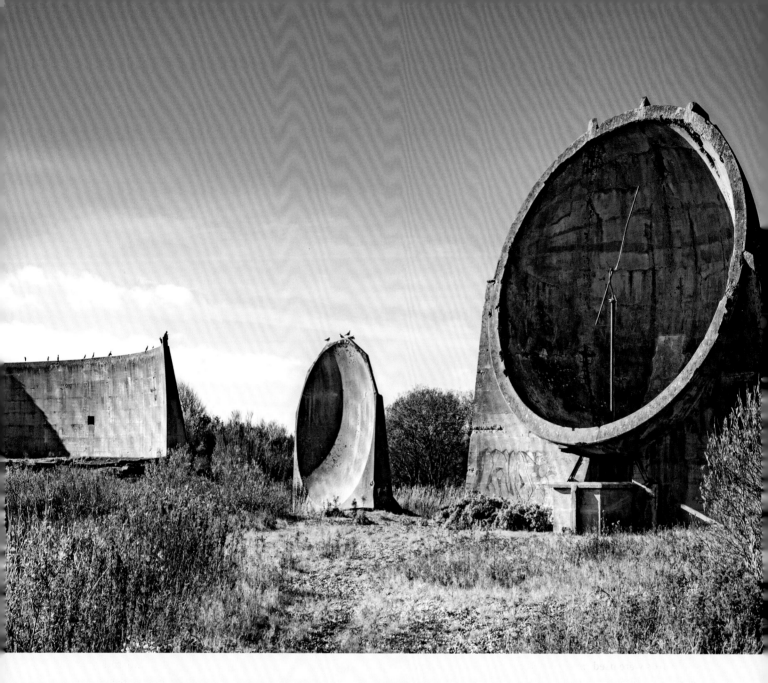

1

Chris Wood and David Farrell

The Listening Mirrors

Denge, Kent, England | 1928–30

ARCHITECT/DESIGNER
Unknown

PROJECT DATES
2002–ongoing

PROJECT TEAM
Historic England, client | Rowan Technologies, contractor, engineer, and monitoring | Colin Burns, initial training on patch repair

CLIENT/BUILDING OWNER
Royal Society for the Protection of Birds (RSPB)

INTRODUCTION

The repairs to the Listening Mirrors provided a rare opportunity to trial and monitor a number of techniques that aimed to provide more sympathetic methods of treating concrete structures of historic importance. Conventional concrete repair practices pay little attention to maximizing the retention of old fabric or matching the new repairs to the existing material.

The three reinforced concrete early-warning sound mirrors were built between 1928 and 1930 at Denge, near Dungeness, on the United Kingdom's Kent coast, to detect the distant sounds of enemy aircraft approaching over the English Channel (fig. 1.1). The mirrors comprise two dishes of 20 feet and 30 feet (6.1 m and 9.14 m) in diameter and a parabolic wall 200 feet (60.96 m) long.[1] The structures were built of concrete because the material was readily available and they could be rapidly constructed when war was an imminent threat. They quickly became redundant with the invention of radar. They were constructed using advanced concrete technology that was well ahead of its time, involving complex new systems of reinforcement that allowed for more slender structures. Sawn boards were used for the shuttering, which provided a board-marked finish to most of the surfaces. Sea-dredged shingle was used for the larger aggregate, which was brought to the site by a narrow-gauge railway. Cement and sand were brought in from local sources.

The Listening Mirrors are situated less than one mile from the sea, and over the last eighty years the reinforced concrete has slowly deteriorated in the marine environment; many areas are now suffering from corrosion of the reinforcement and delamination of the concrete cover. The three mirrors were protected as scheduled monuments

in the latter part of the twentieth century because of their outstanding national importance.[2]

THE PROJECT

Historic England (HE), formerly named English Heritage (EH), is the government agency responsible for caring for England's historic environment. HE and its predecessors have long experience conserving scheduled monuments, a term that is more commonly associated with ruined medieval abbeys, grand houses, and castles than with concrete civil defense structures. Despite the fact that scheduling of twentieth-century structures is comparatively unusual, the same principles of conservation were applied to the Listening Mirrors as to earlier scheduled structures, namely to preserve as much original historic fabric—in this case concrete and reinforcement bars—for as long as possible because of their historical and evidential importance. Functional design was important; the mirrors' aesthetic appearance was not of primary significance when they were built. Nevertheless, they are now dramatic features in the landscape, and their aging surface qualities are perceived as attractive. Originally, a uniform finish of cement render was applied to the dishes of all three mirrors to maximize sound attenuation, although the quality of the surface finishes varied. The aim of the conservation and repair work was to retain most of the original fabric and match in repairs as far as possible, but retain the structures' appearance as aging, weathered monuments, roughly finished and decaying very slowly. Furthermore, it was important to ensure that visitors would not be hurt by falling debris.

Conserving the Listening Mirrors was made possible by funding in 2003 from a levy on local aggregate producers. Management of the repairs was provided by EH. The primary objectives were to structurally stabilize the mirrors, which had been affected by quarrying, and to implement the most urgent repairs. The opportunity was also taken to carry out a number of trials of repair methods and then to monitor their performance.

The foundations of the Listening Mirrors were strengthened and an island was created around them to try and prevent unauthorized access, as graffiti and mechanical damage to the concrete had been an ongoing problem. Rowan Technologies was invited by EH to carry out the trial work. A local masonry engineer from a national firm

Fig. 1.1. View of the reinforced concrete dish of the iconic 30-foot-diameter Listening Mirror in 2005. Note the additional two Listening Mirrors, which together make this scheduled monument an important site. Photo: Tony Watson / Alamy Stock Photo

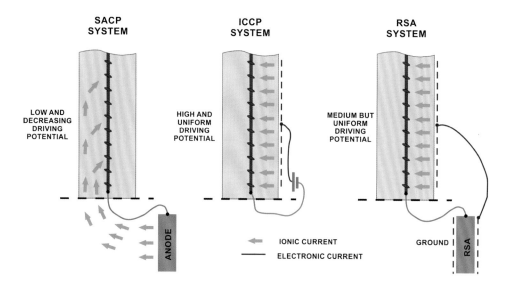

Fig. 1.2. Schematic showing the arrangements for sacrificial anode cathodic protection (SACP), impressed current cathodic protection (ICCP), and remote sacrificial anode (RSA) systems.

of contractors specializing in concrete repairs was allocated to the project to conduct the cutting out and concrete replacement work. Some initial training was given by Colin Burns, an experienced stonemason previously with EH, who had developed some of the innovative patch repair techniques that were to be trialed. These included small- and medium-scale repairs using like-for-like materials to match the original concrete. The success of these repair trials led to these techniques being used in a number of historic concrete projects that followed, including Tynemouth coastal battery, England; the National Theatre, London (see p. 166 in this volume); Dudley Zoological Gardens, England (see p. 58 in this volume); Alexandra Road Park, London; and a number of concrete churches (Farrell and Wood 2015; Odgers 2012).

The mainstream concrete repair industry favors a number of techniques that claim to significantly reduce or control the onset of carbonation and the reinforcement corrosion that follows. Migratory corrosion inhibitors, protective paint coatings, and surface finishing techniques were evaluated during the trials and found to be largely ineffective; these are not covered here. Rather, the project team identified cathodic protection as the appropriate technique for addressing the specific problems at the Listening Mirrors, made possible by the fact that this method could be introduced without compromising the significance of the structures. This case study describes the application of cathodic protection for the conservation of the Listening Mirrors.

Cathodic Protection Techniques

Cathodic protection (CP) is now a widely accepted method for preventing or minimizing the ongoing corrosion of steel and iron in concrete and masonry. EH first utilized CP to prevent ongoing corrosion of iron cramps in the grade 1 listed Inigo Jones Gateway, Chiswick House, in 1996 (Blackney and Martin 1998). This system is still fully operational today, although the power supply was changed to a remote sacrificial anode (see below) in 2001. Further papers describe how CP can be used for protecting both iron and steel in masonry (McCaig, Davies, and Farrell 2001; Farrell and Davies 2005; Farrell 2015).

CP can be achieved by two somewhat different techniques, although the principles are similar. These are sacrificial anode cathodic protection and impressed current cathodic protection (fig. 1.2).

Sacrificial Anode Cathodic Protection (SACP)

The sacrificial anodes used in this system (usually zinc or magnesium for non-seawater applications) corrode preferentially to the metalwork. These are normally placed in close proximity to the corroding metal and are electrically connected to it. As the sacrificial anode corrodes, it generates a current that passes ionically through the building material, by means of the pore water, to provide protection to the embedded steel.

The main restriction in using SACP is that these anode materials have only a small natural driving potential (i.e.,

the force that drives the electrons through the CP circuit, typically 1.5 V or less) when coupled to the embedded metalwork, and this is further reduced by having to overcome the high ionic resistance encountered in the building material. For this reason, the distance between the sacrificial anode and the steel is normally restricted to a few feet. These anodes (normally buried in the ground but sometimes in damp concrete) are capable of protecting small metal components, such as embedded iron cramps and tie rods set into floors or at a low level in walls of buildings.

Remote sacrificial anodes (RSAs) were developed by Rowan Technologies in the early 2000s. Instead of the current having to overcome the high ionic resistance encountered in the building material, it is collected by a metallic current collector that closely surrounds the sacrificial anode. The current from the RSA thus flows electronically (via two low-resistance copper cables, +ve and −ve) to the location where it is needed. It is then converted back to an ionic current at a non-consumable anode, which provides protection to the embedded metal. The first application to a historic structure occurred in 2000, when two RSAs were buried in the ground (in parallel) to power a CP system to protect a tie bar located at the top of a church spire 45 feet (13.72 m) tall.[3] It should be noted that ionic resistances can be many hundreds or thousands of times higher than electronic resistances.

The RSAs (which could be called long-term low-power batteries, as they typically have a life of more than thirty years) enable the sacrificial anodes to be installed at much greater distances—up to approximately 3,000 feet (914.4 m)—from the embedded metal. The RSAs have been used for a number of installations (mainly conservation projects) over the past sixteen years, usually where other CP techniques would have been impractical. The other benefit of using RSAs, as compared to ordinary sacrificial anodes, is that they can be coupled together in series, using suitable isolation techniques, to increase their driving potential. In 2010, Rowan Technologies installed an RSA system to protect metal cramps in a Victorian arch in Dublin, which included four 22 lb (9.98 kg) magnesium-based RSAs in series providing an initial driving potential of 6 V (4 by 1.5 V).

Impressed Current Cathodic Protection (ICCP)

ICCP systems require an external power supply, normally a transformer rectifier connected to a power main, to provide the DC current to the embedded metalwork to be protected. Solar panels and wind turbines have also been used. These systems use non-corroding anodes located close to the metalwork to provide part of the current pathway. ICCP systems are generally more complex than SACP systems, but with their much higher driving voltage they are suitable for providing current to much larger areas of embedded metal and at greater distances, or where the concrete or masonry has an inherently higher electrical resistance. A power main was not available at the relatively remote Listening Mirrors site, and solar or wind solutions would have been vulnerable to vandalism.

Practical Problems of Locating Non-Corroding Anodes on Historic Buildings

One of the major problems with using CP to protect historic concrete is positioning the non-corroding anode so that it sufficiently protects the embedded steel reinforcements, but does not unacceptably affect the appearance of the weathered concrete surfaces. The anodes have to be distributed sufficiently to perform their role. To protect a single length of reinforcement, for example, a strip of anode ribbon would be sufficient. If the steel reinforcement runs in two directions (as in many types of concrete), then a two-dimensional anode mesh is required.

CP is widely used for protecting non-historic reinforced concrete such as bridges, tunnels, and other structures, especially within transport systems. The damaged concrete is removed, the steel is cleaned up, repairs are carried out, and a thin layer of new cover is applied. Typically, a two-dimensional anode mesh is fixed to the concrete surface (using polymer studs), which is then overcoated with a layer of sprayed concrete (fig. 1.3). This enables the current to be transmitted from the anode mesh directly into the concrete to protect the underlying steel reinforcements. This process normally wouldn't be recommended for historic concrete unless the concrete cover itself had been extensively damaged and was going to be replaced anyway, or if the surface was not significant or had originally been coated.

Sometimes the reinforcement in historic concrete can be centralized and deeply embedded, and CP can then be applied using anode ribbons mortared into existing joints, as shown in the church steeple in figure 1.4. The steeple had initially been built with concrete blocks. These concrete blocks were used as permanent shuttering, with the concrete poured in from the top, but its poor quality, in conjunction with marine rainwater ingress, had resulted in corrosion of the steel. For this application, anode ribbon (½ in. [1.27 cm] wide by 40 milli-inches [1 mm] deep) was introduced into alternate joints cut to a depth of 2 in. (5.08 cm) between the concrete blocks and mortared in

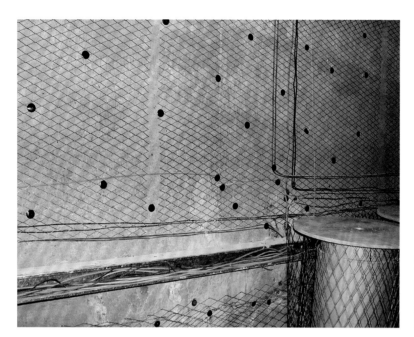

Fig. 1.3. Typical arrangement for applying two-dimensional anode mesh over repaired reinforced concrete prior to overcoating using sprayed concrete.

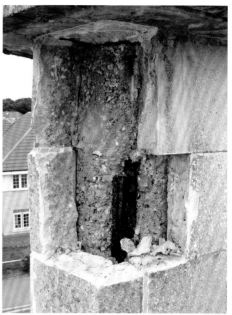

Fig. 1.4. Damage to a reinforced concrete steeple due to poor-quality concrete in combination with marine rainwater entry. The outer concrete blocks were placed and used as permanent shuttering, then the concrete poured around the internal steel reinforcement.

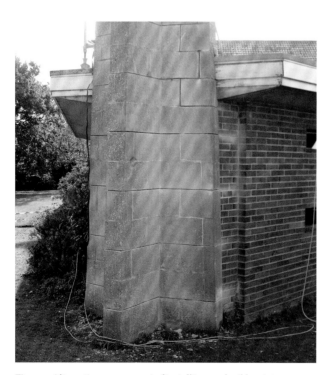

Fig. 1.5. Alternative arrangement of installing anode ribbon into every other horizontal joint in concrete block construction, suitable if the steel is deeply embedded.

place (fig. 1.5). This type of arrangement may also be suitable where individual corroding steel reinforcements are encountered. Chases may be cut directly into the sides of the concrete following the lines of the reinforcements to allow anode ribbons to be inserted; these can subsequently be covered by pointing, the visibility of which will depend on the nature and articulation of the concrete surface.

Standards for Cathodic Protection

The main standard for cathodic protection for above ground structures in the United Kingdom is *Cathodic Protection of Steel in Concrete* BS EN ISO 12696:2016 (British Standards Institute 2017). Deviations from this standard are made for smaller applications protecting historic concrete.

INVESTIGATIONS: BACKGROUND RESEARCH, ANALYSIS, DIAGNOSTIC WORK, TESTING, AND TRIALS

Unfortunately, the original construction details of the mirrors could not be found, but some historical photographs were discovered that assisted our research. Limited testing of the concrete on all three mirrors was carried

out in 2002 and a report was subsequently issued by Wright Consulting Engineers. A technical paper was produced in 2008 (Wright and Kendall 2008). This showed that the concrete had been formed using a low water-to-cement ratio mix, was well compacted and of high quality, and had a typical compressive strength of 29 to 48 N/mm². The coarse siliceous aggregates were shingle, dredged locally and mostly washed; the water was from a local aquifer, which should have been mostly fresh. The concrete had been mixed in small quantities and placed in molds constructed on-site from timber boards. The concrete would have been hand applied to ensure it reached behind the reinforcements and hand tamped to remove air pockets. The fronts of the dishes were probably hand finished with a timber float and had a fine cement-to-sand render applied to provide a smooth finish.

The chloride content of the concrete varied between the three mirrors. For the 30-foot mirror, a large proportion of the chloride measurements (taken from drill samples at depths of between ¼ in. [0.64 cm] and 1½ in. [3.81 cm]) were above 0.4% by weight of cement, with a maximum value of 4.5% recorded. This high value probably relates to sea-dredged aggregates not being properly washed with fresh water before use. The lower values were probably attributable to the action of wind-blown salts over the past eighty years. The cover to the steel was typically between 1¼ in. (3.18 cm) and 1¾ in. (4.45 cm), although some areas showed less than ½ in. (1.27 cm); the carbonation depth varied between ½ in. (1.27 cm) and 2 in. (5.08 cm). Many areas showed active corrosion of the steel reinforcements.

One of the main objectives of the work on the Listening Mirrors was to identify appropriate conservation methods and materials of good longevity. As some areas of concrete, particularly on the iconic 30-foot mirror, had high chloride concentrations (above 0.4% by weight of cement), it was generally accepted that cathodic protection was the only proven method for preventing ongoing corrosion. Rowan Technologies was subsequently asked to trial CP techniques to assess their effectiveness in preventing ongoing corrosion of the embedded steel reinforcements.

The primary aim of the work was to test the performance of concrete patch repairs and CP techniques, but the opportunity was also taken to test migratory corrosion inhibitors and their ability to slow or stop corrosion of steel reinforcements. Four systems were tested, and an electrochemical corrosion monitor was used to monitor corrosion over a twelve-year period. The silane-based product tested was effective for one year. Following this, like the other products tested, it performed no better than the untreated areas.

CONSERVATION

Because of the challenges in providing a power supply to the mirrors' relatively remote location, the only option was to use sacrificial anodes, which could be buried under the shingles, for the trial CP systems. CP systems are generally embedded within the masonry or concrete and hidden from view; the only components that need to be accessed are the electronic cabinets for ICCP systems or a manhole (normally covered up) for SACP systems.

A number of other logistical problems were encountered at this site. Generators and compressors had to be brought to the island, all tools and consumables had to be carried more than half a mile over loose shingle, and trespassers often visited in the evening.

The first trial included placing two 22 lb (9.98 kg) magnesium sacrificial anodes (connected in parallel to double the surface area and thus the maximum current that could be drawn) in the shingle at the base of one end of the 200-foot mirror. The anodes were connected to the steel reinforcements belowground. This area of the mirror had not yet been affected by reinforcement corrosion, and the sections of steel were found to be still electrically continuous. A square matrix was marked up on the concrete surface at intervals at 1½ feet (.46 m) and the surface cleaned up so that electrical potential measurements could be taken. The anodes were given three months to become fully active. The electrical potential measurements were made using a remote silver/silver chloride reference electrode. The reference electrode makes contact with the concrete using a damp sponge, and this allows potential measurements of the embedded steel reinforcements to be made using a digital voltmeter. The results were as expected, with only a very limited polarization of the embedded steel at 1½ feet (.46 m) above the ground and no effect whatsoever at 3 feet (.91 m) above the ground. This trial was subsequently abandoned.

The second trial involved an area 30 feet (9.14 m) square of concrete that had been severely damaged by reinforcement corrosion within the central dish of the 30-foot mirror (fig. 1.6). The cover to the steel had been less than 1¼ in. (3.18 cm) in places. The concrete was removed to a depth of 2¼ in. (5.72 cm), including concrete behind the corroded steel. The steel was grit blasted and the individual sections of horizontal and vertical reinforcements were made electrically continuous by drilling between them at their intersections and fitting threaded bars between. Coating of the cleaned steel was not carried out, as this would have prevented it from becoming polarized. A thin layer of a commercial mortar (Weber CP mortar with a

Fig. 1.6. Close-up of the damage to an area of the reinforced concrete cover to the dish of the 30-foot mirror. An area of damaged cover 30 feet (9.14 m) square was mechanically removed for the CP trial.

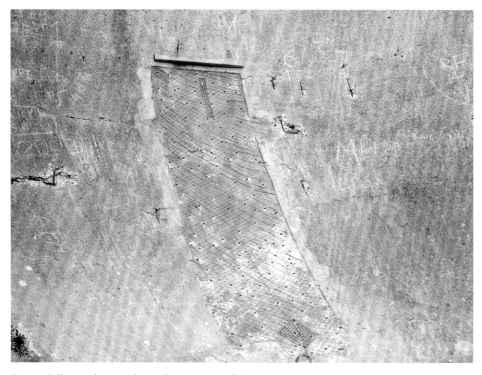

Fig. 1.7. Following cleaning, electrical reconnection of rebar, and repair to the reinforcements, a thin layer of new concrete was applied and a mixed metal oxide–coated titanium mesh was inserted to provide a uniform protective current to the steel.

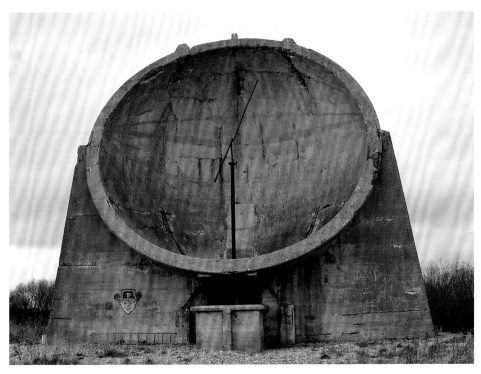

Fig. 1.8. View of the 30-foot Listening Mirror on completion of the project. A thin mortar layer had been applied over the anode mesh to complete the repair. The color match was poor.

low electrical resistance) was used to cover the cleaned-up reinforcements and a mixed metal oxide–coated titanium anode mesh was inserted over the top and fixed into the concrete using polymer studs (fig. 1.7). There are many different types of non-consumable anodes available for CP applications, but the mixed metal oxide–coated titanium mesh and ribbon are considered to give the longest life (more than seventy-five years), and these are normally recommended for historic structures. The wiring to the steel reinforcements and also to the anode mesh was installed within the repair patch, together with two silver/silver chloride reference electrodes. All wiring from the trial area was buried in a chase in the concrete, and the cables were then led underneath and into the ground at the side of the mirror. The trial area was repaired using a first layer over the reinforcement. The anode mesh was then fixed to this layer using plastic studs and finished with a final thin layer of like-for-like cement-to-sand mortar, without the larger aggregate. The color of the top cementitious layer was disappointingly poor and failed to match that of the original weathered concrete (fig. 1.8).

Two remote sacrificial anodes were built to power the trial CP system; an example is shown in figure 1.9. The RSAs comprised 22 lb (9.98 kg) of high-grade magnesium that

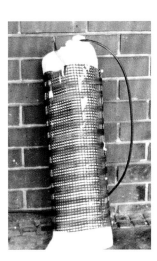

Fig. 1.9. An example of a remote sacrificial anode. RSAs were used to power the cathodic protection system to the 30-foot Listening Mirror. The magnesium anode is covered in muslin and surrounded by the metallic current collector.

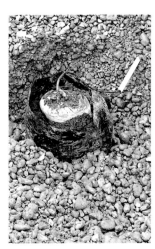

Fig. 1.10. Two RSAs were buried under the shingle with a spacing of 10 feet (3.05 m) and electrically isolated using polymer jackets. The RSA wires were fed through to a manhole and connected in series to double the driving voltage to 3 VDC.

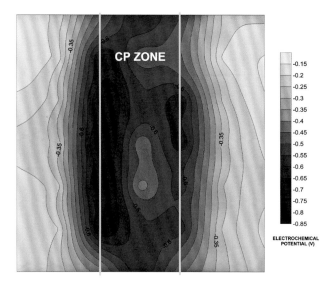

Fig. 1.11. Electrical potential map of the trial CP area of the 30-foot Listening Mirror showing good polarization of the steel reinforcements in 2005.

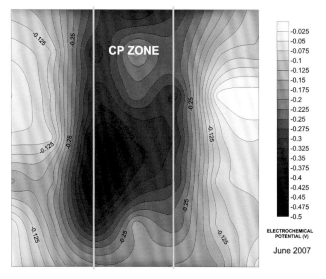

Fig. 1.12. Electrical potential map of the trial CP area of the 30-foot Listening Mirror in 2007.

was surrounded by a backfill mix consisting of 75% calcium sulfate, 20% bentonite, and 5% sodium sulfate. The calcium and sodium sulfates react with the magnesium anode and the system becomes active within a short time; the bentonite clay allows the backfill to retain moisture during dry periods. The backfill was contained in a muslin bag surrounded by a stainless steel current collector. The two wires from the RSA (–ve from the magnesium anode and +ve from the current collector) exited from the top of the RSA. Two of the RSAs were buried at a depth of 3 feet

(.91 m), under the shingle at the left side of the 30-foot mirror (fig. 1.10). The spacing between the two RSAs was 10 feet (3.05 m). They also had polymer jackets fitted, which enabled them to be electrically isolated from each other. The wires from the RSAs led to a manhole, where they were connected in series to double their driving voltage to 3 VDC.

The RSAs were given a three-month window to become fully active and their performance was subsequently assessed. The European standard calls for a minimum depolarization (after the RSA power supplies have been disconnected) of 100 mV over a twenty-four-hour period. The embedded reference electrodes were used to measure the depolarization of the steel. The upper reference electrode recorded a depolarization of 197 mV and the lower one 174 mV over a twenty-four-hour period. This is substantially more than that required to prevent ongoing corrosion.

A portable silver/silver chloride reference electrode was used to take polarization measurements (power on results) on the top surface of the repaired concrete dish. A map of the front of the CP trial area after three months of operation is shown in figure 1.11. The steel, which initially had measured electrical potentials of between –150 mV and –200 mV (with respect to the silver/silver chloride reference electrode), was successfully polarized down to below –800 mV with the protection extending beyond the CP trial area. Potential measurements were also made on the back of the mirror, and these showed that the polarization from the RSAs was effective even through the 10 in. (25.4 cm) thickness of the dish.

Monitoring and Maintenance

As with all conservation trials, there is a need to monitor their performance over extended lifetimes. Regular visits were made to the Listening Mirrors at approximately two-year intervals to monitor performance of the CP trials, patch and medium-scale repairs, inhibitor trials, and paint coating tests.

The potential map of the front of the CP trial area in 2007 (after two years of operation) is shown in figure 1.12. The embedded steel in the test area is still successfully polarized, although the level of polarization is lower than that seen after the first three months of operation. The maximum polarization was recorded as 500 mV (with respect to the silver/silver chloride reference electrode). This was expected, as the magnesium-based RSAs initially give a high driving potential and current, but these decrease once the anode starts to form corrosion products on its surfaces, as this reduces its activity.

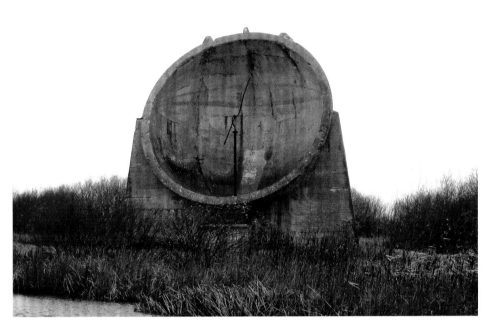

Fig. 1.13. View of the 30-foot Listening Mirror in 2016 showing the beginning of weathering, with algal and lichen growth starting to become established on the repaired concrete cover to the CP trial area.

The Listening Mirrors continue to be visited regularly to monitor the repair work and the efficacy of the CP system. During the visit in December 2015, it was noted that one of the underground wires from an RSA had been exposed and damaged by vandals. The RSA was still outputting 1.5 VDC but was disconnected from the CP circuit. One of the problems with connecting RSAs in series is that if one of the wires becomes damaged, then all current is lost to the CP system, whereas if are connected in parallel, then only half the current is lost. Repairs were duly made and the RSA system to the CP trial area was reactivated.

A view of the 30-foot mirror in 2016 is shown in figure 1.13. The lightened area of top concrete on the CP trial area has now weathered, and both algal growth and green lichens have become established on its surface.

The most recent monitoring inspection was conducted in late 2017, following the wet period, so that monitoring and testing can be carried out when corrosion is most active. The evaluation will include the areas of patch repairs and protective coatings trials.

CONCLUSIONS

The use of cathodic protection using remote sacrificial anodes on the 30-foot mirror has proved to be successful. The corrosion of the reinforcement has stopped. Despite

occasional vandalism causing a partial disconnection, an electrical supply has been maintained. Visually, the installation work is relatively discreet, with most of the wiring buried out of sight. The rendering of the new concrete has weathered down after ten years so that it now blends in with the rest of the surface.

The beneficial effects of the sacrificial anode extend right through the depth of the concrete within the area of repair. It is also apparent that reinforcement surrounding it is also being passivated, although its extent has not been measured. The proposed monitoring in late 2017 will attempt to test this.

It is probable that the whole of the 30-foot mirror could be protected by RSAs. However, this could mean removing a significant amount of surface cement render and installing titanium mesh over a large part of the dish. The loss of so much original fabric may not be acceptable at present, given that the corrosion is relatively minor.

The use of cathodic protection may not be acceptable in many conservation projects because a significant amount of surface material may need to be removed to facilitate embedding the wiring in the concrete. In the case of the Listening Mirrors, the internal surface had originally been rendered in a cementitious layer, and the test area had already been significantly damaged by corrosion of the steel reinforcements. The rendered layer was of less aesthetic

significance than may be the case in other structures, and it already required significant replacement; therefore, the treatment could be justified on two counts, and it was also not difficult to reintegrate the new render with the existing using a like-for-like material to create a very similar homogeneous surface.

CP systems require ongoing monitoring and testing to ensure that they are working effectively. This should be carried out every two years. Ideally, regular inspections should be carried out by locally based individuals who could report any obvious problems. CP is the only known treatment to arrest ongoing corrosion completely and has shown in this case that it can be used as a means of minimizing the amount of invasive repair. Through ongoing maintenance and monitoring it thus takes a preventive approach. There are limited examples of the application of CP systems for historic buildings and structures, but there is potential for research, trials, and testing to further develop its potential for application in conservation projects.

NOTES

1. Hereafter we will refer to the mirrors as we did during the project, as the 20-foot, 30-foot, and 200-foot mirrors.

2. Scheduling is the oldest form of heritage protection in the United Kingdom. Archaeological sites and monuments of national importance may be scheduled. Scheduled monuments have a higher status and enjoy stronger protections than listed buildings (a category of nationally protected historic buildings in the United Kingdom).

3. This spire was at Saint Philip and Saint James Parish Church in Wittington, Worcester, England.

WORKS CITED

Blackney, Keith, and Bill Martin. 1998. "The Application of Cathodic Protection to Historic Buildings." *English Heritage Research Transactions Metals* 1: 83–94.

British Standards Institute. 2017. *Cathodic Protection of Steel in Concrete.* BS EN ISO 12696:2016. London: British Standards Institute.

Farrell, David. 2015. "Cathodic Protection of Embedded Iron in Church Towers." *Context* 139 (May): 20–23.

Farrell, David, and Kevin Davies. 2005. "Cathodic Protection of Iron and Steel in Heritage Buildings in the United Kingdom." *APT Bulletin* 36 (1): 19–24.

Farrell, David, and Chris Wood. 2015. "Concrete Repairs: Traditional Methods and Like-for-Like Materials." In *Building Conservation Directory 2015*, 53–58. Tisbury, Wiltshire, England: Cathedral Communications.

McCaig, Iain, Kevin Davies, and David Farrell. 2001. "Cathodic Protection of Iron and Steel: Recent Developments to Heritage Buildings." In *Building Conservation Directory 2001*, 42–44. Tisbury, Wiltshire, England: Cathedral Communications.

Odgers, David, ed. 2012. *Practical Building Conservation: Concrete.* London: English Heritage; Farnham, Surrey, and Burlington, VT: Ashgate.

Wright, Alan, and Peter Kendall, 2008. "The Listening Mirrors: A Conservation Approach to Concrete Repair Techniques." *Journal of Architectural Conservation* 14 (1): 33–54.

2

François Chatillon and Richard Palmer

Halles du Boulingrin

Reims, France | 1929

ARCHITECT/DESIGNER

Emile Maigrot, architect | Eugène Freyssinet, engineer

PROJECT DATES

2006: development of the conservation project begins |
2010–12: execution

PROJECT TEAM

François Chatillon, architect | Richard Palmer, engineer consultant
for concrete diagnostic and repair

CLIENT/BUILDING OWNER

City of Reims

INTRODUCTION

At the end of World War I, after bombardment had all but
destroyed the city of Reims, the city's new covered market,
the Halles du Boulingrin, was built at the edge of its his-
toric center (fig. 2.2). The structure comprises a parabolic
reinforced concrete arch 38 m wide by 20 m high by 109 m
long. The arch is a thin-shell structure stiffened by para-
bolic beams visible from the exterior. From inside, one sees
a smooth, majestic arch punctuated, at each third of its
length, by parabolic bands of skylights. The building was
a collaborative effort by Reims architect Emile Maigrot
(1880–1961) and engineer Eugène Freyssinet (1879–1962), at
that time technical director of Limousin and Company.
The form and techniques used for the reinforced concrete

structure were an extension of Freyssinet's work on thin-
shell structures, preceded by the wonderful Orly airship
hangars (1921–23) and contemporary with the Halles
des Messageries (freight offices) at the Gare d'Austerlitz,
Paris (1927–29).

Emile Maigrot graduated from the École des Beaux-Arts
in Paris in 1906 and subsequently specialized in the con-
struction of abattoirs and public buildings in the Marne
district of France. Eugène Freyssinet completed his wide-
ranging studies at the Ponts et Chaussées, a Paris-based,
university-level institution of higher education and research
in the fields of science, engineering, and technology. He
started his career with the construction of reinforced con-
crete bridges. In 1916, he became technical director and
partner in the construction firm Mercier, Limousin and
Company, which later became Limousin and Company.
He developed innovative construction techniques such as
thin-ribbed vaults used for very large structures, such
as the airship hangar at the Orly airfield. In 1928, he filed a
patent, together with Jean-Charles Séailles, for concrete
prestressed by the addition of steel cables. After World
War II he developed a method of prestressing concrete for
use in the construction of bridges and other structures.
He was also responsible for the construction of the
Basilica of Saint Pius X in Lourdes, in collaboration with
architects Pierre Vago and André Le Donné, in 1955–58.

Fig. 2.1. *overleaf* Interior view after completed conservation, 2012. Photo: © Cyrille Weiner
Fig. 2.2. *above* Location of the Halles du Boulingrin. Photo: François Chatillon

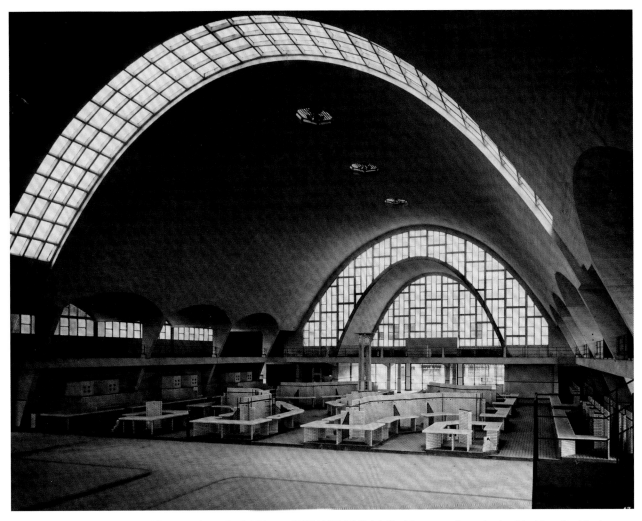

2

Fig. 2.3. Les Halles open to the public, 1929. Photo: Fonds Maigrot. CNAM / SIAF / Cité de l'architecture et du patrimoine / Archives d'architecture du XXe siècle. Photo: Chevojon

The period of design and construction of the Halles du Boulingrin, from 1923 to 1929, was extraordinary. Buoyed by enthusiasm for reconstruction after World War I, audacious and innovative creation abounded. The Halles du Boulingrin was the result of an architectural competition launched in 1922. Maigrot's project was declared the winner in 1923, with Limousin and Company awarded the construction contract in 1926, thereby giving Freyssinet the opportunity to demonstrate his technical expertise. Freyssinet's involvement propelled the building into the realm of great historic monuments representing key milestones of architecture and structural innovation (fig. 2.3).

Construction took place between 1927 and 1929, largely made possible by Freyssinet's latest innovation, movable formwork (fig. 2.4). This method of casting reinforced concrete was particularly suited to the realization of such

a structure. The building might have completely escaped damage in World War II had its glass not been shattered during bombing of the nearby railway station. Nonetheless, its subsequent intensive use as a covered market has been recognized as of great social significance to the city.

THE PROJECT

The building's fortunes waned over time and it fell into increasing disrepair, until it was finally closed in 1988 due to falling concrete. It was granted a reprieve from demolition when, following determined advocacy efforts and a successful media campaign, it was listed as a historic monument in 1990. The structure was essentially suffering from extensive concrete carbonation and resultant reinforcement corrosion. This, combined with a lack of

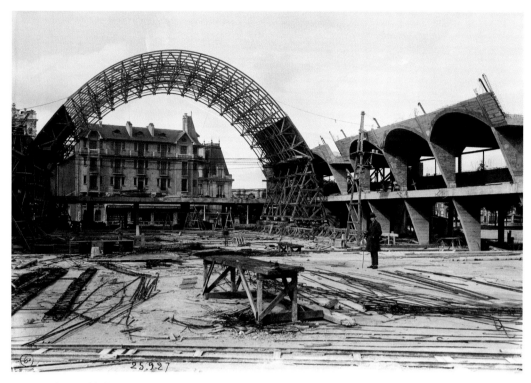

Fig. 2.4. The movable formwork at the start of construction, 1927. Médiathèque de l'Architecture et du Patrimoine, Charenton-le-Pont, France. Photo: © Henri Deneux–RMN / © Ministère de la Culture / Médiathèque du Patrimoine, Dist. RMN-Grand Palais / Art Resource, NY

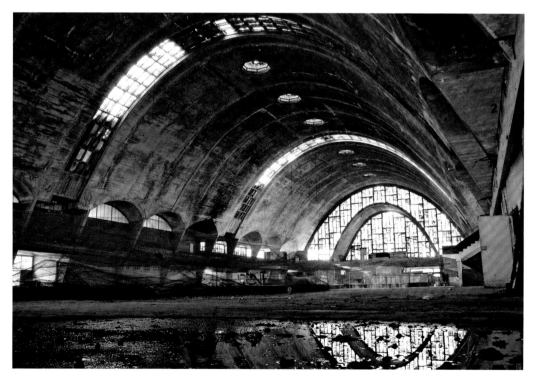

Fig. 2.5. Degradation prior to conservation, 2008. Photo: © Véronique Nosbaum

maintenance, allowing much water penetration into the building, had caused inevitable damage. Coupled with vandalism, the Halles du Boulingrin was in a sorry state (fig. 2.5). A hiatus followed its listing, during which time various studies were undertaken and proposals for reuse were developed. In 2007, the local council decided to restore the building to its original market hall function.

Having determined to retain the hall, several professional organizations were engaged to undertake structural and deterioration assessments. They concluded that, despite significant concrete deterioration, it was possible to conserve the structure. The question then was how to achieve that goal. The approach taken was to treat Les Halles as a typical historic monument conservation project. This involved identifying the needs to sustain its function, preserving the structure largely unchanged, recognizing the constraints arising due to its status as a listed building, and sympathetically dealing with any requirements to upgrade the building to meet modern demands and uses. However, historic buildings are not always easily adapted to today's standards and users' expectations despite aspirations for their preservation. The essential first step is to fully understand the building in order to develop the project so that it is compatible with its architectural and structural significance.

Therefore, various reuse options were examined and their suitability for the historic structure were assessed. In the end, this process confirmed that the building's continued function as a covered market was indeed the best solution.

From 2010 to 2012, a series of trials of different remedial techniques were undertaken. These included the latest electrochemical techniques and corrosion inhibitors, as well as conventional repairs. The results enabled selection of the most suitable methods for repairing the different areas of reinforced concrete within the structure. Innovative materials were also required, such as ultra-high-performance fiber-reinforced concrete for replacing the glazing in the tympana and skylights.

The project was developed in three phases: the application of concrete repair technology to protect Freyssinet's innovative structure; the delicate restoration of Maigrot's art deco interior to preserve this work from the 1920s; and, finally, an architectural solution for the building's reuse in compliance with current building standards. This case study examines the first two phases of this work as pertaining to the repair of the concrete structure, including the technical characteristics of Freyssinet and Maigrot's seminal work, its pathologies due to age and neglect, the causes thereof, and the techniques used in repair and conservation.

History and Building Description

The following key dates provide a snapshot of the building's history:[1]

- 1920: project initiated within the framework of the reconstruction of the city following its destruction during World War I
- 1922: launch of the architectural competition for Les Halles, won by Maigrot
- 1927: start of site work
- 1929: opening to the public
- 1940: total destruction of the skylights due to German bombing during World War II
- 1957: investigation of the extent of deterioration. Freyssinet's conclusion was that it was premature aging of the concrete due to condensation provoked by an inadequate ventilation system. A security mesh was installed to protect against falling concrete; demolition was envisaged
- 1988: building closed to the public
- 1990: classified as a historic monument by decree of the Conseil d'État (Council of State) at the request of Minister of Culture Jack Lang, under pressure from supporters and architects
- 2006: development of the conservation project begins
- 2010: start of works
- 2012: Les Halles reopens to the public

The interior of the Halles du Boulingrin is dominated by a large central space covered with a parabolic arch (*voûte*) with a span of 38 m and height of 20 m. The arch is stiffened by external reinforced concrete ribs, a structural form known in French as *arcs doubleaux extradossés*, the term describing the unusual device of placing the reinforcing arcs on the outside of the continuous shell. This leaves a smooth interior surface interrupted by two high radial skylights. The loads of the parabolic arch are carried to the ground by a series of small vault structures (*voûtains*) that extend to either side of it. In the basement, tie beams supported by rows of pillars, combined with the external landmass surrounding the building, supply the stabilizing thrust forces in a manner that is both static and dynamic. The fully glazed tympana of the *voûtains* ensure the penetration of lateral light. The two extremities of the main arch differ, but each offers a glazed tympanum that provides most of the interior illumination, as shown in figure 2.6.

Unlike medieval buildings, in which the plasticity of the mortar allows movement between the stones, monolithic reinforced concrete creates a rigid structure.

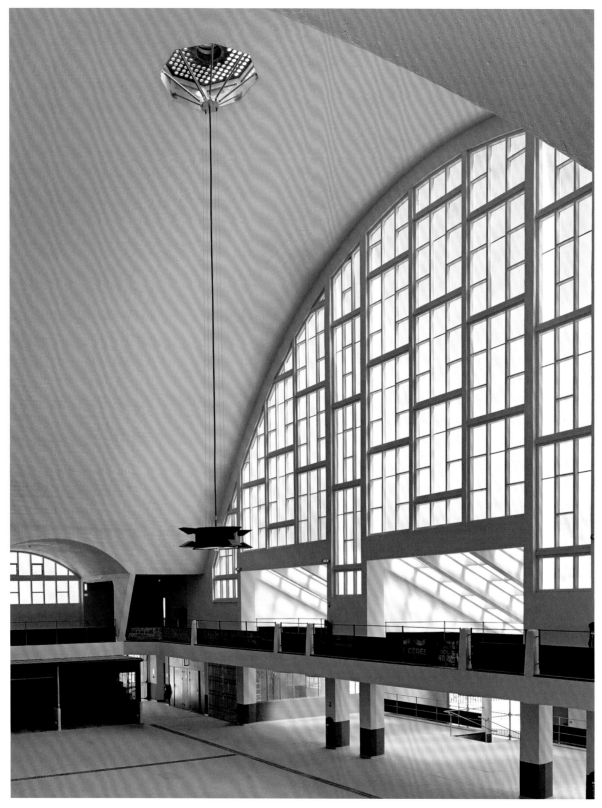

Fig. 2.6. Eastern tympanum after conservation, 2012. Photo: © Cyrille Weiner

Freyssinet devised several methods to compensate for this phenomenon. In the transverse plane, the column bases are hinged at floor level to absorb some of the thrust and expansion forces. In the longitudinal plane, the building is split into three equal parts, each corresponding to the length of three side vaults. Movement joints were provided, located along the line where the high radial skylight structures bear upon the adjacent arch. These joints were carefully designed to be imperceptible while ensuring a perfect seal against water ingress.

The Thin Shell

Freyssinet was not the inventor of the smooth vault (*voûte plate*), which has a long history, nor of the thin reinforced concrete shell.[2] Between 1894 and 1904, Anatole de Baudot, inspired by the rationalist theories of his master, Eugène Viollet-le-Duc, had already covered the nave of the Saint Jean de Montmartre Church with a thin-walled vault of reinforced concrete using the system developed by French engineer Paul Cottancin, Baudot's collaborator for the design. In 1923, Auguste Perret completed the Notre-Dame du Raincy Church, a structure built entirely of reinforced concrete, covered with a thin-walled vault stiffened by small perpendicular vaults. Freyssinet himself, in realizing the airship hangars at Orly between 1916 and 1924, had conceived a thin-shelled arch structure measuring 300 m long by 62.5 m high, considerably larger than the Halles du Boulingrin.

Freyssinet's work can be seen as a continuation of the work of engineers and architects of the nineteenth century. Its modernity comes from the use of reinforced concrete to produce a monolithic, smooth, unified space. From the inside, no tension member, beam, or arc defines the structure. Concrete hence acquires its aesthetic autonomy: the structure is not visible and yet is everywhere. The architecture is but the structure.

The Skylights

Whether vertical or inclined, the skylights are far from mere secondary elements. The choice of a reinforced concrete frame was integral to the structural system. Whatever the reasons (perhaps simply that the company Limousin, whose specialty was reinforced concrete, had no interest in proposing metal frames), the result is spectacular: the skylights merge seamlessly into the structure as light streams through holes in the smooth internal arch.

INVESTIGATIONS: BACKGROUND RESEARCH, ANALYSIS, DIAGNOSTIC WORK, TESTING, AND TRIALS

After advocating demolition, several professional organizations responsible for structural and deterioration assessment concluded that, despite significant concrete deterioration, the structure could be restored. The question then was how to achieve that goal. The prevailing thought was to treat Les Halles as a historic monument, and thus like any other architectural conservation project. The conservation program would be defined by conservation needs and the structure would be largely unchanged, guided by specific conditions or "heritage constraints," to which would be added a degree of "upgrading."

The monuments we inherit, through the centuries or through the decades, stubbornly refuse to keep up with the times, age making them less flexible and hence unable to bend to the requirements and standards of a world that is not the one in which they were born. However, they aspire to resume service and exist once again. Hence, we must first understand their structures in order to conceive a renovation program compatible with their "architectural osteoarthritis."

Reuse

All options were discussed, including supermarket, museum, theater, and so on, until a thorough study demonstrated the unsuitability of any option other than the original—a covered market. An initial general study was conducted in 1991 by Pierre-Antoine Gatier, a senior architect with responsibility for historical monuments (*architecte en chef des monuments historiques* [ACMH]), which identified the monument's main features and principal points of interest. Thereafter a detailed diagnostic study was undertaken based on observations and surveys, while comparing them with the Limousin and Company records kept at the French Institute of Architecture in Paris.[3] The Henri Deneux archives provided invaluable information on the progress of the initial site work.[4] These archives, plans, details, and photographs were compared to the building's material state to provide a coherent understanding of the work and its history. They also documented the state of the structure in 1929, which served as reference for the project, which had to balance the dual objectives of conservation and viable use. It was therefore necessary to arbitrate at each stage between conservation, restoration, renovation, and adaptation.

In general, the architectural detail and decoration were subject to conservation and restoration, notably the covered market stalls and clock tower, with their decorative tiles. The overall appearance was also generally treated in this

way excepting certain technical aspects, such as the upper ventilator fans, where new technology was incorporated to improve the environment within the structure. The building's structural frame, notably the parabolic arch, required repair and adaptation to meet safety needs and to satisfy current building standards. However, the need to conserve and restore the architecture of the original structure was always at the forefront of the project and the structural repair works.

Diagnostic Work and the Evaluation of Repair Options

Of primary concern was the condition of the concrete. Numerous studies commissioned by the city and by state authorities had shown that the structure's stability was not in question, notwithstanding extensive concrete deterioration. In brief, technical studies were conducted by SOCOTEC (Society for the Control of Technology) in 1980, by CEBTP (Center of Expertise for Building and Public Works) in 1982, and by the engineering office DUNE in 1989, which concluded that the concrete deterioration was due to natural aging, and that the general balance of the structure and substantial alteration to the slab of the floor was due to the poor quality of construction and subsequent passage of vehicles.

The principal deterioration mechanism of the concrete was determined to be the extent of carbonation leading to reinforcement corrosion. Not all of the different reinforced concrete elements had been constructed with the same care, and there was considerable variation in their levels of deterioration. The extent of deterioration was also influenced by the concrete's local interface: soil, water, or air. Analyses carried out during the diagnostic investigations revealed the presence of two different concretes: one of homogeneous composition for the thin shells and ribs of the arched roof, and another, more heterogeneous and of coarser constituency, used for other structural elements such as the slabs and columns. The original specification does not mention these two types, referring only to a concrete based on 300 kg of portland cement per cubic meter of sand. According to analysis during the construction works, the differences resulted from the method of concrete vibration using pneumatic hammers on the formwork of the thin-shell structure during casting, a method not used on the other structural elements (Caseau 1928). Laboratory analysis also showed that the aggregates were variable, with poor distribution of sizes, and that the reinforcing steel was of two types: ductile steel for large-diameter bars, and high-temperature, work-hardened steel for small-diameter bars.

After studying all available documentary and diagnostic information, the following distinct areas of the building were identified according to potential repair approaches: the thin (5 cm thick) shells of the principal and stiffening arches (*voûte* and *voûtains*); the peripheral walls of the basement; the supporting columns at ground and at basement level; and the floor slabs. The junctions between different parts of the structure (upper and lower arch elements, the arch and stiffeners, and elements penetrating the arch structure) also exhibited great deterioration, as they were subjected to higher local stress and hence were more heavily reinforced. They also were frequently in areas of greater water accumulation; the slopes of the gutters and roofs had been insufficient to adequately discharge rainwater.

The consultant engineer identified a number of potentially suitable carbonation treatments. These were evaluated during an initial bid phase of work designed to assess the effectiveness of different repair solutions on the principal areas of the structure. Of those responding to an initial invitation for an expression of interest in undertaking the project, three contractors were invited to take part in the repair bid. The effectiveness of the different repair solutions and carbonation treatments were measured by the concrete materials laboratory of the specialist testing company Eurofins, and the results evaluated with the technical support of the Laboratoire de recherche des monuments historiques, represented by Élisabeth Marie-Victoire. The Lefevre Group was selected as the most suitable contractor based on a number of criteria, of which quality of restoration work was the most important.

This investigative and trial stage of the works enabled the development of different repair strategies according to the particularities of each zone as outlined in the following section.

Principal Parabolic Arched Roof and Its Lateral Stiffening Arches

Material and structural characteristics:

- cracked or delaminated 2 cm thick external cementitious waterproofing render, allowing water penetration
- 5 cm thick reinforced concrete thin shell subject to cycles of internal condensation
- porous concrete
- lack of concrete cover to steel reinforcement
- significant concrete carbonation, to depths of 170 mm in the stiffening arches and generally to the full depth

of the thin concrete shell, leading to oxidation of the steel reinforcement
- the presence of aggregates susceptible to alkali-aggregate reaction, as revealed by laboratory analysis
- significant sulfate pollution of the concrete
- adequate structural stability according to current construction standards, notwithstanding a reduction in concrete strength

Treatments evaluated and discarded:

- electrochemical realkalization (applied current density approximately 1 amp/m² of concrete surface), eliminated due to the high cost and risk of triggering an alkali-aggregate reaction
- cathodic protection using an anode system that initially operates under an applied external current (current density approximately 0.01 amp/m² of concrete surface) and then continues to supply current due to the galvanic reaction between the anode material and the reinforcing steel, eliminated due to its low efficiency and lack of long-term data regarding its lifetime effectiveness

Treatments retained:

- penetrating corrosion inhibitor (type Na2PO3F): adequate penetration, some concern of surface efflorescence resulting from the concrete's sulfate pollution
- conventional concrete repair: removal of carbonated concrete, cleaning of corroded steel reinforcement, concrete cover reconstruction using a cement-based mortar
- application of an external waterproof membrane

CONSERVATION

Shells and Stiffening Arches

Treatment of the parabolic arch roof structure was essentially a mix of restoration and repair. The work started with the external surface. The deteriorated original waterproofing render was removed with a combination of high-pressure waterborne abrasive blasting and light percussive chisels. This operation required care to avoid further cracking of the fragile, thin concrete shell. Nonetheless, some areas of the stiffening arches were so deteriorated that it was necessary to rebuild them. This was done using timber formwork to match the original and polymer-

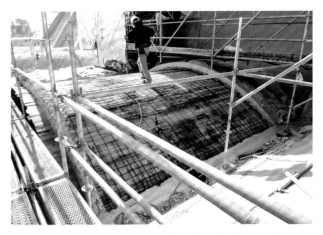

Fig. 2.7. Re-casting the entire thin shell of a lateral arch, 2011. Photo: François Chatillon

Fig. 2.8. Application of the external acrylic resin waterproof membrane, 2011. Photo: François Chatillon

modified fine-aggregate concrete of similar strength to the old concrete (fig. 2.7). At the same time, the small-diameter reinforcing steel was replaced by new welded steel mesh. Elsewhere small patch concrete repairs were carried out to restore the surface profile. Significant cracks were repaired by raking out a V channel on the outer surface and filling it with mastic. The entire outer surface of the arch, including the stiffening arcs, was then sealed by application of a three-layer acrylic resin waterproof membrane (fig. 2.8). Junctions between different surfaces were reinforced with a fine PVC mesh; bands of this material were also placed along repaired cracks after first fixing a narrow band of polythene to act as a bond breaker in the event of continued crack movement. This avoided placing excessive stress on the waterproof membrane in order to avoid cracking. The

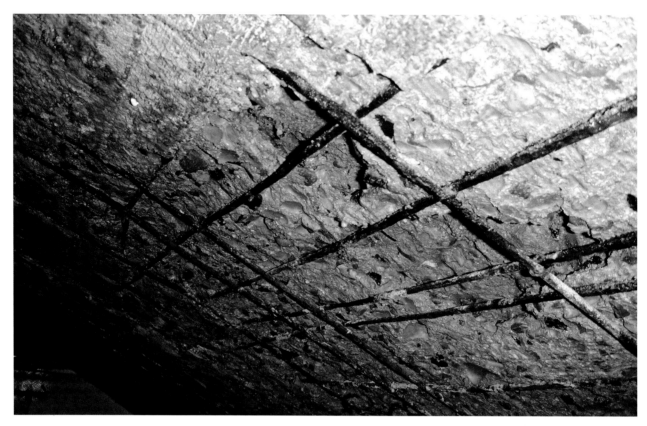

Fig. 2.9. The roof of a lateral arch after removal of deteriorated concrete. Photo: Richard Palmer

Fig. 2.10. The thenardite/mirabilite phase diagram. Diagram: after Doehne, Selwitz, and Carson 2002.

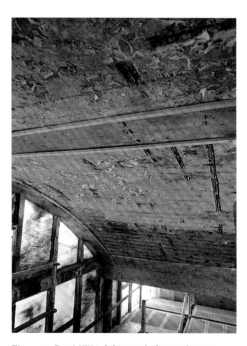

Fig. 2.11. Dry MFX inhibitor gel after application to a lateral arch during initial trials. Photo: François Chatillon

rainwater drainage channels were repaired. Large electrically powered, microprocessor-controlled ventilation fans were installed along the apex of the arch to avoid condensation forming on the inner surface of the arch's thin shell.

At the inner surface of the parabolic arch, areas of deteriorated concrete were removed using high-pressure waterborne abrasive blasting, a technique that also served to clean corrosion scale from the surface of the reinforcing steel (fig. 2.9). The concrete surface profile was restored by patching with a trowel-applied, polymer-modified, fine-aggregate mortar, the distinctive shutter board marking being re-created by lightly tapping timber bars against the still-soft mortar surface.

Sample analysis during the repair trials had confirmed that efflorescence appearing after application of the penetrating sodium monofluorophosphate corrosion inhibitor was due to high concentrations of sulfate in the concrete. A subsequent, more detailed analysis revealed the sulfate to be a mixture of thenardite and mirabilite. In addition to the unsightly nature of surface efflorescence, there was concern regarding durability, because relative humidity and temperature changes cause conversion between these sulfate types, as shown by the phase diagram in figure 2.10. The mirabilite crystals occupy far greater volume (on the order of 300%), and this would lead to cracking of the cement paste, giving rise to further deterioration. However, these sulfate crystals are very soluble, particularly as thenardite, hence a pretreatment by washing with hot water was devised to dissolve and thereby allow removal of the sulfate before application of the migrating corrosion inhibitor. The generally high porosity of the thin-shell concrete contributed to the effectiveness of this action. The migrating corrosion inhibitor was applied to the entire inner surface of the parabolic arch and its lateral stiffening arches. Application was done by projecting an inhibitor-loaded gel onto the concrete surface. By this method, a liquid high inhibitor concentration was maintained at the concrete surface, ensuring an optimum concentration gradient for maximum penetration. Once dry, the gel was easily brushed from the surface (fig. 2.11).

The final treatment of the arch's inner surface involved the application of a two-layer mineral-based coating. This served as a moisture and carbonation barrier while in addition unifying the surface appearance. This requirement effectively avoided the difficult task of matching new repaired concrete surfaces to the original raw concrete finish.

While renewal of the entire interior arch surface, initially proposed by the consultant in 1989, was rejected, the applied coating did reveal the authentic original finish, showing the timber formwork detail indicative of the unique construction method. This detail was carefully re-created at the surface of areas requiring concrete repair patching.

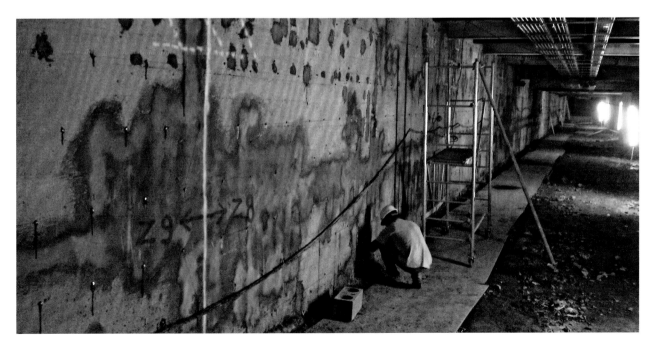

Fig. 2.12. Cathodic protection applied to the peripheral basement walls. Photo: Richard Palmer

Peripheral Basement Walls

The reinforced concrete basement walls were also carbonated, and they were affected by rising damp and the lack of an external waterproof membrane. It was not possible to dig down and add an external membrane, as that would have changed the static lateral force and hence destabilized the arched roof. Treatment by penetrating corrosion inhibitor was discounted, as the constant movement of water across the wall would wash out the active inhibitor reserves. Therefore, impressed current cathodic protection was chosen as the optimal solution for protecting the steel reinforcement. The chosen cathodic protection anode system comprises a grid of interconnected discrete anodes (fig. 2.12). There are eleven independently controlled grids of anodes that cover the entire basement peripheral wall surface. The active anode surface is a mixed metal oxide coating on a titanium substrate, which has an operating lifetime in excess of one hundred years. Each discrete anode has an integral resistor that serves to balance the current applied to protect the steel reinforcement. This ensures that changes of system resistance, due principally to variations of moisture content, do not greatly perturb the protective current distribution. Each of the eleven cathodic protection zones has its own local control unit, each one connected to a central control unit that permits the entire system to be monitored and controlled from one location as well as remotely, via a GSM modem link. Control of the system was undertaken by Lefevre during the first year following installation and has now passed to another specialist company. The monitoring has been principally via modem link and all results to date satisfy the required performance criteria.

Normally a cementitious render would be applied over the entire area of cathodic protection in order to protect the wire interconnects between the anodes and other surface electrical cabling and to provide a uniform surface finish. In this case, however, the lack of waterproof barriers meant that moisture would continue to move across the wall. This raised concern for the long-term bond of the render to the original concrete. It was therefore decided to apply a lime render. This has the advantage of remaining porous and being compatible with the substrate concrete strength and with continued moisture movement and evaporation.

Supporting Columns

The reinforced concrete of all columns was carbonated to varying depths. Any local concrete spalls were repaired by concrete repair as per the method used for the arches.

All surfaces were then treated with the sodium monofluorophosphate migrating corrosion inhibitor.

The basement columns were simply sleeved with an additional 3 cm of concrete cover. This resulted in a thicker barrier against moisture penetration to prevent the onset of reinforcement corrosion, while stiffening the columns.

Floor Slabs

The soffit of the ground floor slab was subject to local patch repairs where necessary. Otherwise, for reasons of economy, no additional treatment was prescribed. The soffits of the gallery floor slabs were destined to be hidden. It was therefore decided, for structural as well as economic reasons, to deal with local areas of corrosion damage by patch repairs and then install a reinforcing steel framework to accommodate the increased imposed loadings due to the new use and as required for compliance with current regulations (fig. 2.13).

RECONSTRUCTION

Some parts of the structure that were too heavily deteriorated to be conserved or restored had to be reconstructed. Rebuilding them in a manner faithful to the original would inevitably have led to the same problems of durability, particularly in the case of the curved, inclined, or vertical skylights. The slender reinforced concrete frames provided insufficient cover to embedded reinforcing steel to ensure the necessary durability. Furthermore, it was not possible to increase the sections of the frames without compromising the overall appearance of the structure. The solution was to construct these elements from ultra-high-performance, fiber-reinforced concrete, an innovative approach that required a technical experimentation assessment before approval.

A similar question arose for other concrete elements such as the plinth facade panels, which form a colored band around the exterior wall above ground level, or the panels over the entrances. These were originally cast using a blue-green-colored aluminum cement, a material that has an interesting history. It was discovered in 1923, apparently by chance, by mezzo soprano and artist Spéranza Calo. She and her husband, Jean Charles Séailles, a Sorbonne professor with wide-ranging interests who was a friend of Freyssinet, developed and patented the material called LAP, short for *lapis*, Latin for "stone." The renewal of these elements cast in glass-fiber-reinforced concrete (GFRC) provided a durable solution without the need for steel reinforcement, thereby eliminating the risk of steel corrosion.

2

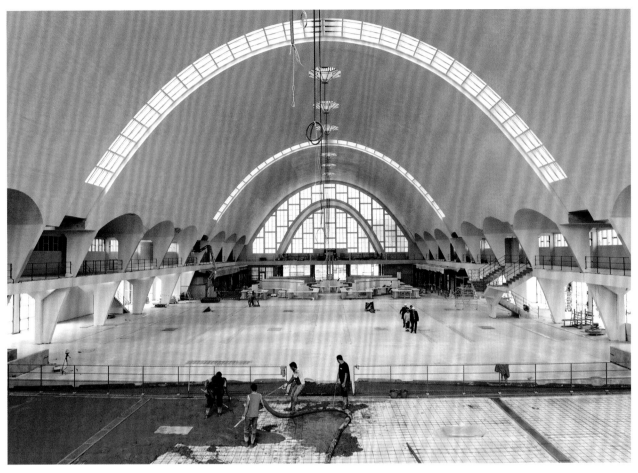

Fig. 2.13. Interior view nearing the end of restoration, 2012. Photo: Alain Hatat

The four roof panels, comprising glass blocks embedded in reinforced concrete over the gallery at either end of the parabolic arch skylights, were completely replaced by prefabricated panels, also made using GFRC.

The Thermalux windows installed to replace the originals after their destruction in 1940 were an early attempt at double glazing made by the company Saint Gobain. These comprised a 3 cm sandwich of inner plain glass and outer armored glass, with the space between the two panes filled with glass fiber. Unfortunately, the cold bridge created by the glass fiber negated the insulating effect, resulting in continued problems with condensation on the inner surface. The Thermalux windows of the two parabolic-arch skylights and the inclined skylights were replaced with double-glazed units, fabricated using Polish-manufactured, yellow-tinted armored glass externally and clear glass internally. These echo the original appearance while meeting today's safety requirements. The glazing of the tympana of the main and smaller lateral

arches was replaced with single-glazed units fabricated using the same yellow-tinted armored glass (see fig. 2.13).

The original problem of condensation within the building was rectified with the addition of new ventilation towers along the apex of the main arch. These are equipped with high-performance microprocessor-controlled ventilator fans. Additional ventilation is provided by air inlets in the tympana of the lateral arches.

BUILDING ADAPTATION

While the plan was to reuse the Halles as a covered market, the demands associated with such a use in the twenty-first century are different from those of the 1930s. The needs of the market traders, requirements in terms of hygiene, issues of fire safety, and provision of access for the handicapped required careful study in order to adapt the monument without impacting its heritage significance.

The Covered Market

The project provided for the occasional use of the building for sporting or cultural events. Consequently, there was a need to provide much technical equipment, which has been accommodated beneath the gallery area or located in the basement. The services required for operating the building (caretaker's lodge, security equipment, refuse room, toilet blocks, etc.) are located in the corner pavilions, specifically refurbished for these functions. Communal rooms for the various commercial activities are provided outside the building, on the rue de Mars, in a building constructed on the site of the former post office building. Several new fixed stalls were created at the periphery, under the first-floor gallery, to create more permanent accommodation. Their contemporary architecture, while clearly not of the 1930s, references elements and colors from the original market area to give a homogeneous appearance. Additional work to provide new spaces, address fire safety issues, meet access provisions, and integrate new building technology created challenges met as part of the project.

CONCLUSIONS

The Halles du Boulingrin has retained its original use as a covered market (fig. 2.14). Retaining the original use usually means that the level of physical intervention can be mini-

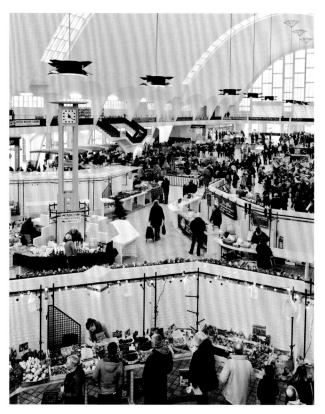

Fig. 2.14. Market day in the conserved Halles du Boulingrin, 2013. Photo: © Cyrille Weiner

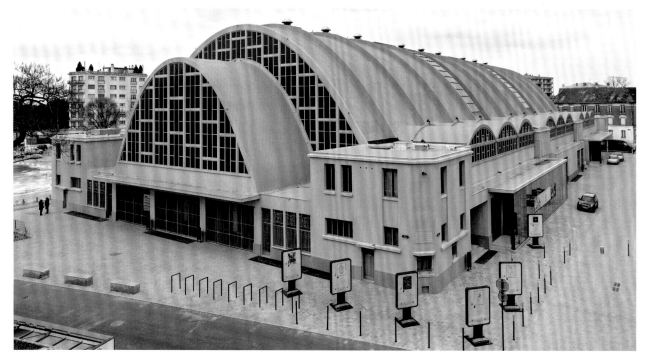

Fig. 2.15. Halles du Boulingrin following conservation, 2012. Photo: © Cyrille Weiner

mized and the social values associated with the use are preserved. The project team approached this challenge on the basis that there is no theoretical distinction between the conservation of heritage of the twentieth century and that of earlier eras, but that different methods are required for its study, conservation, and restoration.

Understanding the building's genesis with the aid of texts and archival documents provides critical information, including an understanding of the designer's original intention and the material characteristics of the structure beyond dimensional measurements; in effect, it is an exercise in reverse engineering. Technical knowledge along with creativity are important aspects of developing appropriate architectural solutions in these types of projects (fig. 2.15).

The project demonstrates the need for careful investigation of a building historically and technically. In this case, assessments revealed that there were specific problems and needs associated with different reinforced concrete elements of the building according to their material characteristics, location, and environment. The project therefore identified a variety of different repair techniques targeting these specific problems and causes. It also highlights the need for trialing different repair techniques and contractors to better understand the implications of the proposed repair options and to test the suitability of the contractor for work with sensitive historic buildings. This reinforces the message that historic concrete buildings rarely lend themselves to a uniform approach. Rather, a bespoke repair strategy is needed to address the different problems and causes and the conservation demands across the building.

NOTES

1. On the genesis of the building and its conservation project, see Murienne (2012).

2. See for example d'Espié (1754) and Araguas (1998).

3. Institut francais d'architecture, Archives d'architectures du XXè siècle, Fonds Emile Maigrot. Numerous documents and illustrations are conserved there, notably many contract documents describing the construction.

4. Henri Deneux, ACMH, led the restoration of the Reims cathedral and the *abbatiale* at Saint-Rémi following their destruction during World War I, and perfected the restoration of a complex framework of small reinforced concrete elements. He was passionate about this work by Freyssinet and recorded an account of the Halles construction (with particular reference to the construction of the main arch) as well as skillfully photographing its different phases (Deneux 1928). The Deneux archives are held by the Médiathèque de l'architecture et du patrimoine.

WORKS CITED

Araguas, Philippe. 1998. "L'acte de naissance de la 'Boveda Tabicada,' ou, le certificat de naturalisation de la voûte catalane." *Bulletin Monumental* 156 (2): 129–36.

Caseau, M. 1928. "VIIème section–Reims. Réunion du 27 novembre 1927." *Bulletin de l'Association des Amis de l'Ecole des Travaux Publics* (January 1928): 4.

Deneux, Henri. 1928. "Les halles de Reims." *L'Architecture* 41 (7): 223–24.

Doehne, Eric, Charles Selwitz, and David Carson. 2002. "The Damage Mechanism of Sodium Sulfate in Porous Stone." In *Proceedings of the SALTeXPERT Meeting, November 2002, Prague*. Prague: ARCCHIP; Los Angeles: GCI. http://publicationslist.org/data/eric.doehne/ref-129/2002_Doehne_NaSO4_SALTeXPERT.pdf.

d'Espié, Félix-François. 1754. *Manière de rendre toutes sortes d'édifices incombustibles ou traité sur la construction des voutes, faites avec des briques & du plâtre, dites voutes plates, & d'un toit de brique, sans charpente, appellé comble briqueté*. Paris: Chez Duchesne.

Murienne, Frédéric. 2012. "Les Halles du Boulingrin: Histoire d'une restauration." In *Les Halles du Boulingrin 1920–2012*, edited by Véronique Charlot and Jonathan Truillet, 108–15. Paris: Somogy Éditions d'Art; Reims: Ville de Reims.

FURTHER READING

Chatillon, François. 2016. "La restauration des Halles du Boulingrin à Reims: Sauvetage d'une prouesse technique des années 1930." In *La sauvegarde des grandes œuvres de l'ingénierie du XXe Siècle*, Cahiers du TSAM 1, edited by Franz Graf and Yvan Delemontey, 54–71. Lausanne: Presses polytechniques et universitaires romandes.

Charlot, Véronique, and Jonathan Truillet, eds. 2012. *Les Halles du Boulingrin 1920–2012*. Paris: Somogy Éditions d'Art; Reims: Ville de Reims.

3

Michele Secco, Elena Stievanin, Claudio Modena, Gilberto Artioli, and Francesca da Porto

Villa Girasole

Verona, Italy │ 1929–35

3

ARCHITECT/DESIGNER

Angelo Invernizzi, designer and railway engineer, with Romolo Carapacchi, engineer, and Ettore Fagiuoli, architect

PROJECT DATES

2002–5

PROJECT TEAM

Simone Nicolini, architect | Claudio Modena, structural engineer | Aurelio Galletti, architectural advice | Fratelli Montresor S.n.c. and Veronese Costruzioni S.r.l., concrete repair contractor | SM Engineering, engineer

CLIENT/BUILDING OWNER

Cariverona Foundation

INTRODUCTION

Villa Girasole in Marcellise, near Verona, is a significant but neglected example of early Italian experimentation with concrete construction (fig. 3.1). The building is the extraordinary realization of the dream of a railway engineer, Angelo Invernizzi (1884–1958), who had a visionary concept of a house that would revolve with the sun. It was built between 1929 and 1935 under the supervision of engineer Romolo Carapacchi (1900–1974) and architect Ettore Fagiuoli (1884–1961).

Sunlight was important in Italy during the 1930s under the Fascist regime, which saw it as symbolic of its desire to promote autonomy and celebrate healthy living. Although there are no comparable built examples in Italy, the project was inspired by Pier Luigi Nervi's 1934 unrealized design for a revolving house. Villa Girasole is a tangible expression of the vibrant artistic and cultural environment that characterized Italian architecture during the 1930s.

Built on a natural slope of friable carbonate rock, the load-bearing structure of the building is made almost exclusively of reinforced concrete. It can be subdivided into two clearly distinct structures: the basement structure and the main villa. The cylindrical basement (fig. 3.2) has an overall 44.5 m diameter, and consists of an access gallery under a large open hall. Above it, the villa itself (fig. 3.3) consists of two rectangular wings perpendicular to each other, both abutting a central tower. The whole of this upper portion of the building rotates about the central axis of the tower. The tower rests on a central bearing with truncated conical rollers. This is covered by a steel lattice plat-

form on which the load-bearing concrete columns of the tower rest, in turn supporting both the helical staircase and the lift (fig. 3.4). The tower is finished with a structure similar to that of a lighthouse lantern. The wings are supported on fifteen wheeled trolleys, which run on three concentric rails. Furthermore, a circular gear rim equipped with twenty rotating rollers facilitates the rotating movement. The whole 1,500 ton building is moved by two low-power electrical bogies (1.5 horsepower each) mounted over the external rail.

The perpendicular wings are two stories high with a roof terrace above, and have a reinforced concrete frame. This supports concrete and masonry slabs, as well as nonstructural infill walls made of composite materials that were innovative for the time and designed to provide good thermal and acoustic insulation while being comparatively lightweight.

THE PROJECT

In Italy, a specific chapter of the building code is dedicated to existing concrete buildings and their repair (D.M. 14/01/2008). Generally works to existing buildings must provide a structural upgrade to meet current code requirements, including any specific requirements demanded by a proposed new end use. However, given the structural and architectural significance of Villa Girasole, the interventions could be limited to achieving structural repairs and/or eliminating causes and signs of decay.

The house has passed from the Invernizzi family to the Girasole Foundation and most recently the Cariverona Foundation, and it no longer functions as a private house. To date, a new use has not yet been identified, therefore no seismic assessments were required. The conservation approach considered Villa Girasole an artwork rather than a functioning residence, and the approach adopted was to conserve the artwork as conceived by the designer, eliminating signs of decay and allowing observers to enjoy its aesthetic significance.

INVESTIGATIONS: BACKGROUND RESEARCH, ANALYSIS, DIAGNOSTIC WORK, TESTING, AND TRIALS

In order to appropriately target any interventions, developing an in-depth understanding of the structural

Fig. 3.1. The tower and rotating portion of Villa Girasole. Photo: Diego Martini

Fig. 3.2. General view of the fixed cylindrical basement of the villa, 2015. Photo: Reproduced with permission of the photographer, Michele Mascalzoni

Fig. 3.3. General view of the rotating part of the villa, 2015. Photo: Reproduced with permission of the photographer, Michele Mascalzoni

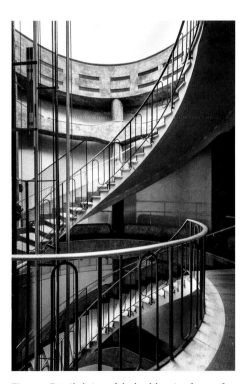

Fig. 3.4. Detailed view of the load-bearing frame of the tower, with the Vierendeel reticular beams and the circular beam clearly visible, 2015. Photo: Reproduced with permission of the photographer, Michele Mascalzoni

characteristics of the building, its materials, and its deterioration was an important part of the project, especially given the early date of the building and its use of nonstandard pioneering technical solutions. Approaches typically used for industrial archaeology (da Porto et al. 2009) were adopted. The research and investigation phase was divided into four fundamental tasks:

- complete documentation of the geometric and structural features of the villa, including both the load-bearing concrete frame and the nonstructural parts
- examination of the form and role of each structural element
- on-site condition survey to identify extent and cause of degradation
- static assessment of the building through finite element models

The study of historical documents was fundamental for the first task. A substantial amount of data was collected from handbooks written during the construction period, and from original photos and reports in the archives of the Cariverona Foundation (the current owner of the building). This was complemented by information in period architectural journals, and was correlated to structural drawings and reports following on-site inspections by SM Engineering.

It was determined that Villa Girasole had not experienced any strong earthquakes or changes in its use over the years. However, the design was subjected to several modifications during its construction. The most significant change was the completion of the building rotation path through a full 360 degrees, necessitating an extension of the rails, which had at first been conceived only for a 180-degree rotation. The new sections of rail were built on beams supported only by soil, whereas the original rails were supported by structural foundations. This resulted in a significant loss of structural integrity for the additional 180-degree rotation. Other alterations included a mechanical review of the rotation mechanism in 1964, the partial replacement of drainpipes and aluminum sheet coverings, and plaster repairs in the open hall in 1993. This research informed a detailed reconstruction (figs. 3.5a, 3.5b) and development of 3D models of the structure (figs. 3.6, 3.7). These later served as input data for the finite element modeling.

Detailed examination of the form and role of each structural element covered the foundation system, the steel frame on which the structural frame of the tower moves, the

Fig. 3.5a. Full section of the villa.

Fig. 3.5b. Villa plans (top left to bottom right): configuration of the foundational structures at the cellar level; open hall level; ground floor of the upper part of the villa; first floor of the rotating structure.

Fig. 3.6. 3D models of the villa.

Fig. 3.7. 3D models of the load-bearing concrete frames of the villa.

Fig. 3.8. Construction of the Excelsior concrete and masonry slab, 1931.

load-bearing concrete columns, and other elements of the load-bearing frame of the tower (which includes a form of Vierendeel truss [Brunoli and Armenise 1939]), a complex lattice-reinforced concrete slab over the open hall of the basement, and the floor slab that forms the base of the rotating structure (fig. 3.8). The beams of the external circle are characterized by a rectangular section. They are connected

to the foundation columns downstream and placed directly above the ground upstream, where the design was later altered to complete the rotation path. Such geometry is respected also for the inner circles, characterized by different geometries of the beams. The three arc layers are connected by stiffening beams, placed with a variable spacing and non-radial geometry. The frame is completed by a central reinforced concrete thrust ring with a rectangular section connected to the internal circle by beams.

The floor slab that constitutes the base of the rotating structure is constructed from square reinforced concrete blocks of variable thickness, connected by rectangular concrete beams of variable geometries, all covered by a thin single-piece concrete and masonry Excelsior-type slab, a standard concrete and masonry slab designed in Italy during the years of construction of the building, which is double ribbed (see fig. 3.8). The reinforced concrete columns that constitute the frame of the two rotating wings are attached to the concrete blocks of the floor slab. The frame is completed by connection beams along the whole perimeter of the building. These have a rectangular section, strengthened toward the columns.

The pavement of the first floor is placed over a Stimip B concrete and masonry slab (another common concrete system of the 1930s, double ribbed like the one of the ground floor). The frame of the first floor is similar to the one of the ground floor, apart from the different geometries of the structural elements. The roof is constituted of a single-ribbed Stimip A concrete and masonry slab.

The supporting frame for the covering of the roof terrace is constituted of eight reinforced concrete columns connected with beams. The load-bearing frame of the tower is directly connected to its reticular structure through concrete cantilevers that sustain a circular beam. Such beams support six squared columns that connect to a top circular beam. The roof of the tower is made of concrete-framed glass blocks.

All the concrete structural elements are made using high-quality Granito portland cement produced by Italcementi. Such hydraulic binder is produced from specially selected mixes of limestones and clays, and it is finely ground to guarantee rapid setting and high strength gain during the first twenty-eight days. The steel rebar was produced by Soardo.

The infill walls of the rotating building are made of an innovative composite material called Eraclit. It consists of two panels of wood wool separated with steel spacers to create a 25 cm cavity. The panels are fixed to a zinc-coated steel frame and plastered on the interior. On the exterior, a timber frame supports a thin layer of bituminous felt

covered by 0.8 mm Aluman foils, fixed through Anticorodal screws. Both Aluman and Anticorodal are lightweight aluminum alloys with magnesium, silicon, and manganese. They are derived from the aeronautic industry and characterized by high flexibility, mechanical strength, and resistance to degradation.

Testing

An overall degradation survey was performed by thorough on-site visual inspection and recording. Despite the overall good condition of the structure, several cracking patterns were observed both in the rotating upper part of the building and in the fixed cylindrical basement. The worst damage was to the rotating part, where severe degradation of the concrete frame and the concrete and masonry slab was identified at the roof terrace level. The open hall of the basement had a crack on the floor around the main entrance, also visible from the cellar beneath. Secondary damage was noticed in the walls of the open hall, in the staff rooms, and in the cellar aisle, where a long horizontal crack located at a height of 1 m from the floor highlighted a sliding mechanism between the top and the bottom parts of the masonry wall.

The Laboratorio provinciale prove sui materiali di Verona (Provincial Materials Testing Laboratory of Verona) took a very minimal number of samples so as not to remove excess original material or risk compromising the overall safety level and soundness of the building. The sampled materials tested included:

- two microcores to determine concrete carbonation depth, according to UNI 9944:1992
- two cores to determine concrete compressive strength, according to EN 12504-1:2009 and EN 12390-3:2009
- six samples of reinforcement bars to determine their tensile strength, according to EN 10002-1:2004

The two microcores were extracted from two different parts of the building. The number of cores was minimized due to the heritage significance of the building, and the locations were carefully selected to ensure they were as representative as possible. The first (MC1) was from a reinforced concrete beam of the rotating floor slab, and the second (MC2) was from a reinforced concrete column of the fixed cylindrical support basement near the entrance to the garage. The values for the carbonation depth were 45 and 65 mm, which is typical of the rate of carbonation one would expect to find in concrete of this date and higher than the mean value of concrete cover thickness determined during the inspections, which ranged between 25 and 65 mm. However, there was no evidence of reinforcement corrosion due to carbonation. Nevertheless, the carbonation depths recorded underlined the necessity of monitoring future possible progression of the carbonation

Table 3.1. Results of the uniaxial compressive strength tests on the sampled concrete cores.

Id	Weight (g)	Height (mm)	Average diameter (mm)	h/Ø	Density (kN/m³)	Maximum load (kN)	Compressive strength (N/mm²)
C1	244.0	53.5	50.0	1.10	23.23	60.75	30.9
C2	236.0	52.9	50.0	1.10	22.72	33.31	17.0

Table 3.2. Results of the tensile strength tests on the sampled rebar.

Id	Diameter (mm)	Yielding		Failure		f_t / f_y	Elongation (%)
		(kN)	f_y (N/mm²)	(kN)	f_t (N/mm²)		
F1	5.86	9.4	347.1	13.1	484.3	1.39	29.1
F2	5.61	13.0	525.2	14.8	598.3	1.14	18.4
F3	7.71	16.2	346.3	20.8	445.1	1.29	N/A
F4	7.23	16.4	398.2	18.8	458.5	1.15	N/A
F5	4.99	7.2	368.4	9.2	472.6	1.28	23.7
F6	5.08	6.1	301.4	9.6	475.9	1.58	31.6

front in order to avoid extensive degradation of the structural elements.

Concrete compressive strength was also tested on two of the structural elements with different loading characteristics. The first core (C1) was extracted from a column of the structural frame of the rotating part, while the second (C2) was taken from the same basement support column already sampled to test carbonation depth. The results (table 3.1) highlighted significant differences in the concrete mixes used. These may reflect the deliberate choice of a stronger mix for the rotating part, since it would be subjected to unconventional loads relating to the movement. Alternatively, they may differ because manual mixing procedures during the early phases of reinforced concrete production were often inaccurate.

The rebar samples were taken mainly from concrete structural elements located on the roof terrace of the rotating structure. Two pieces of rebar were sampled from the edge beams of the terrace (F1, F2), and three pieces of rebar were sampled from the supporting frame for the covering of the roof terrace (F4, F5, F6). Only one piece of rebar (F3) was sampled from a column of the structural frame of the rotating building. The results of the tensile strength tests (table 3.2) were more consistent than the results of the concrete strength tests, probably reflecting the more consistent industrial production process. The obtained strength values suggested that a FeB32k type steel had been used (Zembaty and De Stefano 2016).

Testing was followed by a static assessment according to D.M. 09/01/1996. The aim was to compare the final results of calculations with both the original design method and current building codes. The Italian building code at the time of construction was the D.M. 10/01/1907, which required verifications according to admissible stress design. The required strength at failure for rebar was between 360 and 460 N/mm^2, whereas the required concrete compressive strength was 15 N/mm^2 or higher, so that the experimental values determined by the material testing program complied with what would have been required at the time of construction. Then, a global assessment of the whole structure was performed considering the more recent D.M. 09/01/1996, which requires the use of ultimate limit states for the structural design. Straus7 finite element model software (G+D Computing 2004) was used for this, initially just looking at main structural elements and then considering the presence of the infill walls as well.

The main outcome of the static assessments, according to the more recent standards, was that all reinforced concrete structural elements are still satisfying current standards and normative requirements.

CONSERVATION

Decay was most significant in two areas of the roof terrace level: in the topmost hollow flat tiles of the concrete and masonry slab near the edge concrete beam of the right wing of the upper rotating part of the building, and in the main concrete beam connecting the two wings. The cause of the former was an imperfect planarity of the rails' horizontal surfaces. Stresses were concentrated toward the edges of the roof terrace, causing extensive fracturing of the tiles and severe fracture of the concrete beam, with widespread corrosion of the rebar clearly visible (fig. 3.9).

Thorough inspection of the beam connecting the two wings of the building revealed severe damage to its sides, with widespread corrosion and breaking of the shear rebar due to water infiltration (figs. 3.10a, 3.10b). Over time, more waterproofing materials had been added in an attempt to address the widespread degradation due to water ingress. The original waterproofing system consisted of natural asphalt along the gutters and on the vertical coverings along the borders of the terrace, while the remaining parts were covered by a complex sandwich of a layer of Ruberoid felt bitumen, two thick layers of tar paper, and four layers of Holzcement, a waterproofing material that consists of four or five tar paper layers bound together with a bitumen varnish.

Demolition work revealed two additional waterproofing layers that had been overlaid on the original system over the years. Such thick and complex layering, however, failed to prevent a progressive loss of waterproofing properties; thus a complete replacement system was included in the repair strategy.

The project to repair the roof terrace was developed and managed by architect Simone Nicolini, with the technical support of structural engineer Claudio Modena and architectural advice provided by Aurelio Galletti. The concrete repair was undertaken by Fratelli Montresor S.n.c. and Veronese Costruzioni S.r.l., while the waterproofing works were executed by Beretta e Peruzzi Manti Impermeabili S.r.l. Given that the developed models did not indicate serious structural issues in the basement section of the house, the complete repair work for this area has been postponed until a final end use for the house is determined.

For the repair of the damaged terrace slab of the right wing of the building, concerns arose as to whether simple conservation of the damaged structural elements to their original condition was sufficient, or whether the structure should be upgraded to accommodate an increased load if one was required by a new future end use. With the adoption of the first strategy, it would not be necessary

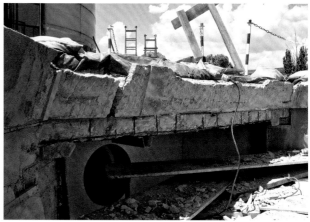

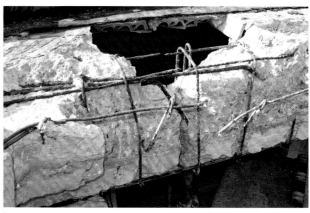

Fig. 3.9. Degradation of the right wing of the rotating part at the roof terrace level, showing cracks in the edge beam, 2003.

Figs. 3.10a and 3.10b. Degradation of the beam connecting the two wings of the building, before (a) and after (b) the removal of the concrete collar, 2003.

to introduce a new edge beam for reinforcement. This would limit the intervention to reconstructing the sections of both rebar and concrete, substituting the damaged rebar, and filling the cracks in the damaged flat tiles, with possible replacement of the most damaged tiles around the edge beam with a new reinforced concrete jacket or covering. For the second option, the bearing capacity of the slabs for the new expected loads would need to be estimated. The project aimed for a conservation approach based on the principles of minimum intervention, but also considered the need to ensure an adequate structural repair. Therefore, a mixed approach was chosen using repair products of a new generation that provided adequate load-bearing capacity without compromising the overall geometry of the treated structural elements.

Various solutions were considered for the repair of the cracks in the hollow flat tiles and to improve the structural behavior of the terrace area. The repair option finally chosen for the slab was strengthening by the application of carbon fiber–based foils and tissues (fig. 3.11). The detached superficial portions of both tiles and concrete elements were removed through sandblasting and pressurized air until a sound and dry surface was obtained. Then the external upper angle of the edge beam was rounded in order to allow the carbon fiber sheets to be bent around it (care was taken to ensure sufficient concrete cover was maintained). A layer of bi-component epoxy-polyamide primer (Degussa MBT MBrace Primer) was applied to the surface, and then a series of carbon fiber sheets (carbon fibers in polymer resin) with a 50 by 1.4 mm section and high elastic modulus (Degussa MBT MBrace Laminate) were glued on the treated surface with a thixotropic bi-component epoxy adhesive (Degussa MBT MBrace Laminate Adesivo). A layer of sand was applied on the lateral surface of the edge beam to increase the surface roughness, and the treated surface was refined with a final layer of

Fig. 3.11. General section of the repair strategies adopted for the right-wing slab.

Fig. 3.12. General section of the repair strategies adopted for the connection beam.

topcoat plaster applied through manual tooling to eliminate any possible superficial defect. The treated surfaces were finally covered by the new inclined screed and floor to restore the surface of the terrace.

The concrete beam connecting the two wings of the building was so badly damaged that a more invasive solution was required. Deep through cracks in the concrete toward the edges of the structural element had been caused by extensive water infiltration leading to severe corrosion of the rebar and the breaking of the shear bars (see figs. 3.10a, 3.10b). This beam was largely demolished and reconstructed by pouring within plastic formworks a fiber-reinforced, shrinkage-compensated cementitious mortar, with coarse aggregates added to the premixed product (fig. 3.12). Surface preparation of the existing concrete is critical to successful concrete repairs of this type to create a good bond with the existing concrete elements. Therefore, it is important to achieve a sufficiently rough surface exceeding 5 mm in

depth to guarantee an adequate bond with the new repair material, with the surface adequately prewetted. The possibility of preparing the surfaces by hydroblasting was rejected because of difficulties in water disposal, so sandblasting was adopted. This also provided the ideal surface roughness for the adhesion of the repair mortar.

Another important aspect of the repair strategy consisted of the repair of damaged sections and external renders of the reinforced concrete columns and beams that make up the frame at the terrace sides. Despite being covered by a thick layer of cementitious render, the structural elements were characterized by extensive carbonation of the concrete, up to 5 to 6 cm in depth, with consequent corrosion of the rebar. All the areas repaired were prepared by cutting out and sandblasting. The shallower repairs were achieved using a polymer-modified cementitious mortar applied by manual tooling. Larger repairs where sections were to be reconstructed were poured-in-place,

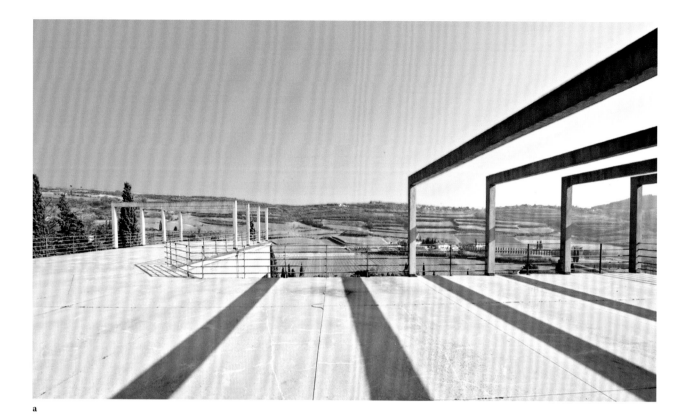

a

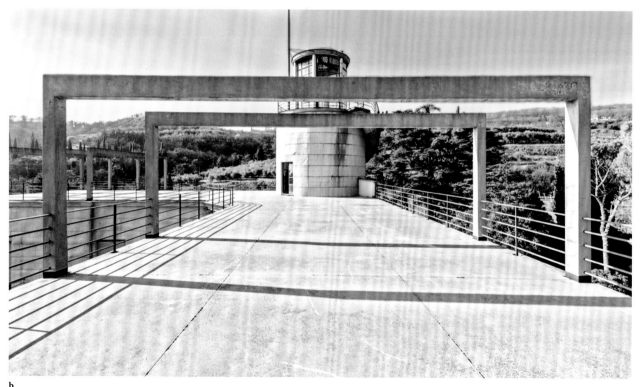

b

Figs. 3.13a and 3.13b. Final result of the conservation campaign of the roof terrace, 2015. Photos: Diego Martini

fiber-reinforced, shrinkage-compensated cementitious mortar with coarse aggregates, with a topcoat of render, followed by an invisible layer of siloxane-based hydro-repellent and anti-carbonation coating.

Although it would have been preferred to preserve the original screed and waterproofing system of the terrace, this did not prove possible due to the extent of damage, and both were replaced. The concrete and masonry slab was completely exposed, then a new inclined screed was poured using special cementitious mortars with high fluidity and cohesion in order to consolidate the original hollow flat tiles. There was no need to add insulation, as this was adequately provided by the existing construction. The waterproofing system was built up by applying a multilayer membrane system laid over a cementitious mortar to provide a first impermeable layer. The final result was a perfect reconstruction of the roof terrace to its pristine state (figs. 3.13a, 3.13b), which guaranteed an adequate usability of the floor while ensuring a watertight system to prevent future water ingress and decay.

CONCLUSIONS

The research, diagnostic work, and subsequent conservation campaign conducted on Villa Girasole has shed light on the unique characteristics of an unknown showpiece of early reinforced concrete construction, revealing its significance and addressing its ongoing deterioration and decay. The combination of material quality and thorough design procedures allowed construction of a building that still satisfies contemporary structural requirements despite the natural decay of the structural materials.

The conservation philosophy aimed to preserve the overall features and aesthetics of the structure through targeted and minimally invasive interventions. This conservation strategy may, however, need to be revisited in the near future. The recent change of ownership from the Invernizzi family, initially to the Girasole Foundation and now the Cariverona Foundation, may demand the upgrading of the structure to meet any new proposed end-use requirements. Any revised strategy must be capable of guaranteeing the ongoing maintenance of the building while respecting the cultural significance of this work of art. Bringing the building back to use will probably necessitate the application of additional and more invasive conservation strategies that are sufficient to solve the issues of the structural foundations and seismic performance, while also allowing restoration of the functionality of its peculiar rotation system. However, this may be the only option that can guarantee a lively future and well-deserved public recogni-

tion for Villa Girasole, and hopefully preserve the visionary dream of its owners and designers.

ACKNOWLEDGMENTS

The authors would like to thank Fondazione Cariverona and SM Ingegneria, in particular engineer Mirko Sgaravato, for their support during the on-site inspections and for access to the archives. They further thank Michele Mascalzoni (www.michelemascalzoni.it) and Diego Martini (www.phplus.it) for granting permission to use their photos of the building. Many thanks as well to Francesca Andolfo for revising the English text.

WORKS CITED

Brunoli, Carlo Luigi, and Leopoldo Armenise. 1939. *Calcolo delle travi reticolari (vierendeel) in ogni condizione di carico e di vincolo*. Milan: Hoepli.

D.M. 09/01/1996. Norme tecniche per il calcolo, l'esecuzione ed il collaudo delle strutture in cemento armato, normale e precompresso e per le strutture metalliche.

D.M. 10/01/1907. Allegato B—Prescrizioni normali per l'esecuzione delle opere in cemento armato.

D.M. 14/01/2008. Norme Tecniche per le Costruzioni.

EN 10002-1:2004. Metallic materials—Tensile testing Part 1: Method of test at ambient temperature.

EN 12390-3:2009. Testing hardened concrete—Part 3: Compressive strength of test specimens.

EN 12504-1:2009. Testing concrete in structures—Part 1: Cored specimens—Taking, examining and testing in compression.

G+D Computing. 2004. Straus7 Release 2.3.3 Finite Element Analysis.

da Porto, Francesca, Maria Rosa Valluzzi, Elena Stievanin, and Claudio Modena. 2009. "Appraisal of Two Early Twentieth Century Composite Masonry-Concrete Structures: The Civic Theatre in Schio (Italy, 1907) and the Carraresi's Castle in Padua (Italy, XIII Century)." In *Evolution and Trends in Design, Analysis and Construction of Shell and Spatial Structures: 50th Anniversary Symposium of the International Association for Shell and Spatial Structures (IASS); Valencia, Spain, 28 September–2 October, 2009*, edited by Alberto Domingo and Carlos Lázaro, 697–709. Valencia: Ed. de la UPV.

UNI 9944:1992. Corrosione e protezione dell'armatura del calcestruzzo. Determinazione della profondità di carbonatazione e del profilo di penetrazione degli ioni cloruro nel calcestruzzo.

Zembaty, Zbigniew, and Mario De Stefano. 2016. *Seismic Behaviour and Design of Irregular and Complex Civil Structures II*. Cham, Switzerland: Springer.

FURTHER READING

Cappellato, G. 2000. "Villa il Girasole, Marcellise, Invernizzi Fagiuoli." *Area* 49: 82–89.

Griffini, Enrico. 1932. *Costruzione razionale della casa*. Milan: Hoepli.

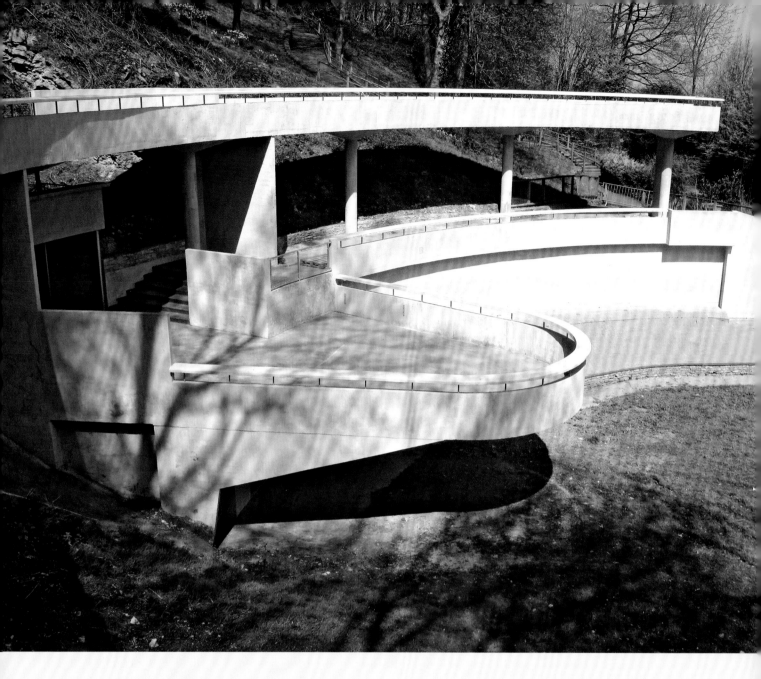

4

Stuart Tappin

Dudley Zoological Gardens

Dudley, England | 1937

ARCHITECT/DESIGNER

Tecton Architects | Ove Arup, engineer

PROJECT DATES

2011–15

PROJECT TEAM

Bryant Priest Newman Architects | Stand Consulting Engineers

CLIENT/BUILDING OWNER

Dudley Zoological Gardens

INTRODUCTION

The town of Dudley is in the West Midlands of the United Kingdom. It lies within an area that became known in the mid-nineteenth century as the Black Country, a reference to the pollution generated by the thousands of ironworking foundries and coal mines when this region was a center of industry and manufacturing. "Black by day and red by night" was how Elihu Burritt, the American consul to Birmingham, described it in 1868, and this could have equally applied in 1935 when the proposals for a zoo were first developed.

The zoo is located on a small hill below the ruins of Dudley Castle. The site was owned by William Humble Eric Ward, the third Earl of Dudley. Ward, together with a local businessman, Ernest Marsh, and Captain Frank Cooper, formed the first board of directors of the Dudley Zoological Society. Cooper owned Oxford Zoo and was looking to close it and find a new home for his animals. Doctor Geoffrey Vevers, the superintendent at London Zoo, was appointed as their adviser. Vevers had recently worked with Tecton Architects, led by Tbilisi-born Berthold Lubetkin (1901–1990), at London Zoo, where they had designed the gorilla house and the penguin pool with structural engineer Ove Arup (1895–1988). Arup had recently left the contractor Christiani and Nielsen, and his involvement at Dudley was as the director responsible for designs and tenders at J. L. Kier and Company.

The directors at Dudley set a timetable for the zoo to open in the spring of 1937, which meant that design and construction had to proceed at a rapid pace. In addition to the tight schedule, there were further pressures from dealing with the Ancient Monuments Department of the Office of Works, which was concerned about the setting and integrity of the castle. There were also unexpected

engineering challenges from the unrecorded and obsolete tunnels and mines once used for the extraction of limestone and coal below the site. One consequence of these factors is that it appears that much of the final design was carried out on-site by the project architect, Francis Skinner, and Kier's resident engineer, Ronald Sheldrake (Allan 2012, 221). There were also compromises to the design, most notably for the bear ravine structure (fig. 4.1, postconservation view), where problems with the ground conditions reduced the three-quarter circular plan and stepped form to less than a half-circle with a level viewing platform.

The zoo opened to the public on May 6, 1937, and two weeks later the front page of the *Dudley Herald* reported, "Bewildering Bank Holiday Traffic Scenes on Castle Hill. Estimated 150,000 Visitors—50,000 Admitted" (*Dudley Herald* 1937). By the end of that first summer, the zoo had welcomed nearly seven hundred thousand visitors. The main interest was undoubtedly the animals, but the buildings were also an attraction. For many, it was likely their first experience with modern architecture.

Twelve of the original thirteen buildings constructed for animals or visitors remain; the penguin pool was demolished in 1979 (fig. 4.2). All are now listed grade II* or grade II and together they form, arguably, the most complete set of buildings of the modern movement period in the UK.[1] The national and international importance of these buildings and their perilous state led to them being placed on the 2010 World Monuments [Fund] Watch list.

THE PROJECT

The design team of Bryant Priest Newman Architects and Stand Consulting Engineers was appointed in 2011 to prepare an application to the Heritage Lottery Fund (HLF) for the repair and refurbishment of four of the structures: the entrance, the bear ravine, and a nearby kiosk, all individually listed at grade II*, and the grade II listed shop, originally known as the Station Café. They were all generally in poor condition, with some parts of the bear ravine in a very poor state with extensive areas of spalled concrete due to corrosion of the reinforcement. A range of repairs had been carried out previously, including some using polymer-modified mortars. None of these repairs had addressed the underlying causes of decay or prevented further damage, and the majority of them had failed. A

Fig. 4.1. Dudley Zoological Gardens. The repaired bear ravine, 2015.

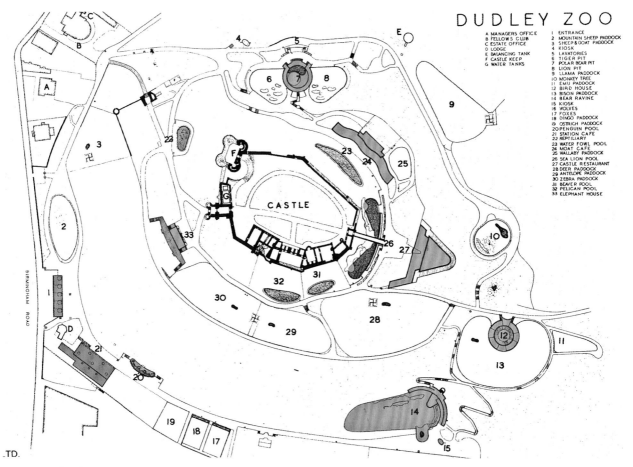

Fig. 4.2. Site plan showing the layout of the Tecton-designed buildings: (1) entrance, (21) Station Café, (14) bear ravine, (15) kiosk. Map: Courtesy Dudley Zoological Gardens

number of earlier reports concluded that a combination of major repairs and partial rebuilding was required.

None of the structures were in use as originally designed, and they were all in a state of neglect. The original entrance was located on Castle Hill, close to the Dudley town center. This was ideal when visitors arrived by bus or tram, but by 2009 that entrance was partly boarded up, as the majority of visitors were arriving by car and parking on the opposite side of the hill, entering near the former Station Café. This building had seen a number of different uses, and in 2011 it was serving as the zoo's souvenir shop. Both the bear ravine and kiosk were disused.

INVESTIGATIONS: BACKGROUND RESEARCH, ANALYSIS, DIAGNOSTIC WORK, TESTING, AND TRIALS

From the outset, the client agreed that the approach to the project would be the same as that for pre-twentieth-century historic buildings. This involved first gaining an under-standing of the form and condition of the structures in order to target repairs based on the principles of using compatible materials and the minimum amount of intervention into the historic fabric wherever possible. A key part of this approach was not to repair unless there were clear signs of damage. For example, poorly formed construction joints and local irregularities in the surface from poor compaction of the concrete would be retained as a record of how the structures were built.

The appraisal began with a visual assessment of the structures and a review of the historical documents held in the zoo's archive. This extensive record allowed us to build up a detailed picture of the structures, their intended uses and original forms, and an indication of the original color schemes. Copies of the original Tecton drawings clearly outlined each structure's intended form. Photographs taken soon after completion showed materials and finishes, and even though they were black and white, the tones provided an indication of the use of color. These

photographs also helped to identify elements that had been altered. For example, the "ZOO" lettering on the front of the entrance kiosks was thought to be original, but a review of the archive found that the Z had a slightly different shape on the corners, revealing that at least one letter had been replaced at a later date. The archive contained visitor guides from every year dating back to the zoo's opening. On the souvenir program from 1937, a hand-painted image of the entrance clearly showed red lettering with a white border.

The next stage was a visual assessment of the structures. Questions posed included: How would they have been designed? How were they built with reinforced concrete in the 1930s? What was the quality of the construction? How had they been altered or repaired? From this process, it was possible to get a general "feel" for the structures, assess if the defects were generic or specific, and identify if there were particular structural issues.

The entrance, with its undulating reinforced concrete roof structure, was now used only during peak times. Several of the entrance building's five brick kiosks had been boarded up, the turnstiles had been removed, and each element of the structure had been painted with a variety of inappropriate colors. The proposal was to strip away all of the added items, reopen all of the kiosks, and reinstate the original design.

Of the four buildings, the Station Café was the most changed since 1937. Through the years, the building had been altered as its use changed to a fish-and-chips shop, a nightclub, and finally the zoo's souvenir shop. The original open, windowless pavilion style of the building had been lost amid the changes and clutter, and partitions had been installed enclosing sections of the building for storage. Other areas were simply abandoned. The proposal was to remove all of the later additions and reinstate the open layout. In accordance with the wider master plan for the zoo, the shop was to provide a proper entrance for visitors and an interpretation space to explain the history of the zoo and its buildings (fig. 4.3).

The bear ravine and kiosk were the most unchanged due to the fact they had been left unused for many years. This neglect meant that the bear ravine in particular was in very poor condition, with large sections of concrete missing and exposed reinforcement. The approach for these two structures followed the principle of reinstating the original design, although the enclosure will not be used to house bears again.

The structural assessment found that the majority of the problems with all four buildings were due to corrosion of the reinforcement. In many areas, the cover to the reinforcement was much less than the 1 in. (25.4 mm) cover for main bars and ½ in. (12.7 mm) for secondary reinforcement recommended in the *Report of the Reinforced Concrete Structures Committee of the Building Research Board with Recommendations for a Code of Practice of the Use of Reinforced Concrete in Buildings* (Department of Scientific and Industrial Research 1933).

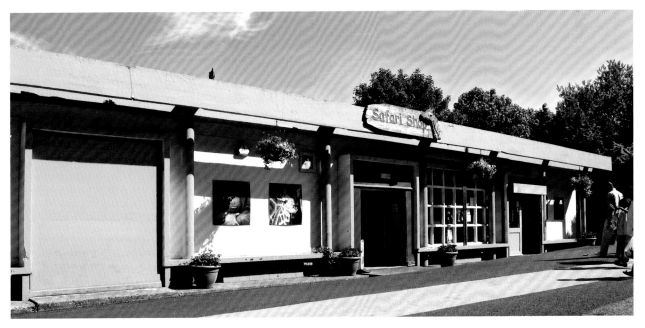

Fig. 4.3. The shop before the works, 2011.

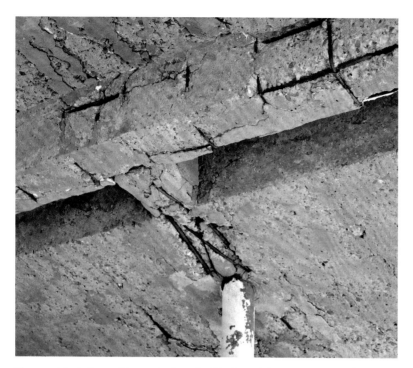

Fig. 4.4. A typical area of damage to the underside of one of the entrance canopy slabs, 2012.

There were, however, some areas with structural problems generated by their daring form. At the entrance building, transverse cracks were identified in similar locations on the top faces of each of the five curved slabs. There were also concerns about the integrity of the connection between the tops of the solid steel columns and the roof slabs. At the bear ravine, there were cracks in the side walls of the cantilevered viewing platform, a longitudinal crack in the top face of the slab above a downstand beam, and a distinct bounce when walking at the outside edge of the platform.

Concurrent with the initial work to prepare a report for the HLF, a series of investigations and tests were carried out by Rowan Technologies. Schmidt hammer tests found the compressive strength to be mostly in the range of 40 to 55 N/mm², with only a few readings between 30 and 40 N/mm². All the readings were greater than the minimum cube strengths for the four categories of ordinary grade concrete listed in table 1 of the 1933 Building Research Board report (Department of Scientific and Industrial Research 1933, 21). This, combined with our own assessment, confirmed that the strength of the concrete was not a concern.

Tests on samples of the concrete found the chloride and sulfate levels to be within acceptable levels. The main issue was the combination of widespread, inadequate concrete cover to the steel reinforcement and carbonation depths reaching up to 40 mm. The curved roof slabs of the entrance generally had a cover on the top surface of between 13 and 65 mm with only occasional signs of corroding bars on this face. On the undersides of the roof slabs, however, the cover meter survey was hardly required, as large areas of reinforcement were clearly visible through the many layers of paint. A fundamental question was, why was the concrete cover to the reinforcement so poor?

There is little information from the 1930s about how reinforcement was to be supported during concreting. One contemporary reference, in *Cassell's Reinforced Concrete*, mentions the use of notched timber templates that "can be removed shortly after the concreting has begun, quite a small quantity of concrete sufficing to hold the rods in place" (Jones and Lakeman 1920, 140). If this was the method used here, then the undulating shape of the slabs meant it was almost inevitable that the bars would slump toward the bottom of the wet concrete and rest on the shuttering. We can only surmise that the pressure to open the zoo to the public led to a make-do approach, with a render coat and paint applied to hide the exposed reinforcement (fig. 4.4).

There were also areas of exposed reinforcement and spalled concrete present at the shop and kiosk buildings, but the greatest damage was to the bear ravine. On the

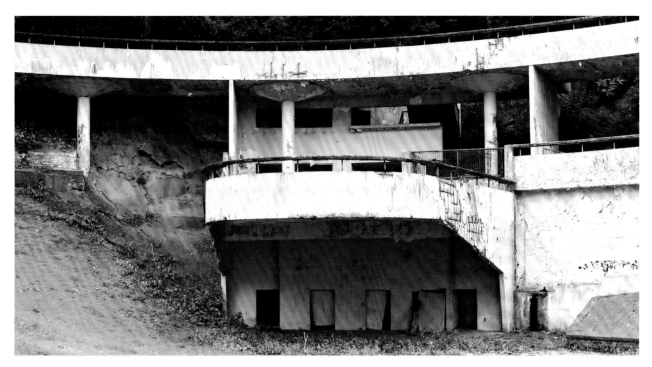

Fig. 4.5. The bear ravine prior to repairs, 2011.

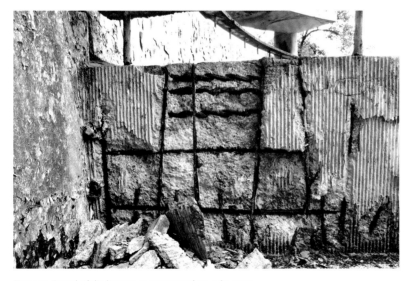

Fig. 4.6. Detail of the bear ravine prior to the works, 2012.

cantilevered viewing platform, there were large areas on both faces of the parapet where the concrete had fallen away and exposed the corroded reinforcement behind. The extent of corrosion to some of the circular hollow steel columns around the stairwell to the upper viewing level was of sufficient concern to prompt immediate installation of temporary props (figs. 4.5, 4.6).

By the end of this initial appraisal, the report to the HLF placed the structural defects into two broad categories. The majority were due to poor-quality construction and subsequent deterioration, with a second, smaller category of damage that indicated structural issues that would require a more extensive intervention. The initial appraisal also confirmed that the proposal to avoid modern polymer-modified

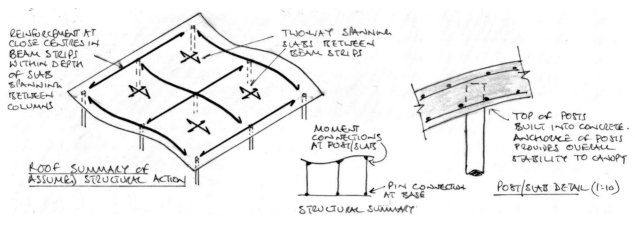

Fig. 4.7. Structural summary of entrance roofs.

materials, and instead use traditional concrete for the repairs wherever possible, was feasible. As with more traditional forms of construction, the use of compatible materials reduces the risk of future differential movements due to thermal expansion and contraction or changes in the moisture content. In addition, for listed structures with exposed concrete like these, a standard concrete mix will provide a closer visual match to the original fabric. This approach has been advocated by the authors alongside the Twentieth Century Society since 2009 and promoted at the annual course on concrete conservation at West Dean College in West Sussex. The tendering of the project at Dudley also coincided with the publication of an English Heritage book on the conservation of concrete that recommends a similar approach (Odgers 2012).

The next stage, begun in early 2013, was to undertake trials on part of the entrance to ascertain the best method of removing the layers of paint while maintaining the concrete's surface texture and board marks. Abrasive cleaning with varying types of blast medium and air pressures was tested until the best balance of effective paint removal and limited damage to the existing surface was found. A trial repair was specified on an area of spalled concrete on the shop to explore methods of how best to remove the damaged concrete and deal with the limited concrete cover to the reinforcement, trial the proportions for the cement-to-aggregate repair mix, and test the best methods of matching the surface finish. While carrying out cleaning and repair samples on the structures, a paint survey was undertaken to analyze the layers of paint present on the different surfaces. This microscopic analysis established the color history of the structures and, more importantly, the original finishes and colors.

How the Structures Work

The Entrance

The entrance to the zoo is formed of five undulating reinforced concrete slabs above individual ticket kiosks that are built of brickwork and timber. Each roof slab is 175 mm thick and approximately 7 by 7 m on plan. The slabs have a projecting edge beam on three sides that prevents rainwater runoff from staining the outside edges. The slabs are supported on nine solid steel posts, each 90 mm in diameter, on a grid of 3 by 3 m. The posts bear onto shallow concrete pad foundations. Two layers of ½ in. (12.7 mm) plain round bars that were observed close to the surface of the soffit indicated that they were designed as two-way spanning slabs. The overall stability is provided by a moment connection between the head of the columns and the slab. The entrance is on sloping ground, and the design cleverly exploits this by having the end of one slab overlapping the next. At each overlap, the three edge columns pass through the lower slab and into the slab above, a detail that provides an additional restraint against lateral movements. This is summarized on the extract from the project drawing by Stand Consulting Engineers in fig. 4.7.

The Station Café / Souvenir Shop

The souvenir shop is a more conventional structure with reinforced concrete walls 100 mm thick and three rows of circular reinforced concrete columns. These columns support the roof, which is formed by a slab 125 mm thick and upstand beams. Three of the internal concrete columns had been removed and replaced with steel beams and columns. Once the works started, it was found that these

alterations had been made to provide a lowered dance floor area during the building's brief life as Bentley's Night Club in the 1970s.

The Bear Ravine and Kiosk

The bear ravine sits into the hillside with the upper level formed by flat slabs supported on mushroom-head columns with thin reinforced concrete walls and hollow steel columns around the stairwell. The cantilevered viewing platform is a more complex structure. The 130 mm-thick slab is supported at the rear by the concrete walls to the bear pens below and propped at mid-span by a downstand beam 350 mm deep by 200 mm wide (see fig. 4.5). The outside edge of the slab is connected to the 100 mm-wide concrete parapet wall that acts as a deep beam that is anchored back to the main structure at each end. The structural action of the parapet as a beam was confirmed when lines of twisted reinforcing bars were observed close to the top of the beam. These are Isteg bars, a patented reinforcement that was developed in Germany and introduced to the UK in the early 1930s (Emperger 1934) (see fig. 4.6). The system used pairs of plain steel bars twisted together so that the cold-working increased their tensile strength by about 50%. They were advertised for use where a higher tensile strength, compared to ordinary steel bars, was required. Spandrel panels below the parapet at each end act as a prop to the parapet walls and provide a support to each end of the downstand beam. Both faces of all the parapets have a ribbed finish, and a small piece of corrugated steel found during the repairs confirmed that this finish was cast.

The small kiosk near the bear ravine uses a combination of reinforced concrete walls and hollow circular steel posts to support the 150 mm-thick elliptical roof slab.

Phasing and Procurement

A strategy for phasing the works was developed, beginning with the entrance and the souvenir shop. As the ticket office in the shop was to be closed during the refurbishment, the works to the entrance also had to be phased to maintain access for visitors. These are the first two buildings that visitors see, so beginning the works there provided an immediate impression that the zoo was improving as an attraction and caring for its building stock. Another consideration was to use these two buildings as a learning exercise for the project team and contractor before embarking on the more extensive works required on the bear ravine. There was also a concern that the scale and extent

of repairs needed on the bear ravine could take a sizable slice of the funds to the detriment of the other buildings.

The majority of the works to the entrance involved concrete repairs, but the shop was a more general refurbishment with the concrete repairs representing just one part of the overall scope of works. Based on this, it was decided to have a tender that included a general contractor and concrete repair specialists. In this second group, we included contractors who dealt exclusively with concrete repair and specialist stonemasons experienced in concrete repairs. A local contractor from this second category was appointed.

The grant from the HLF included the cost of a clerk of works and two apprentices who would study part-time and gain practical experience by working alongside the contractor.[2] The aim was for the apprentices to remain at the zoo at the end of the contract to deal with ongoing repairs and maintenance of the other structures. Finding a clerk of works proved to be more difficult than envisaged, and although candidates were interviewed, no one suitable had been found by the time the work started on-site. However, the eventual outcome proved to be very beneficial, as described below.

The Procurement Process and Information Provided

The tender, or procurement, processes and the information developed through them are important parts of any conservation process. Thoughtfully managed, they can greatly assist in developing a detailed scope of work and help to identify suitable contractors for the work. The Dudley Zoo tender package included drawings and a specification for an initial strip-out that facilitated more detailed inspections and trials. This was informed by research of historical documents and site investigations, and contained detailed drawings that identified areas to be removed—and, equally important, areas and items to remain untouched.

The findings from the various tests, trials, and investigations were all incorporated into the tender package. This included drawings of the existing structures that recorded the areas of damage seen and those areas still covered with finishes where defects could be expected. Clauses in the tender package set out a process of investigations followed by a review of the findings by the project team before final details could be issued. This included most of the inside of the souvenir shop, which continued to trade until the start of the works. Plans and details for the proposed works recorded the known defects and indicated allowances for repairs to be confirmed once the structure was exposed. The repairs were cross-referenced to the specification,

which provided details and methodologies for a number of types of concrete repair. These were referenced to the position (top, side, or soffit) and to the anticipated depth of the repair. This allowed the contractor to cost the scope of works and identify which repair to use for each location.

The standard repair for use on the top of level surfaces and vertical faces was a 1:2:4 mix of cement to sand to aggregate, to match the original concrete. Aggregate up to 10 mm was used in the mix for larger areas of repair work. Shallower repairs used a 1:3 or 1:4 mix of cement and graded aggregate up to 5 mm in size. The procedure was for the edges of the damaged concrete to be cut out using a small disc cutter, taking care not to cut the reinforcement. The arrises were slightly undercut to improve the mechanical adhesion of the repair material. The loose and damaged concrete was specified to be removed so that the entire surface of the exposed reinforcement bars was accessible. These were then cleaned to a bright and shiny finish, given an anticorrosion coating, and covered with a cement slurry immediately before the concrete was placed. In general, the concrete had a plain finish, but the repair was required to match the existing finishes, including lines of joints between the original shutter boards.

There were some locations, mostly to the soffit of the slabs and beams, where a repair using a traditional concrete mix was not possible without significant implications for the historic fabric. Either it would involve the removal of all the existing concrete to re-cast around retained reinforcement, thus sacrificing significant amounts of historic fabric, or the thickness of the slab would have to be increased to place concrete from below in order to provide an acceptable cover to the bars. This option would have structural implications from the additional weight of concrete and would have significantly changed the appearance. Both of these options were rejected. Instead, a 4 mm-thick polymer-modified repair render was applied to the cleaned and primed surface and then manually worked on the surface to match the surrounding, original board marks. For the entrance roof slabs, the tender drawings provided an allowance for this render coating to all of the soffits.

The soffit within the shop was hidden by a suspended ceiling, but an adjacent storeroom showed a considerable amount of exposed reinforcement. It was believed that the rest of the soffit would be in similar condition, and this proved to be the case once all the finishes were removed. For reasons of economy, it was agreed that works could be deferred to the areas of the soffit where the damage was not structurally significant, and only the essential repairs were undertaken. This seemed a reasonable approach, as

new roof coverings meant the structure should remain dry; a plasterboard ceiling was also proposed that covered the majority of the soffit. This ceiling was also used to hide the services, such as cabling for new lighting and safety systems. A detail was developed to set back this new ceiling inside of new glazing around the perimeter of the building and allow the underside of the roof slab to be visible.

CONSERVATION

The contract for the entrance and souvenir shop started in September 2013, beginning with the strip-out and cleaning. The trial cleaning on the underside of the entrance slab had exposed a blue color, and when the entire structure was cleaned, it was found that this blue was used over the entire soffit. The edges however, showed no sign of blue. Microscopic analysis found a layer of dirt on the concrete beneath the first layer of paint, indicating that it had initially been left untreated for some time.

The stripped soffits revealed extensive corroded reinforcement and spalled concrete, confirming that the tender allowance to treat all the soffits was required. Another tender-stage allowance was to break out the concrete around a number of the column heads, install additional bars, and re-cast with new concrete. A trial investigation was carried out to the column head with the greatest amount of damage to the concrete. After the slab had been temporarily supported and the concrete locally removed, the reinforcement around the column was found to be in poor condition. The column was also found to have a 180 by 180 by 20 mm-thick welded head plate that had no significant signs of damage. For the trial repair, the hole formed through the slab was filled with new concrete. Elsewhere the contractor was able to repair the areas from below, either with a traditional concrete repair placed by a letterbox shutter, or with the polymer-modified render repair mix.

As mentioned earlier, there were cracks on the top surface of each canopy of the entrance building, which were on the hogging curve of the slabs. There were no obvious structural reasons for this, and the most likely cause was small-scale folding of the slab from thermal expansion and contraction. As it is not possible to stop these movements, the initial suggestion was to fill these cracks with a soft lime mortar and accept that this was an area that would need a higher level of ongoing maintenance. However, it was decided that water ingress into the slab had to be prevented to inhibit damage to the newly repaired and painted soffit.

The top of the entrance canopies had never been waterproofed and instead relied on a shallow fall to a small outlet

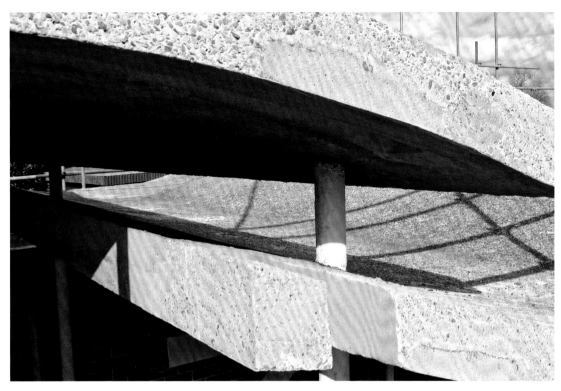

Fig. 4.8. Repair to the entrance canopy slab, 2014.

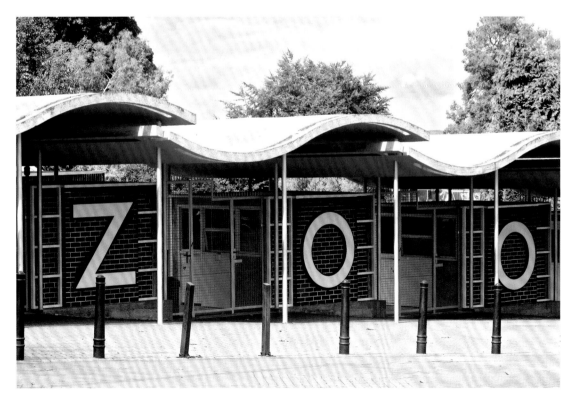

Fig. 4.9. The entrance following conservation work, 2015.

and drainpipe that ran through the kiosks below, although the majority of rainwater ran over the edges of the roof slabs. The concrete was, unsurprisingly, damp. A temporary covering was placed over each section to allow the structure to dry prior to any finish being applied. The tender package included provision to coat the top surface with a silane to stop water penetrating through the concrete. However, through further discussions with various specialists, it was concluded that any ponding water would eventually find its way into the structure.

A roof covering was therefore proposed and the design criteria included the need to be reversible and to accommodate thermal movements. It also needed to be visually acceptable, as the roof of the entrance building can be seen from the top of Castle Hill and the nearby chair lift. No flashings or mechanical fixings could be used, as this would impact on the slender edge detail of the wave forms. With the exposed location of the entrance, the new covering would also need to resist uplift pressures. Through discussions with the project team and agreement with the local conservation officer and English Heritage (now Historic England), a liquid applied membrane was selected. Resinset quartz was then applied to the top to match the surface color and texture of the existing concrete. The aggregate for the quartz was sourced from a local quarry to match the tone and consistency of the concrete. The resulting view from the chair lift is of five seemingly untreated concrete canopies (figs. 4.8, 4.9).

At the souvenir shop, the initial work involved the stripping out of all the internal fixtures and fittings and the removal of the external roof finishes. Once completed, we found that the top surface of the concrete roof structure was in much better condition than had been expected and required only a few local patch repairs. A single-ply membrane was installed as a waterproofing barrier atop new insulation. The infilled circular roof lights were reopened. Combined with the removal of the non-original brickwork above the timber window frames, this completely changed the feeling of the internal space, flooding it once again with natural light (fig. 4.10).

Part of the underside of the roof slab within the storeroom had been removed, and once all the finishes and the black paint (another remainder of the nightclub) were removed, the investigations could be completed and the scope of repairs finalized. The main issue with the underside of the slab was the poor concrete cover to the bars and a number of areas with exposed reinforcing bars that needed to be repaired. As most of the soffit was to be hidden behind a new suspended ceiling, a different approach was adopted for isolated exposed bars and hairline cracks.

Fig. 4.10. The shop interior after the works, 2014.

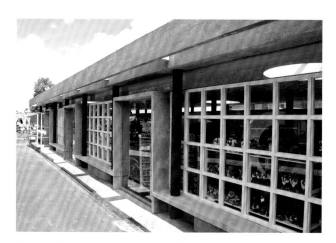

Fig. 4.11. The shop upon completion of repairs, 2014.

As mentioned above, in order to make the best use of available funds, it was agreed that if the current damage was not structural, not at risk in a fire, and not likely to deteriorate in the future, it would be left untouched.

The steel beams and columns that had replaced the two original concrete columns were removed and new steel columns installed onto new concrete pads that were placed around the original damaged foundations. Steelwork was used rather than re-forming in concrete because of the speed and ease of installation and the significantly lower cost. There was also a concern that modern concrete casting techniques might look too good next to the existing columns. Instead, a mold was taken from one of the original columns and used to create a glass-reinforced plaster casing, which was installed in two half sections around the new columns with the joints mimicking the cast lines in the original shuttering.

The most significant repair works to the shop were to the adjacent toilet block. A section of the cantilevered roof slab above one of the entrances was so friable that the concrete could be unpicked by hand. The rebuilt section was considered a piece of new construction and was designed for dead and imposed loads using modern codes. This required additional reinforcement alongside the original rebar before the section was re-cast to the original profile. To the rear of this building were two high-level windows that ran the full length of the building. Each of these openings was 6 m long and had a slender 130 by 130 mm-reinforced concrete mullion at mid-span. Once the damaged concrete had been removed, the reinforcement to one mullion was found to be in a reasonable condition. After cleaning and coating the bars, the mullion was re-cast with new concrete. The bars on the second mullion had lost a significant amount of their cross section and we prepared two repair options: re-casting in concrete with additional bars or replacing with a steel hollow section. After discussions within the project team and with English Heritage, the option for a steel post was agreed upon and installed.

The works to the entrance and shop were substantially completed on schedule and both opened in time for Easter 2014, to much acclaim (fig. 4.11). The zoo now knew how much money was left for the works to the bear ravine and kiosk. Of equal importance, the design team had tested the processes of repair and could develop the best strategy to tackle the more extensive repairs.

Unfortunately, the performance and general level of management by the contractor who had carried out the concrete repairs to the entrance and shop had deteriorated during the course of the project. One consequence of this was that one of their foremen applied for the position of clerk of works. His expertise in concrete and stone repair, and obvious enthusiasm for the project, presented a new possibility. Rather than act in a monitoring role as a clerk of works, he was employed by the zoo to lead the concrete repairs with an assistant and the two apprentices. The zoo now had direct control over the costs and quality of work. A general contractor who had worked on the first phase was used to provide the site mobilization and scaffold. The concrete cleaning, painting, and waterproofing were procured as separate packages by the zoo.

In contrast to the entrance and shop, much of the concrete surface to the bear ravine has a delicate corrugated finish (fig. 4.12). To avoid damage from abrasive cleaning, other techniques to remove debris and paint were tested; at the end of the trials, a two-stage approach was agreed upon. A ThermaTech superheated steam system was used to remove all organic contaminants and the majority of the coatings. Coatings that were more stubborn were treated with chemical strippers and carefully removed by hand. Areas that did not respond to this treatment were

Fig. 4.12. Detail of damaged concrete to the bear ravine's parapet during repairs, 2014.

Fig. 4.13. Bear ravine during the repair works, 2014.

cleaned using a very light abrasive program utilizing both wet and dry blasting. In a few areas, it was not possible to remove all the coatings without significant damage to the surface of the concrete, and it was agreed to leave these coatings in place.

The initial feasibility-stage review of the bear ravine had identified significant structural issues with the cantilevered viewing platform. Based on this, an allowance was made in the cost plan to remove all the concrete to the parapet and place additional reinforcement alongside the existing bars before the parapet was re-formed with new concrete. Allowance was also made for stiffening the cantilevered slab with a layer of mesh reinforcement within a high-strength cementitious render on the top and bottom faces.

With the slab propped by a support scaffold, the layers of paint were removed by the steam cleaning process along with loose and damaged areas of concrete. This revealed that the underlying concrete was in a much better condition than anticipated (fig. 4.13). This enabled the parapet to be repaired rather than rebuilt, as shown in figure 4.12. An alternative to the addition of mesh reinforcement to the slab was also explored.

Investigations found two layers of 9.5 mm (⅜ in.) diameter bars at 100 mm centers near the bottom of the slab. The

downstand beam had six Isteg bars at the bottom and 9.5 mm diameter links at 200 mm centers. Isteg bars were also found in the parapet wall, as can be seen in figure 4.6.

There is no record of the original calculations and there are, unsurprisingly, no specific guides for the imposed loads to be used in the design of a structure like this. The 1933 Building Research Board report (Department of Scientific and Industrial Research 1933, 56) has a category for "churches, schools, reading rooms, art galleries and the like" that gives an imposed load of 80 lb (36.29 kg) per square foot (4 kN/m²). The zoo does plan to allow controlled use of the viewing platform for visitors, but 4 kN/m² seemed excessive. A notional imposed load of 3 kN/m² seemed more reasonable on the basis that visitors could congregate along the prow of the platform. We also wanted to provide a structure that was stiffer than the original to reduce the risk of deflection-induced cracks, and make the platform feel more secure so as not to cause undue concern to visitors.

This imposed load was used to calculate the bending moments, shear forces, and span-to-depth ratios for the slab and beam. This found that the slab would theoretically be able to support the load, but the beam would, again theoretically, fail in bending and shear. From a review of

Fig. 4.14. Bear ravine after the repair works, 2015.

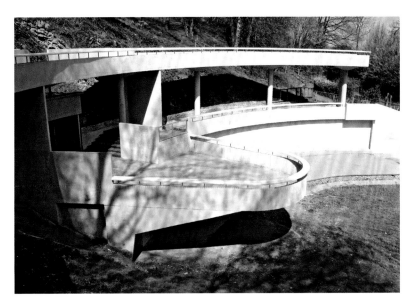

Fig. 4.15. The repaired bear ravine, 2015.

the calculations and the damage viewed on-site, it was concluded that remedial work should be targeted to address three areas: the general lack of stiffness to the slab; the lack of top reinforcement as indicated by the crack above the downstand beam; and the poor connection between the ends of the downstand beam and the spandrel panels.

This led to the proposal that remedial works be carried out using carbon fiber bonded to the concrete to provide the additional strength without any significant change to the thickness of the structure. Once the principle of this approach had been agreed upon by all parties, the works

were discussed with a carbon fiber specialist contractor, and one of the contractor's projects was visited to see how the carbon fiber sheets were fixed onto reinforced concrete. The values of the existing and proposed bending moments and shear forces were provided to the specialist contractor and were used by the contractor to develop a design. The proposal used two layers of 1 mm thick carbon fiber sheets that were applied locally to the slab to enhance the hogging and sagging bending moments. A single layer of sheeting was applied to stiffen the downstand beam. Carbon fiber cables were installed through two small holes

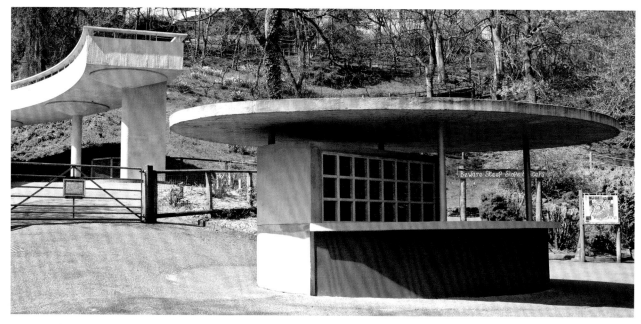

Fig. 4.16. The kiosk with bear ravine behind, following repair works, 2016.

drilled in each spandrel panel and then splayed out to link both sides of the beam with the outside faces of the spandrels. An unscientific heel-drop test found significantly less bounce in the platform than before the repairs. The surfaces of the walkways and viewing platform and the top of the kiosk canopy were treated with the same liquid membrane and quartz layer that had been used on the entrance canopies.

The concrete repairs to the bear ravine, though on a much larger scale than those undertaken on the other buildings, followed the same philosophy. Cement and aggregate mixes were used on all vertical and horizontal surfaces and the polymer-modified repair mortar was used for the undersides of the slabs. The quality of the repairs to the corrugated finish of the parapet walls was a significant achievement by the on-site team. A series of tools were developed, ranging from a float profiled by a latex mold taken from an original section of corrugated metal shuttering to a bespoke timber profiled float. The most useful tool turned out to be a simple round timber dowel that was used to line the profiles through. When breaking out the damaged concrete, any sound surfaces were left in place, no matter how small. These areas ensured that the rhythm of the corrugation matched the existing pattern (figs. 4.14, 4.15).

The structural repairs to the nearby kiosk were relatively minor. The hollow steel columns had all corroded at the base, which meant that the support to the roof relied on friction where the columns passed through the reinforced

concrete slab that formed the counter to the kiosk. Temporary props were installed before the permanent repair of steel sleeves was welded around the base of each post to reinstate the original support (fig. 4.16).

The works were completed early in 2015. Following this, the on-site team began work on the sea lion pool and the former reptiliary, now home to meerkats, which is the only enclosure never to have been painted. This work has been carried out in stages with the meerkats remaining in place; moving a colony is known to disrupt breeding by up to five years.

These repairs now form an important stage in the site's history. To record and communicate this to visitors, a section of the souvenir shop now houses an interpretive display telling the story of the zoo and its buildings. The display uses historical images of the zoo, information on its architectural significance, and a description of the repair works that have been undertaken. The surviving section of the Station Café's original, sinuous concrete counter, with its exposed reinforcement, is part of the exhibit.

During the works, it was proposed that ongoing monitoring of the repairs be undertaken by English Heritage (now Historic England). This will help to accurately assess the durability of the repairs and equip the organization with important information to help develop an understanding of best practices for concrete repair and conservation. The monitoring, which began in 2015, includes a photographic assessment at one-, three-, five-, and ten-year

intervals and corrosion rate mapping pre- and post-repair to assess changes in the corrosion rates of the adjacent reinforcement. Concrete hardness tests using a Schmidt hammer will be undertaken on repaired and surrounding concrete, and samples will be tested to assess changes in the alkalinity at various levels, through the depth of the concrete. Measurements at set distances away from the repair will also test whether the high alkalinity of the new concrete repairs will migrate into the adjacent original concrete.

CONCLUSIONS

The works to the four structures at Dudley Zoo have demonstrated that it is possible to successfully carry out conservation-based repairs to historic reinforced concrete structures. The overall program was set up to allow adequate time during both the design and the construction stages to carefully consider what works were required and how best to execute them. Options were prepared to evaluate key issues such as how much original fabric can be retained and the maintenance of the original appearance. After weighing the implications of each option, a pragmatic approach to the limited use of modern repairs was agreed upon and adopted.

The majority of the defects were due to poor concrete cover to the reinforcement. The repairs involved fully exposing the reinforcements so they could be cleaned and coated, with either an anticorrosion paint or a cement slurry, before the new concrete was placed. This approach also provided some clear space so that by hammering the bars it was possible to improve on the amount of concrete cover. Wherever possible, the repair works used cement-to-aggregate mixes that are compatible with the original concrete. This was feasible where the concrete was being placed to the sides or to a sky-facing surface. It was more problematic for repairs to the undersides of beams and slabs where the wet repair material was working against gravity.

A key part of the success of the project was the very close collaboration between the client, architect, engineer, and contractor, alongside regular reviews with the regulatory heritage agency (English Heritage, now Historic England) and other key stakeholder groups such as the Twentieth Century Society. This is especially important where a "light touch" approach for listed buildings is applied. The project has been fortunate to have a client who has a long-term commitment to the buildings. The zoo understands that it is not possible to solve all the issues with these buildings and structures "once and for all."

Instead, careful repair and ongoing regular maintenance is the appropriate approach.

The project included the training of apprentices in the art of concrete repairs; consequently, the zoo now has an on-site team who can deal with any defects at an early stage. As the conservation-based approach to the repair of historic concrete structures is relatively new, Historic England is undertaking a program of monitoring and testing. This will gauge the effectiveness of the repair works and help to inform future repairs to historic reinforced concrete structures. A number of seminars on the works have been given to interested parties with the aim of explaining the approach and specific works and disseminating the repair methods. It is hoped that the approach taken here can act as an exemplar for other historic reinforced concrete structures in the UK and elsewhere.

NOTES

1. Historic England lists historic buildings in three categories: grade I are of exceptional interest, grade II* are particularly important buildings of more than special interest, and grade II are of special interest.

2. The clerk of works on a construction project is responsible for ensuring that construction materials and workmanship are carried out in accordance with architectural and engineering specifications and that projects meet safety standards. The clerk of works also monitors the project's budget and progress against what is enumerated in the contract.

WORKS CITED

Allan, John. 2012. *Berthold Lubetkin: Architecture and the Tradition of Progress*. London: Artifice.

Burritt, Elihu. 1868. *Walks in the Black Country and Its Green Border-Land*. London: Sampson Low.

Department of Scientific and Industrial Research. 1933. *Report of the Reinforced Concrete Structures Committee of the Building Research Board with Recommendations for a Code of Practice of the Use of Reinforced Concrete in Buildings*. London: His Majesty's Stationery Office.

Dudley Herald. 1937. "Bewildering Bank Holiday Traffic Scenes on Castle Hill." May 22, 1937, front page.

Emperger, F. 1934. "The Application of High Grade Steel in Reinforced Concrete." *Structural Engineer* 12 (3): 160–83.

Jones, Bernard Edward, and Albert Lakeman, eds. 1920. *Cassell's Reinforced Concrete: A Complete Treatise on the Practice and Theory of Modern Construction in Concrete-Steel: With a Section on House Construction in Concrete Blocks and by Reinforced Pre-Cast Methods*. New and enlarged ed. London: Waverley.

Odgers, David, ed. 2012. *Practical Building Conservation: Concrete*. London: English Heritage; Farnham, Surrey, and Burlington, VT: Ashgate.

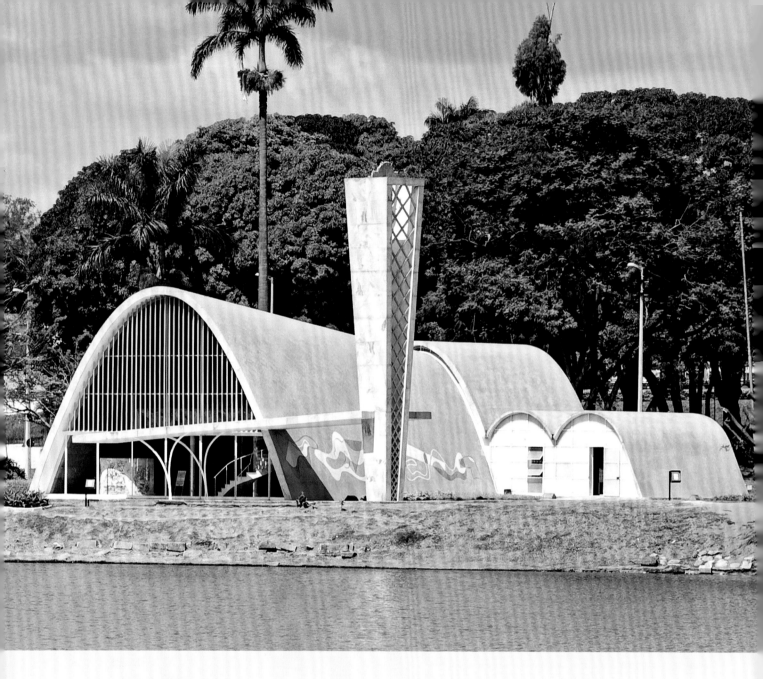

5

Marco Antônio Penido de Rezende, Ulisses Vanucci Lins, and José Eduardo de Aguiar

São Francisco de Assis Church

Belo Horizonte, Brazil | 1943

ARCHITECT/DESIGNER

Oscar Niemeyer

PROJECT DATES

2004–5: execution | 2015: additional repairs

PROJECT TEAM

José Eduardo de Aguiar, engineer, Recuperação Serviços Especiais de Engenharia Ltda. | Instituto do Patrimônio Histórico e Artístico Nacional, Instituto Estadual do Patrimônio Histórico e Artístico de Minas Gerais, and the City of Belo Horizonte, supervision | Biapó Construction Company, general contractor | Hemisfério and Imperbelo, roof waterproofing | Cosimo Cataldo, construction company for expansion joints

CLIENT/BUILDING OWNER

Prefeitura Municipal de Belo Horizonte (SUDECAP) and the Archdiocese of Belo Horizonte

INTRODUCTION

"Pampulha was the beginning of my life as an architect" (Niemeyer 1998, 94, authors' translation). With these words, the famous Brazilian architect Oscar Niemeyer (1907–2012) stressed the importance of this project in his career. Pampulha is an artificial lake in the city of Belo Horizonte, the capital of the state of Minas Gerais, in the southeastern region of Brazil, around which in the 1940s Niemeyer designed six important examples of his innovative architecture: two clubs, a house, a ballroom, a casino, and a small Catholic church (fig. 5.1).[1]

The importance of this architectural complex reaches far beyond the buildings themselves. The design brought together for the first time a renowned team that would later build the architectural wonders of Brazil's capital city, Brasília: Niemeyer as chief architect; Candido Portinari in the applied arts; Roberto Burle Marx as landscape designer; sculptor Alfredo Ceschiatti; Joaquim Cardoso as structural engineer; and as developer, Juscelino Kubitschek, mayor of Belo Horizonte, who would later become president of Brazil.

All of the buildings are architecturally impressive individually and as an ensemble. However, the most remarkable is the São Francisco de Assis Church, which is listed as a national monument by Brazil's Instituto do Patrimônio Histórico e Artístico Nacional (IPHAN, National Institute for Historic and Artistic Heritage) and is inscribed on UNESCO's World Heritage List as part of the listing of the

ensemble of Pampulha. Niemeyer scholars routinely identify this small church as one of his masterpieces. Not only is it a good example of Brazilian modern architecture, but it also illustrates the problems related to the conservation of these types of buildings and exemplifies the need for specific knowledge and expertise to preserve them.

The church comprises five undulating concrete vaulting roofs (fig. 5.2), with the front elevation of glass and a brise-soleil (fig. 5.3). The rear wall is of brick finished in painted tile (see fig. 5.2). The overall structure is in situ reinforced concrete covered by mosaic ceramic tile (see fig. 5.1). The design includes all the elements necessary for Catholic liturgies, including the altar (with its Portinari mural), the pulpit (fig. 5.4), the baptismal font, and the choir (figs. 5.5, 5.6). However, when construction was completed in 1943, the design was so innovative that the local Catholic authorities forbade mass from being celebrated in the church. The building was not put into service and soon began to deteriorate. Following restoration work carried out in 1956, the church was finally consecrated in 1959. As a consequence of its initial abandonment and related problems of deterioration, IPHAN included it on its national cultural heritage list in 1947, a little more than three years after its construction was completed.

THE PROJECT

Soon after construction was finished, the church began to suffer problems due to water infiltration, and various interventions were made (see sidebar, p. 77). Prior to the project described in this case study, the last intervention that attempted to address these challenges took place in 1990. That large-scale intervention replaced the exterior finish layer of the vaults, retaining only the area where the tile mosaic forms an organic design. The adopted solution tried to solve both the water infiltration issues and the thermal structural deformation. Thermal insulation was achieved with the installation of an air-entrained concrete block layer. Although the waterproofing system initially worked well, it began to fail shortly afterward.

In 1998, a group of engineers headed by Silvia Puccioni from IPHAN conducted an inspection of the church to determine the damage occurring to the ceramic tiles covering it. Upon analyzing the extensive cracking that particularly affected the main vault and the sequence

(see sidebar, p. 77)

Fig. 5.1. General view of São Francisco de Assis Church from Pampulha Lake, 2010. Photo: Leandro Mise / Alamy Stock Photo

Fig. 5.2. Rear view showing the five vaulted roofs and the rear wall finished in painted tile, 2016.

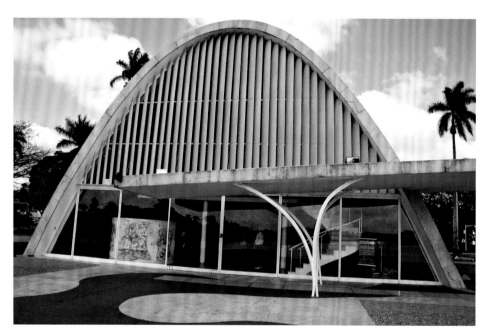

Fig. 5.3. The glass front facade with brise-soleil, 2016.

of interventions undertaken to the church over time, the engineers concluded:

> *Having analyzed the sequence of interventions conducted on the building, it can be observed that at no point did anyone perform a more in-depth study of the main cause of the damage, which is the structural behavior over the long term. All of the interventions executed to date were purely empirical and experimental in nature.* (Puccioni 1998, 37, authors' translation)

After this declaration, the group suggested the need for a series of in-depth studies to determine the underlying cause of the damage in the outer layer of the vaults. The suggestion was accepted by IPHAN, and in 2002 a company was contracted to execute the work. The studies took nine months to complete. They identified possible hypotheses to explain the deterioration, as well as potential solutions.

This case study describes the investigative works begun in 2002, and the execution and subsequent outcomes of this work, which due to poor execution resulted in the current problems. In addition, an update on the current measures to address these issues is presented.

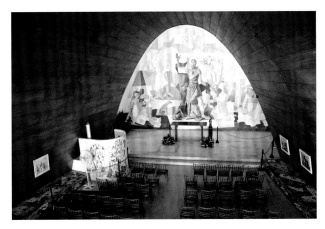

Fig. 5.4. Interior view showing the altar and pulpit, and the mural by Candido Portinari, 2016.

Fig. 5.5. Interior view from the altar showing the choir loft and the baptismal font (at right rear), 2016.

Fig. 5.6. The choir and the baptismal font, 2016.

KEY DATES AND INTERVENTIONS

1943
opening and archdiocese's refusal to consecrate the church

1944
first signs of infiltration and humidity

1944–55
small-scale interventions targeting the infiltration issue

1947
listing by IPHAN

1955–56
first large-scale intervention to install expansion joints where two large cracks had formed on the main vault; introduction of a gutter system to collect water from the joints in a project led by engineer Walter Coscareli

1958
Arch. Prof. Silvio de Vasconcelos, regional coordinator for IPHAN, reports that the intervention has solved the main infiltration issues, but small issues still persist

1958–89
small-scale interventions executed (little documentation has been found on this subject)

1959
consecration of the church and start of its intended use

1990
second large-scale intervention

1996–97
cracks observed on the main vault

1998
IPHAN work group inspects the church and concludes that in-depth studies are needed

2002
company hired for diagnostic requested by IPHAN

2004–5
third large-scale intervention (focus of this paper)

2008
new signs of infiltration are noticed on wood panels that cover the interior surface of the main vault; the affected areas correspond with the locations of the three expansion joints

2015
hiring and development of project for new joint sealant system

2017
awaiting end of pre-scheduled weddings and final funding for project execution

5

INVESTIGATIONS: BACKGROUND RESEARCH, ANALYSIS, DIAGNOSTIC WORK, TESTING, AND TRIALS

In the research phase, the original drawings of the structural project and some photographs taken at the time of construction were available. This was important, as it enabled a comparison between the as-designed structural concept and the realized building. Observing the original project documentation and comparing it to photographs taken during construction, it was recognized that while three expansion joints were initially proposed in the drawings, they were not all built. According to reports and probe inspections during this project, it was determined that two expansion joints were constructed in a repair intervention, probably in 1956, but the third was never executed. A main component of the project described here was a mathematical analysis of the core structure's behavior, which showed the necessity of this third expansion joint.

The testing, investigations, and diagnostic work were undertaken by the company Recuperação Serviços Especiais de Engenharia. They were coordinated by engineer José Eduardo de Aguiar under the supervision of IPHAN, Instituto Estadual do Patrimônio Histórico e Artístico de Minas Gerais (IEPHA-MG, the state agency for cultural heritage protection), and the City of Belo Horizonte.

A study of the foundations was also conducted, as there was a hypothesis that the cracking of the vaults was caused by foundation settling that could be associated with a recent water level change in Pampulha Lake. It included excavations to research the existing foundations and a soil study. This work verified that the structure is set upon a slab of reinforced concrete, executed upon wooden piles, which were found to be in perfectly good condition. The study showed that the foundations were intact and continuing to perform satisfactorily, and not contributing to the cracking recorded in the outer layers of the vaults (Aguiar et al. 2003).

Trials were conducted to characterize the materials used in the structure, particularly the reinforced concrete. A total of three core samples 50 mm in diameter were removed: two from the vaults, one of which went through the full thickness of the vault, and one from the building's foundation slab. Laboratory tests were undertaken to assess the presence of contaminants and the concrete's compressive strength. From this testing, it was possible to assess the quality of the materials. The results confirmed the quality of the concrete used in the construction as satisfactory and suitable for this type of structure. Moreover, the reinforcement in the concrete showed no signs of corrosion.

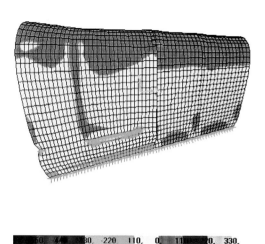

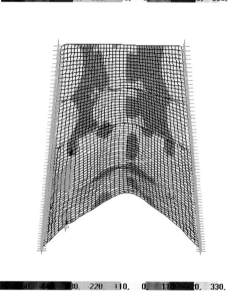

Fig. 5.7. Core structure behavior simulation, modeling the two existing expansion joints. The orange area indicates a concentration of stress in the location originally proposed for a third expansion joint. Image: Arquivo IPHAN/MG

The existing structure and the outer layer were measured using a Profometer cover meter and rebar locator. Pundit ultrasonic technique was also used to evaluate the concrete. The core structure of the concrete vaults contains a steel mesh of 10 by 10 cm with a diameter of 8 mm. A monitoring study was performed to understand the thermal behavior of the outer layer of the church relative to the interior of the church, using digital laser thermometers and the installation of thermocouples. The objective was to identify the variations in the structure's temperature (Aguiar et al. 2006). The monitoring was carried out for twenty-four hours a day over a three-month period. The results showed that the outer layer of the vaults (ceramic-

mosaic tiles set in a mortar bedding) was subject to extremely high temperatures of more than 50°C (122°F), but this high thermal gradient was not being transferred to the underlying concrete, indicating that the finish layer installed in the 1990s, though extremely cracked and with a deficiency of adherence, was still providing good thermal protection to the underlying concrete structure.

The core structure's behavior was mathematically studied. This included:

- parameterization through finite elements
- analyzing the original drawings, which illustrated the geometric and architectonic components of the outer layer
- study of the incidence of insolation and temperature
- electronic surveillance of insolation
- material characterization testing, especially resistance, elasticity mode, and the thickness of the concrete

Given that the historical research revealed that only two of the three originally proposed joints were constructed, simulations were carried out modeling both two and three expansion joints based on a temperature variation of 0° to 50°C (32° to 122°F). The simulation of the building with the two existing expansion joints showed a concentration of radial stress, which could be observed in the front portion of the main vault. This indicated the need to introduce a third expansion joint in that location (fig. 5.7). Cracks found in this location on the building also indicated this need. Thus, it was concluded that the main cause of cracking to the outer layer (ceramic mosaic tiles and bedding mortar) and subsequent water ingress into the structure was due to the lack of a third expansion joint rather than problems with the foundations, as had been initially suspected. The studies also demonstrated that the cracks affected only the outer layer (ceramic mosaic tiles and bedding mortar) and not the underlying concrete structure.

CONSERVATION

In addition to identifying the lack of the third expansion joint, investigations established that the diverse materials applied in the outer layer during the 1990s repair campaign presented different thermodynamic behaviors, with an inadequate bond between materials (non-monolithic system). This caused a number of cracks that spread out in many directions and with no clear symmetry across the entire surface of the outer layer. Therefore, two main objectives were identified as being key to a successful repair. First

was the introduction of a new third expansion joint, and second was to ensure that the materials that composed the outer layer were compatible, with improved bonding between the various layers and enhanced waterproofing capacity. The repair was executed by the Biapó Construction Company in consultation with Recuperação Serviços Especiais de Engenharia, the same company and professionals who undertook the investigation and diagnostic work. Roof waterproofing was provided by the Hemisfério and Imperbelo companies. The expansion joints were executed by the Cosimo Cataldo construction company. All work was conducted under the supervision of IPHAN, IEPHA-MG, and the City of Belo Horizonte.

To provide a solution to the surface cracking of the outer layer, all materials added in the prior interventions were removed. The previous interventions had all preserved the original ceramic tiles that form an organic design on the main vault, and the current intervention used the same approach. The original ceramic mosaic tiles were retained, while the non-original tiles were replaced along with layers of material down to the concrete substrate. The outer layer was then reconstructed with a leveling base of cement-based mortar (thickness of up to 3 cm) and with micro-concrete (thickness of greater than 3 cm) (fig. 5.8) reinforced with a mesh of 15 by 15 cm with 3.2 mm steel reinforced bars (fig. 5.9). These materials were selected because they were compatible with each other and the original concrete. This new outer layer replaced the air-entrained concrete blocks that were installed in the 1990s.

The mortar and micro-concrete application was performed manually, on top of the saturated original substrate, followed by a rigorously managed concrete curing period of seven days to prevent cracks from forming. After this leveling layer, a cementitious acrylic waterproof coating was used. The new ceramic tiles, which have water absorption of less than 0.5%, required special mortar to be properly laid; a pre-bagged cement mortar with pull-out resistance greater than 1.0 MPa was used. The grouting of the ceramic tiles was performed by applying an industrialized grouting mortar made of white cement mixed with hydrophobic additives and fungicides in an attempt to guarantee the durability and aesthetics of the ceramic tile layer.

A major challenge was how to introduce the new expansion joint so as to accommodate the necessary stresses but also minimize physical intervention into the original materials. As a consequence, the opening of the joint was achieved by cutting through the concrete vault after removal of non-original outer-layer material (fig. 5.10) and careful localized removal of original mosaic tile, with proper documentation and numbering of each piece so that

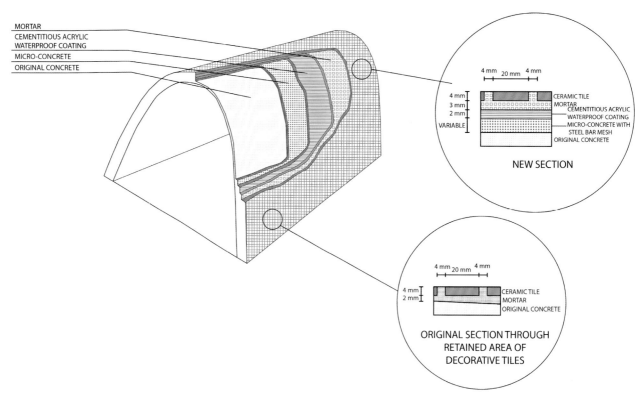

MORTAR
CEMENTITIOUS ACRYLIC
WATERPROOF COATING
MICRO-CONCRETE
ORIGINAL CONCRETE

4 mm 20 mm 4 mm

4 mm
3 mm
2 mm
VARIABLE

CERAMIC TILE
MORTAR
CEMENTITIOUS ACRYLIC
WATERPROOF COATING
MICRO-CONCRETE WITH
STEEL BAR MESH
ORIGINAL CONCRETE

NEW SECTION

4 mm 20 mm 4 mm

4 mm
2 mm

CERAMIC TILE
MORTAR
ORIGINAL CONCRETE

ORIGINAL SECTION THROUGH
RETAINED AREA OF
DECORATIVE TILES

Fig. 5.8. Illustration comparing the section of the original outer layer that was retained in the area covered by an organic decorative mosaic and the new outer layer that replaced the 1990s intervention. The thickness of the original concrete structure and new micro-concrete vary depending on location. Image: Ana Marta Lins, 2016, based on an illustration from IPHAN report on the conservation of São Francisco de Assis Church.

Fig. 5.9. The new mesh of steel reinforcement bars added to the leveling mortar. Photo: Arquivo IPHAN/MG

Fig. 5.10. Construction of the new expansion joint.

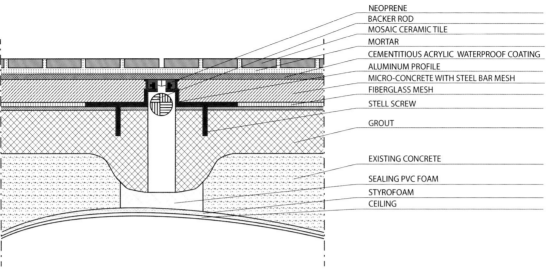

NEOPRENE
BACKER ROD
MOSAIC CERAMIC TILE
MORTAR
CEMENTITIOUS ACRYLIC WATERPROOF COATING
ALUMINUM PROFILE
MICRO-CONCRETE WITH STEEL BAR MESH
FIBERGLASS MESH
STELL SCREW
GROUT
EXISTING CONCRETE
SEALING PVC FOAM
STYROFOAM
CEILING

Fig. 5.11. Section of the executed expansion joint. Image: Ana Marta Lins, 2016, based on an illustration from IPHAN report on the conservation of São Francisco de Assis Church.

Fig. 5.12. Installation of expansion joint aluminum profiles.

Fig. 5.13. Cutting the ceramic tiles over the expansion joint.

the original tiles could be later reinstalled. New and old joints received the same treatment: aluminum profiles were attached to the reinforced concrete vault by galvanized screws with a neoprene sealant (figs. 5.11, 5.12). The aluminum profiles were adapted to the parabolic format of the structure. To achieve this, incisions were made in the metal, and later soldered, in such a way as to guarantee a continuous structure without infiltrations. The external layers at the expansion joint were installed in the same way as in the rest of the structure, with only grout and fiberglass mesh added around the galvanized screws. This was finalized by saw-cutting the mortar and tile layers on top of the expansion joints and sealing with silicone (fig. 5.13).

Following the diagnostic and research work conducted in 2003, the repair work to the church was performed between 2004 and 2005. Unfortunately, following this work, the mosaic tiles began to detach on the edges of the expansion joints, and later water started to infiltrate through the expansion joints in the main vault. The current problems have prompted a new repair proposal for the expansion joints of the main vault.

An Execution Problem

The repair project of 2004 proposed a floating tile system to be installed on top of the expansion joints. However, due

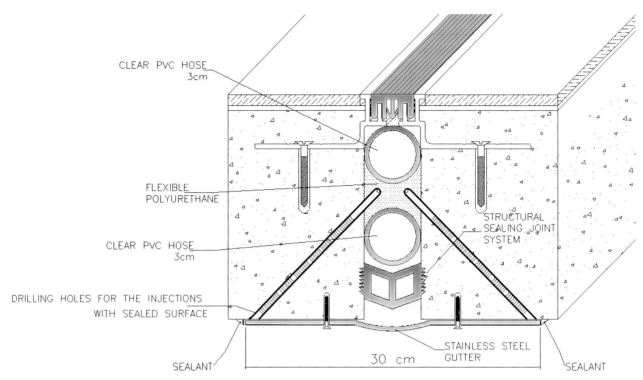

Fig. 5.14. New proposed solution for the expansion joints on the main vault.

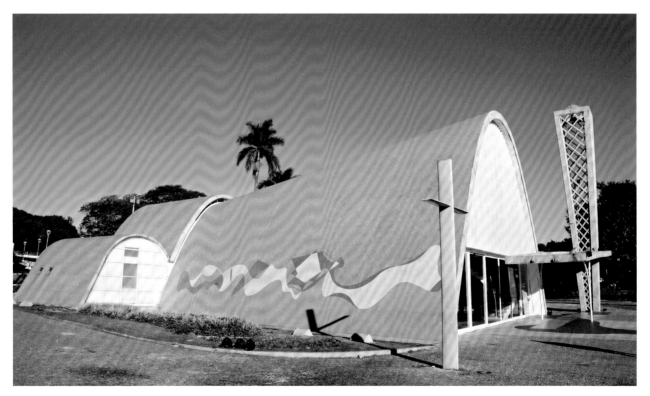

Fig. 5.15. The concrete vaults finished in mosaic ceramic tile following repair, 2016. At the time of the 2004 intervention, only the portion with the organic design was original.

to the need to respect the original layout of the tile, which runs diagonally to the new expansion joints, the proposed solution proved to be impossible, as it required laying the tiles in parallel to the joints. Therefore, it was later decided to apply the tiles directly to the mortar. This option required the use of a mechanical saw to cut the ceramic tiles following the position of the joints. It is likely that the neoprene sealant was cut when this work was undertaken, due to a lack of proper control of the cutting depth. Unfortunately, this was not realized until the first leaking was noticed inside the church some years after the repair.

Current leaking is restricted to the location of each of the expansion joints. A repair project will be undertaken to solve that problem and a proposal has been developed (fig. 5.14). It includes injection of flexible polyurethane by low pressure between two clear PVC hoses and the use of a Jeene rubber sealing joint system. This work also proposes the installation of a stainless steel gutter under each joint on the interior surface of the vault. This intervention will be executed from the inside of the church without removing the exterior tiles. The wood-paneled ceiling will be partially removed to give access to the repair area, but reinstalled once work is complete. Since this repair campaign requires closing the church to the public, the authorities are currently waiting until the end of the upcoming scheduled weddings to begin the execution.

CONCLUSIONS

This work sought to present one stage in the process of the conservation of a significant example of modern Brazilian architecture: the São Francisco de Assis Church, located on the banks of Pampulha Lake. The church's protection as national cultural heritage has been fundamental in its preservation, establishing its importance early in its history and providing access to federal grants for its maintenance (fig. 5.15).

The church's vaults suffered cracking and the loss of outer layers of ceramic tiles soon after its completion. Probably due to the young age of the monument, the previous interventions carried out did not include the necessary phases of study and diagnosis typically required for cultural heritage buildings, and were unsuccessful in correctly diagnosing the causes of the problems and identifying appropriate solutions. More systematic studies on the existing building defects only began to be performed in 1998. These studies involved a number of different parameters that helped to develop a more precise understanding of the existing problems and targeting repairs.

In addition to all of the technological resources available, a crucial factor in the diagnosis was access to the original architectural drawings and construction photographs, which facilitated comparison of the structural concept with the actual execution of the building. This analysis clearly identified that the three expansion joints proposed in the original structural project were not executed when the church was built. Two of the joints were probably added in 1956, in the exact locations originally proposed, in response to the cracking that occurred soon after construction. The simulations of the stress on the vaults confirmed the need for a third expansion joint, and this became the main principle of this repair project.

However, problems during the execution of the repair project meant that the work again failed and once again leakage occurred. The history of the conservation of the church reconfirms the need for careful study before carrying out interventions on any monument, including monuments of the modern era, as well as the careful execution of repair work.

This project demonstrates the care needed in developing and executing repair work. Proposed solutions should be fully tested and detailed before the start of any work. Securing skilled contractors for the job and ensuring that the engineers and architects involved in designing the repair are able to follow through on-site during the repair is crucial, particularly when dealing with complex issues and important historic buildings. Budgeting for these necessary items to achieve the high quality demanded in this type of work is essential. Failure to do so can result in not only damage to the building but also significant additional costs.

NOTE

1. Four of these structures comprise the Pampulha Modern Ensemble, inscribed on UNESCO's World Heritage List in 2016.

WORKS CITED

Aguiar, José Eduardo de, Abdias Magalhães Gomes, Paulo Roberto Takahashi, and Fabiano Sales de Menezes. 2003. "Monitoramento e avaliação estrutural da Igreja da Pampulha—como resolver um problema de 50 anos." In *Anais do 45o. Congresso Brasileiro do Concreto*. Vitória: IBRACON (CD).

Aguiar, José Eduardo de, Ana Carolina Lamego Moraes, Abdias M. Gomes, and Antônio Neves C. Jr. 2006. "Recuperação e Restauro da Igrejinha da Pampulha—Restoring and Restoration of Pampulha Church." In *Anais do 48o. Congresso Brasileiro do Concreto*. Florianópolis: IBRACON (CD).

Niemeyer, Oscar. 1998. *As curvas do tempo. Memórias*. Rio de Janeiro: Editora Revan.

Puccioni, Silvia. 1998. "Relatório de Análise da Igreja de São Francisco de Assis na Pampulha." Brasília: IPHAN. Unpublished report.

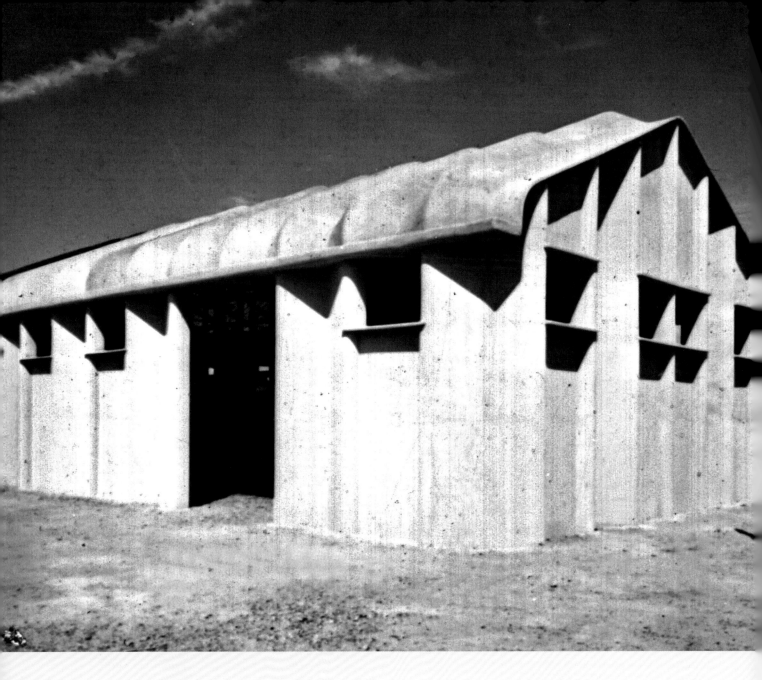

6

Tullia Iori and Sergio Poretti

Magliana Pavilion

Rome | 1945

ARCHITECT/DESIGNER

Pier Luigi Nervi

PROJECT DATES

2012–13

PROJECT TEAM

SIXXI: Storia dell'ingegneria strutturale in Italia (Twentieth-Century Structural Engineering: The Italian Contribution) | European Research Council Advanced Grant, PI Sergio Poretti

CLIENT/BUILDING OWNER

Private property

INTRODUCTION

The Magliana Pavilion (fig. 6.1) is a spacious hall constructed of ferrocement that was designed and built in Rome by Pier Luigi Nervi (1891–1979). Nervi's ferrocement, a material of his own invention, consists of a unique combination of concrete and reinforcement that completely reverses the proportions of the two components found in ordinary reinforced concrete. He developed the very thin application (never more than 3 cm thick) of cementitious material to fine steel mesh as a solution to the material restrictions (particularly steel) imposed by Italy's Fascist regime during its autarkic propaganda campaign at the end of the 1930s. Nervi's famous structures of the 1930s and 1940s, from Florence's municipal stadium to his hangars in Orvieto and Orbetello, had fully exploited reinforced concrete's structural capabilities. In his ferrocement, he continued these experiments with the material's architectonic, building, and structural potential.

In 2013, conservation of the pavilion was undertaken as part of the applied experimental research activities of SIXXI: Storia dell'ingegneria strutturale in Italia (Twentieth-Century Structural Engineering: The Italian Contribution), funded by a European Research Council Advanced Grant. The conservation adopted an experimental approach, as the typical treatment techniques developed and tested for ordinary reinforced concrete are not applicable for ferrocement.

The pavilion, originally a warehouse, was built at 238 via della Magliana in Rome on property belonging to the firm Nervi and Bartoli. It has a rectangular footprint, 21 meters long and slightly more than half as wide. The entire perimeter of the structure has a characteristic,

undulating profile (fig. 6.2). The resistance of the walls and roof, which are made entirely out of ferrocement 3.5 cm thick, results from its form, with the wave-shaped contour creating a great moment of inertia. Construction of the pavilion began in the summer of 1944, a few weeks after the arrival of Anglo-American troops during World War II. When the Nazis invaded Italy following the Armistice of Cassibile, announced on September 8, 1943, Nervi refused to collaborate with the Todt Organization and closed his construction company. For many long months, he worked secretly in his house on the Lungotevere in Rome, perfecting his particular formulation of ferrocement. As soon as the city was liberated, he summoned his trusted workers to commence construction and together they built, completely by hand and with great effort, this small masterpiece of craftsmanship, envisaged as a large sculpture.

Before the pavilion was completed, the project was published in the first and most famous of Nervi's books, *Scienza o arte del costruire?* (Science or Art of Construction?) (Nervi 1945). The book celebrated the end of the war and the beginning of Nervi's new professional life, which would elevate him to the pinnacle of international engineering.

An experimental design, the pavilion was his first building conceived and completed in ferrocement and remains the only building made entirely on-site from this material. In Nervi's later, more complex architectural works, he used ferrocement in combination with another of his building inventions, structural prefabrication, which entailed the creation of separate small pieces of ferrocement assembled on the ground and then put together like puzzle pieces. This combination of innovations became the basis of the "Nervi system" (Iori 2009a; Iori and Poretti 2013, 2015b), which was employed in the construction of all his later masterpieces, including the Salone B in Turin (1947), the Palazzetto dello Sport in Rome (1957), and the Papal Audience Hall in the Vatican (1971) (Poretti 2008, 2010). The pavilion is a unique prototype in its use of ferrocement, and it represents the beginning of Nervi's innovative and creative journey, eventually securing his position as one of the most famous engineers in the world. Thus, the pavilion holds significant historic, scientific, and social value in that it demonstrates the evolution of Nervi's ideas and his contribution to modern architecture. The material, ferrocement, is of importance to the building's

6

Fig. 6.1. The Magliana Pavilion under construction, 1945. Photo: MAXXI Museo nazionale delle arti del XXI secolo, Rome. MAXXI Architettura Collection, P. L. Nervi Collection

Fig. 6.2. Plan and perspective drawings of the Magliana Pavilion, undated [1944]. Drawing: P. L. Nervi Collection, Study Center and Archive of Communication. Photo: CSAC, University of Parma

authenticity and integrity; the conservation of the building, therefore, aimed to conserve this significant fabric.

THE PROJECT

A long history led to the conservation of the pavilion. Ten years were spent researching the building's history, in particular the history of reinforced concrete and the works of Nervi (Poretti 1983; Iori 2001, 2009a; Iori and Poretti 2010). The project engaged some twenty young researchers over the years (Iori and Poretti 2015a).[1] The genesis of the undertaking can be traced to the 2010 exhibition *Pier Luigi Nervi in Rome: Architecture as Challenge—Genius and Building* at Rome's MAXXI, Museo nazionale delle arti del XXI secolo (National Museum of Twenty-First Century Arts).[2] In the exhibition, the place of honor was occupied by the motorboat *La Giuseppa*, constructed entirely from ferrocement by Pier Luigi and his son, Antonio Nervi, in 1972. *La Giuseppa* was the family boat and was in use for six years during summer vacations, principally along the

Amalfi Coast. After the show, the boat's voyage continued from the interior of the headquarters of the Food and Agriculture Organization of the United Nations to the Circus Maximus, where it was displayed in an exhibition dedicated to Nervi's boats made from ferrocement. Before going on view, the motorboat underwent careful and pioneering conservation that informed the subsequent conservation work to the Magliana Pavilion.

The body of the ferrocement vessel is barely 1.5 cm thick. Ordinary repair treatments for reinforced concrete were not considered appropriate, and the intervention offered a unique opportunity to analyze the material directly and experiment with possible conservation methods. The conservation of the motorboat was made possible by sponsorship of the Italcementi Group Bergamo, who developed innovative materials for the treatment and provided technical assistance to the researchers from the University of Rome Tor Vergata involved in the project (Iori and Meda 2012). As a result of this positive and formative experience, Italcementi expressed interest

in sponsoring the conservation of additional ferrocement works by Nervi utilizing the products developed for the motorboat. This catalyzed negotiations with the owner of the Magliana Pavilion.

Following the deaths of Pier Luigi Nervi and Antonio Nervi in 1979, a small private firm purchased the property, including all of its buildings. This owner later helped prevent the demolition of the small building. Around 1990, the Commune of Rome decided to expropriate and raze to the ground all of the area's buildings (including the pavilion) in order to build a public parking lot for the nearby train station. At that time, the architect Irene Nervi, Pier Luigi's granddaughter, alerted to the threat of demolition by the owner, succeeded in obstructing the proceedings and preventing the demolition (Greco 1994). Over the years, the building has lacked suitable maintenance. It currently serves as a covered parking lot.

In 2003, the pavilion was added to the local heritage inventory, preventing demolition and enabling it to be further investigated. In the meantime, many plans to transform the site into a cultural center were considered, but none were financially viable. Over time the pavilion had fallen into a state of advanced disrepair, and given the pioneering nature of the ferrocement employed, this disrepair could have become dangerous and irreversible. At the end of 2012, the owner finally agreed to proceed with partial conservation, sponsored by the Italcementi Group, who covered the material and labor costs of the project, which was planned and led by the SIXXI team (Iori 2015; Iori and Poretti 2016). In 2016, proceedings were initiated to add the pavilion to the Italian state's list of monumental heritage sites.

INVESTIGATIONS: BACKGROUND RESEARCH, ANALYSIS, DIAGNOSTIC WORK, TESTING, AND TRIALS

A detailed historical study of the building and ferrocement preceded the conservation. The research was undertaken using the working drawings of the pavilion found in the Communication Study Centre and Archive at the University of Parma, which holds the main body of Pier Luigi Nervi's design archive, as well as the Architecture Archives Centre at MAXXI, which holds an important group of drawings and the principal collection of photographs of Nervi's building sites (Zhara Buda 2016). The physical investigations and analytical work were undertaken within a short period in advance of the repair work, which is described in the conservation section below.

Nervi's ferrocement originated during the Italian autarkic period, which followed the country's invasion of Ethiopia in 1935. In response, the League of Nations condemned the invasion and imposed economic sanctions. Despite the fact that the sanctions lasted only a few months, the Fascist regime took advantage of them and launched its national policy of economic self-sufficiency (autarky). Fascist propaganda pushed the use of Italian materials and prohibited the use of steel; Italy's modest production, along with the small quantity that the country was able to purchase abroad, was reserved for military purposes in preparation for the imminent world war. Reinforced concrete, which requires steel reinforcement for its structural framework, was classified non-autarkic. Its use was progressively limited until it was finally prohibited entirely in 1939.

Nervi, who had worked with reinforced concrete since he completed his studies, persevered until he devised an alternative solution, ferrocement. This unique invention is a variation on reinforced concrete, beginning with the same materials: concrete and steel. The ratio of concrete to steel in ordinary reinforced concrete is much higher than in ferrocement, in which steel is the prevalent component. Although it seems contradictory, Nervi demonstrated that for any given span, his material, with its reduced thickness, would require much less steel than ordinary reinforced concrete, thus fulfilling the Italian regime's goal of autarky or self-sufficiency. Of course, in order to be useful in construction, ferrocement had to be formed into appropriate shapes (wavy or pleated, for example) to make it "shape-resistant."

Nervi was guided in his experiments by Arturo Danusso, one of the most important Italian scholars of structural theory, and the two collaborated during these years. Nervi's structures were highly complex and hyperstatic, making it too difficult to calculate using traditional analytic tools. For this reason, Danusso constructed and tested celluloid scale models in his lab at the Polytechnic University of Milan as a means of verifying Nervi's designs.

Nervi completed his first ferrocement slabs in 1943. They were produced by spreading high-strength cement mixed with fine aggregates onto panels made up of many layers of thin metal mesh or chicken wire. The concrete was pressed with a sponge float trowel on one side until it emerged from the other. The slabs were generally 2 to 3 cm thick. The new material was very resistant, elastic, ductile, isotropic, practically homogeneous, and light. Extraordinarily malleable, it could be made into any shape or form. It was also exceptionally economical. Above all, the new material did not require the wooden formwork typical of ordinary reinforced concrete. Metal mesh can be bent into any shape and then saturated with directly applied cement

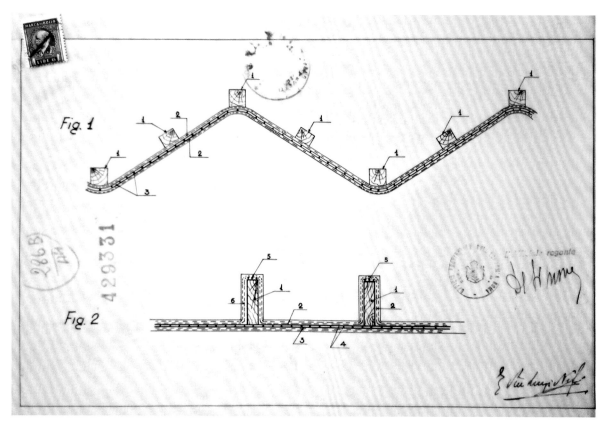

Fig. 6.3. Patent 429331 by Pier Luigi Nervi, protecting the ferrocement used in the Magliana Warehouse, 1944. Photo: SIXXI Collection, Rome Tor Vergata University

Fig. 6.4. Detail of the perimeter wall of the Magliana Pavilion, undated [1944]. Drawing: P. L. Nervi Collection, Study Center and Archive of Communication. Photo: CSAC, University of Parma

mortar, without the need for a reverse mold. Freeing construction from the constraints of wooden formwork, Nervi was able to explore a world of shapes that until then was unthinkable.

The first patent protecting the invention of ferrocement, titled "Perfection of the Construction of Slabs, Sheets, and Other Reinforced Cement Structures" (patent no. 406296), was registered by Nervi in Italy on April 15, 1943 (Nervi 1943; Greco 2008).

By the winter of 1943, Nervi was considering using ferrocement for the construction of boats. Ferrocement was an easy and economical material with which to construct a doubly curved hull by folding the metal mesh and then applying cement by hand. Using this invention, between 1945 and 1948 he constructed the 400 metric ton motorized sailboat *Irene* (1945), the pontoon *Toscana*, the fishing vessel *Santa Rita*, and the elegant luxury ketch *Nennele* (Nervi 1950). However, he abandoned the nautical projects immediately after these initial experiments, dedicating himself to large structures.[3] Subsequently, he found many other applications for ferrocement, initiated by the small, experimental Magliana Pavilion.

The pavilion's undulating walls (created through the repetition of a standard module, with the shape providing structural inertia/resistance), pitched roof, eaves gutters along the long sides of the building, windowsills, and architraves are all made from ferrocement. Nervi explained: "The construction yields excellent technical results, even if it is slightly more expensive than traditional materials" (Nervi 1951, 75).[4]

The method of execution of the pavilion was patented in Italy in September 1944 (patent no. 429331), an elaboration of the principal patent of 1943 (Nervi 1944) (fig. 6.3). The patent is accompanied by a design that closely resembles the pavilion's walls (fig. 6.4). The procedure for constructing the building can be outlined in a few steps. First, one places temporary wooden uprights in direct proportion to the resistance capacity of the metal mesh (fig. 6.5), then the metal layers are prepared, and the reinforcing steel bars and square wooden battens are inserted inside them. The different layers of mesh and steel bars are secured to one another by means of iron wire in order to reach the right resistance and stability. A premade wooden profile is used to model and bend the mesh and steel into the correct shape (fig. 6.6). Once the metal layers are in place, the concrete is applied to the structure from the side opposite the uprights, while ensuring that it reaches full stability through uniform distribution inside the structure (fig. 6.7).

Fig. 6.5. The Magliana Pavilion under construction, undated [1944]. Photo: P. L. Nervi Collection, Architectural Archive Center, MAXXI, Rome

Fig. 6.6. Wooden profile for modeling the ferrocement framework for construction of the Magliana Pavilion, undated [1944]. Photo: P. L. Nervi Collection, Architectural Archive Center, MAXXI, Rome

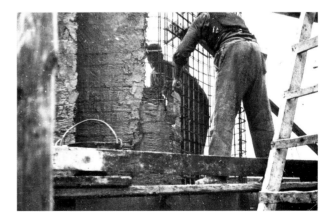

Fig. 6.7. Workers spreading concrete by hand for the ferrocement walls of the Magliana Pavilion, undated [1944]. Photo: P. L. Nervi Collection, Architectural Archive Center, MAXXI, Rome

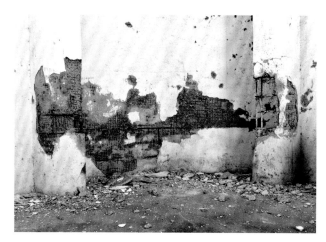

Fig. 6.8. Condition of one of the perimeter walls of the Magliana Pavilion before conservation, 2013. Photo: SIXXI Collection, Rome Tor Vergata University

Fig. 6.9. Condition of the roof of the Magliana Pavilion, seen from the inside, before conservation, 2013. Photo: SIXXI Collection, Rome Tor Vergata University

The ferrocement patented in April 1943 was very different from that patented in 1944, and the latter was ultimately used to create the pavilion. Through 1960, ferrocement was continuously perfected and adapted to varying construction requirements. Just as the material characteristics of reinforced concrete differ according to the economic conditions of the country, historical period, designer, and so on, the composition of Nervi's early ferrocement, as described in the first patents and realized in his initial experiments during the war, differs from the materials used in the postwar era and Italy's subsequent economic boom.

For example, the ferrocement that Nervi used to complete the 1,620 rhomboid precast elements for the cupola of the Palazzetto dello Sport (1957) is greatly simplified in comparison with the earlier version. For the latter, there is a broad weave of steel bars and only one layer of mesh in the 2.5 cm thick layer (Iori 2009b). Notwithstanding the simplifications that evolved over time, the material's underlying characteristics are consistent. It is economical, light, and shapeable into any form, even complex ones, without the need for wooden formworks.

Various deterioration effects and mechanisms were present prior to the conservation of the pavilion. Vast portions of the concrete were missing, and the metal mesh reinforcement was corroded in areas. Most of the damage was concentrated in the lowest horizontal area ringing the pavilion, caused by impact damage from cars during parking (fig. 6.8). The upper sections of the walls, which initially appeared to be better preserved, in fact had suffered more severe deterioration, which was revealed after removal of the surface coating. The coating had masked previous, inappropriate interventions that patched over large areas of concrete loss. Many of these were caused by attempts to hang lamps or security devices from the thin ferrocement walls.

The exterior surface of the concrete roof of the pavilion was also badly damaged. In fact, the roof had not originally been coated to waterproof it (fig. 6.9). Rather, in an effort to test the properties of the ferrocement, Nervi said, "It is also foreseeable that the impermeability of the roof will remain intact, without the need for an additional protective layer or moisture barrier, yet in this respect, we cannot draw definite conclusions until it has undergone the seasonal change from summer to winter at least two times" (Nervi 1945, 133).[5] However, a coating of bituminous tar was applied a few years after construction when water infiltration became apparent, disappointing the engineer. When conservation work began, widespread damage to the external impermeable coating and the resulting clumsy attempts at maintenance had created pools of standing rainwater, leading to infiltration and resulting in clearly evident corrosion of the metal reinforcement and subsequent spalling of the concrete. Unfortunately, the extent of damage was more than anticipated, and the available funds were inadequate to cover the costs associated with retreatment of the roof with an impermeable barrier. This work is still urgently needed.

Laboratory analysis was carried out on a portion of the original ferrocement that was selected from an area unaffected by later interventions. This original fragment was of sufficient size to determine the range of grain sizes

present in the mortar. Laboratory tests established the maximum (1.2 mm) and minimum (0.07 mm) diameter of the aggregates and an almost linear distribution between the two values. In addition, a petrographic analysis by means of thin-section microscopy was undertaken. This showed the presence of natural aggregates within the closed structure of the cement, in particular sand and crushed stone derived from shattered rock, and enabled a matching of the aggregates and their grading. These tests did not provide information about the water-to-cement ratio used, which required that a series of trials be undertaken.

CONSERVATION

The pavilion's continued use as a car park limited access to the site, so the assessment of the condition of the concrete, the physical investigations, and the repair program were undertaken over a relatively short period, informed by the extensive historical research on Nervi's construction

methods employed for ferrocement. From June to September 2012, the general survey and inspection works were conducted directly on the building. The new repair material to be used was produced by Italcementi according to the outcomes of the physical analysis and investigations. In late December 2012, treatment methods were tested on a restricted portion of the wall. Conservation began in January 2013 and was completed by early February 2013. All work was scheduled between late morning, when the pavilion became more or less free of cars, and early evening, when people leasing the parking spaces returned with their cars.

First, the internal surfaces of the pavilion were cleaned with pressurized water in order to remove the existing coatings. Light hammering over the entire internal surface facilitated detachment of already loosened areas of concrete and areas that had previously been poorly patched. At this point, the data detailing the materials and geometry gathered from the pavilion's historical records was

Fig. 6.10. Wooden profile used in the fabrication of the 1:1 scale model of the Magliana Pavilion's perimeter wall, 2013. Photo: SIXXI Collection, Rome Tor Vergata University

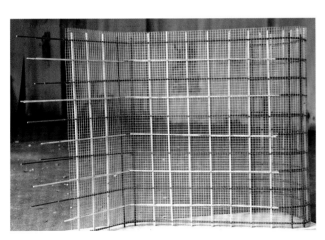

Fig. 6.11. Steel and wooden reinforcement used in the fabrication of the 1:1 scale model of the Magliana Pavilion's perimeter wall, 2013. Photo: SIXXI Collection, Rome Tor Vergata University

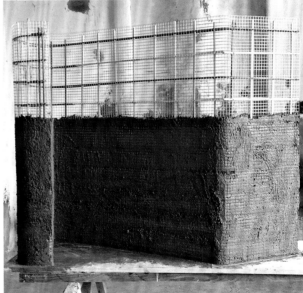

Fig. 6.12. Application of concrete in the fabrication of the 1:1 scale model of the Magliana Pavilion's perimeter wall, 2013. Photo: SIXXI Collection, Rome Tor Vergata University

meticulously verified. A survey of all visible parts was carried out, confirming the exact position of the reinforcing steel bars in the framework, the square wooden battens, and the thin metal mesh. The survey results matched Nervi's working drawings for the pavilion exactly.

Soon after the start of works, a 1:1 model of the wave-form wall of the pavilion was created, 135 by 45 cm square by 1 m high (fig. 6.10). This served as a mock-up for the workers to use in trialing the repair in advance of conservation work. The trials re-created the sequence of steps undertaken by Nervi. First, the curvilinear wooden profile was created and placed horizontally for shaping and securing the metal reinforcement components together by hand using iron wire. Then, 6 mm diameter horizontal and vertical reinforcing steel rods were bent and arranged with 5 by 5 mm square battens of wood that stiffened the whole (fig. 6.11). This framework was then placed vertically, fixed to a wooden base, and completed with the attachment of two layers (one external and one internal) of 1 by 1 cm weave welded wire mesh, secured with iron wire. To follow, the mixture of cement and carefully selected aggregates was applied about halfway up the framework, for a maximum final thickness of 2.5 cm (fig. 6.12). This phase of the work allowed testing of the correct ratio of water to cement to provide adequate workability. This 1:1 scale model is currently preserved in the SIXXI laboratory in the civil engineering building at the University of Rome Tor Vergata. Once the ability of the workers to re-create ferrocement had been tested, the conservation of the pavilion began.

Portions of the metal reinforcement that had been exposed after cleaning and hammering were cleaned by hand with metal brushes and treated with a protective realkalizing corrosion-inhibiting protective coating. Sections of the original metal reinforcement that had been lost due to corrosion and breakage were replaced with a new layer of mesh of the same diameter and weave spacing. The new reinforcement was secured to the existing steel rods. In one section of the roof, corrosion of the principal framework of steel reinforcement rods had progressed to the stage where it compromised structural integrity and needed to be replaced. The rest of the structure was well preserved. In no case was it necessary to replace the wooden slats in the walls, which were perfectly anchored in the cement and as a result in an excellent state of preservation.

After repair of the metal reinforcement, a cement-based product developed by the Italcementi Group Bergamo laboratory especially for this specific treatment was applied.

The product required the following properties:

- cement-based
- compatible with the original composite
- granularity as similar as possible to the original
- matching the color of the very aged original material
- with thixotropic consistency adequate for application by hand, following the same techniques utilized for manufacture of the original ferrocement
- able to be applied in layers of only a few millimeters, preventing alteration of the geometric peculiarities of the structural materials (thickness less than 30 mm)
- ability to protect the structure over time, guaranteeing an adequate durability for the ferrocement, consistency of color over time, and retention of the smooth texture of the treated surface

For this final reason, TX Active, a proprietary photocatalytic cement, was added to the repair material mix. The material aims to reduce atmospheric pollutants, including exhaust emissions from cars, and consequently provides a self-cleaning surface. This high-performance material was premixed and produced by the Italcementi laboratory with the brand name Effix Design ST. The product, created for the pavilion and patented, is not commercially available. Despite this, the project demonstrated the potential to work with repair product companies to create bespoke repair materials. Here, the company was able to respond to the special needs for this project and create a site-specific mortar. This is an approach that the university repeated recently for another important building.

As the material is workable only for a limited time, it was mixed with water in small quantities and immediately applied with a plastering trowel (fig. 6.13). Its application, carried out by the firm SA.GI. Lavori snr of Rome, required exceptional care, following the curvature of the walls and roof (fig. 6.14). The repair mortar was extensively applied, in some places for only a few millimeters in depth; in others the full depth of the wall was reconstructed. The resulting somewhat patchy surface appearance is similar to its original state. This reflects the building's utilitarian function as a warehouse and the experimental use of the material. The surface was not repainted, enabling monitoring of the repair over time.

The work was filmed in its entirety, and the footage was edited into a documentary film titled *Conservare il ferrocemento di Pier Luigi Nervi* (SIXXI 2012), which also includes video documentation of the restoration of the motorboat *La Giuseppa* and original archival materials such as construction photographs, patents, and working drawings.

Fig. 6.13. Repair of the perimeter walls, 2013. Photo: SIXXI Collection, Rome Tor Vergata University

Fig. 6.14. Repair of the roof, 2013. Photo: SIXXI Collection, Rome Tor Vergata University

CONCLUSIONS

Conservation of the Magliana Pavilion provided an exceptional opportunity to study Nervi's works and his ferrocement (fig. 6.15). The intense manual labor involved contributed greatly to our understanding of the material's history and construction methods. Indeed, it was possible to reconstruct the original sequence of steps involved in the manufacture of ferrocement, rediscovering the construction process, which had been difficult to deduce from the available archival documentation.

The workers who completed the project described the manual labor as extremely strenuous. Even if the kind of movement required to carry out the intervention was similar to that used when spreading out plaster, the cement composite is much less workable and therefore requires considerable power and strength in the arms. This feedback led to the conclusion that the original workers in 1944–45 encountered similar difficulties and probably shared this information with Nervi. This may explain why few additional buildings were constructed by Nervi using ferrocement produced on-site; the work is too strenuous. Of the other works completed by Nervi using ferrocement produced on-site, none have survived. These included the undulating roof of the hemicycle building at the 1948 Fiera di Milano (demolished in 2008), the diving tower at the Kursaal beach resort at Ostia (the landmark that still characterizes the beachfront at Ostia, demolished in the 1970s and recently reconstructed in wood), and a spherical sculpture exhibited at the 1953 International Agricultural Exposition of Rome, designed by Adalberto Libera, Amedeo Luccichenti, and Vincenzo Monaco, and completed by Nervi and Bartoli, which was demolished shortly after the exposition.

In his later, most famous masterpieces, Nervi adopted a new strategy utilizing a combination of in situ traditional reinforced concrete and ferrocement. Generally, the elevated portions such as columns and walls were constructed of reinforced concrete and the roof was constructed of small prefabricated components of ferrocement. This facilitated great structural innovations coupled with construction efficiencies.

The conservation of the Magliana Pavilion facilitated substantial advancements in the theoretical and practical understanding of the techniques invented by Nervi for accomplishing his designs. Historical research into his patents enabled a deeper understanding of his material selection and construction techniques. This allowed the team to reverse engineer the building, which was necessary in order to determine how to conserve it. It also provided

6

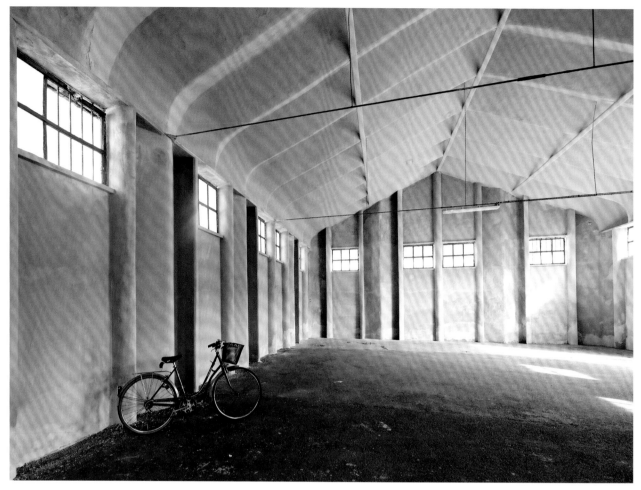

Fig. 6.15. Inside of the Magliana Pavilion after conservation, 2013. Photo: SIXXI Collection, Rome Tor Vergata University

information on how closely Nervi's patents matched his buildings. This know-how could be useful when, in the future, it is necessary to treat more complex structures, such as the large dome of the Palazzetto dello Sport.

Further work is needed to secure the Magliana Pavilion, including waterproofing the roof. As it is in private use, its ongoing conservation is dependent on the owner's good-will to continue to preserve such a utilitarian but nevertheless important building, as well as the ability to sustain a use that has some economic utility.

Translated from the Italian by Aimée Ducey-Gessner

ACKNOWLEDGMENTS

The authors would like to thank the European Research Council for financing the SIXXI research project (ERC Advanced Grant 2011). We are grateful to Italcementi Group for sponsoring the conservation of the motorboat *La Giuseppa* and the Magliana Pavilion, in particular Sergio Crippa, Italcementi Group communication and image director, and Gianluca Guerrini and Giovanni D'Ambrosio, Italcementi Group innovation department engineers. Our gratitude also goes to Margherita Guccione, MAXXI architecture director; Carla Zhara Buda, MAXXI archive center, Rome, P. L. Nervi Photography and Drawings Collection; and Simona Riva, CSAC, Parma, P. L. Nervi Drawings Archive.

NOTES

1. The European Research Council Advanced Grant, received in 2011 by Sergio Poretti, the principal investigator, made possible the creation of a research group within the University of Rome Tor Vergata, led by Poretti and Tullia Iori (www.sixxi.eu).

2. The exhibition was on view December 15, 2010, to March 20, 2011, and was co-curated by Iori and Poretti (Iori and Poretti 2010).

3. In 1970, however, the United Nations Food and Agriculture Organization asked Nervi to design two motorboats to be taken to Egypt and used to teach the local population how to economically construct a fishing boat. Nervi completed the project pro bono. Shortly thereafter

he built the aforementioned motorboat, *La Giuseppa*, for his family, still full of enthusiasm for this application of ferrocement, which he felt had been cast aside too early.

4. Translation by Aimée Ducey-Gessner.

5. Ibid.

WORKS CITED

Greco, Claudio. 1994. "Pier Luigi Nervi e il ferrocemento" [Pier Luigi Nervi and Ferrocement]. *Domus* 766: 80–83.

———. 2008. *Pier Luigi Nervi. Dai primi brevetti al Palazzo delle Esposizioni di Torino, 1917–1948* [Pier Luigi Nervi: From the First Patents to the Turin Exhibition Palace, 1917–1948]. Lucerne, Switzerland: Quart Editions.

Iori, Tullia. 2001. *Il cemento armato in Italia dalle origini alla seconda guerra mondiale* [Reinforced Concrete in Italy from its Origins to World War II]. Rome: Edilstampa.

———. 2009a. *Pier Luigi Nervi*. Milan: Motta Architettura.

———. 2009b. "Pier Luigi Nervi Annibale Vitellozzi. Palazzetto dello sport a Roma, un prototipo ripetibile e a buon mercato" [Pier Luigi Nervi Annibale Vitellozzi: Palazzetto dello Sport in Rome: A Repeatable and Affordable Prototype]. *Casabella* 782: 50–65.

———. 2015. "Connaître et restaurer le ferrociment de Pier Luigi Nervi. Deux opportunités récentes" [Understanding and Restoring Pier Luigi Nervi's Ferrocement: Two Recent Case Studies]. In *La sauvegarde des grandes œuvres de l'ingénierie de XXe siècle* [Preserving the Great Engineering Works of the 20th Century], edited by Franz Graf and Yvan Delemontey, 140–57. Cahier du TSAM 1. Lausanne, Switzerland: Presses Polytechniques et universitaires romandes (PPUR).

Iori, Tullia, and Alberto Meda. 2012. "Il restauro della motobarca in ferrocemento La Giuseppa di Pier Luigi Nervi." [Restoration of Pier Luigi Nervi's Ferrocement Motor Boat La Giuseppa]. *Enco Journal* 55: 19–23.

Iori, Tullia, and Sergio Poretti. 2010. *Pier Luigi Nervi. Architettura come sfida. Roma. Ingegno e costruzione. Guida alla mostra.* [Pier Luigi Nervi in Rome: Architecture as Challenge. Genius and Building]. Milan: Electa.

———. 2013. "Pier Luigi Nervi: His Construction System for Shell and Spatial Structures." *Journal of the International Association for Shell and Spatial Structures* 54 (176/177): 117–26.

———, eds. 2015a. *SIXXI 2. Storia dell'ingegneria strutturale in Italia* [SIXXI 2: History of Structural Engineering in Italy]. Rome: Gangemi.

———, eds. 2015b. *SIXXI 3. Storia dell'ingegneria strutturale in Italia* [SIXXI 3: History of Structural Engineering in Italy]. Rome: Gangemi.

———. 2016. "Conserving Pier Luigi Nervi's Ferroconcrete." *Engineering History and Heritage* 169 (1): 22–35.

Nervi, Pier Luigi. 1943. "Perfezionamento nella costruzione di solette, lastre e altre strutture cementizie armate" [Perfection of the Construction of Slabs, Sheets, and Other Reinforced Concrete Structures]. Italian patent 406296, filed April 15, 1943, and issued November 15, 1943.

———. 1944. "Perfezionamento nella costruzione di solette, lastre e altre strutture cementizie armate" [Perfection of the Construction of Slabs, Sheets, and Other Reinforced Concrete Structures]. Italian patent of addition 429331, filed September 29, 1944, related to main patent 406296.

———. 1945. *Scienza o arte del costruire? Caratteristiche e possibilità del cemento armato* [Science or Art of Construction? Characteristics and Possibilities of Reinforced Concrete]. Rome: Edizioni della Bussola.

———. 1950. "Le costruzioni navali in ferro-cemento" [Ferro-Cement Naval Structures]. *L'Industria italiana del Cemento* 7–8: 163–66.

———. 1951. *El lenguaje arquitectónico* [Architectonic Language]. Buenos Aires: Platt S.A.C. e I.

Poretti, Sergio. 1983. "Considerazioni sull'opera di P. L. Nervi" [Contemplating the Work of P. L. Nervi]. In *Nervi oggi* [Nervi Today], edited by Luigi Ramazzotti, 102–12. Rome: Kappa.

———. 2008. "Nervi che visse tre volte" [Nervi's Three Lives]. In *Pier Luigi Nervi. L'Ambasciata d'Italia a Brasilia* [Pier Luigi Nervi: Italian Ambassador in Brasilia], edited by Tullia Iori and Sergio Poretti, 8–49. Milan: Electa.

———. 2010. "Pier Luigi Nervi: An Italian Builder." In *Pier Luigi Nervi: Architecture as Challenge*, edited by Carlo Olmo and Cristiana Chiorino, 192–97. Milan: Silvana Editoriale.

SIXXI. 2012. *Conservare il ferrocemento di Pier Luigi Nervi* [Conservation of Pier Luigi Nervi's Cement]. Documentary filmed by David Nasorri and edited by Ilaria Giannetti. Rome: SIXXI Research Group.

Zhara Buda, Carla, ed. 2016. *L'archivio Pier Luigi Nervi nelle collezioni del MAXXI Architettura* [The Pier Luigi Nervi Archive in the Architectural Collections of MAXXI]. Rome: Quaderni del Centro Archivi del MAXXI Architettura.

6

NUR FÜR FRAUEN

7

Wolfgang H. Salcher

Gänsehäufel Swimming Facility

Vienna | 1950

ARCHITECT/DESIGNER

Max Fellerer and Eugen Wörle

PROJECT DATES

2000–2004: phase I, focus of this case study | 2015–16: phase II

PROJECT TEAM

Municipal Department 44, Hubert Teubenbacher, project management | Municipal Department 24—Health Care and Social Welfare Planning—building construction, project head | Hannes Morocutti (now Municipal Department 34—Building and Facility Management), project supervision | Architect Wolfgang Holzhacker, planning and accompanying monitoring. Public authorities: Municipal Department 19—Architecture and Urban Design | Municipal Department 37—Building Inspection | Federal Monuments Authority Austria (Bundesdenkmalamt): Dr. Bruno Maldoner, Wolfgang H. Salcher

CLIENT/BUILDING OWNER

Municipal Department 44—Municipal Swimming Pools, City of Vienna

INTRODUCTION

The municipal outdoor swimming facility known as the Strandbad Gänsehäufel opened in 1907. It was the first such facility designed for the whole family, and today is still operated by the City of Vienna. The Gänsehäufel itself is a large island used for swimming and recreational purposes in the middle of the Old Danube. During World War II, the island was severely damaged by bombing, all the buildings were destroyed, and 130 bomb craters were left (Jost 1951).

An architecture competition for rebuilding the swimming facility was held in 1947 and was won by architects Max Fellerer (1889–1957) and Eugen Wörle (1909–1996). Between September 1948 and June 1950, they rebuilt what was to become the largest and most modern summer bathing facility in Vienna. These two architects were also responsible for the reconstruction of the Austrian Parliament (1945–56).

The Gänsehäufel Swimming Facility was a reconstruction project of particular importance in the aftermath of the war, as it was aimed at giving people a positive outlook for the future (fig. 7.2). It was intended to be a symbol for the creation of a more beautiful, healthier, and better world: light, air, sun, water. In comparison to the Gänsehäufel, other signature reconstruction projects, such as the Vienna State Opera (1955), the Burgtheater (1955), and Saint Stephen's Cathedral (1960), were completed considerably later (Maldoner 2008).

Fig. 7.1. Detail of the perforated concrete block screen of the changing pavilion of the Gänsehäufel Swimming Facility (see fig. 7.10). Photo: Bettina Neubauer-Pregl / Courtesy of Federal Monuments Authority Austria, Vienna

Fig. 7.2. Cover of a postcard folder about the Gänsehäufel with the spiral stairs to the clock tower in the background, ca. 1950. Image: © Wien Museum

This is one of the largest bathing facilities on the European continent (330,000 square meters [81 acres]), with space for about thirty thousand people (Fellerer and Wörle 1951a). But despite its considerable dimensions, the architects' aim was to avoid the impression of monumentality, and thus they rejected axial or symbolic layouts. The buildings were laid out in a very relaxed, loose way with a number of internal courtyards—the impression is of a natural, well-tended garden and buildings without any sense of pretentiousness. To create large, continuous green areas, they set the buildings—for example, the elegant concrete clock tower with its external spiral staircase (fig. 7.3)—right in the middle of the island.

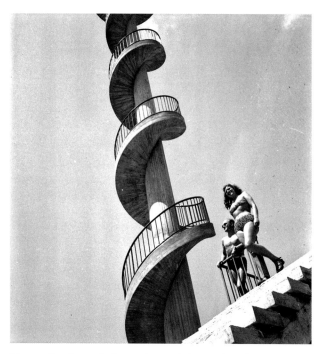

Fig. 7.3. The elegant clock tower is regarded as a technical master-piece that not only tells the time but also serves as a wayfinding device, ca. 1950. Photo: ANL/Vienna 124314B

All the buildings were made of exposed in situ concrete, and particular attention was given to the surface finish created by the timber formwork. The only prefabricated elements were a number of the concrete staircases. The simple concrete frame structure of the buildings is time-less and remains most impressive today. The Gänsehäufel is one of the icons of exposed concrete architecture in Europe. Through the deliberate restraint of the architec-tural form and the consistent use of the relatively modest technical and material means available in the immediate postwar period, it is a unified complex designed with the greatest care and thought, down to the details. In its ele-gant functionality and unobtrusive, relaxed aesthetic, it is related to the best traditions of the municipal housing erected by "Red Vienna" in the 1920s and 1930s.

THE PROJECT

Fifty years of intensive use had inevitably left their mark on the buildings of the Gänsehäufel. The weather, the effects of chemicals and corrosion, and simply the ravages of time had all taken their toll. The concrete of the build-ings, in particular on the surfaces, was in poor condition.

The conventional method used to repair concrete, for instance in the case of a bridge, results in a completely new surface. But here it was of vital importance that the architectural character as represented by the proportions, form, colors, and materials of these listed buildings not be changed.[1] In conserving the modern architecture of the Gänsehäufel, the preservation, conservation, and partial replication of both materials and finishes were the most problematic concerns. Structural safety and functional suitability were also fundamental goals.

Successful conservation relies on sound knowledge of a place. Consequently, much like in the field of medicine—where a study of symptoms and the patient's case history precedes diagnosis and therapy—extensive examinations were undertaken at the start of the project. To invoke (in a slightly modified way) Johann Wolfgang von Goethe's aphorism "Man sieht nur das, was man weiß" (You only see what you know), in this case we could also say, "You only see what you have first examined." Although the entrance building, clock tower, water tower, beach cabanas, changing pavilions with lockers, changing pavilions with cubicles, multistory cubicle buildings, café-restaurant (fig. 7.4), administration building, pool attendant's house, small storage buildings, and even the small circular tables on the lawn are all made, by and large, of concrete, in each case specific, customized conservation measures had to be determined and applied.

Besides the conservation needs, as a public facility the Gänsehäufel had to meet strict technical and safety stan-dards. Furthermore, an important aim was to upgrade the facility to provide modern, environmentally friendly services in engineering terms. The Gänsehäufel also had to be made accessible for disabled persons, which meant installing barrier-free toilets, showers, and changing rooms, and fitting stair lifts. The facility was to be kept running during the conservation work, and thus disturbance to visitors was to be restricted to an absolute minimum. To meet these aims, 90% of the conservation work was carried out during the off-season, when the facility is closed.

From the beginning, the process was characterized by constructive teamwork among all the parties involved and the public authorities. This fruitful cooperation between the architect, owner's agent, research institutes, laborato-ries, certification services, construction companies, struc-tural engineer, conservators, curators of monuments, and municipal departments of the City of Vienna was of vital importance for achieving the best possible results in terms of conservation and restoration. Without the efforts of this team, the project would not have been possible.

Work was undertaken in two stages. Between 2000 and 2004, the focus was on investigations, development of a conservation concept, and concrete conservation work for

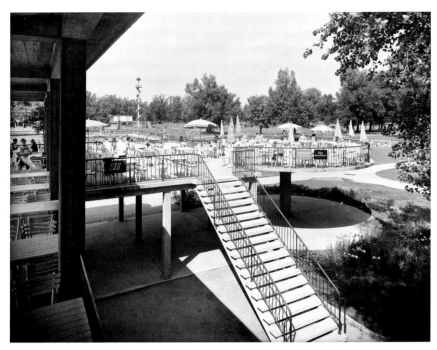

Fig. 7.4. A 1953 photo shows the in situ concrete frame construction, precast staircase, and rounded café-restaurant terrace supported by a mushroom-head column; in the background are the pool and clock tower. Photo: ANL/Vienna 245811B

all main buildings (this paper is focused on the first campaign). Evaluation and concrete conservation of small components took place in 2015–16.

INVESTIGATIONS: BACKGROUND RESEARCH, ANALYSIS, DIAGNOSTIC WORK, TESTING, AND TRIALS

Before conservation could start, preliminary investigations were necessary. These included a search for historical plans, scrutiny of architectural journals, and the collection and evaluation of as much detailed information as possible about the construction methods that had been used in the 1940s. An investigation into how each specific building had been constructed also formed part of the initial research phase. The buildings are monolithic frame structures built of reinforced concrete. The frames are infilled with what were known as Vibroblocks, which are large, hollow-core concrete blocks produced from a mix of rubble, pieces of brick, and cement. After the war, in May 1947 the Swedish European Relief Fund (Svenska Europahjälpen) had donated to the City of Vienna two Vibroblock machines. With these machines, the rubble of the buildings that had been destroyed in the bombing raids could be put to use in new construction. The blocks measured 30 by 20 by 16.5 cm and were plastered on both sides. Timber formwork was used

to produce the exposed surfaces of the concrete frame.

In erecting the Gänsehäufel buildings in the late 1940s, 25,000 cubic meters of sand, 5,000 tons of cement, 130 cubic meters of lime, 6,000 kg of gypsum, 880 tons of steel, and 20,000 kg of paint were used. The infrastructure provided 3,500 cubicles, 10,000 lockers, 500 season cabins, and seating for 2,500 in the restaurant.

Béton Brut

In the 1940s, at the time of the original construction, consideration was given to using smooth steel formwork panels to make the columns. Alternatively, the application of a render or treating the concrete by means of stone masonry techniques was also considered to achieve a uniform surface finish in the different elements of the structures. Apart from aesthetic considerations, the higher maintenance costs of a render finish excluded that option, while the use of stone masonry techniques would have resulted in considerably higher construction costs.

The original exposed or fair-faced concrete surfaces are an aspect of the architects' artistic expression and therefore are very carefully detailed. In the architecture of modernism, considerable thought was devoted to surface, in terms of not only aesthetic quality but also symbolic and cultural

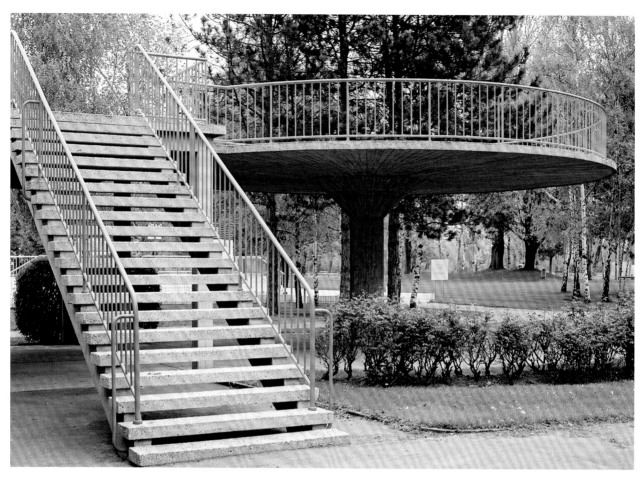

Fig. 7.5. The terrace to the café-restaurant is supported by a mushroom-head column, shown here following conservation.
Photo: Bettina Neubauer-Pregl / Courtesy of Federal Monuments Authority Austria, Vienna

expressive strength. In his "theory of dress," Gottfried Semper understood the facade as the "clothing" of the building. The texture left by the board formwork, eventually chosen for the Gänsehäufel buildings, can also be seen as clothing that reflects the process by which it was made and presents this in a symbolic manner.

The architects paid special attention to the placing of the formwork joints. For instance, for the soffits of the rounded building volumes, such as the water tower, clock tower, and terrace to the café-restaurant on the mushroom head column (fig. 7.5), they produced special formwork plans that specified the direction and position of the form-work joints. In producing the concrete, the greatest care was also taken. It was regarded as imperative to avoid any honeycombing that would have to be remedied later.

Given the importance of the concrete surfaces, it was vital that these should be retained as far as possible in the conservation work. To learn from comparable examples,

the author of this article visited the following concrete buildings, among others: Centennial Hall (1913) in Wrocław, by Max Berg; Church of Notre Dame du Raincy (1923) near Paris, by Auguste and Gustave Perret; Saint Antonius Church (1927) in Basel, by Karl Moser; Goetheanum (1928) in Dornbach, by Rudolf Steiner; Church of Saint Agatha (1930) in Merchingen-Merzig, by Clemens Holzmeister; Le Havre (1945–64) by Auguste Perret; Istituto Marchiondi (1959) in Milan/Baggio, by Vittoriano Viganò; Bensberg City Hall (1972) near Cologne, by Gottfried Böhm; Pilgrim-age Church (1968) in Neviges, by Gottfried Böhm; and some of Le Corbusier's buildings, including the chapel of Notre Dame du Haut (1955) in Ronchamp, Sainte Marie de la Tourette (1960), and buildings in Chandigarh (1955) and Ahmedabad (1954). In these buildings, depending on the level of damage, the range of concrete conservation work extends from complete renovation of the surfaces to minor interventions.

At the beginning of the work on the Gänsehäufel, all the concrete structural elements were examined. Each element was examined in terms of:

- tensile strength of concrete surface
- compressive strength of the concrete, by taking core samples
- thickness of the concrete cover over the steel reinforcement bars, and condition of the reinforcement and bar size/diameter
- carbonation depth
- locating the position of the rebars by means of a concrete cover measuring device that does not cause any damage to the concrete

The structures were all surveyed to identify the depth of cover and marked as (a) a cover of 10 mm or less, or (b) a cover between 10 and 15 mm. To calibrate these results, in each case one of the areas examined was opened up using a chisel and measurements were taken with a Vernier caliper.

As a result of the survey and diagnostic testing of the overall building defects, above all with regard to safety, and of the condition of the reinforced concrete, it was discovered that for their age, the buildings were generally in good condition. The reinforced concrete did not have to be demolished, but could be repaired. It was also discovered that in most cases the damage to the concrete had resulted from inadequate concrete cover to the reinforcement.

The task then was, by means of theoretical and practical examinations, to identify possible conservation methods. Through collaboration between engineers, concrete repair specialists, and conservators, solutions had to be found for cleaning, exposing damaged areas, repairing them, re-creating the surface texture, and conserving the various parts of the buildings. The precise approach to conserving those areas where the concrete had spalled was worked out by means of experiments on sample areas.

Cleaning

The aim of cleaning the concrete surfaces was to remove the dirt, rust, and calciferous deposits that had accumulated over the course of fifty years, along with any paint layers that had been added in the intervening period. The goal laid down for the conservation work was to preserve all the surface textures (wood grain and formwork board markings) of the concrete. This could be achieved only via special cleaning processes.

To arrive at an economical and minimally invasive method of cleaning, a number of sample areas were treated.

The first sample areas were sandblasted. The results showed that the grit chosen was too hard and resulted in the loss of too much of the surface as well as producing an unnaturally rough texture. In the case of three of the reinforced concrete columns, the surfaces were cleaned by means of the dry JOS procedure, using sharp-edged aluminum silicate with a grain of 0.2 to 0.8 mm. The dirt and calcified deposits were removed, while the structure of the wood grain was, for the most part, retained. Consequently, this method was selected in the conservation work. The intensity of the cleaning process depends also on the person using the appliance. For successful cleaning, suitably qualified staff are essential.

Calcite powder was used for cleaning one of the sample areas. This leaves a whitish-gray coat that has to be washed off and the surfaces then allowed to dry, so this method cannot be used at low temperatures due to the danger of freeze-thaw damage. Another method was considered in which high-pressure water jets are used at up to 300 bar, with a rotating jet and a water temperature of 90°C (194°F). The possible advantages of this process are that it creates less dust and uses less cleaning material. But as it was planned to carry out most of the conservation work outside the swimming season (in the cold half of the year), both calcite powder and wet high-pressure cleaning methods were rejected.

Before cleaning the concrete areas that had been severely affected by freeze-thaw damage, and sandy and silted areas, pre-strengthening with a stone stabilizer (Funcosil Stone Strengthener 100, which uses a silicic acid ester base) was carried out to prevent disintegration and loss of material.

Sample patch repairs were carried out on spalled areas according to the usual procedure for concrete restoration. The original appearance of the columns was to be preserved. As the first sample areas of the columns did not meet this objective, further sample repairs were carried out. In three columns, it was important that the existing wood-grain finish created by the formwork boards be retained. It was recommended that the advice of a conservator should be sought to produce these sample areas. Sand was added to the repair mortar in order to match the variable grain size of the original concrete's aggregate mix. By adapting the mortar through the addition of a 5 mm round aggregate to the covering layer in order to restore the surface, it was possible to imitate a weathered surface, in particular immediately adjacent to intact surface areas. To create the wood formwork texture, selected wooden boards were pressed into the fine mortar while it was still soft and were removed after it had hardened, one day later.

Floor Screed

In many areas, the screed in the Gänsehäufel was in very poor condition, and in places it was less than 2 cm thick. Where the screed was still in reasonable condition, an epoxy primer was applied to its dusted surface. To match the existing appearance, large amounts of quartz sand (grain 1 to 3 mm) were then strewn on the surface and brushed off. After hardening, the surface was treated using a diamond grinding machine to match the original finish. The screeds were covered with a moisture-resistant, crack-bridging, UV-resistant epoxy coat in the color RAL 7044, silk gray. This sealing and coating made it possible to protect the building from moisture and to ensure that moisture does not enter the concrete construction.

However, in many areas, particularly in those most exposed to the weather, the screed was in such a poor state that it could not be repaired and had to be reconstructed. On this account, the following steps were taken on a sample area:

- removal of the old screed
- cleaning
- creation of drainage holes through the construction (diameter 2 cm, four holes per slab)
- sealing (bitumen basis)
- new reinforced screed
- water-repellent treatment

For areas where replacement of the screed was necessary, samples were made both on- and off-site.

Along with a leveling layer, an epoxy coating was applied. Here a kind of sand was used that is very similar to the aggregate used in the existing areas of screed. After it had hardened sufficiently, the surface was sanded. This did not prove satisfactory. In subsequent trials, a layer with a thickness of at least 5 mm was applied directly on-site and then sanded. This consisted of (a) at least 1 to 2 mm quartz sand, resin-to-sand ratio of 1:2 parts by weight, and (b) 3 mm quartz sand, resin-to-sand ratio of 1:2:3 parts by weight. Loss due to sanding was a maximum of 2 mm, leaving a final thickness of 3 mm. This trial re-creation of the texture of the screed surface produced the desired results in terms of form, structure, and color.

Corrosion Inhibitors and Water-Repellent Treatment

On the sample areas of the columns, a corrosion-inhibiting coating and a hydrophobic agent were applied in accordance with the manufacturer's instructions (application in several stages) and then examined. Although neither of these products affected the color or texture of the surface, it was decided not to use them, as there was no proof that either would have a significant impact. Therefore, the concrete surfaces were just given a water-repellent treatment (siloxane and silane-based water-repellent agent).

CONSERVATION

First, the condition of the existing concrete structures had to be assessed, and then a system of repair and conservation techniques introduced. The main aim of the work was the conservation and repair of the original qualities of the structural shell and the surfaces. This aim was defined at the beginning of the preliminary studies. In order to optimize the different conservation methods, sufficient time had to be allowed for numerous preliminary studies and for treating a series of sample areas of the exposed concrete surface. On the basis of these numerous trials and mock-ups, it was possible to develop a specific package of suitable measures.

Similar to Auguste Perret's concrete architecture in Le Havre, in the Gänsehäufel buildings great importance was attached to carefully designed details and surfaces. These surface finishes are an important part of their architectural significance. From a conservation viewpoint, the uncoated, fair-faced concrete surfaces (fig. 7.6) of the buildings are an essential element of the architecture as a whole.

Initially the conservation concept proposed completely covering the surface with paint or coatings in order to prevent any further corrosion of the reinforcement. The removal of certain areas of concrete was also proposed. The staircases were to be replaced entirely by precast concrete elements; however, for aesthetic reasons the proposal to coat the exposed surfaces to prevent further carbonization of the concrete, as envisaged in building construction standards, was rejected. As it was recognized as important to preserve the original surface appearance, large-scale replacement of existing concrete was also rejected. Damaged areas of concrete were to be repaired by conservators. Structurally necessary strengthening was to be limited to what was absolutely essential and was to be integrated into the existing buildings. However, in certain areas such as the building joints and the cantilevered slabs in the cubicle towers, the required repair measures were larger in scale.

The concrete conservation measures were applied to six changing pavilions with cubicles, four changing pavilions with lockers, the connecting walkways, the clock tower, the water tower, four cubicle towers, the entrance and administration building, the café-restaurant, two seasonal cubicle

Fig. 7.6. Detail of a restored walkway column showing the exposed concrete surface, which was re-created using boards to match the original wood-grain surface finish.

Fig. 7.7. The spiral staircase to the clock tower, shown here following cleaning and repair, had suffered less damage than the central shaft, and it proved possible to avoid giving the exposed concrete a full coating. Photo: Bettina Neubauer-Pregl / Courtesy of Federal Monuments Authority Austria, Vienna

blocks, the filtration building, and workshops. The repairs are described below.

Clock Tower

The clock tower (fig. 7.7) is a slender, conical reinforced concrete tower 27 m high. Its diameter in the lower area is 1.05 m, in the upper section 0.35 m. A spiraling reinforced concrete staircase with ninety-nine steps winds around it. At the top there is a platform (3.85 m in diameter), a loud-speaker system, and a clock with four faces, each 2 m in diameter (Fellerer and Wörle 1951b). As reinforcement, TOR-steel-40 rebar was used. This slender tower is regarded as a technical masterpiece.

Spalling was discovered along its entire height, and in most cases this had led to the exposure of the reinforce-ment stirrups and to corrosion of the main reinforcement. In some places, even the principal reinforcement was exposed. The damage was generally the result of insufficient concrete cover and was restricted to the load-bearing structure of the tower. Only some slight cracking and minor spalling were discovered in the staircase.

The vegetation growing up the clock tower was stripped away, as it had contributed to the damage caused to the reinforcement. The original plan to provide a protective coating to the entire clock tower was abandoned. The conservation work included cleaning the concrete using an abrasive material, chipping off the necessary carbonated areas of concrete, carrying out concrete restoration measures and reconstructing the surfaces, and applying a water-repellent treatment.

7

Fig. 7.8. In the projecting upper platform of the water tower, shown here following conservation, cracks and exposed reinforcement were discovered and remediated. Photo: Bettina Neubauer-Pregl / Courtesy of Federal Monuments Authority Austria, Vienna

Water Tower

The water tower (fig. 7.8) is 25 m high and consists of a hollow reinforced concrete cylinder with a diameter of 3 m. Ladders fixed internally allow one to climb up its interior. There is an accessible reinforced concrete platform at a height of 17 m. Above this circular platform, there is a round steel tank at a height of 20 m. It rests on reinforced concrete brackets that are connected to the load-bearing structure of the tower.

Damage was detected at the building joints, the bearing points for the stairs, and the cantilevered concrete elements. This damage was the result of inadequate concrete cover. To assess the load-bearing capacity and to evaluate the extent of the damage to the critical upper reinforcement, the screed on the uppermost landing was removed. In the cantilevered upper platform, three continuous radiating cracks and exposed reinforcement were discovered. In general, the low load-bearing strength suggested that repair work should be undertaken as soon as possible.

The conservation of the concrete was carried out in the same way as in the clock tower. The radial reinforcement of the landing platform was repaired in accordance with the structural engineer's requirements. A protective coating was applied to the repaired concrete layer. To prevent rainwater entry, a film-like synthetic resin coating that bridges cracks was then applied. It directs rainwater outward to the drip edge.

Cubicle Towers

The changing cubicles are in three four-story towers and one three-story tower (fig. 7.9). The towers are particularly slender in terms of construction. Each structure is a reinforced concrete frame, with the cubicles on each level connected by continuous, open, cantilevered access decks. The reinforced concrete slabs are covered with a screed. The individual levels are connected by external single-flight staircases.

Due to the considerable deformation at the outer edges of the access decks, further survey and diagnostic work was undertaken as follows:

- opening up of the corner areas of the slabs
- determining the exact thicknesses of the slabs
- estimating the concrete quality
- determining the position of the upper reinforcement
- determining the thickness of the steel

Fig. 7.9. The repair of the four cubicle towers with their thin projecting platforms, shown here following conservation, presented a particular challenge. Photo: Bettina Neubauer-Pregl / Courtesy of Federal Monuments Authority Austria, Vienna

7

The examination showed that the reinforced concrete slabs of the different levels in the cubicle towers were extremely thin (between 8 and 10 cm), there was insufficient reinforcement, and the existing reinforcement had not been well placed. The screed, particularly on the upper levels, had a number of open cracks. Here rainwater could enter the slab construction, leading to increased corrosion and consequently damaging the slabs.

Due to the minimal dimensions of the elements, sizable deformation had occurred at the outer corners of the cantilevered reinforced concrete access decks. With a cantilever of 2 m, the deformation amounted to between 8 and 9 cm, about ten times greater than the permissible figure; therefore the load-bearing capacity was insufficient. Immediate measures were required. These took the form of temporarily supporting the thin concrete cantilevered slabs with timber. Repair work was necessary.

Due to the structural problems, demolition or partial demolition of the cubicle towers was considered. Due to the requirement of the Federal Monuments Authority Austria (Bundesdenkmalamt) that wherever possible, permanent visible interventions to the building should be avoided, long-term support of the slabs by means of newly introduced columns was not an option. To preserve the original

fabric, a permanent conservation method was devised in conjunction with a structural engineer. Thus, in the case of the cubicle towers, the issue was more than just a cosmetic treatment of the surfaces and involved increasing the load-bearing capacity of the cantilevered slabs.

To achieve a structurally acceptable solution for the concrete slabs, the protective screed on the access decks was removed and new reinforcement was bonded to the existing construction by means of synthetic resin. Instead of the screed, a very fine-grained and dense composite concrete was applied. Together with the additional reinforcement, this new concrete layer is only 4 cm thick. Between the outer edges of the slabs and the increased slab thickness a wedge of polymer concrete was made at the railings. This allowed the original, clearly visible thin edge of the slab to be retained. The new composite concrete slabs were given a synthetic resin coating that allows the rainwater to run off. This prevents moisture from reaching the construction of the thin floor slabs. These measures have ensured that the building can now take a load of 400 kg/m^2, which is in accordance with the standards.

The load-bearing construction of the towers, which consists of columns and downstand beams, showed no indication of excessive loading. No significant defects were

Fig. 7.10. Perforated concrete blocks, shown here following cleaning and repair, form a light curtain between the more intimate inner courtyard of the changing pavilions and the surrounding area. Photo: Bettina Neubauer-Pregl / Courtesy of Federal Monuments Authority Austria, Vienna

Fig. 7.11. The exposed concrete surfaces and the wooden lockers in the interior of the changing pavilions were retained. Fluorescent tubes were removed and replaced with reconstructions of the original light fittings.

Fig. 7.12. The new surface of the second floor of the internal courtyard of a pavilion with lockers was adapted to match the original appearance. Photo: Bettina Neubauer-Pregl / Courtesy of Federal Monuments Authority Austria, Vienna

found in the downstand beams and staircases of the towers. Any slight spalling of the concrete was repaired in the course of conserving the towers.

In the case of the cubicle towers, a further detail had to be addressed. As the thickness of the access decks to the towers was increased by a few centimeters, the height of the existing railing also had to be increased. As a provisional, reversible solution, simple tube clamps were used to fix a wooden handrail to the existing railings. This complied with the building regulations regarding railing height (100 cm). As the provisional measure is very discreet and also economical, it was decided to retain this solution.

The conservation measures undertaken on the cubicle towers turned out to be the most economical solutions. Using the simplest means, the original fabric was preserved and the original slenderness of the building parts was retained, enabling the overall appearance of the buildings to remain unchanged.

Changing Pavilions with Lockers

Between the two wings of the pavilions with lockers, which are organized around smaller internal courtyards, timber portals and grill-like walls (fig. 7.10) are used to provide screening and create an almost Mediterranean patio effect. The pavilions with lockers (fig. 7.11) and the pavilions with cubicles are concrete buildings with gently pitched roofs, which at places continue beyond the external walls. The reinforced concrete frames are infilled with Vibroblocks or perforated concrete blocks (fig. 7.12).

In all the columns and beams in the pavilions with lockers, the reinforcement stirrups were corroded in the areas examined. The average concrete cover of the stirrups was 8.7 mm, the average carbonation depth was 16 mm. This meant that alkali protection of the concrete around the stirrups no longer existed and, therefore, it was assumed that they would be entirely corroded. In places, the concrete cover had already broken off as a result of carbonation.

In the case of the main reinforcement to the columns, an average concrete cover of 28 mm was noted. With an average carbonation depth of 16 mm, this meant that in substantial areas the longitudinal reinforcement of the columns was still protected against corrosion. It was only where the corrosion of the stirrups had resulted in damage to the concrete surrounding the main reinforcement that the concrete had, at places, carbonated to a greater depth.

The main reinforcement to the downstand beams and cantilevered slabs had an average cover of 21 mm. The average depth of carbonation was discovered to be 16 mm. However, in some areas with a carbonation depth of up to

50 mm, corrosion of the reinforcement had occurred. This was particularly evident in places where water had entered from above through cracks and defective joints in the cantilevered slabs. The repair work to the concrete took place in the same way as in the other buildings: cleaning, exposure of defective areas, protection of the reinforcement against corrosion, and re-creation of the profile.

Connecting Walkway

A concrete walkway (fig. 7.13) connects the four pavilions containing lockers. It was made as a reinforced concrete slab and beam bridge with a length of 172 m and a width of 3.56 m. The walkway is carried by eighty-four reinforced concrete columns (fig. 7.14) that have a square cross section of 25 by 25 cm. The structure is supported every 4 m by two columns connected by a transverse downstand beam. The slab of this structure is made of reinforced concrete, 8 to 10 cm thick. It was covered by a slightly cambered screed that varies in thickness between 2 and 4 cm. The structure is divided by four expansion joints. Every 4 m, expansion joints were made in the screed and filled with asphalt.

Four double staircases with a width of 1.94 m are placed between the walkway and the locker pavilions. These staircases are made of precast elements. On the northern side of the walkway, there is a curved staircase made of in situ concrete (fig. 7.15).

The walkway was badly weathered and covered with a considerable amount of lichen. There were numerous cracks and hollow areas in the concrete. The nature of the damage was much the same as in the pavilions with lockers. However, in the case of the walkway, the damage caused by water entering from above was greater. The damage was located in the area of the expansion joints and at brackets. It took the form of concrete spalling due to insufficient concrete cover to the reinforcement steel. Spalling was also discovered in the staircases, walkway surface, and railings.

In 27% of the columns, the main reinforcement was exposed. The damage was principally at the base and lower ends of the columns. As the columns are overdimensioned, there were no stability problems. In 33% of the columns, there were cracks and spalling; in 40% of them, no visible defects were detected.

Damage caused by freeze-thaw and mechanical stress was discovered in the screed that had been applied as the finished surface to the walkway. The expansion joints that were filled with bituminous jointing material were not watertight. The walkway surface was applied directly to the structure, no sealing layer was used, and the structure had no rainwater drainage system. As a result, water

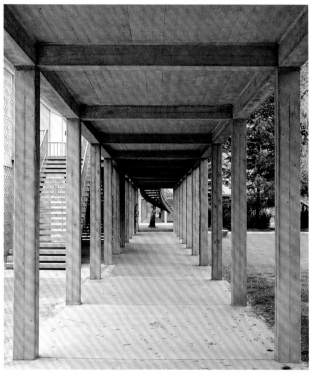

Fig. 7.13. A walkway 172 m in length, shown here following conservation, connects the changing pavilions. Due to its exposed location and the lack of a sealing layer, the screed and the 8 to 10 cm thick reinforced concrete slab had suffered serious damage.

Fig. 7.14. The eighty-four square columns of the covered walkway had suffered damage, especially in the lower areas. This photo, taken following conservation, shows the original surface finish with partial, visually matching improvements. Photo: Bettina Neubauer-Pregl / Courtesy of Federal Monuments Authority Austria, Vienna

and freeze-thaw damage had occurred to the reinforced concrete slab below. Particularly in the area of the expansion joints and brackets, serious corrosion damage had occurred with substantial reduction of the cross-sectional area of the steel reinforcement. A suitable way of sealing the slab construction had to found and adapted to the existing structure by means of tests on sample areas.

A certain amount of repair work had been carried out in the past; however, these measures to re-create the surface texture had themselves been badly damaged by the reoccurrence of cracking and spalling.

The concrete surrounding the heavily rusted reinforcement in the columns was chipped away as far as possible, sandblasted (surface preparation grade of steel substrate: SA 2½ International ISO-norm 8501-1: 2002-03, which is comparable with SP10 Near White Metal Blast Cleaning) (International Organization for Standardization 2002–3; Society for Protective Coatings [SSPC] 2007), and cleaned with dry air, and, without any waiting period, the reinforcement was immediately completely treated with an epoxy-cement-based bonding agent and anticorrosion coating

for steel reinforcement (Sika Top Armatec 110 EpoCem). A second coating followed after the first one had dried.

The damaged screed was removed. After the repair of the concrete, the renewed horizontal surface was coated with synthetic resin in order to seal it. This ensures that rainwater cannot enter the building elements but rather drains off at the sides, where it can trickle down into the areas of greenery. The weathered concrete surfaces were given a water-repellent treatment. The expansion joints were renewed.

Staircases

Most of the external staircases (fig. 7.16) in the Gänsehäufel were built from prefabricated elements and consist of two beams that carry slab-like steps. In the main beams to the staircases and at the bearing brackets, deep spalling with exposed and corroded reinforcement was visible. In places, the cross-sectional area of the main reinforcement had been clearly weakened due to corrosion. The evaluation of the main beams to the staircases produced the following

Fig. 7.15. The curving, self-supporting in situ concrete staircase, shown here following conservation, is a flight of twenty-one steps to the connecting walkway 3.62 m higher. Photo: Bettina Neubauer-Pregl / Courtesy of Federal Monuments Authority Austria, Vienna

Fig. 7.16. It was by and large possible to preserve the precast concrete staircases between the changing pavilions. Photo: Bettina Neubauer-Pregl / Courtesy of Federal Monuments Authority Austria, Vienna

results: 0% had no visible damage, 39% had cracks and spalling, and 61% had exposed reinforcement. Most of the staircases could be repaired. A number of steps were replaced as precast elements, after being surface treated to achieve a good visual match.

In the case of the cabin pavilions (see fig. 7.16), in the area of the staircases, repairs had been carried out earlier. Below the upper bearing points of the staircases, transverse galvanized steel beams that are bolted to the columns had been introduced. These are barely visible. In addition, cracks and areas of spalling were closed in the course of restoring the concrete. Through this measure, the stability of the main staircase beams has been ensured in the medium term. Consideration was given to rebuilding the staircases to match the originals, but it was decided for the time being to retain the existing solution with the steel beams.

Ongoing Monitoring

Every year the concrete surfaces in the Gänsehäufel are visually inspected to detect any possible damage as early as possible. Attention is also paid to the possible development of fine surface cracking. In the future, individual areas of damage that occur are to be repaired immediately during the following off-season. Those in positions of responsibility are conscious of the significance of the Gänsehäufel architecture; they maintain it in an appropriate way and are aware that, as far as concrete is concerned, deferring maintenance work never makes economic sense.

The conservation of the Gänsehäufel (2000–2004, 2015–16) was particularly successful because the work was achieved with minimal visual impact. This project demonstrates that, thanks to the important preliminary work (research, analysis, and diagnostics), the cost of conserving original concrete surfaces is, depending on the area, only 5% to 12% higher than the cost of "standard" concrete repair. However, if the standard treatment had been used here, the entire architecture ensemble would have lost its most important feature: the fine concrete surface patterns created by the timber formwork. Even years after completion, the results of this conservation work remain most compelling.

CONCLUSIONS

In erecting the Gänsehäufel, Vienna established a link to the remarkable heyday of a culture of municipal swimming facilities that the city had developed in the 1920s. In the conservation of the Gänsehäufel complex, its importance as a legacy of postwar modernism played a most significant role.

To ensure the best possible conservation work of the Gänsehäufel, the team started with comprehensive examinations and devised the concept for the repairs in a series of steps by undertaking trials and sample mock-ups. Looking back, it is now clear that taking enough time for this investigative and experimental phase was vitally important. The time and money spent was then later saved when carrying out the work. For the client, this certainty about costs was highly important in terms of accepting the conservationists' concept as sensible and justifying the expenditure. The conservation of the Gänsehäufel was the biggest project in the history of refurbishing Viennese swimming facilities; the cost of the construction work was 8.2 million euros.

It was successfully demonstrated that sensitive conservation is possible, even in such exposed and intensively used buildings as the Gänsehäufel. Thanks to careful repair of the deteriorated parts using special finish techniques, and extensive preservation of the original concrete surfaces, the architects' original design intent is still apparent today. As material changes could be avoided, it was also possible to preserve the architectural integrity of the structure.

The experience with concrete conservation gained in the Gänsehäufel has already been applied to other projects and will be of assistance in the future in preserving further important exposed concrete buildings in Austria, including the Heilig-Geist-Kirche (1913), by Jože Plečnik; the New Vault (1962) at the Imperial Crypt, by Karl Schwanzer; and the Wotruba Church (1976), by Fritz Wotruba and Fritz Gerhard Mayr.

Translated from the German by Roderick O'Donovan

NOTE

1. In 1993, the Gänsehäufel was placed under a protection order by the Federal Monuments Authority Austria (Bundesdenkmalamt; GZ 16.423/2/1993).

WORKS CITED

Fellerer, Max, and Eugen Wörle. 1951a. "Der Neubau des Gänsehäufels." *Der Aufbau* 6 (8): 286–91.

———. 1951b. "Details vom Strandbad Gänsehäufel." *Der Aufbau* 6 (8): 309–11.

International Organization for Standardization. 2002–3. *Preparation of Steel Substrates before Application of Paints and Related Products— Visual Assessment of Surface Cleanliness.* ISO 8501-1:2002-06 (followed by ISO 8501-1:2007). Geneva: International Organization for Standardization.

Jost, Karl. 1951. "Das Strandbad Gänsehäufel gestern und heute." *Der Aufbau* 6 (8): 281–85.

Maldoner, Bruno. 2008. "Sichtbeton und Restaurierung." In *Denk-mal an Beton!*, edited by Vereinigung der Landesdenkmalpfleger in der Bundesrepublik Deutschland, 213–17. Volume 16 of Berichte zu Forschung und Praxis der Denkmalpflege in Deutschland. Petersberg, Germany: Michael Imhof Verlag.

Society for Protective Coatings (SSPC). 2007. *SP 10/NACE No. 2, Near-White Blast Cleaning.* Pittsburgh: SSPC.

7

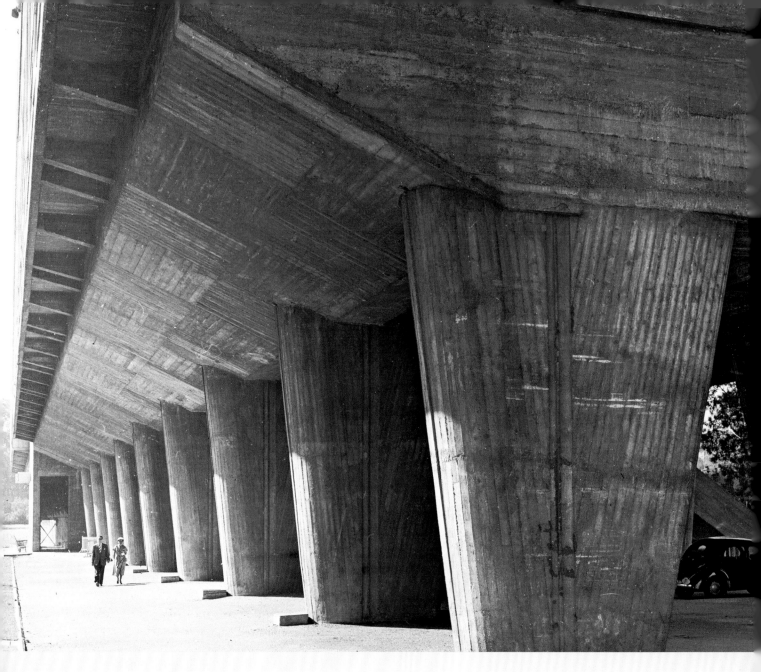

8

François Botton

Unité d'Habitation

Marseille, France | 1952

ARCHITECT/DESIGNER

Le Corbusier

PROJECT DATES

2000–2001: preliminary studies | 2003–17: execution

PROJECT TEAM

François Botton, conservation architect | Vivian, masonry contractor (west facade works) | Freyssinet, masonry contractor (east facade works)

CLIENT/BUILDING OWNER

Private, co-owned

INTRODUCTION

The Unité d'Habitation in Marseille was commissioned by the French state in 1945 and built between 1947 and 1952. It was the first in a series of projects designed by Swiss-French architect Charles-Édouard Jeanneret, better known as Le Corbusier (1887–1965), that expressed his architectural and urban theories during the period of postwar reconstruction.[1] Marseille's plan was the most complete of the Unité d'Habitation series, featuring 330 units for 1,200 residents and a range of facilities that made it a vertical village: a shopping arcade, offices, a hotel, a glazed gallery on the third level, and on the roof terrace a nursery school, gymnasium, running track, and outdoor theater (figs. 8.1, 8.2). The success of the project, built by the Ministère de la reconstruction et de l'urbanisme (Ministry of Reconstruction and Urbanism) to house civil servants in what was then the second most populous city in France, was indisputable, and it remains highly prized by both the residents of its 330 units and the many who visit it. Some families have lived there since it was built.

Le Corbusier was assisted by French architects André Wogenscky and Jean Prouvé, as well as the engineers of ATBAT (l'Atelier des bâtisseurs, or builders' workshop), directed by French engineer Vladimir Bodiansky. The furnishings were designed by French architect and designer Charlotte Perriand. The architectural style can be called brutalist because of the use of materials left in a raw state (unpainted concrete poured into rough-board formwork or with exposed aggregate) whose sculptural qualities catch the light, which Le Corbusier regarded as an element of architecture in its own right. The company responsible for the structure and the concrete works was La Construction moderne française.

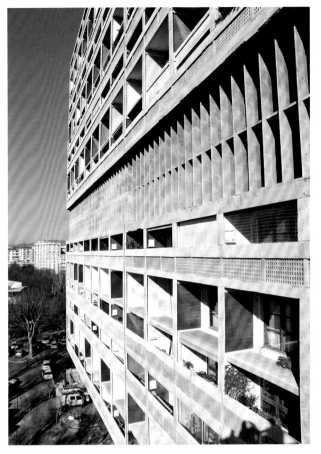

Fig. 8.2. General view of west facade, 2008.

Since 1986, the building has been listed as a historic monument and accorded the title *patrimoine du XXᵉ siècle* (twentieth-century heritage) by the French Ministère de la culture (Ministry of Culture).[2] In 2016, it became a UNESCO World Heritage site, one of seventeen such sites in the transnational dossier "The Architectural and Urban Work of Le Corbusier." The innovative principles of its architectural conception and composition include:

- separation from the ground by means of pilotis and creation of a raised ground level
- main structure of post-and-beam type, with residential units structurally isolated from one another to improve sound insulation
- arrangement of apartments along interior streets

Fig. 8.1. An early view of the concrete colonnade at the base of Unité d'Habitation, ca. 1950. Photo: Allan Cash Picture Library / Alamy Stock Photo

8

- dual-aspect apartments with openings on two opposite facades, to receive both morning and afternoon light
- bi-level layout, with a double-height living space
- high standard of apartment furnishings, with innovations for the period

The building system makes use of reinforced concrete in several forms: main posts and beams of reinforced concrete; pilotis of reinforced concrete poured into rough-board formwork; facade elements prefabricated in exposed, fine-gravel concrete; and shotcrete to the roof of the gymnasium.

Preliminary studies were undertaken between 2000 and 2001, and between 2003 and 2017 a series of conservation and repair techniques were implemented, first on trial areas, then on a larger scale to different facades as follows:

- 2004–6: trial repairs and mock-ups to a section of the pilotis and facade
- 2007–10: conservation of the west facade
- 2015–16: conservation of the east facade

This work was financed jointly by the owners (44%), the City of Marseille (9%), the local council (17%), and the French Ministry of Culture (30%). This case study describes this series of projects.

THE PROJECT

The project's origin dates to 1999, when the author was contacted in his capacity as head architect of historic monuments in the Bouches-du-Rhône district. At that time the degradation of the facades had led the co-owners to undertake annual emergency spot repairs. These involved manually removing loose areas of concrete in the interest of public safety, as there was a significant risk of falling concrete and the co-owners were legally responsible for any casualties.

During the preliminary studies, the condition of the building was assessed and the responsible parties were quickly notified that while they temporarily ensured safety, the emergency spot repairs could by no means be considered an adequate conservation response. Also, as the frequency of undertaking the emergency spot repairs was clearly accelerating, the monument's original material was therefore being eroded at a correspondingly increased rate. No preventive measures had been put in place. The areas of concrete removed overwhelmingly corresponded to previous repairs, indicating that these were not of a durable nature. It was concluded that the cycle of degradation/spot repair/degradation did not encompass any broader consideration of the conservation of the structure as a whole, and was focused on preventing harm to people rather than addressing the underlying problem of the deterioration of the concrete. This approach would progressively lead to the irreversible loss of a great amount of original building material and would eventually require replacing all the concrete work on the facades—a serious loss in terms of authenticity.

The studies identified additional problems, such as the loss of original polychromy (present in the loggias) and the modification of the exterior door and window frames, which was addressed in the course of the work.

The previous restoration work that had been undertaken in 1980 (facades) and 1994 (roof deck) was analyzed with the benefit of hindsight afforded by the time that had passed since its completion (fig. 8.3).[3] Likewise, an analysis and critique was undertaken of the conservation work performed during the same period on two other Unités d'Habitations by Le Corbusier, in Rezé and Firminy, France. These experiences helped inform the solutions to be either followed or avoided and were adapted as closely as possible to the conservation project undertaken in Marseille.

INVESTIGATIONS: BACKGROUND RESEARCH, ANALYSIS, DIAGNOSTIC WORK, TESTING, AND TRIALS

The preliminary phase of study was performed in 2000 and 2001, under the author's direction in his role as *architect en chef*. The testing work was conducted by Laboratoire d'études et de recherches sur les matériaux (LERM), a private laboratory, as well as by the government Laboratoire de recherche des monuments historiques (LRMH). The testing program for this preliminary phase of study had the following goals: characterize the materials and construction processes; itemize and characterize the deterioration mechanisms affecting these materials; propose protocols and repair processes to conserve the facades to appropriate architectural and technical standards; research potential methods of preventive conservation to the areas in good condition; and identify and develop technically and aesthetically compatible repair methods and materials for areas of concrete requiring replacement.

The testing program and its results were presented in a report by LERM (2000) and included in the preliminary study. The testing program included the following investigations:

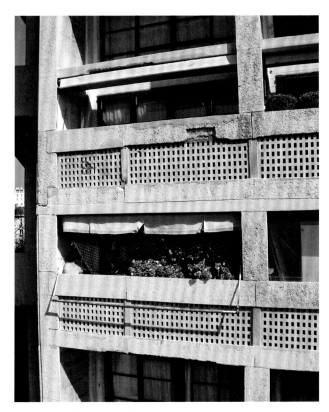

Fig. 8.3. Detail on west facade showing damage before conservation, 2001.

- observation with an optical microscope
- observation with an electronic microscope
- characterization of the physical properties of the concretes
- chemical characterization of the concretes
- identification of the original concrete mixes
- depth of cover measurements of the concrete to steel reinforcement
- depth of carbonation measurements
- measure of the corrosion potential
- chlorine content measurements
- analysis of the sulfate content
- analysis of the potential for alkali-aggregate reaction

The testing utilized samples from several facades in order to verify the possible effects of orientation on the nature and extent of the damage. The main facades are oriented east and west; the gables are oriented to the north and the south. The building is located in proximity to the sea, to its west facade.

The outcomes of the testing program and preliminary investigative phase indicated that the building presented numerous defects and deterioration mechanisms, located on the load-bearing structures of the lower part (pilotis and underside of lowest deck) as well as on the prefabricated elements of the facade. The raised load-bearing structures (posts and beams) at the level of the loggias exhibited little damage, and the same was true of the north window-less gable. There were, however, other large areas of visible damage due to extensive reinforcement corrosion and subsequent spalling of the concrete. The depth of cover to the steel reinforcement is irregular across much of the building and sometimes is nonexistent.

The extent of damage to the building did not seem to relate to its orientation. For the in situ concrete, the corrosion was mostly located on the lower elements near the ground and in zones where the quality of the concrete was poor and there was visible honeycombing. On the prefabricated elements of the facade, the corrosion was extensive; this could be related to the limited thickness of these elements (and therefore limited concrete cover to reinforcement) and the high ratio of surface area to mass. This was especially evident on the parapets of the balconies.

The testing identified types of concrete: Concrete A, consisting of a light-colored cement paste that is micro-porous and has a rather fine granular mix of a calcareous nature, was found in combination with the aggregate embedded on the facing of the prefabricated elements. Concrete B is gray in color and more compact, with rougher aggregates than in Concrete A. It was found deep within the prefabricated elements, beneath the fine-aggregate facing (Concrete A) and in the elements poured into rough-board formwork and left exposed. It was also used for the pilotis of the ground floor, the underside of the lowest deck, and the works on the upper terrace, including the ventilation stacks, garden walls, and theater.

The concrete characterization identified the presence of old portland cement, type CEM I, as a binder. The aggregates are composed of part gravel and part sand, both from carbonate calcareous rock. Concrete A, which is lighter, also contains dolomitic rock. The porosity was about 24% for Concrete A and 18% for Concrete B. The amount of cement was estimated at 350 kg/m^3, with a water-to-cement ratio of 0.7. The alkali-aggregate reactivity was rated low, and there was an absence of reactive minerals in the aggregates (< 2%). The chloride and sulfate contents were also low, and overall below current norms. The chloride gradient decreased from the surface to the interior, indicating that this was a result of environmental factors—specifically the site's proximity to the sea (a source of chlorides) rather than the original composition of the concrete. The average depth of carbonation was on the order of 30 mm for the entire building and 15 to 20 mm for the pilotis.

8

The repair work had to take into account the main characteristics of the concrete revealed during the testing program. The critical points were that there was significant depth of concrete carbonation, between 10 and 45 mm; that the reinforcement cover was of irregular depth and often minimal; that there was a limited presence of chloride and sulfate ions; and that the porosity of the concrete was generally high (24% for Concrete A and 18% for Concrete B).

These factors led the laboratory to recommend, in addition to repair work, two preventive methods to provide some measure of long-term corrosion control. First, the application of a corrosion inhibitor on the facades (prefabricated elements, floor bands, and nosing) was suggested. A sodium monofluorophosphate (MFP) product was selected on the recommendation of the LRMH. Second, realkalization of the in situ structural elements (pilotis, and the underside of the lowest deck) was suggested. The laboratory recommended that preliminary trials be undertaken before implementing these methods on a large scale. These preventive methods were proposed to be applied to the areas of concrete in good condition. Elements that had deteriorated to the extent of visible damage would be repaired as appropriate or, for the most severely damaged precast elements, replaced.

Other methods considered but ruled out at this phase of the study included the complete replacement of the prefabricated elements of the facade, as had been done at Rezé. This project aimed to conserve the original fabric on philosophical grounds whenever this was technically and economically feasible. The installation of zinc galvanic anodes, such as those installed at Firminy, was also discounted owing to the difficulty of sustaining an electrical current between zinc and reinforcement steel in a dry environment (that is, dry concrete) and the difficulty in verifying and obtaining electrical continuity of the reinforcement. Continuing the practice of undertaking localized repairs with spot reinforcement treatment, followed by a coating, as had been implemented since 1980, was not considered a viable long-term approach, as these repairs had proved to have a limited life span.

The work was thus targeted to the development of a series of treatments that could be undertaken across the whole building based on three complementary protocols:

- like-for-like replacement of elements deemed unable to be conserved
- local reconstruction of partly degraded elements that were able to be conserved
- preventive treatment for all of the elements conserved

These protocols raised a number of questions and challenges. First was how to distinguish between the elements to be preserved, repaired, or replaced. Another was how to technically and aesthetically match the new elements with the existing concrete that was to be conserved. There were also questions as to how to select the appropriate preventive treatment to each situation or element.

Another challenge was how to arbitrate between conservation treatment and replacement with regard to cost and durability. In effect, durability may be considered proportional to the extent of replacement, whereas authenticity, the value specific to historic monuments, is inversely proportional to this. Where does one draw the line? The lack of models for this type of work posed difficulties. In addition, areas of conserved material would generate an ongoing cost for the owners due to the need for repeated cycles of maintenance.

It was also not precisely known how durable the preventive treatments would be, and thus how frequently maintenance operations would be needed. Operational considerations included how to manage the disturbances of heavy construction on an occupied site, and what the impacts would be of managing these disturbances in terms of cost, time, and above all acceptance by the residents.

This long list of concerns and the magnitude of what was at stake both technically and financially led the project team to propose work on a trial section of the building, of significant size, that would cover the range of problems that were likely to be encountered during the conservation works over a complete facade. These issues were clearly presented to representatives of the owners, who commissioned the work and who approved the plan for a trial phase of work.

CONSERVATION

Trial and Mock-up Works

A proposal was developed to undertake a trial phase of work on one-eighth of the surface of the west facade; a section between the ground and fourth "street" levels was chosen to facilitate access. The width of the test area was limited to the span between the north end of the building and the first expansion joint (fig. 8.4). This trial area enabled the selected repair methods to be tested on eight pilotis, one of which was greatly degraded, the underside of the lowest deck (750 square meters), thirty-two loggias faced with fine-gravel-aggregate finished prefabricated elements, and thirty-six vertical slats of the brise-soleils at the level of the third and fourth streets. The work took place from

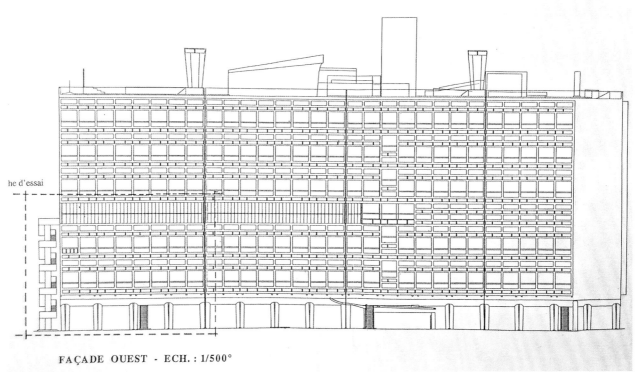

he d'essai

FAÇADE OUEST - ECH. : 1/500°

Fig. 8.4. Position of the test zone (bottom left).

8

November 2004 to July 2006. It was decided to use mobile platforms rather than scaffolding to carry out work in order to minimize the impact on residents.

The protocols were implemented as described in the preliminary study with regard to preventive treatments, the repair of elements deemed reparable, and replacement of totally degraded elements. During the study phase, a detailed condition survey of the facade elements was made from a cherry picker, in order to accurately estimate the extent of work for costing purposes. A contingency was allowed in the service contract to cover any additional decay that might be discovered in the course of the work (figs. 8.5, 8.6).

In order to monitor and document work on the trial section as closely as possible, with a view to confirming or modifying the protocols for the subsequent sections, the specifications required an internal check by the company carrying out the work as well as an external check by an independent laboratory recruited by the owners' representatives. Preliminary trials of the different methods were performed on the test elements and areas and then checked by the external laboratory.

Repair of Board-Marked Elements

Before repair commenced, the chloride level of the concrete was checked and a survey was undertaken using a rebound hammer (Schmidt hammer) to measure compressive strength around damaged zones, determine the extent of repair needed, and map the repair zones. Cleaning was undertaken by pressure washing or hydroabrasion depending on the degree of soiling. The extent of each repair area was taken to the nearest board mark so as not to introduce random demarcations on the facing. Each repair area was cut back to a minimum depth of 15 mm behind the reinforcement. The reinforcement bars were either repositioned, repaired, or replaced.

The béton brut repair was undertaken according to one of two methods: for shallow areas, the mortar was applied, then stamped with a press of rough wooden boards to match the existing board marking; for larger volumes, where the concrete could be poured, shuttering was built in rough wooden boards and the concrete poured, then vibrated.

For one of the pilotis that was highly degraded with very significant honeycombing, the amount of concrete to repair was so great that temporary shoring had to be put in place

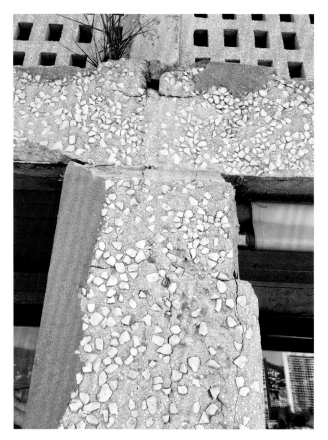

Fig. 8.5. Damage on prefabricated panels and trace of former repairs, 2016.

Fig. 8.6. Damage on a prefabricated parapet, 2016.

while the repair was carried out (figs. 8.7, 8.8). The shoring was calculated to compensate for the loss of load-bearing capacity equivalent to the capacity of the concrete removed. The reinforcement was either replaced or repaired, and then the new concrete was poured into formwork (fig. 8.9). The concrete was formulated to match the original, following the analyses conducted during the preliminary studies, with no additives. A light cement wash was applied after pouring the concrete in order to cosmetically harmonize the conserved parts and the new ones. The result was quite satisfactory.

Repair of Prefabricated Elements

Careful study was undertaken before making the critical choice between repair or replacement of each of the prefabricated elements, as this was key to the durability of the operation. Indeed, the prefabricated elements represent the most important critical mass on the facades, as well as the most serious risk of falling material. The most secure elements were conserved, with or without repairs, following

rigorous criteria. Elements that were cracked, either lengthwise or crosswise, were systematically removed since their limited thickness (4 to 7 cm) precluded any lasting repair. Irregularities located at the edge of an element, if only one per piece, were repaired following the same method as for formed concrete (cutting out, cleaning, placing of repair concrete, surface treatment, and application of decorative aggregate to the surface). Any elements with extensive damage or more than a single irregularity were removed (fig. 8.10).

Wooden and synthetic molds were created based on archival plans and elements measured on-site to provide for identical reproduction of the elements to be replaced. There were twenty-seven different types of prefabricated elements, each one requiring a different mold (figs. 8.11, 8.12). One of the difficulties was that the concrete's limited thickness does not allow for adequate depth of cover to the reinforcement bars, and certainly does not allow cover to the standards applied for new construction today: 3 cm in ordinary environments but 5 cm by the sea, which is the case for Marseille. The options were either to thicken the concrete

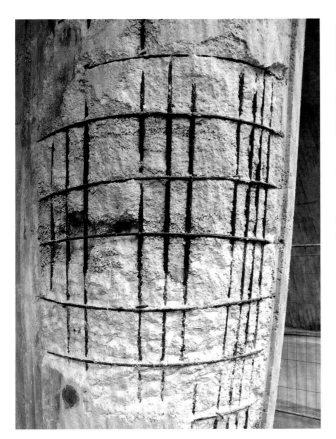

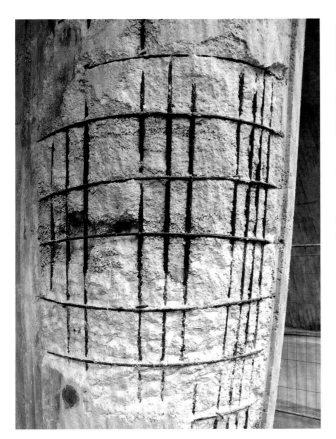

Fig. 8.7. Condition of piloti number 2: poor quality of concrete and corroded reinforcement bars, 2004.

Fig. 8.8. Partial reconstruction of piloti number 2, 2004.

8

sections, which was not possible given the need to respect the original and match the conserved elements to the new ones, or to use stainless steel reinforcement, which was the option selected. Fibraflex, a proprietary amorphous metallic reinforcement fiber, was considered as an alternative to stainless steel reinforcement with fibers, but the technical approval process proved too complex. Fibraflex was applied in the works undertaken on the east facade from 2015 to 2017.

In fabricating the new elements, in order to obtain cosmetic irregularities and variations comparable to those present in the original, the conditions of the 1950s construction site were replicated in that fabrication occurred on-site rather than in a workshop and was undertaken manually rather than mechanically. The concrete was prepared in small batches and poured into the molds, and then the decorative aggregate was placed by hand, using pressure to embed it in the fresh concrete (fig. 8.13). Installation occurred after about a week of curing. Each element was grouted in place. The assessment of the trial section revealed that 40% of the prefabricated elements

Fig. 8.9. Reconstruction of piloti showing board formwork, 2004.

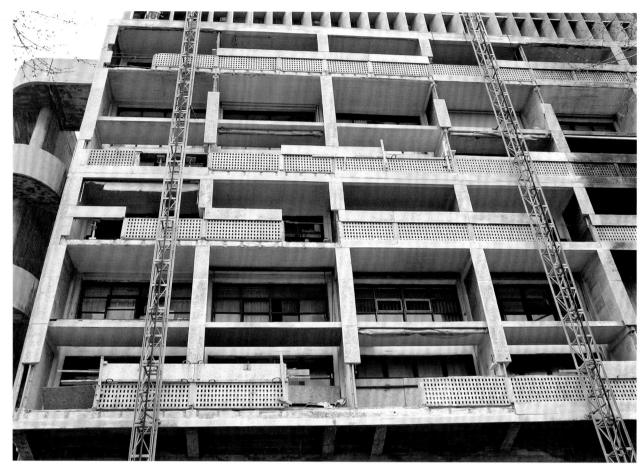

Fig. 8.10. Section of a facade after selective removal of panels to be replaced, 2003.

Fig. 8.11. Wooden mold for balcony railing panel, 2003.

Fig. 8.12. Composite mold for parapet panel, 2011.

Fig. 8.13. Gravel applied on the surface of freshly cast concrete panels, 2011.

8

required replacement, thus 60% had been conserved, of which about a third underwent minor repairs.

For the trial section, all surfaces of conserved concrete—whether on the pilotis, beneath the lowest deck, or on prefabricated or non-prefabricated elements—received a preventive treatment. Corrosion inhibitor was applied to the facades and the underside of the lowest deck, and realkalization was carried out to the in situ structural pilotis. The corrosion inhibitor was applied by repeated spraying until the surface was saturated, then rinsed. The product was used in liquid form on the facade and in gel form on the underside of the lowest deck to facilitate application. The depth of penetration and the amount applied were periodically checked. Karsten tube tests were used to verify the possible presence of previously applied water-repellent treatments, which would prohibit or complicate application. In the case of the facades, no water resistance was found, which facilitated application. The issue came up, however, with the roof-deck ventilation

stacks, which had been waterproofed in 1994 with IMLAR clear protective coating.

On the insides of the loggias, the protocol for application of the inhibitor included stripping the painted concrete surfaces by sandblasting (chemical paint strippers were not used). The colored panels of the loggias were also stripped, but only for the purpose of repainting, not for treatment, since they are made of unreinforced cement tiles. All the windows were carefully protected, because the product attacks glass. The treatment was followed by rinsing with water. Repair and then painting of the concrete followed (fig. 8.14).

Since the longevity of realkalization treatment is not well known, its application was limited to eight of the thirty ground-floor columns in the trial section. The operation combined dechlorination and then realkalization by the application of two different electrolytes: first water to dechlorinate, then the alkaline solution for the treatment.

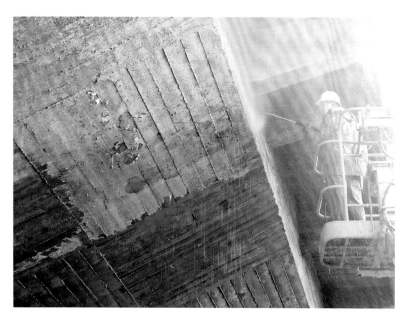

Fig. 8.14. Rinsing the surface of the lower deck after application of corrosion inhibitor, 2005.　　**Fig. 8.15.** A piloti undergoing realkalization, 2005.

The method for realkalization commenced with an assessment of the reinforcement. The extensive collection of plans and construction site photos at the Le Corbusier Foundation were used to identify and locate the distribution of the rebar and the connections. It was difficult to achieve electrical continuity in zones where the reinforcement was corroded and verification of electrical continuity needed to be confirmed through the assessment process. Placement of power supply points on the reinforcement was the next step, then the installation of the anode network in the form of titanium mesh. This was followed by the application of electrolyte paste, then alkaline impregnation and covering of the surface with plastic foil to prevent evaporation. The system was then powered on and the current left in place for about three weeks, after which it was removed and checked (fig. 8.15).

University studies are divided on the effectiveness and durability of realkalization treatment (Tong 2009; Gonzalez-Diaz 2010). The effects seen immediately following treatment appear to diminish after several months owing to a rise in the pH. In this case, a check six months after applying the paste revealed a loss in the treatment's effectiveness, so it was decided not to use realkalization on the sections of the building restored after the trial section, pending technical progress.

Following the repair work and preventive treatment, the question of finishes arose, not only for cosmetic reasons but particularly with regard to whether water-resistant protection was needed. It was a delicate question, because

while water resistance products protect concrete from the penetration of pollutants and to a certain degree liquid water, their application is irreversible and precludes some later treatments. It was decided not to waterproof the concrete in the trial section, as it was at a low level on the building and not very exposed, but the question remained. Here again, the issue of maintenance arose. For purposes of comparison, the upper parapet of the east facade was waterproofed in 1980, while that on the west facade, which is likewise very exposed, was not. A comparative study would be interesting in order to advance knowledge on this subject.

Lessons Learned from the Mock-ups and Trial Works

Following work on the mock-ups and trial section, and taking into account the results obtained, two major operations were planned: conservation of the rest of the west facade (2007–10) and conservation of the east facade (2015–17). The trial phase of work had assisted in developing methods to conserve the greatest amount of original material while remaining within an acceptable technical and economic framework.

In 2016, with more than ten years of hindsight, no cracks or spalls have been reported on the treated works, but it would be worthwhile to carry out a new hammer survey and record the results to confirm that there are no problems.

In 2016, tests and quantification of the amount of corrosion inhibitor found in the areas treated in 2004

showed variable but still present levels of sodium MFP. These ranged from one to four times the threshold value for protecting reinforcement. The lesser values are close to the threshold; this fact should guide thinking on a retreatment schedule. This aspect of maintenance is essential, and must be clearly articulated and included in the conservation program from the outset. Otherwise, the treatment can fail, jeopardizing the entire conservation process. A pedagogical approach is necessary, together with rigorous formalization of the timescale and methods of maintenance treatments. Even if the first phases of maintenance are conducted by the contractors who participated in the initial conservation work, after more than twenty years, as new designers and managers take their place, institutional memory will no longer suffice and the danger of falling back on reactive rather than proactive management will be great. This situation poses the greatest difficulty for rational management over time.

The doubts raised by recent research with regard to the longevity of realkalization treatment were reinforced by the experiences of this project, highlighting the importance of the principles of precaution and reversibility when implementing new techniques on a historic monument. Indeed, it appears that the effectiveness of the real-kalization procedure may depend on the level of corrosion before the treatment, or it may simply not last longer than twelve to thirty months. It therefore seems reasonable to impose a moratorium on any new application of this technique and to concentrate available resources on proven technologies.

Evolution of the Conservation Method over the Following Campaigns

Work on the west and then the east facades largely implemented the protocols of the mock-up and trial section, but marginal improvements in technique and organization were developed. The substitution of stainless steel bars with stainless steel fiber mixed with concrete provides the opportunity to potentially reduce creep and subsequent cracking, since the tension can be better dispersed through the mass of concrete, as opposed to being concentrated at the center of the section, in the plane of the neutral axis. This fiber reinforcement technique was also approved for the prefabricated elements fixed directly to the structure (skirting boards, architraves), but was not used in two other cases: for works subject to tensile stress, such as handrails and balusters, or for the parapet infill panels, which have a concrete surface that is neither painted nor covered in fine aggregate, and therefore the fiber would be visible.

The planning of the work was modified during conservation of the west facade in order to reduce the duration of work in each loggia and thus limit the disturbances for each residence. Work was organized into phases and undertaken in groups of four to six loggias, with all the necessary steps performed consecutively on the same group without interruption instead of sequencing tasks one after another across the whole facade. This required more precise organization but improved the residents' experience of the construction work—a human dimension that cannot be ignored (fig. 8.16).

Maintenance and Monitoring

The importance of maintenance as an integral component of conservation work has already been noted. Building managers, who tend to be more reactive than proactive in terms of upkeep and maintenance, need to be prepared to handle this issue. Now that a series of important conservation works have been completed at the Unité d'Habitation in Marseille, it is important to implement a programmed maintenance regime that is sustained over time.

CONCLUSIONS

The subject of conserving architectural works of concrete is likely to experience accelerated development as many such structures reach the end of their life expectancies. It is worth noting, in the case of the Unité d'Habitation in Marseille, that the need for extensive conservation appeared less than thirty years after the building's construction, which attests to a very rapid degradation in comparison to the aging of traditional masonry structures. This is the paradox of reinforced concrete, a material that projects an image of durable solidity, but proves to be fragile. Another paradox is that the conservation of this material can entail higher upkeep and maintenance costs than that of its nobler counterpart, stone. As a result, these structures face a dual risk: abandonment and demolition at the end of their aging cycle or radical repairs that run counter to their architectural integrity and significance.

These concerns pose a challenge for the conservation of many of the icons of modern architecture. It is necessary to compile a reference guide of exemplary conservation treatments and the long-term performance of the conservation and restoration methods that have been implemented over the past thirty years. Conservation is a recent and rapidly evolving science that calls on industry to play a leading role. It is striking to consider that in the space of fifteen years, certain techniques that were initially thought

Fig. 8.16. Completed works on west facade, 2012.

to provide long-awaited solutions were subsequently called into question or even abandoned because they proved ineffective in the long term. The lack of knowledge of some methods demands that these techniques be used prudently and that they be monitored attentively, and highlights the importance of avoiding doing anything irreversible. The situation is urgent because the decay processes involved are rapid. Architects or engineers who implement new methods find themselves in the delicate position of needing to respond quickly to acute and urgent problems while lacking the security of experience and hindsight. We hope that the dissemination of the important work realized in Marseille over the last ten-plus years will contribute to enriching the field of knowledge and experience for the benefit of modern heritage.

Translated from the French by Rose Vekony

NOTES

1. The others in the series are Rezé (1953–55), Berlin (1957–58), Briey (1959–60), and Firminy (1965–67).

2. Classified by the decree of June 20, 1986, were the facades; the roof deck and its facilities; and the common areas of the entry hall, circulation routes, and the display unit (apartment 643).

3. This work was managed by architect Jean-Pierre Dufoix.

WORKS CITED

Gonzalez-Diaz, Francisco. 2010. "Réalcalinisation électrochimique des bétons armés carbonatés: une alternative de prévention contre la corrosion." PhD diss., Université de Toulouse.

Laboratoire d'études et de recherches sur les matériaux (LERM). 2000. *Diagnostic et caractérisation de l'état de conservation du béton.* Arles: LERM.

Tong, Yun Yun. 2009. "Traitement électrochimique de réalcalinisation pour la réparation du béton armé dégradé par carbonatation." PhD diss., Université Paris 6.

8

9

Wessel de Jonge and Jurjen van Beek

First Christian Lower Technical School Patrimonium

Amsterdam | 1956

ARCHITECT/DESIGNER

J. B. (Ben) Ingwersen, architect | F. P. A. Houtschilt and P. Potter, engineers

PROJECT DATES

2011–13

PROJECT TEAM

Wessel de Jonge Architects, architect | ABT, concrete surveyor and building technology consultant | Climatic Design Consult, building physics | HE Advisors, service systems consultant | Bouwbedrijf M. J. de Nijs & Zonen, building contractor | Schouten Techniek BV, systems contractor | Ervas International BV, subcontractor for the concrete repair

CLIENT/BUILDING OWNER

School board

INTRODUCTION

The First Christian Lower Technical School Patrimonium (Eerste Christelijke LTS Patrimonium, or First Technical School) in Amsterdam is located along Wibautstraat, a main avenue that was cut through the fine-grained urban tissue of Amsterdam's 1900s expansion ring. Raised on pilotis and set at a slight angle with the alignment of the plot, the scheme stands out from the small scale of the surrounding buildings. Relying on an extensive use of exposed concrete—a daring but appropriate choice for a building in which a new generation of technical craftsmen were to be educated—its bold modernist architectural language manifests an almost provocative sense of postwar optimism (Hamer 1956) (fig. 9.1). The building was designed in 1953 by architect J. B. (Ben) Ingwersen (1921–1996) of De Geus, Van der Bom, and Ingwersen Architects of Amsterdam, with the help of in-house structural engineers F. P. A. Houtschilt and P. Potter. The school was built by contractor P. Bot and Sons and inaugurated in 1956.

Clearly the building is strongly inspired by Le Corbusier's 1952 Unité d'Habitation in Marseille (see p. 112). Nevertheless, Ingwersen's contemporaries did not regard his work as mere imitation but respected his personal interpretation and virtuosity in mastering Le Corbusier's architectural vocabulary. In its design, the Mediterranean modernism of Le Corbusier has been integrated with local interpretations, sensibilities, and building technologies to suit the northwest European climate.

The structure is based on a 3.5 m three-dimensional grid. As in the Unité, Ingwersen designed the building to make use of precast concrete elements on top of a load-bearing frame cast in situ and supported by board-marked pilotis, but he took his example to another level of development by relying on the innovative technology of Schokbeton. Also known as shockcrete in the United States, this is a unique system for producing high-density precast concrete elements by mechanical compaction, invented in the Netherlands in the mid-1930s and brought to fruition in the postwar building boom (see sidebar, p. 128).

The following Schokbeton components were used at the school:

- sandblasted panels serving as a permanent outside formwork for the facade
- large screen elements of the brise-soleils with sandblasted spandrel sections
- screen elements of the basement facade
- steps and string beams of the main stairs
- stairs and the sandblasted facade elements of the cylindrical emergency staircase
- slender and smooth columns in the auditorium on the upper floor
- polished inner windowsills
- sandblasted spandrel panels of the indoor partitions

Most surfaces were slightly pressure washed or sandblasted after demolding. Apparently inspired by Corbusier's master, Auguste Perret, Ingwersen chose various colors, textures, and finishes for each type of precast element by varying the cement and the coarse aggregates in color and size, and by using different surface treatments.

The school building proliferates with unique concrete reliefs, created by the artist Harry op de Laak and cast in situ into the load-bearing concrete walls. A bronze by artist Willem Reijers adorns the west facade.

THE PROJECT

The building was designed as a life-size model to demonstrate to students the basic principles of building engineering. For instance, even the electrical system was exposed so as to educate future electricians. The use of exposed

Fig. 9.1. The First Technical School after conservation and adaptation of the building for the Cygnus Gymnasium grammar school in 2013, showing the repaired Schokbeton brise-soleil and facing panels. Photo: Raoul Suermondt Architectural Photography

SCHOKBETON

As early as 1934, the Dutch company Schokbeton (shockcrete in English) patented a production method for precast concrete based on a system of mechanical compaction with the aim of economizing on cement. "Shocking" the concrete mass is essentially making use of gravity to compact a low-cement slurry with a water-to-cement ratio of only approximately 0.36 and increasing the fluidity by mechanical means (Ritzen 2004, 191) (fig. 9.2). The mold is fixed to a table that features a series of camshafts that lift and drop the filled-up molds about 8 to 25 mm at high speed. By calibrated shocking the mechanical movements are evenly distributed, producing a consolidated and high-density concrete mass with a uniform consistency (Haas 1938, II.106–9).

Schokbeton elements could be designed to be much more slender than traditional precast concrete ones. Another advantage was the greater precision of detail achievable, which allowed glazing rebates to be cast into the concrete members themselves. Hence, the material could be used for unusually slender elements such as concrete window frames, which came in handy at a time of timber and steel shortages during the 1930s economic crisis. Much of the company's success after World War II was again due to the shortage of building materials; it provided durable and economic alternatives for wooden window frames.

After its initial successes in the Netherlands, the NV Schokbeton company expanded to the United States, other parts of Europe, and beyond. It became obsolete in the 1980s, when admixtures such as plasticizers were widely adopted (see Zuijlen 2004; Pyburn 2008; Voorde 2012; Jonge 2014; Voorde, Bertels, and Wouters 2015; Pyburn and Zuijlen forthcoming 2018).

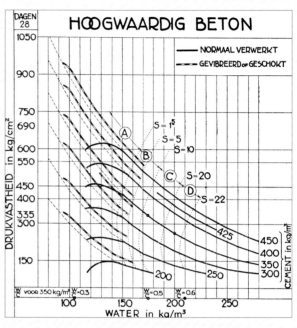

Fig. 9.2. A late 1930s graph showing the ratio between compressive strength (vertical) and water content (horizontal) for various cement contents (curves at right) for standard concrete (continuous lines) versus mechanically compacted high-density concrete (dotted lines). Where standard concrete starts to dro pin strength when the water content decreases under 120–140 kg/m³, mechanically compacted concrete reaches much higher strengths at only 100 kg/m³. Graph: Haas 1938, II.106.

concrete was part of that intention. But after more than forty years of use, the technical school moved out and demolition was considered, until another vocational school was proposed as a new user in 1999. The spatial arrangements and interior finishes were radically altered at this point. In an effort to change the atmosphere of the building altogether, all the interior concrete work, including the bas-reliefs, was painted mint green and peach. In order to address obvious damage to exterior concrete work, an expert concrete survey was commissioned, although actual repairs were only carried out in 2006 and 2007.

Early in 2007, the tide turned after the Dutch Ministry of Education, Culture, and Science announced a campaign

to consider postwar buildings for listing, which raised a broader awareness of the cultural value of the technical school. Listing followed in August 2009. The school board decided to offer the building to another educational department as an intermediate business school in 2007. The authors were invited as the architects for what was initially just a basic adaptive reuse project to accommodate the new user. Main funding came from a government program to improve the interior ventilation of school buildings. Rather than simply implementing a new HVAC system, the school board was convinced that it would not make sense to do so unless the thermal insulation of the single-glazed facade could be improved and further sustainability issues

were also addressed. Due to the international economic crisis, after obtaining the heritage permit the intended contractor went bankrupt during the negotiations, and the project was put on hold altogether when the school board wasn't able to secure the appropriate budget.

In April 2011, when the board seized the opportunity to accommodate a grammar school in the building, Wessel de Jonge Architects was involved again in planning the works. Fortunately, during the earlier project, we had successfully proposed that a historic building survey be commissioned even if the building wasn't listed yet. This served as a tool in, step by step, raising the enthusiasm of the new users to restore and preserve the architectural, spatial, and technological qualities of the building to a great extent. Remarkably, the school team recognized the educational value of the building for their teaching curriculum.

Since most of the exterior concrete work had been repaired in 2006 to 2007, further concrete repairs were initially limited to the remaining parts. Additional concrete repair was included in the project only during the works, when closer visual inspections revealed that some of the recent repairs had re-cracked or detached, and latent damage was apparent in other parts.

Although it took almost a year and a half to find additional funding and a new contractor, the efforts to broaden the scope resulted in an integrated preservation and adaptive reuse project. Between 2012 and 2013, the building was refurbished again to accommodate the Cygnus Gymnasium (grammar school).

Apart from the functional and spatial adaptations, the technical brief could be summarized as follows:

- removal of the colored paint from the interior concrete surfaces
- architecturally respectful repair and cleaning of the various kinds of exposed concrete of the exterior
- application of an anti-graffiti coating at street level
- new insulated glazing to replace the single glass-in-concrete glazing
- introduction of a mechanical ventilation system and improved climate control, but avoiding a cooling system in order to curb operating costs

The works were overseen by a building/project manager, and the resultant contractual relationships distanced the architects from the client and on-site design decision making informed by test results. The design team also included ABT as a concrete surveyor and building technology consultant with particular experience in concrete conservation; Climatic Design Consult for building physics; and HE Advisors as a service systems consultant. When the project was reactivated in 2011, a limited selection procedure was set up and Bouwbedrijf M. J. de Nijs & Zonen was appointed as building contractor and Schouten Techniek BV as systems contractor. Ervas International BV was engaged as a subcontractor for the concrete repair works.

INVESTIGATIONS: BACKGROUND RESEARCH, ANALYSIS, DIAGNOSTIC WORK, TESTING, AND TRIALS

Background Research and Documentation

Although the name Schokbeton is frequently found in modern architecture's historiography and may be familiar to many professionals dealing with postwar modern architecture, there was very little in-depth information available about its material qualities and technical properties. The archives of the company's various international branches have largely been lost. Some pioneering research was available from American architect and researcher Jack Pyburn of the Georgia Institute of Technology, who had worked together with independent Dutch researcher and architect Lucas van Zuijlen since 2003 to survey some of the remaining archives in the United States and the Netherlands. In addition, we studied earlier hands-on case studies dealing with the preservation of Schokbeton in the Netherlands, which included some projects from our own portfolio as well as the refurbishments of the Groothandelsgebouw (Hugh Maaskant and Willem van Tijen, 1953) by Van Stigt Architects in 2005 and the Las Palmas warehouse (Van den Broek and Bakema Architects, 1953) by Benthem Crouwel Architects in 2008. Both Rotterdam buildings feature story-high facade panels of Schokbeton.

Even if it was beyond the scope of the architects' commission and the client didn't fully recognize its importance, we decided to compile a dossier on the available knowledge of Schokbeton and its preservation. The findings raised doubts about the extent to which repair techniques applied in previous cases had been specifically developed to meet the particular properties of Schokbeton. We found that there are actually no known repair methods specific to this type of high-density concrete.

Meanwhile, the historic building survey had uncovered archival material on the building itself, including period publications, the original specifications, and photographic documentation of its construction and the precasting of the facade elements, which confirmed the origin of the components to be the Schokbeton company (figs. 9.3, 9.4, 9.5). It was only long after the works had been completed that

9

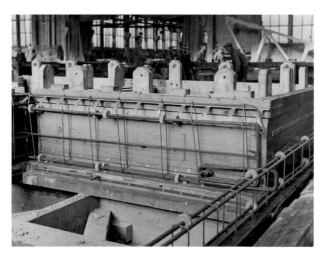

Fig. 9.3. Preparation of the reinforcement and the formwork for one of the brise-soleil elements for the Patrimonium school in the Schokbeton workshop. From such photographs, it has not been possible to confirm to what extent the elements were actually mechanically compacted. Photo: N. V. Schokbeton; Collection Het Nieuwe Instituut/ INGW

Fig. 9.4. Some brise-soleil elements for the First Technical School after removal of the formwork, apparently in a test assembly to see that the elements properly interlock. Photo: © Jan Versnel/MAI / Digital image: Collection Het Nieuwe Instituut/ INGW

Fig. 9.5. On-site assembly of the brise-soleil at the east facade, probably late 1954. To the right is the scaffold used to build up the cylindrical emergency staircase. Photo: © Jan Versnel/MAI / Digital image: Collection Het Nieuwe Instituut/ INGW

we learned that not all the precast elements produced by the company were indeed produced using the shockcrete process; by 1960, only an estimated half of the production was mechanically compacted. Moreover, not all product series were compacted to the same degree. Components are also known to have been produced as a two-layer concrete with a "shocked" outer shell and regular concrete as a back concrete. Hence, a distinction must be made between the product and process of Schokbeton and the producer of the same name.

Indeed, when shown photographs, former company employees could not confirm to what extent the brise-soleil components had been mechanically compacted.[1] In retrospect, and given the surface qualities (which are less refined and show more advanced weathering than the shockcrete panels), the dimensions of the members (which are not really slender), and the extensive damage pattern, our assumption is that the elements of the brise-soleil may not have had the same technical properties as those generally attributed to Schokbeton.

On the other hand, the thin cladding panels and the segmented facade elements of the cylindrical staircase, which both have a sandblasted surface showing a rough texture exposing coarse aggregates, were believed to have been produced by the shockcrete process because of their shallow dimensions. This assumption was later supported by the low carbonation depths that were found, which are typical for mechanically compacted concrete (fig. 9.6).

Joints

The geometry of the large precast concrete frames was such that each component of the brise-soleil was cleverly interlocked with the previous one (fig. 9.7). The joints were originally filled with a cement mortar covered by 20 mm elastic sealant. The non-elastic cement caulking may have prevented proper thermal expansion of the elements, which could have caused initial cracks from the edge of the members that may have left them prone to carbonation. The joints between the shockcrete flat facade panels were filled with bitumen-drenched jute fiber of about 15 mm depth that was still in reasonable condition and could therefore largely be kept.

Cast In Situ

In addition, there was the cast-in-situ concrete of the pilotis, the supporting chassis, and the interior load-bearing walls. The concrete mixture was specified as 1 part cement to 2 parts sand to 3 parts coarse aggregate. The gravel

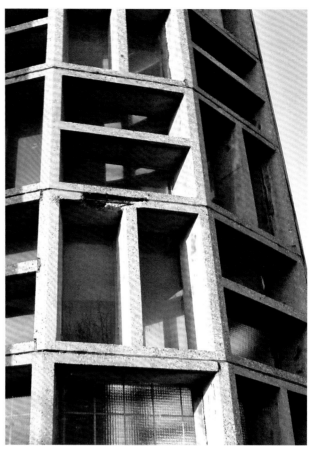

Fig. 9.6. The segmented facade elements of the cylindrical staircase feature shallow members just 40 mm wide, with integrated glazing rebates. Although generally in good condition, some of the members showed spalling due to rebar corrosion. Photo: © Wessel de Jonge Architects, Rotterdam

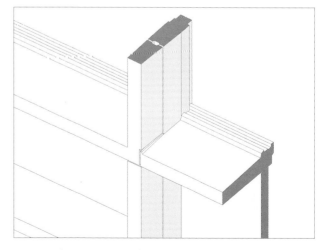

Fig. 9.7. Schematic drawing of the interlocking precast concrete elements of the brise-soleil. Drawing: © Wessel de Jonge Architects, Rotterdam

gradation varied from 0.5 to 2 mm grain size. For all exposed parts, a particular light-colored German gravel was specified that had been revealed by sandblasting. According to the original specifications, all the in situ concrete of the building "must be made using only one type of portland cement," the latter perhaps as well to ensure an equal color for the entire building. Although it is therefore likely that this was applied to the precast concrete as well, no evidence has been found to support this.

Furthermore the specs indicated the use of an "air entraining agent" for which Darex AEA was selected, which is still on the market.[2] When casting the concrete on-site, it was mechanically compacted with an immersion vibrator. The compressive strength was originally specified to meet a value of 7 N/mm^2. Given the fact that structural engineer Potter was also the clerk of works, we can be fairly sure these parameters were met.

Investigations and Diagnostics

In 2007 to 2008, ABT was commissioned to evaluate a survey that had been carried out in 1998, and to perform a new visual assessment of the building, including the repair works carried out in 2003 to 2008. Their conclusion was that the specifications for previous repairs did not comply with the regulations and certifications that apply to concrete repair, but that repairs had still been "decently executed" (fig. 9.8). From earlier reports, it could be concluded

that the depth of concrete cover was generally less than 25 mm, but thanks to the density of the material this has not resulted in large-scale damage. No chloride-induced corrosion, alkalisilica-reaction-related distresses, or other serious threats to the structural integrity of the building were found. Because the damage was regarded as an issue of durability and aesthetics, the client agreed that concrete repair was not a top priority. Although visible damage had to be treated, the client felt no need to have a systematic diagnostic investigation or material sample testing done.

The integrated preservation and adaptive reuse project restarted by mid-2011 with a strict time frame to allow the grammar school to move in after the summer of 2012. The design team was given only a few months to rework the design for the new users, define the specifications with the new contractors, and negotiate with the heritage authorities to adjust the heritage permit in order to avoid a new and lengthy permit procedure. Within this context, and with the lack of acknowledgment of urgency by the client, little attention was given to preparatory on-site research and diagnostic investigations of the building's various concrete types and components. Therefore, treatment of the concrete relied largely on observations and trials after contracting the works.

The project manager made direct arrangements with the contractor and Ervas regarding the diagnostic analysis and the specifications for the concrete repair work, based on the consultancy reports of the engineer. Our office was

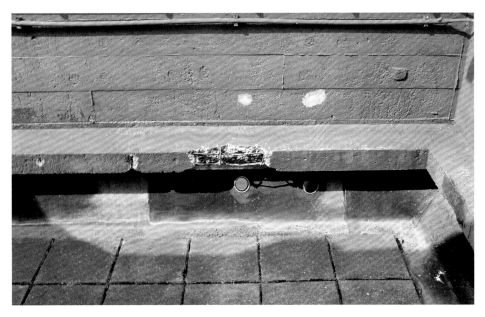

Fig. 9.8. Despite previous repairs, the inside of the concrete roof parapet cast in situ again showed damage and spalling due to corroding rebar. Photo: © Wessel de Jonge Architects, Rotterdam

only called in later to review sample tests. At this point it became clear that only very basic specifications had been developed, including strength and durability requirements, and there were no clear guidelines about cement color, type and appearance of aggregates, or surface textures, all of which would have a major impact on the visual appearance of the repair. Hence, the concrete repair was not approached as part of the design process within a historic preservation project, but merely seen as a technical issue that was assessed in terms of price, durability, and guarantees. This was a prime example of the adopted project management method failing to deliver the integrated approach required for high-quality historic conservation projects.

For the 50 mm-thick shockcrete facade panels, the average cover was around 20 mm. Phenolphthalein tests of core samples convinced us of the superb quality of shockcrete. Even after almost sixty years of exposure along one of the city's busiest avenues, the carbonation fronts typically had advanced just a few millimeters if at all, as compared to the 10 to 20 mm we often find in concrete cast in situ under such circumstances. The precast segments of the cylindrical staircase showed very limited carbonation depths as well.

No problems were found that would pose serious threats to the structural integrity of the building. Steel corrosion concerned secondary reinforcement bars rather than main reinforcement. Damage was assessed as being primarily a matter of aesthetics and durability that needed to be addressed.

CONSERVATION

Cleaning the Interior Concrete Surfaces

The first challenge to meet as part of our commission was the removal of the brightly colored paint from the interior concrete surfaces. There were two specific sets of circumstances where a solution was needed: removal of the paint around the artworks (where extreme caution was required) and the extensive areas of interior surface where it was envisaged that a more economic cleaning solution would be acceptable. Conservator Annefloor Schlotter, supported by Dr. Mariël Polman of the Netherlands National Department for Conservation RCE, tested various chemical peeling agents, covering the surfaces with a paste or gel and scraping off the paint film a few hours later, after which the surface was washed a few times using sponges. Some of these agents worked very well, and because this seemed to be reasonably cost effective, with the advantage of minimizing mess and potential water damage, it was decided to use this approach for the main interior surfaces. Fluxaf Green,

a pH-neutral and biodegradable paint remover, was selected for these works.

However, what wasn't mentioned in the provided product documentation was that, for large-scale applications, the supplier suggested using high-pressure steam jets to rinse off the residue of the peel-away agent instead of sponging by hand as was presented to us during the test phase. Given the tight budget, which was strictly controlled by the project manager, we could not prevent the contractor from steam blasting most of the inside of the building, causing damage to (among other things) the remaining original parquet flooring in some of the workshops on the lower floors.

Cleaning the Bas-Reliefs

A particular challenge was posed by Harry op de Laak's biggest and most important bas-relief, located on a load-bearing concrete wall over the full height of the main staircase, measuring about 8 by 28 m. Although originally in unpainted concrete, the bas-relief was later filled in with some color, long before the area around it was painted in a peach color in the 1990s. As it was uncertain to what extent Op de Laak had been involved in this alteration of the artwork, we decided to retain the polychromy.

Most of the staircase walls could be cleaned with the peel-away agent followed by steam blasting, while keeping the bas-relief sealed under a thick plastic film. The wall with the artwork itself was fortunately excluded from the contract to clean the interior surfaces, as jet blasting would have spread the peel-away agent all over the bas-relief as well, and would have threatened the polychromy.

Observing the effects of working with the paint remover on the other walls, we came to reconsider the suitability of the peeling agent for the cautious work required around the artwork after all, even if the residue of the chemicals would be rinsed off with sponges by hand. The help of the conservators was called for again for the area adjacent to the bas-relief; further trials were carried out with dry ice and dry snow blast cleaning. Recently developed and successfully tested in Germany for, as an example, removing graffiti from concrete surfaces in parking garages, these methods make use of frozen carbon dioxide, which allows for very cautious work. The carbon dioxide crystals instantly evaporate, leaving a dry deposit and preventing contaminated water from flowing down into the building. The conservator carried out various trials using dry ice alone as well as dry ice with lime and soda powder added. Dry snow, with its slightly finer ice crystals, was successfully tried with various nozzle widths (fig. 9.9).

9

Fig. 9.9. Tests of paint removal around the main bas-relief by blasting with a mixture of dry ice and lime (top), and dry ice and soda powder (middle). Blasting with just dry snow using a variable nozzle width (bottom) was finally selected for the area adjacent to the artworks. Photo: © Wessel de Jonge Architects, Rotterdam

Fig. 9.10. The bas-relief in the main staircase after carefully removing the peach-colored paint around it, successfully using the snow-blasting technique. Photo: Raoul Suermondt Architectural Photography

Ultimately, dry snow blasting was chosen, as it appeared that the original texture of the concrete surface was hardly affected, if at all. Indeed, the finer nozzles allowed work within millimeters of the artwork. By filling the bas-relief grooves with rubber strings during the works, the coloring on the bas-relief itself could effectively be protected from the impact of the snow crystals (fig. 9.10).

Disadvantages were the slow pace (and thus high cost) of cleaning centimeter by centimeter, and the excessive noise during the works that limited accessibility to the main staircase for other workers for weeks.

Cleaning the Exterior Concrete Surfaces

The exterior concrete surfaces of the facade were cleaned primarily to remove grime. Additionally, the brise-soleil elements suffered from extensive pigeon droppings and sealant stains that remained after removal of the thousands of pigeon pins that had been glued and stapled onto the concrete sills in 1999. On the basis of earlier experience and a few confirmative trials on-site, low-pressure steam cleaning was selected in order to minimize the impact to the concrete surfaces and to avoid an increase of surface porosity that would render the material more vulnerable to future carbonation and decay.

Concrete Repair

Because of the primacy of the project manager's role and the very limited time frame for preparations, trials, and execution of the repairs—actually for the project as a whole—we had to find a pragmatic working method to make the most out of the concrete repairs in terms of historical and architectural integrity, while causing minimal disruption to other works. In doing so, we put our full confidence in the professionalism of the concrete repair

firm Ervas, even if we remained unsure about the outcome of the preparatory analyses. Under the circumstances, combining their experience and skills with our architectural, historical, and technical knowledge and aesthetic insights was our best bet.

Selection Criteria for Repair Materials

In selecting concrete repair materials, a few general criteria regarding strength and consistency must be taken into account:

- the strength, plasticity, and creep of the repair mortar must match the existing concrete substrate
- the adhesion properties between the repair mortar and the reinforcement must be at least equivalent to those of the existing concrete
- the modulus of elasticity of the repair mortar must be high

Important factors to be taken into account are therefore density, strength, moisture resistance, crack resistance, adhesion capacities, and durability in general. Cement/sand-based resin-modified mortars are regarded as suitable for (small) manual repairs, as the cement component ensures an alkaline environment for the reinforcement steel in order to passivate the rebar and prevent corrosion, and the resin component increases the density of the mortar so as to curb future carbonation (Haar, Steijaert, and Boon 1977; Steijaert, Haar, and Kreijger 1982).

Repair Products and Method

The adopted repair method for the thin shockcrete facade panels involved the application of two products: a bonding mortar and a concrete repair mortar. The applied bonding mortar was a cement-based product that restores high alkalinity around the rebar, modified with a methyl-methacrylate-based co-polymer that is added to improve bonding. The inclusion of quartz sand aids bonding of the repair mortar. The bonding strength reaches at least 2 N/mm².

The defective concrete was removed from along the corroded reinforcement for 100 mm beyond the point of corrosion. The rebar was completely cleaned of remaining rust and traces of previous polymer repair products and then, together with the substrate, immediately wetted, after which two layers of bonding mortar were applied to the rebar and the surrounding concrete with a paintbrush until a thickness of at least 1 mm was achieved.

The concrete repair mortar Bostik Quellmörtel Schnell, which was specified in the contract for the concrete conservation works, belongs to the MG III type according to DIN 1053 (Mathias 1996) and comprises a non-shrinking, high-performance, cement-based mortar modified with polypropylene synthetic fiber. The thermoplastic polymers are added to give the mortar more consistency for vertical and overhead repairs, to reduce the risk of unmixing, and to reduce shrinkage and sensitivity to thermal plasticity.

The repair mortar is mixed on-site into a clay-like consistency, then manually applied to fill up the various repair patches in layers of up to 20 mm thickness, leveled, and compacted with a pneumatic vibrating trowel. The resulting filler has a compressive strength of $f'_b \geq 40$ N/mm² and a flexural strength of $f_{br} \geq 9$ N/mm². These values are similar to regular higher-density concrete types.

A particular challenge related to the properties of shockcrete is that the certifications for present-day repair mortar are based on a cover of 20 to 25 mm in order to achieve a guaranteed result. It is often impossible to provide this depth for the most slender elements; for instance the members of the segments of the cylindrical staircase are just about 40 mm thick in total; nor could the repairs on the 50 mm thin facade panels meet this requirement. However, the repair company was ready to provide the required guarantee despite the fact that the cover did not comply with those standards.

Aesthetics

Prefabrication allows for the manufacturing of a relatively uniform series of products, also regarding the color and texture of the surface appearance, although slight diversities can never be avoided. Although less so as compared to in situ concrete, Schokbeton also shows varieties in color and texture that must be taken into account during repair. Hence, the repair of Schokbeton components requires craftsmanship and manual restoration in order to get the varying colors and textures right; this is similar to the treatment of exposed in situ concrete.

In this instance, we were able to modify the Bostik Quellmörtel Schnell to take into account the variety of color tones across the building, rather than using a single shade throughout. We worked with the craftspeople to add color pigments to compose a palette of repair mortars in various shades that could be mixed on the spot to match each repair location. These mortars were based on different colors and types of cement, each mixed with carbon black or pigments to best match the parent concrete. It remained a challenge to select the right color for each patch while

Fig. 9.11. One of the flat 50 mm-thick shockcrete facade panels with a half-moon repair patch (above the color card). After applying an appropriate tone of repair mortar, some selected pebbles and grit were pushed into the wet substance to match the original aggregate component. The bitumen-drenched jute fiber joints were retained. Photo: © Wessel de Jonge Architects, Rotterdam

the repair mortar was still wet to match the cured original concrete. In other projects, we have run into the problem that the mixing of various repair mortars or even the addition of slight amounts of pigments to adjust the tone of the product is regarded as an alteration of its composition and violates the product certification. This was not the case here, as Ervas was still willing to give a guarantee that satisfied the client.

After repair of the defected area with the appropriate tone of repair mortar, some matching pebbles and grit (5 to 20 mm) were pushed into the wet substance to match the aggregate component of the original mix. Trials were carried out using different coarse aggregates to arrive at the right surface texture and color for each area and type of component, which were then designated as a reference for further repairs. Immediately after the repair, the patches were rinsed off and, after a short curing time, further cleaned mechanically with a sort of "eraser" to remove the remaining surface laitance (fig. 9.11).[3]

Joints

During the works, it was discovered that the bitumen-drenched jute fiber filler of the joints between the facade panels contained asbestos, again something that would have been identified if adequate pre-design work had been permitted. Yet, even after nearly sixty years, the joints were found stable regarding the precipitation of hazardous particles and were not expected to pose any risk for public health; therefore, the client decided not to replace the filler in this case.

Brise-soleil

Similar to the shockcrete panels, previous repairs on the brise-soleil elements in 2006 and 2007 had used typical concrete repair methods involving standard epoxy agents and resin-modified bonding and repair mortars. Although the patches were not very well matched, their appearance was not prominent due to the daylight contrasts of the expressive facade. What worried us more was that some of these repairs already showed damage such as re-cracking and spalling after a few years, and therefore had to be redone. As the brise-soleil elements showed many poorly matched patch repairs already, and these were mostly intact and to be kept as they were, we decided to save money here by using just one colored mortar that best matched the average parent concrete. Seen from a distance, the many contrasting patches are not very visible, as the sharp contrasts of light and shadow of the brise-soleil predominate. The fact that the building is raised on pilotis and most of the precast components are located high above street level is also helpful in this respect.

Anti-Graffiti Coating

A semipermanent reversible coating that includes natural polysaccharides dissolved in water was applied as an anti-graffiti coating to the exterior concrete surfaces. This was applied up to a level of about 2.5 m from street level, which is all in situ concrete. Sprayed on the vertical surfaces after humidifying the substrate, it leaves an extremely thin protective film that is invisible to the human eye and is completely vapor permeable. The coating is harmless to the concrete itself and even slightly assists in reducing porosity and carbonation risk. The applied product was PSS-20, provided by the Dutch firm Gevelmeesters. The agent is matte and slightly buff-colored, which worked well on the concrete work of the school building (fig. 9.12).

Graffiti sprayed on the facade is caught on the protective film and cannot migrate into the concrete itself. It can then be easily removed by hot water blasting, after which the treatment may have to be repeated. Over time, the protective layer will dissolve due to cleaning and weathering, and the agent will need to be reapplied. Although it is guaranteed for three years, it easily lasts about five years.

Glass-in-Concrete

The indoor air quality of the building originally relied on natural ventilation by opening the wooden sliding windows that make up one-quarter of each concrete facade element. As traffic noise and pollution had increased dramatically since 1956, these were no longer used, often resulting in alarming carbon dioxide levels inside. A regular mechanical ventilation system would have involved a huge number of ducts running through this transparent building. By using the corridors and stairwells as a return channel, the number of ducts could be reduced by half.

The original detail of the single glazing set straight into the fine concrete rebates seemed impossible to maintain

Fig. 9.12. The north end of the school building after conservation works, showing the repaired shockcrete facade panels (top) and segmented elements of the cylindrical staircase (left), and the chassis on pilotis cast in situ (right). The lower 2.5 m of all concrete work was treated with a matte anti-graffiti coating that is almost invisible. Photo: Raoul Suermondt Architectural Photography

ORIGINAL DETAIL

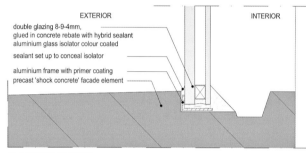

NEW DETAIL (DESIGN)

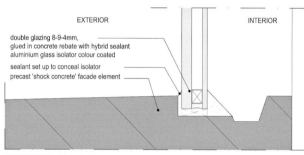

NEW DETAIL (AS BUILT)

Fig. 9.13. Schematic drawing of the original glass-in-concrete detail of the brise-soleil elements (top), the new detail with insulated glass units in an aluminum profile as specified for the works (middle), and as proposed by the supplier and finally made (bottom). Drawing: © Wessel de Jonge Architects, Rotterdam

when installing energy-efficient double-glazing units. At the assessed reference projects, the IGUs were square jointed into the rebates, but here the rebates were no longer flat and smooth, and we didn't expect any glass supplier to guarantee a glazing system when any irregularity of the rebate would present a hazard to the glazing units.

A detail was developed with an aluminum profile that would smoothly receive the glazing, but after contracting the works, the supplier unexpectedly came up with a solution to glue the glazing straight into the concrete rebates with a sealant. Using a product the same color as the concrete made the improved fixing of the double-glazing units unobtrusive (fig. 9.13). Waterproofing relies completely on the sealant, but as the windows are recessed behind the brise-soleils that act as windbreakers, the settings are less directly prone to wind or rain impact. Still, the sealant must be periodically checked from inside and outside, and replaced when necessary, to prevent water infiltration.

The next challenge was determining what to do with the continuous concrete members of the window frames themselves. In theory, the introduction of double glazing turns these concrete fins into cold bridges, and the design team was aware of the condensation risk, which may cause mold and grime to settle on the concrete surfaces and increases the risk of rebar corrosion as well. But as the fins have a larger surface area outside than in, it was expected that they would radiate heat toward the outside rather than cold toward the inside. With the help of the building physics consultant, the f-values—the relative "temperature factor" on the internal surface, which is decisive for the occurrence of condensation—of the various parts of the concrete members were calculated to be f = 0.35–0.4, which was indeed only slightly lower than the acceptable values f = 0.4–0.45. Together with the heating radiators, the mechanical ventilation system that was introduced to climatize the building was calculated to easily resolve the average amount of condensation. In case of excessive humidity levels—generated, for example, by large numbers of students being present at the same time—condensation is expected to occur occasionally on the glazing. It will be collected in the original gutter on the inside of the sill, which was cleaned and inspected, and will easily evaporate as soon as humidity levels in the room drop. Although not strictly meeting the current environmental standards, the clients were convinced that this would work in practice and that the architects would arrive at a balanced proposal to be agreed upon by the heritage authorities.

Fig. 9.14. The main entrance of the school building after conservation works, showing shockcrete facade elements of the bicycle storage in the basement to the left, and the brise-soleil of the higher floors. Photo: Raoul Suermondt Architectural Photography

Fig. 9.15. Close-up of the brise-soleil facade. Earlier patch repairs are concealed by the light-and-shadow effect, which allowed them to be left as they were and the budget to be spent on the other facade panels. Photo: Raoul Suermondt Architectural Photography

CONCLUSIONS

Even if it were possible to specify an ideal preparatory procedure for concrete conservation that identifies all defects and provides the specifications for careful repair efforts in advance, the reality is sometimes unpredictable. Listing a building once the preparatory phase of the project is well under way does not aid the timely involvement of specialists and heritage authorities, nor in this case was the adopted project management model helpful.

One of the project's big drawbacks was the extremely tight time frame established for the works. The project demanded that it go to tender within a few months of its restarting in 2011; therefore, preparatory research and discussion, and the possible results thereof, was limited and many decisions had to be made while the works were under way. This is not optimal when working with listed buildings, which need careful consideration. In retrospect, it would of course have been better to analyze all of the concrete damage, perform material analysis on the exact concrete composition, and test the material properties of the existing concrete before defining specifications for repairs.

Inquiries with concrete repair experts confirmed that there is actually no specific repair method available for mechanically compacted high-density concrete like Schokbeton. In the end, even the repair of the particular shockcrete facade elements had to be done on the basis of craftsmanship and good-practice experience of the workers, rather than by objective standards. Although repair mortars can be selected that are physically sympathetic to the original material, this still means that the repair patches may actually perform differently in terms of strength, porosity, and density, and thus may be more susceptible to carbonation than the original concrete. The polymer admixtures in the present resin-modified repair mortars are supposed to render them sufficiently suitable to match the properties of the original material, but only time will tell whether the approach and works were right for this type of high-density concrete.

A further conclusion may be that painting exposed concrete, for instance to conceal later repairs, is an almost irreversible intervention and should be avoided if possible. Removing the paint was an extremely costly and invasive job.

The works were completed in April 2013 (fig. 9.14). Despite the many technical challenges, the adaptive reuse project was awarded the 2013 Brinkgreve Bokaal, the annual heritage preservation prize of the City of Amsterdam, because, according to the jury report, it "recognizes and underlines the value of postwar modernism and sets an example for the proper stewardship of Amsterdam's many great postwar school buildings."[4] The project was also awarded the 2014 Golden Phoenix (Gulden Feniks), the national Dutch preservation prize.

NOTES

1. Interview with a former staff member of Schokbeton by Lucas van Zuijlen, February 2016 (unpublished).

2. According to page 12 of the original specifications of the architect, either Darex AEA or Frioplast was to be added. The report of the executed works according to Hamer (1956) confirms the use of Darex AEA, which is still being produced as an "Air Entraining Admixture" by Grace Concrete Products.

3. According to the 2012 work plan of subcontractor Ervas International, which was produced when the works were already well under way.

4. Translation by the author.

WORKS CITED

Haar, P. W. van de, P. D. Steijaert, and J. Boon. 1977. "Reparaties van betonconstructies deel 1: Vervangen of repareren van beschadigde constructies." *CUR Rapport* 90, 3rd edition. Netherlands Committee for Research, Codes and Specifications for Concrete (CUR-VB).

Haas, A. M. 1938. "Hoogwaardig beton." *De Ingenieur in Nederlandsch-Indië* 5 (10): II.105–12.

Hamer, G. J. 1956. "Christelijke Technische School te Amsterdam." *Cement* 8 (19/20): 449–58.

Jonge, Wessel de. 2014. "Something Concrete! The 1956 First Technical School in Amsterdam Restored." In *Expansion and Conflict: Proceedings of the 13th Docomomo International Conference, Seoul, September 19–29, 2014*, edited by Ana Tostões, Jong Soung Kimm, and Tae-woo Kim, 321–25. Seoul: Docomomo Korea.

Mathias, Berthold. 1996. *Mauerwerk. Teil 1: Berechnung und Ausführung* [Masonry. Volume 1: Design and Construction]. DIN 1053-1: 1996–11. Berlin: Deutsches Institut für Normung.

Pyburn, Jack. 2008. "The Role of Architectural Precast Technology in the Internationalization of Postwar Modernism." In *Import-Export: Postwar Modernism in an Expanding World, 1945–1975: Proceedings VIIIth International Conference, September 26–October 2, 2004, Columbia University, New York*, edited by Theodore H. M. Prudon and Hélène Lipstadt, 113–20. New York: Docomomo International.

Pyburn, Jack, and Lucas van Zuijlen. Forthcoming 2018. "Concrete and Schokbeton." In *Concrete Technology*, Preservation Technology Dossier 14, edited by Theodore Prudon and Kyle Normandin. New York: Docomomo USA.

Ritzen, J. 2004. *Betonbouw: Berekenen, Dimensioneren, Constructie / Deel 4: Materiaalstudie, Technologie, Duurzaamheid, Renovatie*. Ghent: Academia Press.

Steijaert, P. D., P. W. van de Haar, and P. C. Kreijger. 1982. "Reparaties van betonconstructies deel 3: Reparatie en bescherming door middel van kunstharsen." *CUR Rapport* 110. Netherlands Committee for Research, Codes and Specifications for Concrete (CUR-VB).

Voorde, Stephanie Van de. 2012. *Architectonic: 1958–1980: Façades en Béton*. Brussels: Atomium Foundation.

Voorde, Stephanie Van de, Inge Bertels, and Ine Wouters. 2015. *Post-War Building Materials in Housing in Brussels 1945–1975*. Brussels: Vrije Universiteit Brussels.

Zuijlen, Lucas van. 2004. "Schokbeton Is Superbeton." In *Docomomo_NL Nieuwsbrief* 1 (9): 16–19.

FURTHER READING

Heinemann, Herdis A. 2013. "Historic Concrete: From Concrete Repair to Concrete Conservation." PhD diss., TU Delft.

Jonge, Wessel de. 1997. "Concrete Repair and Material Authenticity: Electrochemical Preservation Techniques." *APT Bulletin* 28 (4): 51–57.

———. 1998. "Concrete Repair and Material Authenticity: Non-Destructive Repair Techniques." In *The Fair Face of Concrete: Conservation and Repair of Exposed Concrete*, Preservation Technology Dossier 2, 74–82. Eindhoven: Docomomo International, Eindhoven University of Technology.

———. 1999. "Restauration du béton et authenticité des materiaux. Quelques examples européens." In *Béton et Patrimoine: Cahiers de la section française de l'ICOMOS, Proceedings of ICOMOS Seminar, Le Havre, December 5–7, 1996*, 81–85. Paris: ICOMOS.

Jonge, Wessel de, and Arjan Doolaar, eds. 1998. *The Fair Face of Concrete: Conservation and Repair of Exposed Concrete*. Preservation Technology Dossier 2. Eindhoven: Docomomo International, Eindhoven University of Technology.

9

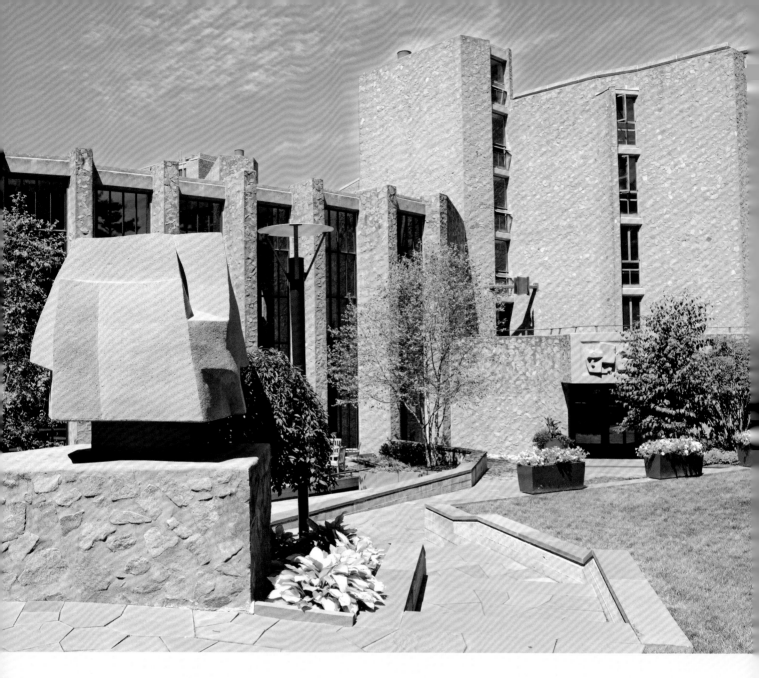

10

Paul Gaudette, Deborah Slaton, and David S. Patterson

Morse and Ezra Stiles Colleges, Yale University

New Haven, Connecticut, USA │ 1958–62

ARCHITECT/DESIGNER

Eero Saarinen

PROJECT DATE

2011

PROJECT TEAM

KieranTimberlake, architect | Wiss, Janney, Elstner Associates, Inc., consultant

CLIENT/BUILDING OWNER

Yale University

INTRODUCTION

Morse and Ezra Stiles Colleges at Yale University are among the last and most distinctive works of Eero Saarinen (1910–1961). Instead of using stone or brick, which are more common on the university campus, Saarinen designed the colleges to be constructed with cast-in-place concrete exterior walls (fig. 10.1). The interiors of the buildings have exposed concrete columns and walls, and exposed roof structures in the common areas.[1]

In his report on the year 1955–56, Yale president A. Whitney Griswold announced his intention to add to the university's then overcrowded residential college system. In 1959, architect Eero Saarinen, who had graduated from Yale in 1934, was selected to design two new colleges. The site of Old York Square, located behind the Yale Graduate School, was selected for construction. The project was funded by a foundation established by Paul Mellon, who had graduated from Yale in 1929, with the goal of building new colleges intended to be different in character from the older colleges of the campus.

As a result of his years as a student at Yale, Saarinen was very familiar with Collegiate Gothic buildings and quadrangles, many of which were completed while he was there (he left in 1934). He had also studied historic sites and landscapes such as the Italian village of San Gimignano and the Campo in Siena. Morse and Stiles Colleges are built on an angular site, with complex, irregularly massed, tall, narrow towers that are reminiscent of Tuscan villages such as San Gimignano. Stepped, winding walks lead between the buildings, which frame a grass-covered courtyard. Through massing, paths, and courtyards, Saarinen sought to relate the new structures to the existing Collegiate Gothic buildings of the campus, including the nearby Payne

Whitney Gymnasium, designed by John Russell Pope, and the Hall of Graduate Studies, designed by James Gamble Rogers, both completed in 1932 and featuring tall, narrow towers. Rogers designed numerous Collegiate Gothic residences at Yale between the world wars, which provided the aesthetic and institutional context for Saarinen's design. In a lecture given in 1959, Saarinen commented, "A way must be found for uniting the whole, because the total environment is more important than a single building. . . . The single building must be carefully related to the whole in the outdoor space it creates. In its mass and scale and material it must become an enhancing element in the total environment" (Papademetriou 1984, 139; Saarinen 1959).

In response to the Collegiate Gothic context, the buildings of Morse (at the eastern end of the complex) and Stiles (at the western end) were organized around asymmetrical courtyards. The buildings of each college include two- and four-story structures with an eleven-story tower (Stiles) and a fourteen-story tower (Morse). They featured more private space per student, and a lower ratio of windows to wall surface, than the older residences. The new buildings shared a common dining room and an elevated walkway leading to Payne Whitney Gymnasium.

An article in the university newspaper at the time of construction was titled "Monolithic Atmosphere Prevails through Designs" (*Yale Daily News* 1959) The concrete of the building facades and site walls incorporated large-scale crushed granite aggregate (fig. 10.2). Large stones, up to 12 in. (30 cm) in diameter, were placed with the concrete, creating a rubble-masonry-like character. In the dining halls, Saarinen used intersecting diagonal concrete trusses related to those of the Collegiate Gothic halls but in a new form.

The design of Morse and Stiles Colleges can be surprising to those familiar with Saarinen's work, in particular when compared to his other structure at Yale, the David S. Ingalls Rink, designed and constructed in 1953–58. That concrete and wood structure, with its sweeping curves and open spans, has a sculptural character found in many icons of modernism, differently expressed but having some similarity to Saarinen's design for the stainless steel Gateway Arch at Jefferson National Expansion Memorial in St. Louis, completed in 1963. The colleges are quite different from these modernist expressions, and in his project statement Saarinen noted: "Flatness, lightness, glistening

Fig. 10.1. Morse and Ezra Stiles Colleges, Yale University. General view of the courtyard, 2013. Photo: Michael Doolittle / Alamy Stock Photo

10

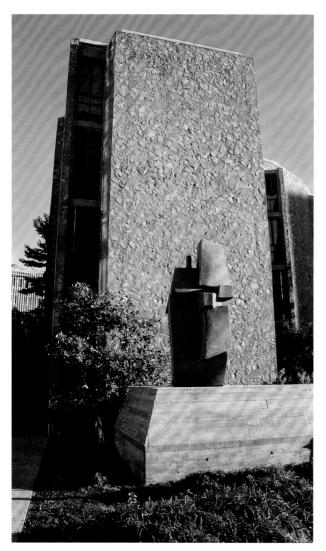

Fig. 10.2. Rubble concrete wall with board-form concrete in foreground. Also note the decorative sculptural element attached to the wall. Photo: Wiss, Janney, Elstner Associates, Inc.

aluminum and glass, smoothness instead of rough texture and the play of light and shade—all these could neither express the spirit we wanted nor be compatible with our neighboring buildings" (Román 2003, 84). In another reference to the older residential college buildings, Saarinen spoke of presenting the new residences as "citadels of earthly, monolithic masonry—buildings where masonry walls would be dominant and whose interiors of stone, oak, and plaster would carry out the spirit of strength and simplicity. Since handicraft methods are anachronistic, we found a new technological method for making these walls: these are 'modern' masonry walls made without masons" (Ezra Stiles College 2017).

The interior plans of the dormitory buildings were also unusual. Seeking diversity in planning, and to reflect the spirit of medieval architecture, Saarinen eliminated all right angles from the living areas. This reportedly resulted in two rooms that had eleven walls, none of which was long enough to put the bed against and still open the door. (Right angles were reintroduced into the architecture of Morse College during the recent rehabilitation.)

THE PROJECT

The repair and conservation of the exterior and interior concrete was undertaken in 2010–11 as part of a comprehensive rehabilitation project designed by architects KieranTimberlake of Philadelphia. The rehabilitation primarily addressed expansion and functional improvements to the buildings but also involved conservation of the architectural concrete. The project involved the renovation of 260,000 square feet (24,155 square meters) of existing structure (containing housing for five hundred students) as well as a 25,000 square foot (2,323 square meter) underground addition beneath the existing courtyard, renovation of the library and dining halls, expansion of the below-grade common rooms, and addition of new skylights and a sunken courtyard to provide daylight for the below-grade spaces. Also added were lounges, fitness spaces, art and music studios, a theater, and outdoor gathering spaces. Landscape alterations were made as well. Wiss, Janney, Elstner Associates served as materials and conservation consultant to KieranTimberlake for the concrete and waterproofing components of the project.

INVESTIGATIONS: BACKGROUND RESEARCH, ANALYSIS, DIAGNOSTIC WORK, TESTING, AND TRIALS

Morse and Stiles Colleges incorporate two distinct types of concrete: the large-aggregate, rubble-like concrete that Saarinen selected to recall the character of buildings in Italian hill towns, and a more familiar board-marked finish. Each type of concrete presented different technical challenges in terms of conservation of character and appearance, although the approach and methodology used in meeting these challenges was essentially consistent for both.

Original construction also included sculptural elements of smooth-finished concrete, embedded in the exterior walls or as freestanding sculpture along walkways and in courtyards (fig. 10.3). Some of these elements had been marred by inappropriate previous repairs that required removal and further repair.

Fig. 10.3. Concrete sculpture with smooth finish set in rubble concrete wall. The sculpture appears to have been mortared in place after construction of the rubble wall. Photo: Wiss, Janney, Elstner Associates, Inc.

Fig. 10.4. Rubble concrete wall made up of very large granite aggregate surrounded by a cementitious mortar. Note the vertical crack at the right in this photo, as well as light to moderate surface soiling. Photo: Wiss, Janney, Elstner Associates, Inc.

10

Fig. 10.5. Detail of adjacent sections of rubble concrete site wall. The top surface of the wall was pargeted with a cementitious mortar as part of original construction to provide a finished surface and enhanced moisture resistance. Note the vertical cracks in the concrete. Photo: Wiss, Janney, Elstner Associates, Inc.

Fig. 10.6. Detail of rubble concrete wall. According to the original construction documents, the large aggregate was placed in forms and cementitious mortar was pumped in to fill the interstitial spaces. Photo: Wiss, Janney, Elstner Associates, Inc.

Field investigation was conducted, relying primarily on visual inspection and nondestructive techniques such as sounding and use of cover meters to locate embedded reinforcing steel. Investigation revealed that the existing concrete was generally in good condition, with minor cracking (fig. 10.4) and localized deterioration at the tops of walls (fig. 10.5). Soiling, deterioration, and localized freeze-thaw damage were observed primarily at the tops of walls, at parapets, and at water outlets, where the concrete elements are exposed to moisture and the elements on multiple sides. Spalling adjacent to windows was found to be related to corrosion of embedded steel window frames. Thus, patch repairs were needed at relatively small and localized areas (fig. 10.6). The fact that the original concrete was air entrained contributed to improved durability in service.

The assessment of the concrete evaluated existing conditions and distress. Small areas of deteriorated concrete were opened to determine existing conditions, causes of deterioration, and as-built conditions. Core samples were removed for laboratory studies, and the project team performed extensive research at the Yale archives to understand the original design and construction processes. Conditions observed were documented with field notes and photographs.

After the field investigation, the original existing and repair materials were analyzed to determine material components, composition, and causes of deterioration. Laboratory studies of the concrete included petrographic evaluation following ASTM C856-04, *Standard Practice for Petrographic Examination of Hardened Concrete* (ASTM International 2004), and tests to determine air content, water-to-cement ratio, cement content, general aggregate identification, carbonation depth, and chloride content. Petrographic evaluation was performed to provide a general identification of components and aggregates of original concrete. This information was used to develop a mix design for the repair concrete.

CONSERVATION

The goal of the project was to repair the concrete on both the exteriors and the interiors of the buildings, using materials and techniques that would match the existing facade as closely as possible and perform well. The repair design needed to match the unique characteristics of the original construction—both rubble and board-formed concrete—and also provide a similar board-formed concrete for new construction incorporated as part of the building expansion.

Based on archival documentation reviewed, the rubble concrete mix consisted of fine aggregate composed of rock fragments and sand, coarse aggregate consisting of Millstone Point granite, cement, water, and entrained air. The original specifications indicated that for the rubble concrete, the coarse aggregate consisted of granite that is 50% buff and 50% pink in color. In terms of size, the original specifications indicate that aggregate would be graded with 50% passing a screen with 8 in. (20.32 cm) square openings and retained on a screen with 6 in. (15.24 cm) square openings, and the remaining 50% passing a screen with 6 in. (15.24 cm) square openings and retained on a screen with 3 in. (7.62 cm) square openings. Visual examination confirmed that the concrete mix was generally as specified.

The original specifications also required that the concrete meet a compressive strength requirement of 5,000 psi for grout and 3,000 psi for the rubble concrete (grout plus aggregate). The compressive strength test method required 2 by 2 by 2 in. (5.08 by 5.08 by 5.08 cm) cubes for the grout, and 18 by 36 in. (45.72 by 91.44 cm) cylinders for the rubble concrete. Note that the very large size of the rubble aggregate would have required that large cylinders rather than cubes be used for this quality control testing during construction. In addition, the specification required air entrainment of 3 to 5%. (It is interesting that a specification developed at the time was so detailed.)

The primary objectives of the repairs were to use materials and techniques that would be sympathetic to the existing facade, meet the specification criteria used in the original construction, and perform well in an exterior environment. The rubble concrete was generally in good condition with only localized cracks, and thus the required repairs primarily involved patching at cracks with a matching repair mortar rather than development of a mix design incorporating the large granite aggregate.

The most challenging aspect of the project was to match the warm buff color and special texture and finish of the original concrete (fig. 10.7). Each type of finished surface—large rubble aggregate, smooth finish, or board-marked finish—required trials and a high level of craftsmanship to properly match the original. The first challenge was to identify the aggregates, sand, and cement used in the original concrete. A series of field mock-ups were conducted to refine the mix design and protocols for repair. The implementation of repairs at trial locations permitted technical and aesthetic evaluation of the completed repairs, and an assessment of the scope of work and the contractor's procedures by all parties, including the personnel performing the work.

Fig. 10.7. Exterior rubble concrete piers with inset windows. Photo: Wiss, Janney, Elstner Associates, Inc.

Fig. 10.8. Detail at window showing typical deterioration of interior concrete due to corrosion of embedded steel window frame anchorage. Also note previously installed cementitious patches. Photo: Wiss, Janney, Elstner Associates, Inc.

An example of a repair that required particular care in implementation involved the thin jamb sections of concrete at the large vertical windows (fig. 10.8). This repair was required at exposed edges of the rubble concrete on the building interior. Because of the complex configuration of the building footprint, the interface at some windows was approximately a 30° angle. The highly textured rubble concrete created a highly uneven surface to be repaired, and the location of the window frame was another constraint on preparation and patch installation.

10

Fig. 10.9. Various concrete mix samples designed to match the original architectural concrete, shown at right. Photo: Wiss, Janney, Elstner Associates, Inc.

Fig. 10.10. View of interior concrete pier after repair to address corrosion of embedded steel window anchorage and prior to final cleaning. Photo: Wiss, Janney, Elstner Associates, Inc.

Fig. 10.11. Board-form-finish concrete walls during removal of forms. Photo: Wiss, Janney, Elstner Associates, Inc.

Fig. 10.12. Board-form-finish concrete walls after removal of formwork and prior to cleaning. Photo: Wiss, Janney, Elstner Associates, Inc.

Fig. 10.13. Completed new board-form-finish concrete walls. Photo: Wiss, Janney, Elstner Associates, Inc.

The contractor developed trial mixes and repair techniques that were performed on shop samples to determine how to best match the original appearance while providing a durable repair (fig. 10.9). Next, in-place trial repairs were performed to permit technical and aesthetic evaluation of the completed repairs and an assessment of the scope of work and the contractor's procedures (fig. 10.10). Once the repair mix and installation procedures were confirmed through the samples and trials, preparation at repair locations was completed; exposed steel cleaned, primed, and painted with a rust-inhibitive coating system; and the new concrete installed and cured.

Another aspect of the project involved development of board-form finish concrete to match the character of existing board-form concrete present at the building. The new board-form concrete was used primarily for site walls, entrance areas where the site was excavated to provide new belowground space, and at building interiors

(figs. 10.11, 10.12, 10.13). The board-marked concrete reflects the texture of the wood forms, with lift lines visible. Wood for the forms was selected and the forms constructed to replicate the pattern left by formwork on the original concrete. New concrete was placed in the forms and vibrated. The formwork was removed after a minimum of three days, followed by the installation of a polyethylene sheet for an additional four days during concrete curing.

Surface preparation is one of the most important steps in any concrete repair. It begins with removal of loose and unsound concrete at spalls or failed previous patches; saw cutting the perimeter edges of the repair area to a depth of 1 in. (2.54 cm) and approximately 1 in. (2.54 cm) beyond visible corrosion of the embedded steel; chipping of concrete within the patch area to a minimum of ¾ in. (1.91 cm) deeper than the reinforcing steel; sandblasting and air blasting of the patch area to clean away laitance, dirt, and other debris from the exposed concrete; and cleaning,

10

Fig. 10.14. Overall view of the facade of Morse and Stiles Colleges. Note the rubble concrete walls with inset windows. Photo: Wiss, Janney, Elstner Associates, Inc.

preparation, and priming and coating of exposed steel with a rust-inhibitive coating, followed by installation of the new patch material.

The procedure for placement and finishing begins with the installation of formwork at repair areas to match the existing profile of adjacent concrete. The concrete is placed in the forms, and internal and external vibration techniques such as hammer tapping of the forms and pencil vibration are used. The concrete is then allowed to cure sufficiently to allow surface finishing, followed by removal of the forms. Formwork is typically removed three days after placement, depending on the specific concrete mix. Finishing is then completed to achieve the designated texture and exposure of the aggregate at the exterior surface of the new concrete. Techniques for finishing included a combination of low-pressure water and hand brushing to resemble the original concrete adjacent to the repair area. The concrete is then covered with polyethylene and allowed to finish curing.

At the Morse and Stiles project, for both the rubble concrete and the board-form concrete, the natural variability of the historic finish and texture required that each

repair area had some level of customization to match the adjacent surfaces. Some locations had a more pronounced exposure or board-form finish than others. Achieving variations in the finish is always a challenge, especially when the contractor may be accustomed to the normal standard of achieving final consistent appearance for new construction.

Mock-ups used for refinement of finishing techniques and aesthetics were a part of this project since original construction; archival photographs taken during construction indicate that architects from Saarinen's office participated in development of mock-ups to confirm that the specified materials and methods resulted in the desired appearance. Among the images from this period reviewed in the collection of Yale University Manuscripts and Archives are photographs of architects Cesar Pelli and John Buenz using hammers and chisels to adjust the appearance of a large concrete wall mock-up.

Finally, a clear, penetrating silane-based sealer is often applied to new concrete to reduce water penetration into the substrate. The sealer reacts chemically with the surfaces

of pores and fine cracks in the concrete to make them water repellent or hydrophobic, while allowing moisture that does enter the concrete to escape; this type of sealer does not bridge cracks. In addition, clear penetrating sealers are designed not to significantly change the color of the concrete, although the treatment may be discernible after rainfall, when the concrete surface is wet. Because this type of treatment is not reversible, it is not necessarily used with historic concrete unless additional protection against moisture is required. It was determined that a clear penetrating sealer was not necessary for the new board-formed or repaired original concrete.

CONCLUSIONS

The process of research, investigation, laboratory analysis, trial samples, mock-ups, and full-scale repairs allowed refinement of the repair design, continuity of installation procedures, and consistent implementation of quality control measures as the project progressed. A conservation approach was used to guide technical and engineering decisions, resulting in repairs that perform to modern practice standards and are aesthetically successful (fig. 10.14).

The importance of craftsmanship in the successful repair of historic concrete cannot be overstated. While preparation of good construction documents and careful implementation of trial repairs and mock-ups are always essential, the skill and experience of the contractor personnel performing the repairs are equally critical to the success of the project.

The project team approached the conservation and repair of the concrete at Morse and Stiles Colleges with an understanding of the higher standards required for repair work for historic concrete and the additional time needed for assessment, trials, and mock-ups. This approach was understood by the entire project team—owner, design architect, consultants, and contractors—leading to an efficient work process and a collegial context highly appropriate to the university setting.

NOTE

1. Photographs of the colleges taken by Balthazar Korab soon after construction are in the collection of Library of Congress and online at https://www.loc.gov/search/?in=&q=Yale+University%2C+Samuel+F.B.+Morse+and+Ezra+Stiles+Colleges+korab&new=true. See also photographs from Yale University Library, Manuscripts and Archives, Digital Images Database, at http://images.library.yale.edu/madid/showthumb.aspx?q=morse+and+stiles. Also of interest is Henry S. F. Cooper, "Morse and Stiles," *New Yorker*, December 22, 1962, 26, describing the dedication of the new colleges and including comments by Saarinen's wife about the architectural design.

WORKS CITED

ASTM International. 2004. *Standard Practice for Petrographic Examination of Hardened Concrete*, ASTM C856-04. West Conshohocken, PA: ASTM International. (The current edition of ASTM C856, *Standard Practice for Petrographic Examination of Hardened Concrete*, is ASTM C856-17 [West Conshohocken, PA: ASTM International, 2017].)

Ezra Stiles College. 2017. Eero Saarinen quoted in "About Ezra Stiles." Accessed October 31, 2017. http://ezrastiles.yalecollege.yale.edu/about-ezra-stiles.

Papademetriou, Peter. 1984. "Coming of Age: Eero Saarinen and Modern American Architecture." *Perspecta* 21: 116–43.

Román, Antonio. 2003. *Eero Saarinen: An Architecture of Multiplicity.* New York: Princeton Architectural Press.

Saarinen, Eero. 1959. Address at Dickinson College, Carlisle, Pennsylvania, December 1, 1959. Yale University, Sterling Memorial Library Manuscripts and Archives, Eero Saarinen Papers, Manuscript Group 591, Series VII, Box 11, 4–5.

Yale Daily News. 1959. "Saarinen Uncovers College Plans: Construction May Begin in February. Present Cost Estimate Established at $6,200,000; Monolithic Atmosphere Prevails through Designs." November 12, 1959, front page.

10

11

Laura N. Buchner, Christopher Gembinski, and Raymond M. Pepi

New York Hall of Science

New York | 1964

ARCHITECT/DESIGNER

Wallace K. Harrison of Harrison and Abramovitz

PROJECT DATES

2005–16

PROJECT TEAM

Building Conservation Associates, building preservation consultant | Ennead Architects, architect | Leslie E. Robertson Associates, structural engineer | New York City Department of Design and Construction, project management

CLIENT/BUILDING OWNER

City of New York, Department of Design and Construction | City of New York, Department of Cultural Affairs | New York Hall of Science

INTRODUCTION

The New York Hall of Science, designed by Wallace K. Harrison (1895–1981) of the architectural firm Harrison and Abramovitz, was constructed for the 1964–65 New York World's Fair in Flushing Meadows, Queens. Unlike the majority of the fair buildings, which were subsequently demolished, the Hall of Science was planned to remain as the New York Museum of Science and Technology; it continues today as an interactive science museum.

The primary exhibition space, known as the Great Hall, is a single-story building 90 feet (27.43 m) high, with undulating walls comprised of approximately 5,400 precast concrete dalle de verre rectangular panels of equal size, set in a cast-in-place reinforced concrete grid (fig. 11.1). Dalle de verre is a twentieth-century form of stained glass that employs slabs of glass (*dalles*), usually about 1 in. (2.54 cm) thick, set in a matrix of either concrete or epoxy. Rather than using traditional lead cames to support the glass, the concrete matrix material is poured around the glass and some steel reinforcement as it lies in horizontal molds. Each panel is subsequently installed in the concrete grid.

At the time of construction, with more than 30,000 square feet (2,787 square meters) of stained glass, the Great Hall was reputed to be the largest installation of dalle de verre in the world. Willet Studios of Philadelphia designed and produced the panels using five different shades of cobalt blue glass, as well as small ruby, gold, and green dalles as accents. Blenko Glass Company of Milton, West Virginia, cast the 1 in. (2.54 cm) thick pot-metal glass. The blue glass was produced in squares of 8 by 8 in. (20.32 by 20.32 cm); most were hand cut to a variety of dimensions, some less than 1 in. (2.54 cm) square, and hand faceted to add a prismatic effect.

Willet Studios set the glass and the ferrous wire reinforcement in a matrix of concrete mixed from Corson's Home-Crete Sand Mix. Contemporary accounts record construction details, including the facts that in order to produce the panels for the Great Hall, Willet used 125 tons (113,398 kg) of Corson's Home-Crete ("Museum of Science and Technology" 1964), and that after the concrete mixture had cured, they applied two coats of Benesco epoxy resin over the entire surface of the panels for waterproofing ("Modern Museum for the Space Age" 1965). Benesco epoxy was developed around 1960, not as a coating but as a setting compound for glass dalles; it was the first epoxy designed specifically as a matrix material for dalle de verre (Millard 1992). The process of coating concrete dalle de verre with Benesco epoxy, as was done at the Hall of Science, appears to have been rare. Though presumably clear when applied, the Benesco epoxy has discolored over time.

The cast-in-place reinforced concrete framework is approximately 13 in. (33.02 cm) thick. The 1 in. (2.54 cm) thick panels are set nearly flush with the exterior facade, creating deep interior coffers. There is a portion of freestanding wall where both sides, including the coffers, are exposed to the exterior environment. Harrison's dramatic design, with shafts of blue light penetrating the dark, voluminous hall, was intended to evoke the feeling of journeying through the cosmos (Pepi, Gembinski, and Buchner 2014) (fig. 11.2).

THE PROJECT

In 2005, the authors, of Building Conservation Associates, joined the design team responsible for rehabilitating the building as consultants for the conservation of the cast-in-place concrete and dalle de verre panels. Ennead Architects oversaw the conservation design, and Leslie E. Robertson Associates was the structural engineer. The Department of Design and Construction managed the project for the City of New York.

The first phase of the undertaking, the exterior conservation of the Great Hall, was completed in 2010 and was followed by interior cleaning and repairs, completed in 2016. The conservation design addressed cracks and spalls

Fig. 11.1. Exterior of the concrete framework and dalle de verre panels at the New York Hall of Science, 2014. Note at left the freestanding wall that overlaps the facade. Photo: Building Conservation Associates, Inc.

11

Fig. 11.2. The deep coffers formed by the concrete framework and panels at the Great Hall interior, 2014. Photo: Building Conservation Associates, Inc.

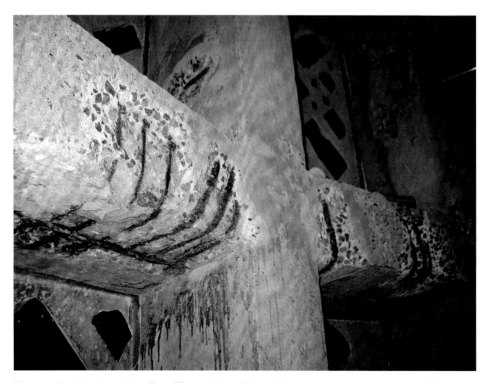

Fig. 11.3. Deterioration at the coffers of freestanding wall, 2009. The conservation contractor removed delaminating concrete with hand tools before chipping the concrete to form the desired patching profile. Photo: Building Conservation Associates, Inc.

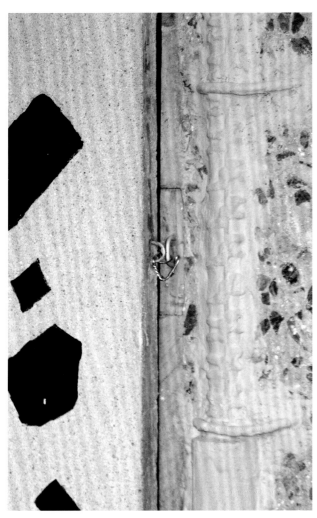

Fig. 11.5. Typical crack in a panel, stretching from glass to panel edge, 2009. Photo: Building Conservation Associates, Inc.

Fig. 11.4. Typical attachment of panel to cast-in-place concrete: a stainless steel loop embedded in the panel is attached to a stainless steel loop embedded in the cast-in-place concrete with a wire tie, 2010. Delaminating concrete was removed at the right side of the photo and exposed rebar was cleaned and coated with a rust-inhibitive coating in preparation for patching. Photo: Building Conservation Associates, Inc.

Fig. 11.6. Deteriorated panel broken apart for laboratory testing, 2009. Ferrous wire reinforcement made it difficult to separate the concrete fragments. Photo: Building Conservation Associates, Inc.

11

in the cast-in-place concrete resulting from corrosion of ferrous metal reinforcement installed with inadequate concrete cover (fig. 11.3). A 1990 repair campaign included numerous exterior patches, which had begun to fail at feathered edges and shallow cover over the steel reinforcement. Cracks and spalls subsequent to the 1990 repair campaign were also observed in the original concrete, indicating ongoing decay.

Each dalle de verre panel measures approximately 23½ in. (59.69 cm) wide and 33 in. (83.82 cm) high. The panels are attached to the concrete framework with embedded stainless steel loops and wire ties at two locations along each long edge (fig. 11.4). Cracks, often penetrating the full depth of the panels, were found to typically radiate from the glass dalles to the panel edges, usually at locations where metal loops are embedded (fig. 11.5). The installation of conduits and equipment had damaged some panels, but the embedded ferrous wire reinforcement successfully cohered even the most severely compromised panels (fig. 11.6). Close-up inspection indicated that the exterior panel surfaces were friable, and isolated locations exhibited severe erosion that exposed corroding reinforcement.

Atmospheric soiling and heavy biological growth were visible on the facade, and dark stains were present at the

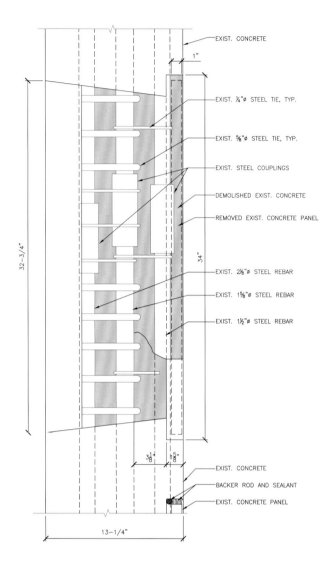

EXIST. CONCRETE

1"

EXIST. ¼"⌀ STEEL TIE, TYP.

EXIST. ⅝"⌀ STEEL TIE, TYP.

EXIST. STEEL COUPLINGS

DEMOLISHED EXIST. CONCRETE

REMOVED EXIST. CONCRETE PANEL

EXIST. 2⅛"⌀ STEEL REBAR

EXIST. 1⅝"⌀ STEEL REBAR

EXIST. 1½"⌀ STEEL REBAR

EXIST. CONCRETE

BACKER ROD AND SEALANT

EXIST. CONCRETE PANEL

32–3/4"

3'4"

3 1/8"

1 5/8"

13–1/4"

Fig. 11.7. Section showing a typical existing rebar configuration within a vertical column at coffers and the surface of the flush walls of the Great Hall. Each column has five vertical strips of rebar; only three are visible in this section due to the rebar configuration. Drawing: Building Conservation Associates, Inc.

building's parapet and base. The interior surfaces exhibited heavy dust deposition and stains from water infiltration around the glass dalles, at deteriorated perimeter sealant, and through cracks in the panels.

The focus of the panel conservation addressed the concrete matrix, as the majority of the glass was in good condition.[1] However, isolated dalles were cracked. Cracks from impact damage were of obvious origin; no pattern or systemic cause was identified for isolated hairline cracks. Whether due to the initial curing of the concrete, thermal movement, and/or the resultant stresses produced by the geometry of the construction, the isolated cracks in the glass generally had not destabilized the dalles.

INVESTIGATIONS: BACKGROUND RESEARCH, ANALYSIS, DIAGNOSTIC WORK, TESTING, AND TRIALS

Archival research and field investigation indicated that the existing conditions correlated to the methods of construction. For example, the original concrete framework was mixed at a plant on-site and cast in relatively small batches of only 10 cubic yards (7.65 cubic meters) daily ("Old Craft Encloses New Museum" 1964). The horizontal concrete "lifts" created by these small pours resulted in differing colors, hues, and color values. The surface of the concrete at the exterior coffers of the freestanding wall was less weathered and had a smoother texture than that of the flush walls. These surface variations posed challenges when attempting to match new patching material to the historic concrete.

The faces of the cast-in-place concrete spandrels and columns measure approximately 7½ in. (19.05 cm) wide at the coffer side and 5½ in. (13.97 cm) wide on the flush side. Each of the vertical columns contains five vertical strips of rebar (fig. 11.7). Archival drawings indicate that these range in size from #8 to #11 (1 to 1.41 in. [2.54 to 3.58 cm] in diameter). At the horizontal spandrels, four strips of reinforcing range in size from #8 to #10 (1 to 1.27 in. [2.54 to 3.23 cm] in diameter). In both the columns and the spandrels, the rebar varies in diameter depending on where it is located, measuring larger at the bottom of the building and smaller at the top (Harrison and Abramovitz 1963b).

Archival drawings specified 1 in. (2.54 cm) of concrete cover at the center of the spandrels on the coffered side of the wall and 2¾ in. (6.99 cm) of cover at the center of the spandrels on the flush side of the wall. The architects anticipated some variation in the concrete cover at the panel rabbets because of the configuration of flat panels installed in a curved wall (Harrison and Abramovitz 1963a). During the conservation, the authors measured represen-

tative areas of concrete cover and found that it ranged from ¹⁄₁₆ to 2¼ in. (0.16 to 5.72 cm) in the horizontal spandrels, soffits, and sills. The concrete cover in the vertical columns was found to range from less than ¹⁄₁₆ to 1½ in. (0.16 to 3.81 cm). Carbonation of exterior concrete at the Great Hall was found to occur as deep as 1¼ in. (3.18 cm) (Materials Technologies 2005, table 3). The existing cover is generally less than is acceptable by the standards of the American Concrete Institute. According to ACI 318, Section 7.7.1, #6 to #18 rebar exposed to weather should have 2 in. (5.08 cm) of cover. This standard has not changed substantively since 1965 (Hageman, Beeston, and Hageman 2008, 151).

Changing the depth of cover over isolated shallow rebar in the flush walls to potentially improve the service life of the concrete would have significantly altered the building appearance as designed by Harrison and was therefore avoided. Only visibly damaged concrete was ultimately treated, although it was assumed that areas of apparently sound concrete had corroding reinforcement beneath and would continue to present maintenance problems even after restoration. One project goal was to slow the rate of corrosion of the shallowly embedded deformed (ridged) reinforcing steel bars in both new patches and in currently sound original concrete. Repairs also considered that the rebar in shallow patches would be vulnerable to future deterioration; maintenance coatings were considered for application over the entire facade to slow the rate of corrosion. Periodic maintenance is critical, and the project team recommended regularly scheduled assessments of facade conditions.

The options for repairing the cast-in-place concrete and applying maintenance coatings had to be coordinated with treatments to adjacent dalle de verre panels. The conservation of both the framework and the panels demanded thorough testing and careful application of the selected repair strategies and coatings to protect the original fabric and the unique visual impact of the dalle de verre.

Laboratory testing was performed to better understand the original construction materials and deterioration. Petrographic analysis of three concrete cores taken from the cast-in-place framework identified the composition as portland cement and well-graded carbonates (calcic dolomite, dolomitic limestone, and fossiliferous limestone). The concrete also contained coarse white and yellow medium-grain aggregates and fine aggregate in the form of siliceous natural sand with quartz and rock fragments. It is air entrained, has a moderate water-to-cement ratio, and weighs 112 lb per cubic foot (1,794 kg/m³); its modulus of elasticity was calculated as 3.59×10^6 psi.[2] Based on the visual and laboratory analysis of these cores, the overall

quality of the concrete was deemed to be poor due to a weak paste-aggregate bond relationship. Microcracks in the concrete were attributed to plastic shrinkage (Materials Technologies 2005, 2–4).[3]

Analysis performed in advance of the conservation found the existing concrete to have a compressive strength of 3,980 psi (Materials Technologies 2005, table 3).[4] This was less than the 5,000 psi structural lightweight concrete that documentary evidence recorded and that the architect had specified for all concrete for grid walls (Harrison and Abramovitz 1963c).

Early photographs of the building indicate that a coating was once visible on the entire exterior framework, giving the concrete a dark, streaky appearance, but weather had worn this from most of the flush walls. There remains a streaky, translucent coating visible on the exterior coffers and on the flush wall of the Great Hall where the freestanding wall overlaps the facade and provides protection from weather. Three samples of this coating were analyzed using Fourier-transform infrared (FTIR) spectroscopy. Two of the samples exhibited spectra indicative of an alkyd resin (Martin 2010, 2). Analysis of the third sample resulted in a spectrum with features consistent with polystyrene and what is likely an acrylic (Martin 2009, 2). These results suggest the possible application of two coatings, either at the same time or during different campaigns.[5]

Permeability tests were conducted on three untreated samples of weathered exterior cast-in-place concrete using method 11.4 by RILEM.[6] In one hour, two untreated samples absorbed zero milliliters of water, and one sample absorbed 1 milliliter.

The Corson's Home-Crete Sand Mix used for the dalle de verre panels' matrix is no longer manufactured. Petrographic and chemical analyses were performed on samples taken from a panel that was removed from an exterior wall of the Great Hall.[7] The concrete is characterized as a fly-ash-modified, gray portland-cement-based matrix with light brownish-gray, fine-grained quartz aggregate. The sand-to-dry-binder ratio is estimated at 4:1 by weight; the fly ash is estimated to represent a 19 to 27% replacement of portland cement by weight. The aggregate is moderately well graded with a relatively low abundance of fines. No pigments or air entrainment was identified in the panels (Walsh 2009, 5–6).

The components of the matrix were well mixed and consolidated. It was found to be hard and dense due to the hydrated binder that resulted from the pozzolanic reaction of the fly-ash addition. The binder had weathered between the grains of sand at the surface, and microscopically thin patches of leached paste were visible between the grains, a

11

condition characteristic of acidic weathering (Walsh 2009, 5–6).

The sample panel was carbonated to a depth of approximately 9 mm from the exterior surface of the panel and approximately 4 mm from the interior. Only approximately 1 mm of carbonation was found at the concrete laterally adjacent to glass. The wire reinforcement is composed of steel wire approximately 2.4 mm in diameter; in the sample tested, it was set approximately 6.4 mm from the outer surface of the panel. Because embedded steel wires at isolated areas are within the outer carbonated section of concrete, they are susceptible to corrosion (Walsh 2009, 5–6).

Original dalle de verre panels inside the lobby of the Great Hall retained a translucent yellow film coating on the surface of the panels set flush with the cast-in-place concrete. The film was found to be flaking from the glass and the concrete matrix. On the exterior of the building, small flakes of this brittle material could be seen on panels protected from the weather by the freestanding wall, suggesting that greater exposure to the elements had worn the coating elsewhere.

Samples of the coating from interior panels were subjected to FTIR. The infrared spectra of this coating exhibited features consistent with a mixture of materials, including epoxy and a phthalate-based material. Phthalates are used to plasticize certain polymers (including epoxy) but also are used to make alkyd resins. It is not known if the phthalate was used as a plasticizer in an epoxy, in a mixture of epoxy and alkyd, or both. A cross section of the coating examined using fluorescence microscopy revealed a single discernible layer of the material (Martin 2009, 2). This layer is likely the epoxy applied by Willet Studios as a waterproofing material (Martin 2010, 2). Benesco epoxy, as noted earlier, was formulated for making cast panels, and it is possible that it was modified with a plasticizer to make it flow better as a coating.

CONSERVATION

A comprehensive testing program for both the cast-in-place concrete and the dalle de verre panels was carried out to identify effective cosmetic treatments that would also slow deterioration and prolong the cycle between repair campaigns. Testing was conducted in the laboratory and in the field over a period of more than three years. The testing program included developing an appropriate patching system to match the appearance of the weathered concrete framework. Methods for repairing cracks in the panels were also evaluated. In addition, consolidants, water repellents,

and corrosion inhibitors were assessed. The physical and aesthetic impact associated with applying protective coatings over the glass was considered. Recommendations for the conservation repairs stemmed from the results of these tests, as well as from compatibility testing performed by the manufacturers of the products reviewed.

The testing campaign began with a review of potential patching materials that would blend with the color and texture of the weathered concrete. Site conditions required a repair mortar with the following properties: durability, low shrinkage upon set, colorfastness, adequate strength for deep patches, manufacturer's technical support, and familiarity of the product to conservation trades in New York. In addition, the selected patching mortar had to be compatible with the maintenance coatings being considered.

The visibility of exposed aggregate on the weathered concrete was an important factor in matching the color and texture of the existing concrete. A sample of the weathered surface of the concrete, approximately 1/16 in. (1.59 mm) deep, was subjected to wet chemical analysis using acid digestion, and isolated aggregate was matched to a blend of sieved local sands.[8] A number of patching mixes produced cosmetically acceptable patches in the laboratory, but only two commercial systems were tested in field mock-ups: a polymer-modified mortar and a mineral-based cementitious repair mortar designed for the repair of concrete. Three types of field mock-ups were performed with each patching material. The mortar was:

- used as designed
- installed with matching aggregate troweled onto its surface
- installed with the aggregate mixed into the dry mortar powder[9]

After curing, the patches were reviewed. The commercially blended cementitious patches, which were comprised of Jahn M90, available from Cathedral Stone Products, did not exhibit shrinkage cracks, and their texture was more similar in appearance to the existing concrete than the ones using polymer-modified mortar.

During construction, five custom colors of Jahn M90 were selected to match the varying concrete colors, and the aggregate blend was troweled onto the surface of the patches to simulate the weathered appearance of the adjacent concrete. The concrete conservation contractor, Structural Preservation Systems, adjusted the aggregate sieving to match the varying levels of weathering across the facade (fig. 11.8). In areas less subject to weathering, such as within the coffers at the base of the freestanding wall, aggregate

Fig. 11.8. A patch with surface-applied aggregate is installed at the top two-thirds of the column at the left, 2009. The bottom third of the column is the original weathered concrete. Photo: Building Conservation Associates, Inc.

was mixed into patches and etched with a weak acid to create a mildly weathered but overall smooth surface.[10]

The effectiveness and compatibility of applying water-repellent coatings to reduce water penetration into the cast-in-place concrete and patching material was evaluated, and a consolidant for the weathered surface of the hand-crafted panels was assessed. New York State environmental regulations restricting volatile organic compound (VOC) content, which went into effect in 2005, limited the options. Panels removed from the Great Hall were treated with the consolidant and water-repellent system selected to conform to the VOC restrictions: KEIM Fixativ, a potassium silicate consolidant, and KEIM Ecotec, a silane water repellent compatible with the consolidant. Phillips microabrasion testing found that the KEIM system substantially increased the mechanical strength of the samples in comparison to untreated samples.[11] Water absorption testing indicated that the system also provided increased water repellency, reducing the absorption by 90% when compared with untreated samples (AMT Laboratories 2006, 4–7). After

one thousand hours of accelerated weathering, the coatings still reduced the rate of absorbance of the concrete by approximately 66% (AMT Laboratories 2007, 4–5). The application of the KEIM coatings did not appear to affect the color of the panels (AMT Laboratories 2006, 6).

Conductivity tests, X-ray diffraction (XRD), and X-ray fluorescence (XRF) were conducted to assess whether the KEIM coatings used in conjunction with the biological growth remover specified for general cleaning would produce salts in the panels. The conductivity tests suggested that neither the biological growth remover nor the consolidant and water-repellent treatment create significant quantities of salts in the concrete matrix. Nearly one-third to one-half of the conductive material in the treated samples was derived from the calcium sulfate hydrate (gypsum) that existed in the panels prior to treatment. The biological growth remover contributed some chloride, and syngenite was detected in both samples treated with the Fixativ. The analysis suggested that potassium in the Fixativ reacted with the calcium sulfate hydrate (gypsum) present in the concrete and formed potassium calcium sulfate hydrate (syngenite). Syngenite is not known to be harmful to concrete.

With the viability of these products on the panel matrix established, field testing was conducted to ascertain how reducing water absorption into the cast-in-place concrete would affect the corrosion rate of steel embedded in the facade. A rust-inhibitive coating applied directly to the rebar was sought for use in combination with the patching material to reduce the rate of corrosion in locations that had already proved susceptible. A potassium silicate rust-inhibitive coating, distributed by Cathedral Stone Products for use with the Jahn M90, was selected for testing.

The effectiveness of the KEIM coatings used in conjunction with the potassium silicate corrosion inhibitor was compared with the effectiveness of using only MCI-2020 V/O, a migrating corrosion inhibitor based on amino-carboxylate chemistry, manufactured by Cortec Corporation. Unlike the potassium silicate corrosion inhibitor, which was applied directly to exposed rebar, the MCI product is designed to be applied to concrete surfaces and migrate through the hardened concrete via diffusion (Cortec Corporation 2005, 5).

Field testing of the MCI product, performed over a two-year period, consisted of installing Model 800 Corrater probes, manufactured by Rohrback Cosasco Systems, to measure the corrosion rate of steel within cementitious patches.[12] AquaMate, a handheld corrosion monitor, was used to measure the instantaneous corrosion rate at the probes, which consisted of a sensor embedded in

11

Fig. 11.9. Electrodes of probe installed for field testing adjacent to existing cleaned rebar, 2005. Photo: Building Conservation Associates, Inc.

the patching material adjacent to the rebar, with carbon steel electrodes designed to corrode at the same rate as the rebar (Rohrback Cosasco Systems 1999, 3). Where the rebar was coated with the potassium silicate rust inhibitor, electrodes were also treated.

Field testing was performed at four locations on the west facade of the building. Cracked and spalling patch material was removed from this area for the probe installation. Exposed rebar at each location was cleaned with a wire wheel, and the probes were installed at three of the four test locations, with the electrodes parallel to and equidistant from the concrete surface and not touching the rebar

(fig. 11.9). Table 11.1 summarizes the materials installed at each test location. Because the testing was performed to independently evaluate the effectiveness of the consolidant and water-repellent system with the addition of a rebar coating against the use of the migrating corrosion inhibitor alone, the effect of combining all coatings was only evaluated qualitatively.

The instantaneous corrosion rate of the electrodes was measured regularly over a two-year period. The control sample initially exhibited the highest rate of corrosion, but this condition abated after ten months. The electrodes in the patch treated with the migrating corrosion inhibitor exhibited a measurable rate of corrosion during only three months. The corrosion rate of the electrodes coated with the rust inhibitor and embedded in the patch coated with the consolidant and water repellent exhibited the most fluctuation. However, the measurements from all of the probes remained relatively low, less than 1 mil per year (MPY), throughout the monitoring process (fig. 11.10). According to Rohrback Cosasco Systems, the manufacturer of the probes, the range of corrosion measured is typical for rebar embedded in a concrete facade.[13]

After two years, the patches were removed and a qualitative comparison of the corrosion on the embedded steel was performed. Visual assessment identified that the least corrosion formed where the steel was coated directly and the patch was treated with both the consolidant and the water repellent. Slightly more corrosion was evident at rebar embedded in the patch treated with only the migrating corrosion inhibitor. Uncoated rebar embedded in the patch treated with the migrating corrosion inhibitor, consolidant, and water repellent applied in combination showed the most corrosion of the three treated samples. However, this sample had the least concrete coverage, and a reduction in the amount of corrosion was still noted in comparison with the control.

The control sample, which consisted of uncoated rebar in cementitious patching mortar, exhibited the most

Table 11.1. Summary of Treatments at Field Probes

Field test location	Patching material installed at test location	Rebar coated with potassium silicate rust inhibitor	Consolidant and water repellent applied to concrete surface	Migrating corrosion inhibitor applied to concrete surface	Quantitative with probe	Qualitative
			Treatment		**Evaluation Method**	
1	Jahn M90			X	X	X
2	Jahn M90	X	X	X		X
3	Jahn M90	X	X		X	X
4	Jahn M90				X	X

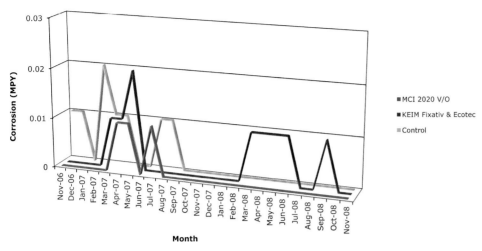

Fig. 11.10. Measured corrosion rates of the probes embedded in the facade from November 2006 to November 2008. Graph: Building Conservation Associates, Inc.

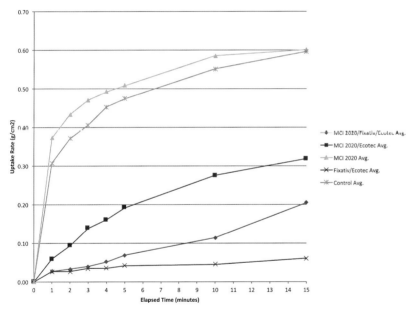

Fig. 11.11. Average water absorption rates recorded during capillary-uptake tests. Graph: Building Conservation Associates, Inc.

corrosion, even though it had the deepest concrete cover, at ½ to ¾ in. (1.27 to 1.91 cm) versus <¼ in. (<0.64 cm) of cover at the other test locations. The amount of corrosion visible at the control was still lower than expected, given the small amount of cover in this area. This was attributed to the fact that the patching material is designed to provide an environment with a pH that prevents corrosion (Cathedral Stone Products 2014).

Testing in collaboration with the coating manufacturers found that KEIM Fixativ consolidant applied over the Cortec

MCI-2020 V/O created potential adhesion issues within the system and was therefore not recommended. The consolidant was necessary only on sound cast-in-place concrete to increase the surface pH for effective application of the water repellent; KEIM determined that the Cortec MCI-2020 V/O product effectively performed this same function.

Capillary-uptake tests were conducted on new concrete pavers treated with the coatings to determine the differential rates of absorption in a saturated environment (fig. 11.11).[14] The combination of Ecotec and MCI-2020 V/O

exhibited overall performance advantages, although it had a slightly higher absorption rate than Ecotec and Fixativ. This particular performance comparison was not considered problematic because the absorption rate of the original cast-in-place concrete is low. Applying the migrating corrosion inhibitor to prevent subsurface corrosion was considered preferential to establishing higher water repellency. Although no known agent or process is available to halt the corrosion completely, field mock-ups suggested that the MCI-2020 V/O product would effectively slow the corrosion rate of rebar embedded in sound cast-in-place concrete.

Based on the Corrater probe readings, visual assessment of the probes, laboratory testing, and manufacturers' recommendations, the combination of the migrating corrosion inhibitor and water repellent, without the consolidant, was deemed the most desirable coating system for the concrete framework. Applying corrosion protection directly to all exposed steel reinforcement prior to the installation of new patches was also recommended to provide additional protection to areas that exhibited corrosion and spalling. During the course of the testing program, the potassium silicate rust inhibitor was discontinued and a rebar-applied coating produced by Cortec was substituted.

The design team considered the consolidation of the friable dalle de verre panels a priority and selected the application of the KEIM Fixativ and Ecotec for the panels. Treatment with the migrating corrosion inhibitor was not recommended due to the manufacturer's compatibility concerns associated with using the Fixativ over the MCI-2020 V/O.

Further laboratory testing assessed the effect of the concrete coatings on the glass. Microscopic examination of the glass found that the KEIM products did not damage the dalles but did produce a visible residue. The consolidant and water repellent, when individually applied, resulted in deposits of product that could be removed with water. When applied in combination, a mild abrasive was required to remove the resultant residue. The implemented protection procedure therefore involved carefully wiping each piece of glass immediately after the consolidant application and again after the water-repellent application, before the coatings could dry on the glass. This minimized the reaction of the coatings. Temporary masking material applied to the glass was considered and tested, but it proved impractical for use during construction.

Before applying any coatings, it was necessary to repair through-panel cracks, which ranged from approximately 0.3 to more than 1 mm, to reduce water infiltration. Three injection epoxies were tested but proved undesirable because their viscosities prevented the selection of only one product to fill the full range of crack widths. Furthermore, access to the interior sides of the panels to control potential leaks was not available during the exterior construction phase.

Four grout-injection treatments were also tested but ruled out. Testing included crack injections and surface applications of the following: natural hydraulic lime, cementitious injection grout, dispersed hydrated lime (DHL) putty, and DHL injection mortar (DHL-IM). Surface application to determine whether the grouts could successfully migrate into the open cracks through capillary action proved unsuccessful. The injected grouts did not flow through the cracks to the backs of the panels, suggesting that these injection grouts could eliminate the need to install temporary protection on the interior surfaces of the panels during treatment. However, the repair procedure only worked using the DHL-IM on cracks approximately 1.25 to 3 mm wide. Successfully injecting the narrower cracks required drilling injection portals, which would have increased the visibility of the repairs and required additional patching.

Due to the time constraints associated with the conservation and the large number of repairs required, a single product for all conditions was desired to expedite work. Cracks open more than 3 mm were able to accept a patching mortar and therefore did not need to be injected with epoxy or grout. Routing and filling the thinner cracks using a custom-color patching mortar was considered. Jahn M90 concrete repair mortar, which was specified to repair the concrete framework, and Jahn M70 sandstone repair mortar were evaluated. The Jahn M70 was selected for crack repairs in the panels because it has finer aggregate and a better working consistency for filling narrow cracks.

Cracks thinner than 0.75 mm in the panels were generally not repaired; this category included hairline separations between stable dalles and the concrete matrix. Cracks wider than 0.75 mm in sound exterior panels were routed with custom-made, 22 mm diameter, ⅛ in. (3 mm) thick, diamond-tipped Dremel blades to a minimum depth of ⅜ in. (1 cm) and filled with the patching mortar. This mortar was also employed for patching holes in the panels where conduits were removed.

Although the original panels at the Hall of Science were cast from a prepackaged concrete mix, they exhibit a wide variation in colors. For efficiency, only two colors of patching mortar, a gray and a tan, were selected for the exterior panel repairs. Aggregate was applied to the surface of the patches to further blend them with the adjacent concrete (fig. 11.12).

After all cast-in-place concrete and panel patches had cured, the concrete framework was coated with two appli-

cations of the migrating corrosion inhibitor while the panels were protected. The panels were then consolidated while the adjacent framework was protected. Finally, the water repellent was applied to both the framework and the panels. Every dalle was wiped clean before either the consolidant or water repellent could dry.[15] The authors inspected each step of the patching and coating process for quality assurance. The methods for repairing the concrete materials were applied again during the interior upgrade of the Great Hall.

Panels exhibiting multiple wide cracks, deflection, and/ or damaged or destabilized glass were selected for replacement by the architect. While dalle de verre is still commonly produced with a concrete matrix elsewhere in the world, the current industry standard in the United States is to produce panels with an epoxy matrix. The original manufacturer of the concrete panels, now called Willet Hauser Architectural Glass, produced replacement panels cast with an epoxy matrix. Two colors of epoxy were selected and a mix of silica and mason sand was broadcast onto the surface of the epoxy to simulate the appearance of the original concrete panels. Natural variations in the aggregate resulted in a range of tan and gray replacement panels nearly identical in appearance to the exterior surfaces of the original panels (fig. 11.13).

The original glass was not salvaged and reused in new panels due to the difficulty and expense of removing the dalles intact from the concrete matrix. Unlike the original glass, the new dalles are not faceted. Due to manufacturing limitations, the replacement glass also has a greater light transmission than the original glass. In order to eliminate the aesthetic impact caused by the variation in the glass translucency, original panels were relocated from the exterior freestanding wall and the non-public projection booth to the main exhibit space. The new epoxy panels were installed only at locations not visible from the interior of the Great Hall.

CONCLUSIONS

The selected conservation treatments enabled the preservation of the building's character-defining dalle de verre panels (fig. 11.14). The current trend in the restoration of concrete dalle de verre in the United States involves replacing historical panels with new panels consisting of an epoxy matrix regardless of whether the matrix was originally concrete or epoxy. By implementing alternative conservation treatments at the Hall of Science, approximately 97% of the original handcrafted concrete panels were retained.

The close cooperation between the restoration design team, product manufacturers, and skilled concrete

Fig. 11.12. Patch repair with surface applied aggregate at the bottom center of the panel, 2010. Photo: Building Conservation Associates, Inc.

Fig. 11.13. New replacement panels with an epoxy matrix matching the exterior appearance of the original precast concrete panels, 2009. Photo: Building Conservation Associates, Inc.

contractors, as well as the laboratory and field testing that was performed on the existing building materials and repair products during the design phase, facilitated efficient problem solving during construction. As a result, the restoration of the entire exterior, which included the installation of more than three thousand cast-in-place concrete patches and approximately four thousand panel crack repairs, was completed in just a little more than a year.[16] Subsequent cleaning of the interior of the panels removed decades of soiling from the facets of the dalles, successfully restoring the dramatic visual effect of this extraordinary midcentury World's Fair building.

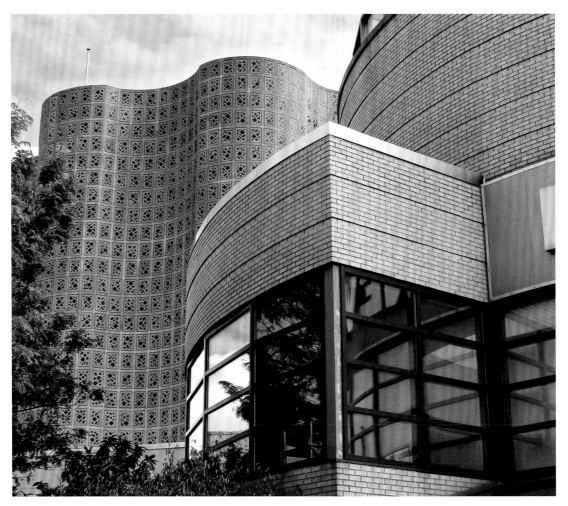

Fig. 11.14. Detail view of the New York Hall of Science. The undulating concrete framework with dalle de verre panels is at left, 2017. Photo: Mark Goldberg / Courtesy of Wikimedia Commons, CC BY-SA 4.0

NOTES

Some content in this article was originally published in *APT Bulletin: The Journal of Preservation Technology* as Raymond M. Pepi, Laura N. Buchner, and Christopher Gembinski, "Conservation of Dalle de Verre at the New York Hall of Science," *APT Bulletin* 45, no. 4 (2014): 3–12; and Laura N. Buchner and Raymond M. Pepi, "Restoration of the Cast-in-Place Concrete at the New York Hall of Science," *APT Bulletin* 46, nos. 2/3 (2015): 54–63.

1. No evidence of an alkali-silica reaction was observed in the panels, nor at the interface of the glass and the concrete.

2. The air contents were estimated at 5 to 6% (by paste) in two samples and 6 to 7% in a third. The water-to-cement ratio was estimated at 0.4 to 0.45.

3. Visual petrographic results were based on New York State Department of Transportation, *Bridge Deck Evaluation Manual* (Code 92-21) (New York State Department of Transportation 1992). Petrographic evaluation was based on ASTM C-856, *Standard Practice for Petrographic Examination of Hardened Concrete* (ASTM International 2004a).

4. Compressive strength was measured for one core during petrographic analysis. The testing was conducted in accordance with the procedures of ASTM C42, *Standard Test Method for Obtaining and Testing Drilled Cores and Sawed Beams of Concrete* (ASTM International 2004b).

5. The interior surfaces of the cast-in-place concrete also exhibit two layers of coating. The coating directly on the concrete is translucent and ocher in color, and it appears to contain plant fibers; where this material was applied thickly, a higher proportion of aggregates was identified. On the surface of the ocher coating is a flaking, discontinuous layer of material; FTIR suggested that this is a styrenated coating (Martin 2010, 1).

6. Tests were performed in accordance with Test Method 11.4 by RILEM (Reunion Internationale des Laboratoires d'Essais et de Recherches sur les Materiaux et les Constructions) Commission 25-PEM.

7. Petrographic and chemical analyses were conducted in accordance with the standard practices contained in ASTM C1324-05 (ASTM International 2005b).

8. In this case, the wet chemical analysis using an acid digestion technique entailed lightly crushing each sample with a mortar and pestle, then digesting the sample in an excess 3 molar hydrochloric acid solution. Acid insoluble residue obtained by filtration and washing with distilled water was then dried to a constant weight in an oven. The sands were passed through sieves to determine the relative proportions of their granular size. The colors and shapes of the sand granules were then visually characterized using a microscope.

9. The cementitious mortar manufacturer recommended the substituted quantity of aggregate. The manufacturer of the polymer-modified mortar did not approve the specific aggregate quantity that was substituted but stated that additional, coarser aggregate could be incorporated.

10. Patching procedures required variations from the standard method of installing Jahn patching material and were developed in cooperation with Cathedral Stone Products.

11. AMT Laboratories performs Phillips microabrasion testing based on ASTM C418, *Standard Test Method for Abrasion Resistance of Concrete by Sandblasting* (ASTM International 2005a). "Laboratory Testing," AMT Laboratories, accessed February 20, 2010, http://www.amt-labs.com/services_testing_special.aspx.

12. Field testing was initially scheduled to last one year beginning in November 2006, but it was extended to two years because of a construction delay.

13. Laura Buchner in phone conversation with Ralph Bowman, representative of Rohrback Cosasco Systems, March 27, 2009.

14. The capillary-uptake tests were a modification of ASTM C67-07a, Section 10: Initial Rate of Absorption (Suction) (Laboratory Test) (ASTM International 2007).

15. At isolated locations these coatings were not sufficiently wiped, and they reacted to form a white residue on the glass, which was gently removed with 3M Scotch Brite Pads, type Light Duty White. This process was found to remove the material without visibly scratching the glass.

16. Laura Buchner in conversation with Denio Sturzeneker, foreman for Structural Preservation Systems, October 30, 2009.

WORKS CITED

AMT Laboratories. 2006. "New York Hall of Science, Queens, NY, Laboratory Report, Project No. 0604-04." May 2006. Unpublished report.

———. 2007. "New York Hall of Science, Queens, NY, Laboratory Report, Project No. 0701-08." April 2007. Unpublished report.

ASTM International. 2004a. *Standard Practice for Petrographic Examination of Hardened Concrete*. ASTM C-856. West Conshohocken, PA: ASTM International.

———. 2004b. *Standard Test Method for Obtaining and Testing Drilled Cores and Sawed Beams of Concrete*. ASTM C42. West Conshohocken, PA: ASTM International.

———. 2005a. *Standard Test Method for Abrasion Resistance of Concrete by Sandblasting*. ASTM C418-05. West Conshohocken, PA: ASTM International.

———. 2005b. *Standard Test Method for Examination and Analysis of Hardened Masonry Mortar*. ASTM C1324-05. West Conshohocken, PA: ASTM International.

———. 2007. *Standard Test Methods for Sampling and Testing Brick and Structural Clay Tile*. ASTM C67-07a. West Conshohocken, PA: ASTM International.

Cathedral Stone Products. 2014. "Mineral Based Mortars: Jahn M90." Accessed June 20, 2017. http://www.cathedralstone.com/public/system/DepartmentDatasheet/1010.pdf.

Cortec Corporation. 2005. "MCI Surface Applied Corrosion Protection Systems for Reinforced Concrete." July 2005.

Hageman, Jack M., Brian E. P. Beeston, and Ken Hageman. 2008. *Contractor's Guide to the Building Code*, 6th ed. Carlsbad, CA: Craftsman Book.

Harrison and Abramovitz. 1963a. "Grid Wall Details, New York City Museum of Science and Technology." September 4, 1963, Sheet No. S18 Supplement. In the collections of the New York Hall of Science.

———. 1963b. "Grid Walls Sections and Details, New York City Museum of Science and Technology." September 4, Sheet No. S19. In the collections of the New York Hall of Science.

———. 1963c. "Wall Plan and Elevations, New York City Museum of Science and Technology." September 4, Sheet No. S17 Supplement. In the collections of the New York Hall of Science.

Martin, James. 2009. "Project 1570/80 Report." Orion Analytical LLC. Williamstown, MA. October 30, 2009. Unpublished report.

———. 2010. "Project 1589 Report." Orion Analytical LLC. Williamstown, MA. January 8, 2010. Unpublished report.

Materials Technologies (Cole Consulting). 2005. "Petrographic Evaluations of Concrete Cores for Building Conservation Associates, Inc., New York, New York (New York Hall of Science, Queens, New York)." September 9, 2005. Unpublished report.

Millard, Richard. 1992. "A Personal View." In chapter 10, "Dalle de Verre." In *SGAA Reference and Technical Manual*: *A Comprehensive Guide to Stained Glass*, edited by Dorothy L. Maddy, Barbara E. Krueger, and Richard L. Hoover, 2nd ed., 227–31. Lee's Summit, MO: The Association.

"A Modern Museum for the Space Age." 1965. *Stained Glass*, Spring 1965, 12.

"The Museum of Science and Technology." 1964. *Corson Flashes!*, August 3, 1964, n.p.

New York State Department of Transportation. 1992. *Bridge Deck Evaluation Manual*. Albany: New York State Department of Transportation. Accessed February 21, 2018. https://www.dot.ny.gov/divisions/engineering/structures/repository/manuals/br_deck_manual/bridge_deck_eval_manual_1992.pdf.

"Old Craft Encloses New Museum." 1964. *Engineering News-Record*, September 10, 1964, 45.

Pepi, Raymond, Chris Gembinski, and Laura Buchner. 2014. "Conservation of Dalle-de-Verre Panels at the New York Hall of Science." In *Meet Me at the Fair: A World's Fair Reader*, edited by Laura Hollengreen, Celia Pearce, Rebecca Rouse, and Bobby Schweizer, 271–77. Pittsburgh: ETC.

Rohrback Cosasco Systems. 1999. "Chapter 2: Specifications." AquaMate User Manual, P/N 710700-Manual Rev C 10-13-99. Accessed June 20, 2017. http://www.cosasco.com/pdfs/AquaMate_LPR_Corrosion_Instrument_Manual.pdf.

Walsh, John J. 2009. "Precast Panel Analysis Report." Highbridge Materials Consulting, November 13, 2009. Unpublished report.

11

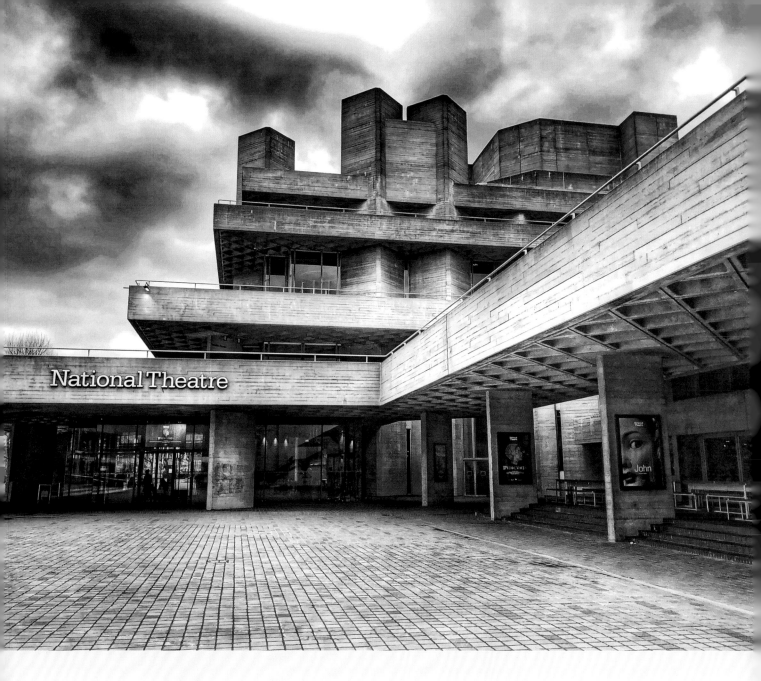

12

Patrick Dillon and Stephen Douglas

National Theatre

London | 1976

ARCHITECT/DESIGNER

Denys Lasdun, architect | Flint and Neill, structural engineer

PROJECT DATES

2011–15

PROJECT TEAM

Haworth Tompkins Architects | Catherine Croft, adviser, Twentieth Century Society | David Farrell, concrete specialist, English Heritage (now Historic England) | Doug Black, local planning authority's conservation officer | Flint and Neill, structural engineer

CLIENT/BUILDING OWNER

National Theatre

INTRODUCTION

A heroic concrete megastructure, and the masterpiece of the architect Denys Lasdun (1914–2001), Britain's National Theatre opened on the banks of the river Thames in 1976 (fig. 12.1). The project had been long in gestation. The first detailed proposal for a national theater had been drawn up in 1904. At one point a foundation stone was laid on the South Bank, only to be dug up again. After a catalog of false starts, Lasdun was eventually appointed architect on November 22, 1963.

Lasdun was young but not inexperienced. His headquarters for the Royal College of Physicians (1964) signaled a precocious mastery of space, and combined uncompromising modernity with sensitivity to the ethos and traditions of a long-established institution. Lasdun had worked for Tecton, the practice established by Berthold Lubetkin, which was among the first to introduce modernism to Britain. He was clearly willing, even eager, to break new ground. His designs for the University of East Anglia, then on the drawing board, ignored precedent and reinvented the university campus from first principles, with shelves of concrete housing zigzagging across the natural landscape.

In 1963, the blighted estates and gutted town centers that would dent modernism's popularity lay in the future. It was still seen as fresh and exciting, embodying the new, more equal, technologically driven world that would appear from the rubble of World War II. Lasdun's designs, which emerged gradually through the 1960s, envisaged a democratic theater building that would welcome audiences not only through a giant portico but also via terraces shelved above the river, engaging seamlessly with the surrounding city. The National Theatre would be less a building than a piece of urban landscape.

Lasdun was not dogmatic in the choice of concrete for his designs (his Royal College of Physicians, for example, was faced in expensive porcelain tiles), but he was fascinated by it. Visiting Le Corbusier's exposed-concrete Pavillon Suisse in Paris as a student, he described "a muddy mix of marl, clay, lime, sand, gravel, water, heavily laced with steel" and "began to get very excited" (Lasdun 1965, 271). But where Le Corbusier embraced béton brut for its directness and tactile qualities, brutalists in Britain indulged its shock value. Lasdun's use of raw concrete was, however, subtly different. He saw its possibility for finesse. The concrete at the National Theatre would not be cast with intentional crudeness against rough-sawn timber forms. Its ingredients—Leighton Buzzard sand, Newmarket shingle, and a 40:60 mix of ordinary and white cement—would be carefully controlled. Formwork would be designed with precision, and the forms of unplaned Douglas fir would be used only twice, to ensure that the board marking remained crisply legible in the concrete's surface. In situ concrete is not a forgiving material. Parts of the structure would repeatedly be poured and demolished to ensure quality, contributing in part to the building's painful sequence of delays.

Concrete may carry associations of the machine age, but in Lasdun's hands it was a crafted material. The resulting building was not a reproducible system but a one-off work of art. The board-marked concrete embodied the complexity and paradox of the whole commission. In the vision of its founding fathers, the National Theatre was democratic but still required the dignity of a great institution. It had to host both the lofty canon of historic theater and the work of angry young radicals. Board-marked concrete was simultaneously industrial and luxurious. It became the emblematic material of Britain's National Theatre.

THE PROJECT

By the time the National Theatre opened in 1976, concrete modernism no longer seeemed heroic. Within a year, the Pompidou Centre in Paris would drag design into a pop art world of bright colors and flexible space beside which Lasdun's concrete looked drab, and his intricate axes and symmetries ponderous. Critical reaction was muted, while public reaction became poisonous, not helped by the Prince

Fig. 12.1. The National Theatre in London as it appeared in January 2018. Photo: Jamie Gladden / Stockimo / Alamy Stock Photo

12

of Wales, who likened Lasdun's masterpiece to a nuclear power station.[1] By 1976, concrete was associated in the public mind with blighted housing projects and disasters like Ronan Point, the collapse of a system-built concrete tower block in the East End of London. Lasdun's National Theatre had nothing in common with these designs, but prominently situated as it is on the bank of the Thames and built with public money, it became the public face of concrete and suffered accordingly.

The first changes to the building were made in the 1990s. Lasdun was still alive and thought them insensitive, but with the building's reputation at its lowest ebb, he was unsuccessful in opposing them. By 2007, however, the climate was becoming more positive and plans began for a major refurbishment. The specific locational context was changing, in that the 1960s vision of regenerating the South Bank through culture was belatedly coming to fruition. The river was clean, a river walk had been completed, and the neighboring Southbank Centre had carried out a successful refurbishment. Meanwhile the 1970s backlash against modernism and concrete had subsided. Mid-century buildings were being reappraised. It was possible to see the National Theatre not for what it superficially appeared to be, a 1970s concrete megastructure, but for what it actually was: an intricately subtle abstract design that fused elements of neoclassicism, modernism, and the Beaux-Arts into a brilliant concrete Gesamtkunstwerk.

The NT Future project launched in 2010. Its aims were varied and complex, and would eventually include remodeling the entrance, regenerating the landscape, constructing new workshop space, and overhauling the foyers. Rather than commence the project with design proposals, in 2007 the National Theatre commissioned Haworth Tompkins Architects to prepare a conservation management plan. The aim was to understand the building before trying to change it. Based on precedents such as James Semple Kerr's conservation plan for the Sydney Opera House (Kerr 2003), the *Conservation Management Plan for the National Theatre* (Haworth Tompkins 2008) was developed in collaboration with the Twentieth Century Society, English Heritage (now Historic England), and the conservation officer from the local planning authority. The plan tracked the theater's genesis, analyzed its design, and assessed its significance. The process was invaluable, bringing together professionals from design disciplines and heritage bodies, forging relationships and enabling shared understandings of a complex building. Among the many conclusions reached was consensus that perception of the building depended on distancing it from the many stained, battered, and degraded structures that the public associated with

exposed concrete. NT Future had to be underpinned by stewardship of the fabric. From the outset, therefore, one of its prime goals was to rescue and safeguard the theater's prime material: concrete.

In the 1990s, a program of works was undertaken in which proprietary repair materials were used to carry out repairs to the concrete. These tended to be epoxy/polymer based and used in small quantities to undertake cosmetic repairs. These were found to have performed in an unsatisfactory manner, and some had failed. Some experienced shrinkage and allowed a buildup of moisture around the repair that accelerated deterioration; others became discolored and very prominent, even white, as they aged (figs. 12.2, 12.3). A small number provided a satisfactory repair in that they sealed the defect, but without a pleasing aesthetic.

The 1990s project also involved substantial refurbishment of the main foyers, removing Lasdun's stainless steel signage and filling in resulting holes in the concrete. The results were not completely successful from a conservation standpoint. A mix of coarse sand and ordinary portland cement (OPC) was used. The color of the resulting concrete repair mix differed from the existing board-marked concrete and attempts to mimic the grain of the adjacent board marking were crude. It was an early warning of the challenge reinforced mass concrete represents for conservationists.

Before NT Future was fully under way, the theater's engineering department sought advice from the concrete industry, whose experts recommended use of specialist repair mortars to fill cracks and holes, and proposed that the entire National Theatre be coated with a protective chemical film against dirt and graffiti. It was common at the time to directly approach companies that supply proprietary repair products, rather than independent professionals, but the specific repair suggestions caused alarm among the professionals, conservation bodies, and theater staff gathering to work on NT Future. The worry was threefold. First, one might test such procedures on out-of-the-way parts of the buildings, but there would be no way of trialing how they would perform, weather, and affect the surrounding fabric over time. Second, the National Theatre is Britain's most prominent and important concrete building. It seemed risky and inappropriate to experiment with new repair and conservation techniques on such an important structure. And third, although the conservation of mid-century concrete buildings is a new challenge, the record of new conservation technologies applied to old buildings has not been good. Well-meaning interventions have very often

backfired, including the application of chemical coatings to historic stone facades.

These concerns inclined the NT Future team to caution. While there was only a limited case history of conservation work on twentieth-century concrete, the team agreed it was important to utilize the general principles of conservation best practices. These include the use of like-for-like materials and techniques, and a conservative approach to intervention. Sharing these concerns and experiences had the beneficial effect of uniting the team, driving them to share knowledge, consider principles, and arrive at a common understanding of the challenge.

Of the design team, Haworth Tompkins Architects was appointed to write the Conservation Management Plan for the building, and was subsequently retained to design and execute the master plan. Meanwhile, Flint and Neill, the structural engineer for the original building, continued to work on it, sharing a profound knowledge of the structure. The early analysis and design process forged strong links with conservation and statutory bodies. Catherine Croft, director of the Twentieth Century Society, was pioneering the study of concrete conservation and disseminating knowledge through lecture courses. English Heritage was also involved, and through Croft the team was introduced to concrete specialist David Farrell, who had worked with English Heritage on their then unpublished guidance on concrete conservation. Doug Black, the local planning authority's conservation officer, was another valuable player, with knowledge of twentieth-century architecture and sensitivity toward the building. Most important of all was the support and expertise of the client, as demonstrated by the participation of members of the theater's building maintenance team in the West Dean College course on concrete conservation run by Croft.

INVESTIGATIONS: BACKGROUND RESEARCH, ANALYSIS, DIAGNOSTIC WORK, TESTING, AND TRIALS

Prior to the commencement of this project, a number of detailed condition surveys were undertaken by materials, structural, and architectural specialists to assess the current condition of the structure and highlight those areas that needed addressing for repair and also those areas of architectural significance needing attention. Inspection by Flint and Neill, the structural engineer, confirmed, perhaps suprisingly, that there were no significant signs of structural failure, but that the structure was on the cusp of deteriorating, so intervention at this stage was important. The theater is a complex building that appears robust but in fact requires a sensitive approach. Rather than being piled,

Fig. 12.2. Repair of 1990s using epoxy-based material that has deteriorated, 2013.

Fig. 12.3. Recent repair of the 1990s epoxy-based repair using a cement mix, 2016.

12

Flint and Neill had designed it on a floating raft. Extensive cantilevers were achieved through post-tensioning strands anchored deep within the structure. The building had been engineered from first principles with great skill, and constructed with the expertise of a British concrete industry that was then at its height. Cracking around some of the cantilevers was identified. It was thought most likely to date from construction, but is being monitored on an ongoing basis. There was further cracking where the poured-concrete main building adjoined the steel-frame structure of the workshops. In general, though, the concrete structure was sound and the widespread signs of damage and degradation were superficial.

The surveys identified some areas of damage to be addressed, but the main categories of damage requiring attention were identified as follows:

- Unsatisfactory former repairs. Typically these were holes that had been crudely filled.
- Repairing concrete following removal of existing fittings. Fittings scheduled for removal included redundant services fittings and the 1990s signage, which would be replaced with new installations based on the original design.
- Impact damage. Although limited in scope, there were places where the board-marked concrete finish had been damaged, for example by trolleys or vehicles.
- Efflorescence. Salts had washed out through cracks. Around external balconies, water had gathered below downstand beams and the original drip detail had proved inadequate to remove water buildup. Consequently, stalactites of calcium carbonate had appeared.
- Cracking. Numerous hairline cracks were discovered, the majority of which were less than 1 mm wide. Unsightly long cracks were present in the sheer walls of the fly towers and at junctions between different structural elements.
- Spalling. Although the theater's concrete was well specified and constructed, with a generally good depth of cover to reinforcement, in some areas where the depth of cover was low, the surface had spalled, revealing reinforcement bars beneath.
- Iron pyrites. The plain concrete external walls were badly disfigured by rust stains. These were traced not to corroding reinforcement but to the presence of ferrous material in the original aggregate.
- Holes. There were numerous holes on the concrete, many remaining unfilled after the removal of redundant fixtures.

- Staining. Foyer interiors were badly grease stained from human contact around doorways, on concrete stair balustrades, and at hip height in public areas.
- Applied surface treatments. This was a catchall for traces of adhesive where redundant fixtures had been removed. This included graffiti.
- Defective expansion joints. The building's movement joints were designed simply as wide gaps filled with gray mastic. Over time, many of these had cracked and withered, leaving gaps open to rain penetration.

This list demonstrates that the work required fell into two categories: repairs and cleaning. The repairs could be further subdivided into filling holes, filling cracks, and making good larger areas of damage. The technical research process that informed the specifications for each of these repair types is described below.

Before developing repair methods, the team first reviewed whether any action should be taken to prevent recurrence of damage or staining in the future. A visual assessment and some limited destructive testing, including chloride, carbonation, and depth of cover testing, was done in discrete areas. Two possibilities to arrest damage and staining were discussed. The first was modifying drip details to prevent recurrence of stalactite buildup. The balconies and terraces had downstand beams with smooth soffits and no drip detail. Most soffits and upstands showed signs of staining. This was particularly severe on concrete external stairs, where rain tracked down the downstands, resulting in stalactite formations. The team reviewed whether it might be feasible to cut a chase in the downstands in these areas to act as a drip, but the notion was soon abandoned. It would have been extremely hard to achieve the detail neatly, and risked changing the appearance of the building. It was decided that there was no realistic alternative to retaining the existing detail, with a consequent need for ongoing cleaning incorporated into the building's maintenance plan.

The second possibility involved applying surface coatings to the concrete to prevent future staining. No coatings were applied as part of the NT Future refurbishment. The team took a conservative approach rather than risk irreversible changes to the concrete. However, London's South Bank is an area of aggressive graffiti attack. Graffiti technology is becoming ever more sophisticated, resulting in tags that are almost impossible to remove and therefore have irreversible impacts on the concrete. Thus, the debate about localized application of protective coatings as a preventive measure is likely to continue.

A further discussion concerned the desirable extent of cleaning and repair. The National Theatre's architect had himself envisaged the building patinating over time: "It will weather and become as though it's an extension of the riverbanks" (Lasdun and Hall 1976, n.p.). A coherent argument could be made that dirt and rust stains were part of this intended patina, and that it would be wrong to return the National Theatre to a state of artificial youth. However, the team was aware that stained concrete carried a negative association that was a barrier to public appreciation of the building. In fact, in later life Lasdun himself advocated cleaning (Denys Lasdun, Peter Softley and Associates 1989). It was also recognized that the building's architecture of clean lines benefited from clarity and crispness of surface. Eventually, a middle course was steered whereby the team accepted that the building could gracefully accommodate some dirt and staining, but that rust stains, graffiti, and unsightly areas of built-up soiling detracted from its architectural significance and should be removed.

What remained to be determined was the practicality of achieving such a result. The National Theatre is a vast structure. Much of it is inaccessible. The NT Future budget included a generous allowance for repair, but almost limitless sums could have been spent filling hairline cracks or expunging stains in invisible parts of the building. Although the team now had a good grasp of the nature of the conservation challenge, there remained little understanding of its scope or potential cost. The next step was therefore to undertake a full survey of the building. This would give the client a baseline for ongoing stewardship, and provide the team with data to scope the repair program. A template was agreed upon, based around the different types of repair noted above. To this was added a simple prioritization matrix assessing the severity of damage from two viewpoints: One, would the defect, damage, or soiling lead to further deterioration of the fabric? And two, what was the impact of defect, damage, or soiling on the significance of the building?

For each instance of damage, each question was assigned a rating of high, medium, or low. For example, a crack on an inaccessible part of an elevator equipment room might be invisible to the public and therefore have a low rating for its impact on significance; however, if left unattended, it might lead to future deterioration through water ingress and would therefore carry a high rating for deterioration. The scoring for an area of graffiti on the ground-level riverfront would be the opposite, with low risk for ongoing deterioration but a high impact on the aesthetic significance of the building. Using this assessment system, the team rated all repairs across the building in order of priority:

1). damage likely to have a high risk of ongoing deterioration of fabric
2). damage having a high impact on the significance of the building
3). damage with a medium risk of ongoing deterioration
4). damage with a medium impact on significance
5). damage with low impact for both deterioration and perception

This survey and priority matrix became a critical tool in managing the conservation process and eventually became the pricing matrix. When the works were tendered, contractors were provided with typical specifications for each repair type, and could put an indicative price against each repair. It was then relatively easy to see how far down the priority list the conservation budget would stretch.

However, further research was needed to arrive at optimum repair techniques for each of the identified types of damage. This work was tendered as part of the first phase of NT Future construction work. Three specialist conservation contractors were invited to tender. The architect provided information on the different types of repair and indicative specifications for each. The contractors provided cost estimates for undertaking the identified repair types. The successful contractor, PAYE Conservation, was asked to develop sample repairs for each type on damaged, out-of-the-way parts of the structure. These were reviewed and commented upon by the entire team. Through an iterative process of experimentation and comment, the contractor arrived at typical repair types for each situation. The deliverable requested for this phase of the contract was a full repair specification for the works.

Broadly speaking, this process worked as envisaged. PAYE proved knowledgeable, helpful, and proactive in researching repair types. They were awarded the subsequent contracts and carried out all the concrete conservation work, which proved beneficial because it brought a consistent, competent approach. Concrete repair knowledge and skills are not yet widespread in the industry. It was important that operatives who had developed skills through the research process could go on to carry out the eventual work, using those skills.

The lack of established concrete conservation skills had led the National Theatre to approach the Heritage Lottery Fund with a request to fund training of two apprentices as part of the conservation program. This initiative was embraced by PAYE and training continued throughout the

12

project. Meanwhile, the research process outlined below enabled the team to develop and agree upon standard repairs for all of the concrete damage.

CONSERVATION

Reinforced concrete structures can deteriorate in a number of ways, and it is therefore essential to investigate a particular structure thoroughly to establish the causes of any evident deterioration. Once the causes are identified, an appropriate approach can be developed. It is also important to identify a hierarchy of repairs, prioritizing the most important to ensure that works are undertaken in the correct sequence to reduce the likelihood of further damage or failure of repairs. It is also important to clearly identify the purpose and expected outcome of the repairs, as this will allow their efficacy to be monitored.

Crack Repairs

Concrete normally exhibits surface cracks due to the expansions and contractions that occur during the hydration and curing processes. Cracks of more than 3 mm were considered to be caused by structural movement, and cracks less than that to be normal shrinkage (fig. 12.4). Cracks can allow moisture and other contaminants to enter the concrete, so sealing them is important. A number of trials were undertaken to investigate the best way to apply repair material to cracks, particularly on vertical faces. Injection of repair mortar using syringes was tried; however, the material clogged the injection point and increasing the moisture content proved detrimental to the mortar. The injection point had to be large enough for the repair material to flow, but small enough to allow the flow rate to be controlled; on this project no successful size was found.

Enlarging cracks to allow material to be applied by hand in sufficient volume and to be finished evenly was found to be effective, unless the crack was in a prominent location. To enlarge cracks, handheld grinders were used to ensure that fracturing of the surrounding material was kept to a minimum, and to ensure that as little as possible of the original material was removed. The fly towers could not be treated this way, as the cracks were highly visible, with some running the full height of the tower; the cracks were also not straight and could be accessed only by rope. In this location, a hand-applied mortar was used with the operative rappelling down the fly tower. On the southern faces of the building, obtaining the correct water-to-cement ratio was difficult, as the normal wetting of the crack was insufficient due to the heat absorption on that side of the

Fig. 12.4. Typical crack, 2013.

structure. Crack repair in other locations was more straightforward, as the material could be hand applied to an adequately prepared and prewetted crack.

There is considerable variation in color and shading of the concrete around the structure, depending mainly on the orientation and exposure. This required that time and care be taken to develop a palette of mixes to provide suitable matches for all the areas to be repaired. The quarry that supplied the aggregate used in the building's contruction was still operating, and the original aggregates were available. By blending ordinary portland cement and white cement, different shades could be achieved. Sieving the fine aggregates and using different grades of the aggregate supplied variations in shade. The finer the sieve, the lighter the resulting color. A palette of twenty different mixes was developed to aid in selecting the correct shade for each work area across the building. It was important that the

Fig. 12.5. Redundant penetration, 2014.

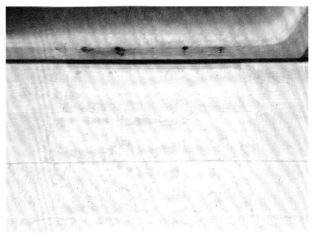

Fig. 12.6. Repaired redundant penetration, 2015.

selected shade match the existing concrete, so decisions on where cleaning was to be undertaken had to be made prior to repair works commencing. This repair material used fine aggregate only, which allowed it to be applied to cracks and shallow areas; therefore these mixes were unsuitable for deep or structural repairs.

Assessing the performance of the crack repairs after twelve months, it was found that the finer cracks did not take the repair material well, probably because the fine aggregate was too large to bond with the surrounding concrete. A higher than usual amount of water was used to place the material in the cracks, and this was also assumed to be a factor. Early loss of the top layer of cement paste has occurred in more exposed areas, revealing more of the dominant aggregate color, which makes the repair more evident. Further investigation will be needed to assess the performance of the repairs in order to inform future works.

It has also become apparent that where crack repairs were undertaken, the adjacent areas have become lighter in color, probably where surplus cement paste spread and prewetting the crack mobilized underlying grime. This was not apparent immediately upon completion of the repairs, but has become more obvious with time and in certain lighting conditions.

Repairing Larger Areas of Damage

As mentioned previously, there were no structural issues to address, but a number of areas of impact damage and spalling were identified in the surveys. Fortunately these were limited in size and not widespread. Where the concrete had been damaged and the reinforcement was exposed, the reinforcement was cleaned and primed prior to building up the repair in layers, with the top 20 mm of the repair being made in a color-matched mix to ensure that it blended with the surrounding sound concrete. It should be noted that if the repair was large enough to retain a standard concrete mix, then the original mix with the large aggregate was used. Smaller repairs used fine aggregate and cement. Timber forms were used to ensure that a match was achieved with the surrounding area.

New Concrete Work

The NT Future works included some areas of new construction and reconfiguration of existing areas. This resulted in removal of sections of concrete, repositioning of services, and various other alterations. Where service ducts became redundant, these were filled and finished to match the surrounding area (figs. 12.5, 12.6). Using the original mix,

Fig. 12.7. Spalling, joint, and pyrite (rust) staining, 2013.

Fig. 12.8. Repairs to spalling, joint, and pyrite staining, 2016.

new concrete was cast against timber forms in an attempt to replicate the original finish. Where new concrete walls were constructed, the original formwork method was replicated. Douglas fir boards were wire brushed to highlight the grain prior to the construction of the formwork and placing of the concrete. It was important to ensure that any new works were sympathetic to the existing structure, but also recognizable as new additions. This was achived by saw cutting the new openings so these new areas now have an almost polished concrete finish. This saw-cut face needed little finishing and forms an attractive part of some of the newly refurbished areas.

Pyrite Staining

Large pyrite (rust) stains were present on some faces and levels of the building (fig. 12.7). Detailed surveys undertaken prior to the works identified these as ferrite-containing aggregate in the original mix rather than corrosion of the reinforcement, which had initially been suspected. While these were not detrimental to the structure, the staining

detracted from the solid architectural presence of the building, so for aesthetic reasons it was agreed that these were to be addressed. Trials undertaken in discrete areas found that a 20 mm diameter core to a depth of approximately 50 mm would remove the offending piece of aggregate. The core was taken at the highest point of the stain, as that was where the ferrous aggregate was usually found. The rust staining below the core was removed using hand tools and a dilute nitric acid (30%) solution while ensuring that the surrounding areas were properly protected. In some cases, particularly where rope access was used, the staining was removed using only tungsten-tipped hand tools to scrape the rust off the surface of the concrete, taking great care not to damage the board-marked finish. The cored hole was made good using the mortars previously described, with the repair built up in layers before being finished by hand to replicate the adjacent grain. These repairs have performed well over the first twelve months, with the areas of rust removal starting to weather to match the surrounding concrete. The areas that were particularly prominent on the fly towers are now barely visible, and

Fig. 12.9. Marks left on concrete following graffiti removal, 2012.

the repair to the cored holes seems to have survived the weathering process better than some of the crack repairs (fig. 12.8).

The earlier, poorly performing repairs were cut out and any fractured or deteriorated concrete removed before being repaired using the relevant mix of mortar. Fortunately the majority of these areas were no more than 50 mm in diameter, and thus were repaired in a similar manner to the core holes that removed the ferrous aggregates.

Cleaning

When the National Theatre was designed, Lasdun had anticipated the weathering and discoloration of the concrete, and this formed part of his vision for the future appearance of the structure, so cleaning had to be carefully considered. The priorities, externally, were:

- removing biological material in areas where damp had encouraged growth
- removing excessive environmental staining and graffiti
- removing scale deposits

Due to the north-south orientation of the building, the north facade retains moisture longer, colonizing algal and fungal growth, particularly on the inner faces of the parapet walls. Specialized steam cleaning equipment (DOFF and TORIC) was used to gently remove this buildup without affecting the underlying concrete finish. This same equipment was also used to remove some of the environmental staining that had occurred on external facades.

The anchor stairs had been subject to a number of graffiti attacks over many years, and while the graffiti had been removed, the impact on the underlying board-marked concrete had not been considered (fig. 12.9). This resulted in an uninviting area that had fallen out of general use. This area was cleaned using the specialist steam cleaning equipment, successfully restoring a consistent finish to this area. Unfortunately, some of the fine detail to the

12

Fig. 12.10. Results of thorough cleaning of concrete stairway, 2016.

board-marked concrete has been lost as a result of earlier overzealous graffiti removal. The stairs are now more inviting and are being used to access the theater and its restaurants (fig. 12.10). Other graffiti-prone but less prominent areas were used to trial additional removal methods. Where graffiti had been in place for some time, it was very difficult to successfully remove. Graffiti attack is now dealt with immediately by the building maintenance team, before the paint fully penetrates the concrete. Specialist graffiti removal teams may not be experienced in treating historic buildings with sensitive surfaces; therefore, the development of in-house teams with knowledge and experience in removing graffiti and sympathetically cleaning concrete surfaces are an important component of the ongoing maintenance strategy.

As the front-of-house areas were mainly carpeted, the use of wet cleaning systems was problematic, so poultices

were used. The soiling consisted of residue from removal of fixtures and fittings, human staining, spills, and malicious marks, such as pen marks, graffiti, and chewing gum. The poultices were applied to the affected area in accordance with the manufacturer's instructions, then covered and protected. The protection allowed the poultice to cure and also protected theater users from the material. The level of soiling governed the duration of application. Trials were undertaken to determine the necessary dwell times. The longer the applied poultice was left, the whiter the cleaned surface became, so a balance between making the cleaned area blend with the surrounding and removing the detritus was needed; dwell times were adjusted depending on the condition of the surrounding areas as well as the type of staining. As the project progressed, more experience was gained. This allowed a more accurate assessment to be made prior to application so the treatment could be applied

in a way that caused as little disruption to users as possible. Once the poultice had been in place for the requisite time, the protection was removed and the material peeled off before the area was rinsed with clean water to remove residual chemicals. Dye-free pads were used to avoid staining the concrete.

A dry-ice cleaning system was proposed for the carpeted areas to manage concerns about wetting the carpets. This was trialed in a rear-of-house area, but was found to remove the fine laitances of the smooth-finished concrete; therefore, this system was not tried on the board-marked concrete due to concerns about removing the textured board-marked finish.

Treated areas were inspected closely to ensure that correct levels of cleaning were achieved. It was important to blend the cleaned areas with their surroundings, as none of the internal cleaned areas were returned to the original shade. This ensured that repairs were not prominent and that they matched the existing variation in shade while retaining an acceptable patina. It was found that the limits of the cleaning needed to be extended in some places to ensure that the cleaned area was not too prominent. For example, where possible the cleaning was extended to the end of a board. As previously mentioned, using coatings to protect the surfaces was suggested early in the project but generally rejected as unsuitable.

Dealing with Water Damage

When considering the conservation of a concrete structure, the influence of environmental factors needs to be considered. At the National Theatre, significant water and calcium carbonate staining and buildup was identified. The causes and sources of this were investigated and remedied to ensure that the integrity of the structure and repairs was maintained. There was a significant quantity of scale buildup in various parts of the building where moisture was passing out of the structure at different levels. The movement of moisture through the structure was predominantly due to time-expired or damaged waterproofing and failed or failing mastic joints. This had been identified in the specialist surveys commissioned prior to the works commencing, although the extent of the problem was greater than initially thought. Repairing and replacing waterproofing was already part of an ongoing maintenance program. Thermographic and ground-penetrating radar surveys were used to track the areas showing the greatest concentration of moisture, which assisted in identifying the source of the water. Relevant works were then developed by the in-house maintenance team to address this issue early in the project,

providing time for the structure to dry out in advance of the conservation works. Replacing the waterproofing systems to a building can be very disruptive. Considering this a continous and ongoing process is of vital importance to ensure the longevity of the building.

The completed works (fig. 12.11) will be monitored and the building will undergo regular surveys to assess the long-term performance and efficacy of the repairs, which will allow the overall condition of the structure to be monitored. This will alert the building managers to the need for early intervention, should further deterioration develop elsewhere in the structure. The project has also encouraged the embedding of the conservation management plan into maintenance strategies, ensuring the long-term future for this heroic structure commensurate with its heritage significance.

CONCLUSIONS

In many respects, the National Theatre offered a straightforward conservation challenge. The original concrete was well specified and well constructed. It did not contain high-alumina cement, it had no major issues of reinforcement corrosion, and there was no evidence of structural failure. However, it is a building of the highest design quality, one of the masterpieces of midcentury modernism. Its use and location give it the highest profile, and its board-marked finish is exceptionally difficult to repair invisibly. This conservation work therefore provides a case study in concrete's sensitivity. It could be argued that it is easier to conserve a medieval stone cathedral than an in situ concrete building with a specialist finish. Stone is modular, and modules can, as a last resort, be replaced. In situ concrete must be repaired as it was built, in situ.

Many lessons were learned over the course of this project, but four stand out. One, be cautious. Repairs carried out in situ are difficult to reverse and have a visual impact. As with constructing poured concrete, you have one only opportunity to get it right, and mistakes can leave permanent damage. Before starting, it is essential to gather expertise and to spend time understanding the aims and purposes of the work. Two, work as a team. Conservation of a large and complex building presents not only technical but logistical, management, and construction challenges. It is vital that the project team members work very closely together in an open manner with all members carrying equal weight. Three, be flexible. Conservation projects must start with clear principles, but in practice, conservation is as much art as science. Every patch of concrete will have weathered slightly differently and can present different

12

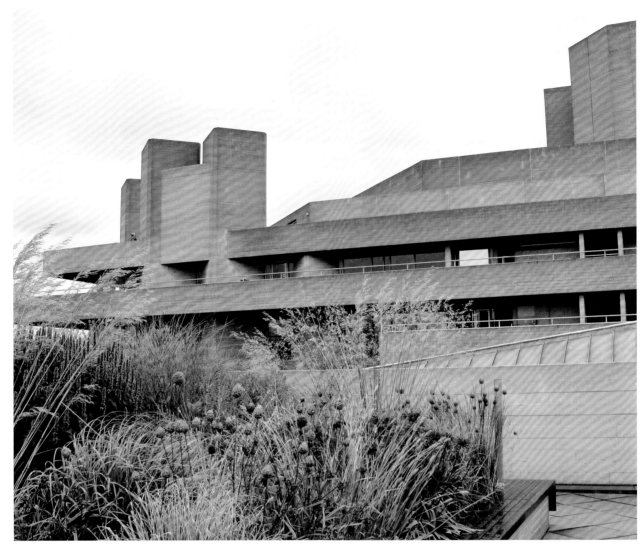

Fig. 12.11. View of the National Theatre following conservation, 2016. Photo: Ana Paula Arato Gonçalves

challenges of access. The team needs to have a strong presence on-site. There is no one method to repair heritage concrete. And four, conservation is an ongoing process. Despite concrete's reputation for toughness, it is innately porous and damageable. The exposed concrete buildings of the mid-twentieth century are sensitive to change. Their maintenance requires constant monitoring, repair, and stewardship.

NOTE

1. This quote is widely cited but has not been attributed to a particular source.

WORKS CITED

Denys Lasdun, Peter Softley and Associates. 1989. "A Strategy for the Future: A Report to the National Theatre Board." In *National Theatre Conservation Management Plan 2008 Final Draft*, appendices by Haworth Tompkins, 258–82. London: Haworth Tompkins.

Haworth Tompkins. 2008. *Conservation Management Plan for the National Theatre*. Final draft (December). London: Haworth Tompkins. Accessed January 27, 2017. https://www.nationaltheatre.org.uk/sites/default/files/nt_conservation_plans_dec_08.pdf.

Kerr, James Semple. 2003. *Sydney Opera House: A Revised Plan for the Conservation of the Sydney Opera House and Its Site*. 3rd (revised) edition. Sydney: Sydney Opera House Trust.

Lasdun, Denys. 1965. "Denys Lasdun: His Approach to Architecture." *Architectural Design* 35 (6): 271–78.

Lasdun, Denys, and Peter Hall. 1976. "Denys Lasdun and Peter Hall Talk about the Building." *National Theatre*. Accessed July 11, 2017. https://archivc.li/aYy1/.

FURTHER READING

Dillon, Patrick. 2015. *Concrete Reality: Denys Lasdun and the National Theatre*. London: National Theatre Publishing.

Douglas, Stephen. 2016. "A Concrete Performance: Conservation at the National Theatre." *Proceedings of the Institution of Civil Engineers: Engineering History and Heritage 2016* 169 (1): 36–41.

Grantham, Michael, ed. 2011. *Concrete Repair: A Practical Guide*. London; New York: Routledge / Taylor and Francis.

Grantham, Michael, Muhammed Basheer, Bryan Magee, and Marios Soutsos. 2014. *Concrete Solutions*. London: CRC and Taylor and Francis.

Odgers, David, ed. 2012. *Practical Building Conservation: Concrete*. London: English Heritage; Farnham, Surrey, and Burlington, VT: Ashgate.

12

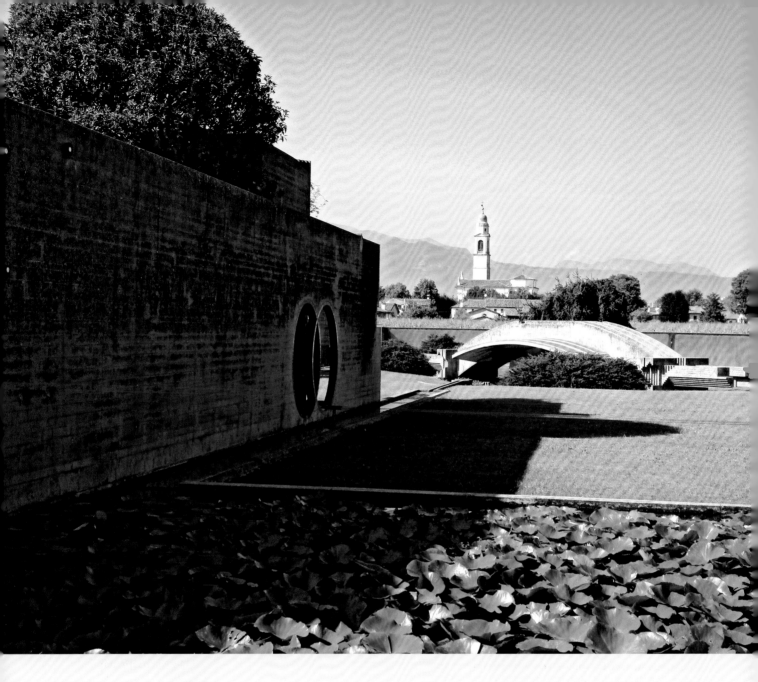

13

Guido Pietropoli, Paolo Faccio, Paola Scaramuzza, and Greta Bruschi

Brion Cemetery

Treviso, Italy │ 1969–78

ARCHITECT/DESIGNER

Carlo Scarpa

PROJECT DATES

November 2015–March 2016: study and analysis of concrete |
March 2017–ongoing: test site

PROJECT TEAM

Guido Pietropoli and Martino Pietropoli, restoration project architects |
Paolo Faccio, engineering architect, Greta Bruschi, architect, and Paola
Scaramuzza, architect, concrete conservation experts | CSG Palladio,
Vicenza, testing laboratory | Cooperativa Edile Artigiana s.c., Parma,
contractor | Leonardo s.r.l., Bologna, contractor

CLIENT/BUILDING OWNER

Ennio Brion

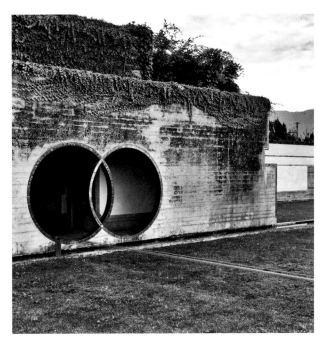

Fig. 13.2. Detail of tomb, Brion Cemetery, 2012. Photo: SEIER+SEIER /
Courtesy of Flickr, CC BY-2.0

INTRODUCTION

Brion Cemetery is a large monumental complex built in
exposed reinforced concrete (fig. 13.1). It is surrounded by
a wall that encloses several structures connected to one
another by paved paths, open porticos, pools, and lawns or
planted areas. The cemetery was designed and built by
Carlo Scarpa (1906–1978) over a ten-year period from 1969
until his death in November 1978. Covering an area of about
2,200 square meters (half an acre), it abuts the eastern and
northern sides of the original nineteenth-century ceme-
tery of San Vito d'Altivole, the town in which the project's
commissioner, Giuseppe Brion, was born and where he
chose to be buried.

The exposed concrete, which has so defined Scarpa's
architecture, in this case is characterized by the imprint
of the spruce formwork in a horizontal-vertical pattern
(fig. 13.2). The texture is intensified by traces of the wooden
formwork left by the removal technique. The concrete
elements are defined by indentations and metal-rimmed
cutouts; the surface is modulated by cement that dripped
from the formwork and was then hammered off. The
reddish, sloped roofing was created with a special propri-
etary mix of concrete and iron oxides (McMaster, originally
made by Mac Spa). Certain modifications in the casting
made it possible to embed black or white marmorino
tiles on a *cocciopesto* (lime-sand mortar with brick or tile
fragments) background.

THE PROJECT

Through his multifarious use of concrete and his study and
experimentation with techniques and surface treatments,
Scarpa sought to maximize the material's technical and
expressive potential, adopting solutions that were often
far from usual or traditional (fig. 13.3). In order to develop
suitable repair strategies, a broad sampling of concrete
structures and elements needed to be carefully examined,
in terms of both their casting and their surface treatments,
also taking into account the different degradation processes
under way, which were likewise affected by the particular
casting technique.

The most prevalent and visible degradation is caused by
the corrosion of the reinforcement bars due to minimal
covering of concrete. This is the most difficult problem to
address in repairing historic concrete. Another prevalent
deterioration mechanism at Brion is biodeteriogens that
can trigger corrosion. The presence of this organic growth
on the concrete surface, which Scarpa had anticipated,
creates challenges to conserving its historic and aesthetic
significance, specifically in balancing how the organic

13

Fig. 13.1. A general view of Brion Cemetery.

Fig. 13.3. Carlo Scarpa's multifarious use of concrete.

growth is contributing to the concrete's patina with the potential damage it may be causing to the underlying material. The rich texture of the concrete that is so characteristic of Brion Cemetery results from the original construction techniques and from the subsequent degradation that has occurred over time. These factors required careful consideration in the identification of suitable analytical methods and conservation treatments that minimize inappropriate impact on the concrete but also address the deterioration and decay (fig. 13.4). The choice of appropriate conservation methods and materials to address or remove the cause of damage, or at least retard its impact, is thus reliant on a detailed understanding of the problems and their causes, balanced with a deep understanding of the significance of the architecture and the concrete.

INVESTIGATIONS: BACKGROUND RESEARCH, ANALYSIS, DIAGNOSTIC WORK, TESTING, AND TRIALS

The work had three objectives. The first was to thoroughly assess the current state of degradation using appropriate diagnostics, including carbonation depth, chloride content, and the identification and assessment of prior treatments, coatings, and the extent/rate of corrosion of reinforcement (fig. 13.5). This, coupled with accurate analyses of the material (components, mix design, and depth of cover), enabled the forecasting of potential ongoing change and progressive damage and helped to determine the material's—and thus the structures'—durability. This investigation was needed in order to develop repair approaches that minimized major intervention to the concrete surface.

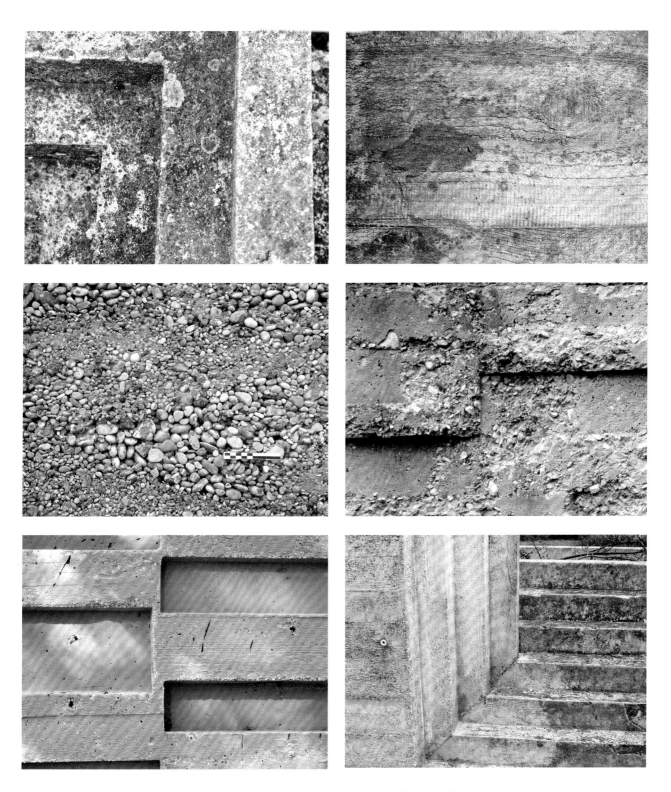

Fig. 13.4. Examples of the highly textured concrete and its patina, which is partially caused by its degradation.

13

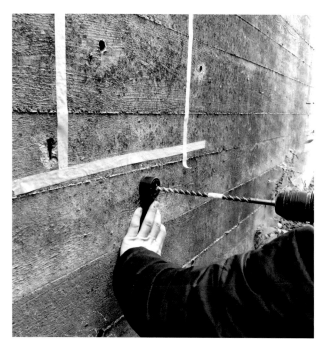

Fig. 13.5. Testing to determine the depth of carbonation.

The second objective was to identify the possible extrinsic causes (environment and exposure, presence of degradation agents, transport mechanisms, regulation/dispersal of rainwater, moisture infiltration) that could potentially be resolved through minimal intervention to the structures' environment wherever possible.

The third objective was closely related to the second and included studies aimed at revealing the rate and causes of cyclical degradation through historical research and reviewing archival documents and photographs.

Insufficient information is available to fully understand the efficacy of a number of the currently used repair methods and materials (such as migrating corrosion inhibitors) or their long-term impact on the existing concrete. Some methods also involve the loss of significant fabric. The project therefore included a series of trials of application methods and materials, carefully selected to meet the needs of the specific characteristics of concrete found across the structures.

CONSERVATION

The project, which at the time of writing was nearing completion, sought a balance between unavoidable interventions and repairs (without which parts of the architecture would be lost) and a desire to conserve the concrete's aesthetic significance, which has been conditioned by

the passing of time, the patina of age having contributed to the character of the architecture. Most of the problems that have arisen concern direct intervention, from cleaning to restoring the previous coatings. These procedures raise issues regarding both the goals of conserving the values established over time and those of the technological efficiency of available repair methods. Scarpa's building is characterized by careful and meticulous detailing. Earlier incongruous and disfiguring interventions had impacted significance and needed to be addressed.

The proposed solution was twofold. First, it addressed the causes of deterioration and included indirect interventions aimed at dispersing and/or redirecting rainwater away from the structures. Reducing the infiltration of moisture into the concrete is the first step in slowing down the corrosion of the reinforcing bars and in limiting the proliferation of biological patinas. Suggested interventions included improving the waterproofing system on the flat roofs; verifying the efficiency of rainwater disposal systems (sloping, interior drainpipes, shafts, and gathering systems); waterproofing the wall tops; removing and/or dispersing rainwater from the foot of the concrete walls in direct contact with the ground; potentially waterproofing the pools and reorganizing the greenery; and waterproofing or introducing drainage in the concrete planters. The second component of the project involved repairs to the concrete itself and included testing techniques and materials in the laboratory and subsequently in situ (on the eastern outer wall) (fig. 13.6).

Based on the preliminary test results and the specific characteristics of the concrete, the conservation strategy began with the lowest-impact interventions possible that were repeatable in the short term, for example cleaning tests performed at different levels in order to retain the existing patina. The interventions were categorized according to the structural role of the element to be repaired, the type and level of damage, and the potential impact of the repair on the architectural significance. For example, substantial interventions were planned for structural elements in less visible areas. Highly visible areas of nonstructural elements were repaired with minimal loss of fabric, but those repairs may need to be redone within a short time frame. The minimal repairs were considered part of an ongoing scheduled maintenance plan.

CONCLUSIONS

In view of the test results and considering the limits of the state of the art for the materials identified, the proposals developed avoided direct intervention in the concrete as

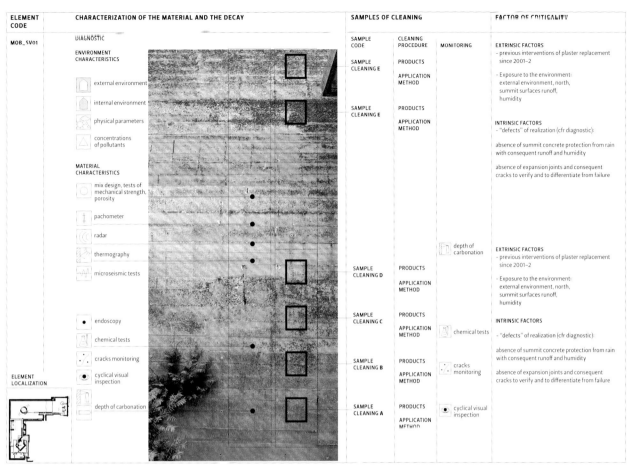

Fig. 13.6. Sample of survey characterizing the concrete and its degradation, with planning of diagnostic, assessment, and testing program.

far as possible and proposed eliminating the causes of deterioration through indirect interventions, coupled with a monitoring and maintenance plan capable of managing conservation over time. Thus the project adopts a preventive conservation approach as a way of avoiding major intervention and the inevitable loss of Scarpa's original and highly significant material.

The underlying objective of the work was to develop an approach that puts maintenance and scheduled monitoring at its core so that the repair work undertaken can be evaluated and its effectiveness assessed. This approach provides an alternative protocol to the conservation of exposed concrete.

FURTHER READING

Bruschi, Greta, Paolo Faccio, Sergio Pratali Maffei, and Paola Scaramuzza. 2005. *Il calcestruzzo nelle architetture di Carlo Scarpa. Forme, alterazioni, interventi.* Bologna: Compositori.

Faccio, Paolo, Greta Bruschi, and Paola Scaramuzza. 2005. "From Artificial Stone to Reinforced Concrete II: Project for Experimental Investigation Protocol for the Characterization of Decay Phenomena"; "From Artificial Stone to Reinforced Concrete: A Plan for a Specialist Method for Diagnostics"; and "From Artificial Stone to Reinforced Concrete III: Analytical Methodologies for the Intervention." In *Scientific Research and Safeguarding of Venice 2006: Corila Research Programme 2004/2006*, vol. 5, 2005 results, edited by Pierpaolo Campostrini, 101–12, 113–21, 147–55. Venice: Corila.

Pietropoli, Guido. 2004. "Carlo Scarpa mostra se stesso. Venezia 1968, Londra e Vicenza 1974, Parigi 1975." In *Studi su Carlo Scarpa, 2000–2002*, edited by Kurt Walter Forster and Paola Marini, 317–35. Venice: Marsilio.

———. 2007. "Un libro di Carlo Scarpa." In *Memoriae Causa: Carlo Scarpa e il complesso monumentale Brion 1969–1978*, 4–19. Exhibition catalogue. Treviso: Fondazione Benetton Iniziative Culturali.

13

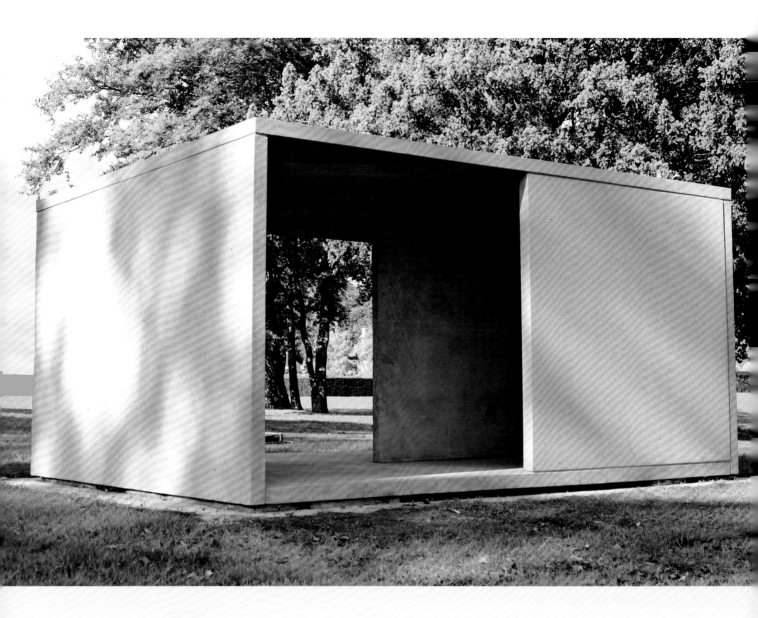

14

Catherine Croft

Untitled by Donald Judd

Southwest England | 1988–91

ARCHITECT/DESIGNER

Donald Judd, sculptor

PROJECT DATES

2014–ongoing

PROJECT TEAM

Tessa Jackson, lead conservator | Andrew Coxall, conservator | Catherine Croft, adviser | Jamie Fairchild, cleaning specialist | Stephen Honey, sealant specialist

CLIENT/BUILDING OWNER

Private collection

INTRODUCTION

This is a large, 66 by 120 by 102 in. (1.68 by 3.05 by 2.59 m) sculptural work by Donald Judd (1928–1994), a major American postwar minimalist artist. It was constructed from reinforced concrete by a fabricator working to the artist's specifications. Although it is a one-off piece, it is part of a series of related works now held in collections throughout the world.

No construction drawings or instructions are known to exist, but there is some literature and archival information about Judd's evolving use of concrete during his career. In order to achieve the same finish on all large surfaces, by the time this work was made, he had switched from casting component slabs in shallow horizontal tray molds to casting vertically, so that the top surface of the pour would be a narrow edge that would be hidden in most cases. Examination showed fragments of wood embedded in surfaces, confirming the use of plywood shuttering. The amount of steel work needed would have been empirically judged and the mix was a standard one, designed to emphasize the ubiquity of concrete as a medium and to produce a consistent, smooth finish. Construction by specialist fabricators in well-controlled circumstances would have enabled reasonable control over depth of cover, although the slabs are quite thin. The work was assembled with metal bolts at the fabricator's workshop and the joints were caulked. It was subsequently transported as a single piece, supported by a bespoke metal cage and crated for protection.

The artist appears to have envisaged his concrete works to be sited in external locations rather than have the benefit of protection in indoor, climate-controlled museum conditions. However, this piece faces very different challenges from others in this series that were sited by Judd at his own property in Marfa, Texas, with its arid climate. This piece is set in a temperate climate, resting on grass and surrounded by trees (figs. 14.1, 14.2).

THE PROJECT

The work is owned by a private collector and located as part of an extensive collection of outdoor sculpture around a private house in southwest England. The collection is well cared for and regularly monitored by an experienced sculpture conservator who carries out annual inspections and maintenance. Considerable attention is given to the potential impact of climatic conditions, with the work being protected by a specially constructed cover that does not touch its surfaces when the property is empty and in the winter. The work is well protected from potential damage by landscape maintenance (grass, cutting machinery, etc.) and human interaction. Documents record that the work was moved from a previous location on the estate to the current site, and that problems with insufficient footings had led to some subsidence in the previous location. Due to the damage caused by the subsidence, a cement screed had been applied over the skyward-facing surface of the work in a bid to cover cracks, but this also obscured the natural aggregate characteristic of Judd's concrete sculpture work.

The owner was concerned that the work was showing signs of aging and staining, and wanted to address the visual impact of the previous repairs and have a record of

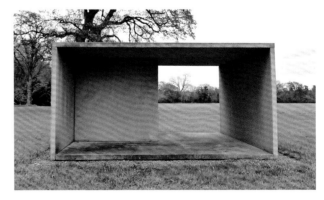

Fig. 14.2. Donald Judd's untitled (1988–91), pictured here prior to conservation, sits in a landscape setting. Photo: Catherine Croft. Donald Judd Art © 2018 Judd Foundation / Artists Rights Society (ARS), New York

Fig. 14.1. Donald Judd's untitled (1988–91), following conservation. Photo: Tessa Jackson. Donald Judd Art © 2018 Judd Foundation / Artists Rights Society (ARS), New York

14

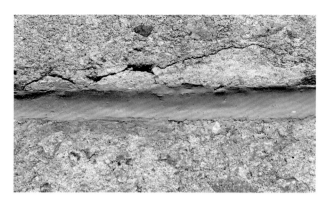

Fig. 14.3. Detail of damage after non-original caulking and repairs were removed. Photo: Tessa Jackson. Donald Judd Art © 2018 Judd Foundation / Artists Rights Society (ARS), New York

the cracks and details in order to monitor any changes. The decision was made to remove the screed layer from the top, along with all other repairs and caulking, and strip the piece down to its original, albeit damaged, state (fig. 14.3).

The high value of the work and the projected ongoing monitoring program meant that it was possible to employ conservation experts to work meticulously on the surfaces, and to work gradually over a period of several years to develop the best strategy. The size and location of the work meant that all treatments had to be carried out in situ, in the open air without damaging any of the landscaping; a marquee was erected over the work so that treatment could be carried out in any weather.

INVESTIGATIONS: BACKGROUND RESEARCH, ANALYSIS, DIAGNOSTIC WORK, TESTING, AND TRIALS

Research was carried out to develop an understanding of how the work was constructed, and its history before and after arriving at its current location. Consideration was given to documentary evidence of the artist's own attitude toward the aging of his work and treatments carried out by conservators who had previously worked on other concrete works by Judd (in Marfa and at Philip Johnson's Glass House).

Core samples were not removed from the work, as this would have represented a significant loss of original fabric. Thus petrographic analysis and carbonation testing were also not possible, but a cover meter survey was used to plot the reinforcement position and depth of cover. A detailed visual analysis of the work was carried out and all staining and other blemishes, including previous repairs and traces of past cleaning, were recorded in a detailed conservation report. The surface of the concrete was examined with a handheld lens to aid selection of suitable patch repair materials.

CONSERVATION

In the first year, minimal work was carried out to fill a small number of cracks and chips to the edges of some of the planes of concrete. This used a slurry mix, chosen for good visual match and reversibility. Both lime-putty and non-lime-putty slurry mixes were considered and a sample board (on a concrete paving slab that was a good match to the concrete of the sculpture) was created so that matching could be assessed for different orientations and lighting conditions.

A range of mixes were trialed on a discreet location on the sculpture, and at the same time a "best guess" was made as to the best match for the limited immediate use planned. The range of trials was left in place for further assessment the subsequent year. The repair mix was hand applied with a mini trowel and brush, left to harden for forty-eight hours, and then rubbed back with nylon wire wool to reveal the underlying aggregate.

The second year it was decided to address cleaning of the piece and seek to reduce the visual impact of previous poorly matched repairs and the screed on the skyward-facing surface. The Jos Vortex/Thermotech system (a proprietary blasting cleaning system) was selected and operated by a specialist cleaning contractor (fig. 14.4). The conservator was present throughout the cleaning process in order to decide on the levels of cleaning. Very careful monitoring ensured that enough cleaning was carried out to create a unified visual appearance, but that cleaning stopped as soon as any original material loss from the surface was detected. On examination after cleaning, very small fragments of original shuttering could be seen at the surface, confirming that loss of original surface was minimal. A crack on the lower horizontal surface had been previously filled with silicon, which Thermotech would not remove, and trials of a poultice treatment to remove this were carried out but proved unsuccessful. The silicone fill was mechanically removed, as were isolated previous fills elsewhere, in cases where they were particularly visually intrusive or unstable.

While there was no evidence of damage from the corrosion of internal concrete reinforcement, there were areas of minor spalling around some of the cramps cast into the edges of the slabs to facilitate assembly. These areas were gently excavated with a scalpel and dental tools, and the cramps received a metal treatment to remove corrosion products and then painted with Rustoleum (for rust prevention). These areas were filled with a 1:1 mix of ordinary portland cement (OPC) and Lias stone dust.

Some areas of intact previous fill, which might have caused damage if removed, were retouched with Lascaux

Fig. 14.4. The conservator closely supervised the Thermotech cleaning process. Photo: Tessa Jackson. Donald Judd Art © 2018 Judd Foundation / Artists Rights Society (ARS), New York

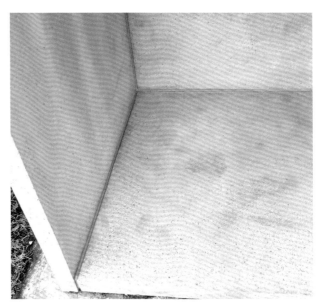

Fig. 14.6. The final result was a uniform, clean surface, with discreetly recessed caulking, allowing the form of the piece to read clearly. Photo: Tessa Jackson. Donald Judd Art © 2018 Judd Foundation / Artists Rights Society (ARS), New York

Fig. 14.5. The sculpture was thoroughly masked before a sealant specialist replaced the caulking. Photo: Tessa Jackson. Donald Judd Art © 2018 Judd Foundation / Artists Rights Society (ARS), New York

498, an acrylic adhesive chosen for its stability with UV, and colored with earth pigments to visually integrate them. The caulking had been patched on many occasions, resulting in unsightly protrusions in some areas and cracking in others with little original material retained, so the decision was taken to remove it. This decision also responded to the need to limit water penetration at the joints and prevent standing water from collecting on the tops of the vertical slabs.

Trials to remove the caulking with scalpels proved that this would be extremely slow and likely to damage fragile arrises of the slabs, so a wet abrasive cleaning method was used here, as this was faster and the calibration of when to stop was easier (all caulking was to be removed). Scalpels were then used to remove some remaining areas of backing rod, before the whole work was masked with sheet poly-thene and masking tape. Dow Corning C60 mid-gray caulking was then applied by a silicone sealant specialist. This is a one-part, low-modulus silicone polymer sealant with good adhesion to porous surfaces and resistance to UV radiation and temperature extremes (fig. 14.5).

CONCLUSIONS

Because this is a precious artwork that is valued for its materiality as well as its concept and has substantial mone-tary value, it was possible to undertake a collaborative and labor-intensive approach involving a number of specialists to gain the best possible result (fig. 14.6; see also fig. 14.1). The owner's commitment to ongoing maintence and moni-toring was also essential to a strategy of carrying out only minimal interventions where possible. Although most architectural projects have to operate in very different circumstances, the approach of minimal intervention and regular maintenance may be sometimes applicable.

14

GLOSSARY

AGGREGATE | a substantial component of the filler in concrete, such as sand, broken or crushed stone, gravel, slag, clinker, or shell

AIR ENTRAINER | an admixture for concrete providing a regular distribution of tiny air pockets within the concrete's pore structure to accommodate freeze-thaw action

ALKALI-AGGREGATE REACTION (AAR) (ALSO CALLED ALKALI-SILICA REACTION [ASR]) | the reaction between certain aggregates and the cement paste in a concrete mix that results in the development of an expansive crystalline gel. As the gel forms from water in the concrete, it causes cracking of the aggregate and thus of the concrete matrix.

ANODE | the positive pole of an electric circuit in a cathodic protection system; a sacrificial material introduced to act as the site of corrosion

ANODIC EFFECT | *see* incipient anode effect

ANTI-CARBONATION COATING | a film-forming coating that creates a barrier to the ingress of moisture and carbon dioxide, thus preventing corrosion of the reinforcement

BINDER (IN COATINGS) | the carrying material or liquid that binds together the fillers, pigments, and other ingredients of the coating and bonds it to the surface to which it is applied

BINDER (IN CONCRETE) | the materials that compose the cementing agents in concrete, mortars, and renders. In concrete, portland cement has been the most common binder over the last hundred years or so, although increasingly other artificial cements are being used such as ground granulated blast-furnace slag.

CARBONATION | the process of the loss of reduction in alkalinity in concrete as a result of calcium hydroxide depletion. This occurs when atmospheric carbon dioxide and moisture react to form carbonic acid, which then reacts with the calcium hydroxide in the concrete to form calcium carbonate. When carbonation reaches the reinforcement steel, the reduction in alkalinity results in the loss of the passivating oxide layer around the steel in the carbonated zone and corrosion can commence.

CARBONATION FRONT | the interface between the uncarbonated concrete and the carbonated concrete as the carbonation progresses toward the steel

CATHODE | the negative pole of an electric circuit in a cathodic protection system or corrosion cell

CATHODIC PROTECTION | an electrochemical process that provides protection of the reinforcement steel by connecting it to a sacrificial anode, thus requiring the reinforcement to act as a cathode and therefore preventing corrosion

CEMENT | the binding material that is one of the components of concrete; in concrete, the cement reacts with water in a process known as hydration, which leads to the formation of an alkali paste that surrounds and binds the aggregate together as a solid mass

CHLORIDE ATTACK | the damage resulting from the reaction between chloride ions and water, which forms an aggressive agent that breaks down the protective passivating layer of the steel and leads to accelerated corrosion of the reinforcement; chlorides may be present in deicing salts, accelerators used to speed up concrete setting, or sea water or sea spray

COMPACTION | a process to eliminate the air in voids in freshly placed concrete by vibration, rolling, or tamping

CONCRETE | a composite material of aggregates of various sizes—broadly categorized as fine (commonly sand) and coarse (typically gravel and stone)—combined with cement paste (cement and water), which acts as a binder

CONSERVATION | all the processes of looking after a place so as to retain what is important about it or its cultural significance; the umbrella term that encompasses actions including repair, restoration, maintenance, and in some instances reconstruction

CORROSION | the decay of steel caused by an electrolytic action between the cathodic and anodic sites of a corrosion cell when they are in contact with oxygen and water; this action creates iron oxides, or rust, which occupies a higher volume than the original steel and can cause the surrounding concrete to crack and spall. Other agents, such as chlorides and acids, can aggravate corrosion.

CORROSION INHIBITOR | a chemical compound that forms a protective barrier around the steel in concrete to protect it from corrosion; this can be added to the concrete mix, applied to the steel, or applied to the concrete surface (migratory corrosion inhibitors)

CORROSION RATE MAPPING | an investigative method of recording the level and rate of corrosion of the steel in concrete

COVER | the amount of concrete that covers the reinforcement

CREEP | the long-term deformation of concrete due to strain by a steady and sustained load

CURING | the process of change that liquid concrete undergoes as it solidifies, due to chemical reactions caused by hydration and carbonation

DELAMINATION | separation of the layers of concrete from the main body of the material; also known as spalling, it typically describes the loss of concrete from above the reinforcement

DEPASSIVATION | reduction in the protective layer to the reinforcement that occurs as the concrete alkalinity reduces from pH 9 due to carbonation or chloride ingress

FAIR-FACED CONCRETE | concrete left in its natural unpainted state, which often reveals the formwork markings

FLY ASH (OR PULVERIZED FUEL ASH [PFA]) | waste product captured from the gaseous output of coal-fired power stations, which has setting properties similar to cement and can be used to reduce the amount of cement needed in a concrete mix

FORMWORK (ALSO SHUTTERING) | the metal or timber framework used in the formation of in situ or precast concrete to hold it in place during pouring and curing; it may be removed after the concrete is cured or left in place as permanent formwork or shuttering

FREEZE-THAW DEGRADATION | damage to concrete due to freeze-thaw action, where expansion within the concrete pores due to freezing causes cracking

GALVANIC ACTION | the reaction when two dissimilar metals are placed together in solution; the most active metal becomes the anode and will begin to corrode as the current flows between the two metals. Galvanic action is used to prevent corrosion by galvanizing or coating steel with zinc and in galvanic cathodic protection.

GRADING | the distribution of grain sizes of sand or aggregate in concrete

HONEYCOMBING | voids left in concrete due to inadequate mixing and consolidating

IMPRESSED CURRENT CATHODIC PROTECTION (ICCP) | a method of cathodic protection that uses a power supply and an inert, non-corroding anode to protect the reinforcement

INCIPIENT ANODE EFFECT (ANODIC EFFECT) | an unfortunate side effect sometimes encountered when a high-alkaline patch repair is inserted into concrete that has extensively carbonated and lost its alkalinity; the repair material stops the action of the existing corrosion cell, but a new cell is set up, creating an extended area of damage. This can be counteracted by installing a sacrificial anode.

IRON PYRITE | an iron sulfide, lumps of which are frequently found among commonly used aggregates. When exposed, these can cause dark red-brown staining on the surface of concrete, which although not structurally damaging can be considered unsightly.

LAITANCE | the fine particles of aggregate and cement that rise to the surface of concrete as it sets and form a smooth coating layer, which will erode over time. This is exacerbated if the mix is too wet or overworked. If an exposed aggregate finish is desired, the laitance layer must be removed before hardening, usually by brushing or abrading.

LIFT | the extent of concrete poured between two construction or daywork joints, usually measured by height

MAINTENANCE | the continuous and regular protective care and upkeep of a building or structure

MIGRATORY CORROSION INHIBITOR | *see* corrosion inhibitor

ORDINARY PORTLAND CEMENT (OPC) | standard gray cement used in most concrete mixes. The term "portland cement" does not necessarily refer to a cement meeting any agreed standard and includes early examples of products that were fired to lower temperatures.

PASSIVATION | a protective coating that steel reinforcement in fresh concrete forms around itself; this is a surface layer of oxide that protects the steel from corrosion. When the concrete surrounding the steel loses its strong alkalinity due to carbonation, the protective layer is lost (depassivation), and the steel is liable to corrode.

PASTE | the cement powder and water components of concrete, excluding the aggregate

PATINA | the natural aging and weathering of a concrete surface

PETROGRAPHIC ANALYSIS | the laboratory-based microscopic examination of a concrete sample to determine components of the original mix. Cylindrical core samples are generally taken from inconspicuous locations, and the fresh face of the core is used.

PHENOLPHTHALEIN | a chemical commonly used to test whether concrete is carbonated; it is brushed or sprayed onto the surface of the concrete and will turn bright pink if the pH remains above 10, in which case it is not carbonated. Carbonated concrete remains unchanged in color.

PLASTICIZER (OR SUPERPLASTICIZER) | additive used to reduce the amount of water needed in a mix and improve workability

POROSITY | the ratio of voids in the concrete to the solid, which affects the ease with which water and water vapor can pass through the concrete

PRECAST/PREFABRICATED CONCRETE | reinforced concrete cast in a mold that is then assembled on-site

PRESERVATION | maintaining a building or structure in its existing state and retarding deterioration

PRESTRESSING | a process by which tensioned steel rods are incorporated into a concrete element prior to its commissioning as a structural element; these forces counteract the live loads that it will carry in use and result in slimmer sections being viable. The tension force may be applied to the reinforcement before the concrete is cast around it (pre-tensioned prestressing) or afterward (post-tensioned prestressing). In the latter case, the sections are usually precast with internal channels through which steel is threaded when the sections are in their final position. The steel is then stretched and anchored at each end, and the channel is filled with grout.

PULVERIZED FUEL ASH (PFA) | *see* fly ash

REALKALIZATION | method by which an electric current is passed through embedded steel reinforcement to produce hydroxyl ions at the surface of the steel. In order to do this, a titanium mesh that serves as an anode is generally fixed to the surface of the concrete and all the parts of the reinforcement are wired together, both factors likely to render it unsuitable for conservation projects.

REBAR (OR REINFORCEMENT BARS) | steel bars or a mesh of steel wires used to add tensile strength; usually these are unfinished tempered steel with a ribbed surface to aid bonding to the concrete. Epoxy-coated galvanized or stainless steel can be used to reduce risk of corrosion. Primary reinforcement provides strength to support the structure itself and anticipated loads. Secondary reinforcement, also known as distribution or thermal reinforcement, is designed to limit cracking and resist stresses caused by effects such as temperature changes and shrinkage.

REBOUND HAMMER | *see* Schmidt hammer

RECONSTRUCTION | returning a place to a known earlier state using new material

REINFORCED CONCRETE | concrete with reinforcement within it—usually steel bars or mesh—to provide added tensile strength

REINFORCEMENT BARS | *see* rebar

REMOTE SACRIFICIAL ANODE (RSA) | a zinc-based anode that is located away from the structure being protected, installed as part of a sacrificial anode cathodic protection system that corrodes preferentially to the adjacent steel reinforcement; *see* sacrificial anode cathodic protection

REPAIR | to restore to sound condition after damage or decay; may involve restoration, including the returning of dislodged parts to their original location, and/or reconstruction, where decayed or lost material is replaced with new material

RESISTIVITY | a measure of the resisting power of a material to the flow of an electric current; there is a direct relationship between the resistivity of concrete and the corrosion rate of the reinforcement within it

RESISTIVITY TESTING | nondestructive testing of resistivity carried out by holding a four-probe device to the concrete surface; a current is applied between the two outer probes and the potential difference measured between the two inner probes. Resistivity measurement is useful for identifying areas of reinforced concrete at risk from corrosion. It should be used in conjunction with half-cell potential testing.

RESTORATION | "Returning a place to a known earlier state by removing accretions or by reassembling existing elements without the introduction of new material" (Australia ICOMOS. 2013. *The Burra Charter: The Australia ICOMOS Charter for Places of Cultural Significance, 2013*, section 1.7)

SACRIFICIAL ANODE CATHODIC PROTECTION (SACP) | a system of cathodic protection using a sacrificial metal such as zinc, aluminum, or magnesium, which is more easily corroded than the reinforcing steel; no power supply is used in this system and the anode is consumed

SCHMIDT HAMMER | brand name for a rebound hammer used for simple nondestructive testing of concrete strength; the concrete surface is impacted and the amount of rebound measured

SHEAR | force acting at right angles to compressive or tensile stress

SHUTTERING | *see* formwork

SILANE TREATMENT | compounds of silane applied as a liquid or spray to the surface of concrete to resist water penetration

SPALLING | the loss of patches of the surface layer of concrete, often caused by expansive corrosion of steel reinforcement within the concrete; also known as delamination

STIRRUP | rebar bent into a loop that helps resist shear forces and ensure correct placing of main bars

SULFATE ATTACK | strength-reducing change in the composition and microstructure of the concrete caused by sulfates, either penetrating from the exterior environment or within the mix itself

SUPERPLASTICIZER | *see* plasticizer

WET ABRASIVE CLEANING | a cleaning method where abrasive material is mixed with water and air at pressure and shot through a pressurized apparatus. It can produce a more carefully controlled cleaning than air abrasion and minimize dust.

WHITE CEMENT (FULL NAME, ORDINARY WHITE PORTLAND CEMENT [OWPC]) | essentially the same basic material as ordinary portland cement (OPC), but the raw limestones selected for white portland cement contain less of the minerals such as chromium, manganese, and iron that contribute to the gray color. It behaves essentially like OPC but requires more complex processing and is more expensive. It began to be used in the 1920s.

SELECTED BIBLIOGRAPHY

This brief bibliography lists texts that have been identified as key resources on the conservation of historic concrete. These include publications on the history of concrete that provide insights into its development and significance, as well as a limited number of texts that specifically cover practical conservation. Each of the case studies in the book also includes its own list of references.

An excellent complementary resource already exists for anyone working on concrete conservation, and therefore a comprehensive bibliography is not provided in this book. Readers should consult the Getty Conservation Institute's 2015 annotated bibliography on the conservation of historic concrete, included below, which is available online. It covers mass concrete, reinforced concrete, precast and cast-in-place concrete, and prestressed and post-tensioned concrete. It will be periodically updated and is intended to be a relatively comprehensive resource on the topic.

Broomfield, John P. 2007. *Corrosion of Steel in Concrete: Understanding, Investigation and Repair.* 2nd ed. London: Taylor and Francis.

Calder, Barnabas. 2016. *Raw Concrete: The Beauty of Realism.* London: William Heinemann Books.

Collins, Peter. 2004. *Concrete: The Vision of a New Architecture.* 2nd ed. Montreal: McGill-Queen's University Press.

Custance-Baker, Alice, Gina Crevello, Susan Macdonald, and Kyle Normandin, eds. 2015. *Conserving Concrete Heritage: An Annotated Bibliography.* Los Angeles: Getty Conservation Institute. http://hdl.handle.net/10020 /gci_pubs/concrete_biblio.

Forty, Adrian. 2012. *Concrete and Culture: A Material History.* London: Reaktion.

Grantham, Michael, ed. 2011. *Concrete Repair: A Practical Guide.* London; New York: Routledge / Taylor and Francis.

Jester, Thomas C., ed. 2014. *Twentieth-Century Building Materials: History and Conservation.* Los Angeles: Getty Conservation Institute. First published 1995 by McGraw-Hill (New York).

Laboratoire de recherche des monuments historiques (LRMH). 1996. *Les altérations visibles du béton. Définitions et aide au diagnostic.* Les cahier techniques du cercle des partenaires du patrimoine 1. Champs-Sur-Marne, France: Cercle des partenaires du patrimoine.

Macdonald, Susan, ed. 2003. *Concrete: Building Pathology.* Oxford: Blackwell Science.

Odgers, David, ed. 2012. *Practical Building Conservation: Concrete.* Farnham: English Heritage and Ashgate.

Urquhart, Dennis. 2014. *Historic Concrete in Scotland. Part 2, Investigation and Assessment of Defects* and *Part 3, Maintenance and Repair of Historic Concrete Structures.* Short Guide 5. Edinburgh: Historic Scotland. https://www.engineshed.org/publications/publication /?publicationId=c2a38944-eb81-44e8-bd5e-a59100fb611a.

CONTRIBUTORS

JOSÉ EDUARDO DE AGUIAR graduated from the engineering school of Minas Gerais Federal University in 1977. He subsequently completed at the same university a master's degree in civil construction from the Materials and Technology Construction Department (2006) and a doctorate in civil construction (2012). He is director of Recuperação Serviços Especiais de Engenharia Ltda., an engineering consulting firm in the field of pathology and durability of constructions headquartered in Belo Horizonte, Brazil. He is a professor of pathology and durability in postgraduate courses at Minas Gerais Federal University, the Pontifical Catholic University of Minas Gerais, and IDD Institute.

GILBERTO ARTIOLI is a professor of mineralogy and crystallography at the University of Padova and director of CIRCe, the center for the investigation of cementitious materials. He received his PhD from the University of Chicago. His interests focus on materials science as applied to the investigation of industrial and cultural heritage materials. He is author of more than 250 publications in international peer-reviewed journals and several books in his fields of expertise.

JURJEN VAN BEEK studied architecture at the University of Applied Sciences in Enschede and earned a master's degree in architecture at Delft University of Technology. He worked at Wessel de Jonge Architects from 2006 to 2016, and is now a conservation consultant and architect for the city of Rotterdam, the Netherlands, where he is involved mainly in projects related to its infrastructure.

FRANÇOIS BOTTON is a French heritage architect and architect for historical monuments, appointed by the French government for the conservation, restoration, and refurbishment of listed monuments. His practice extends to a variety of private and public operations, ranging from archaeological sites to modern architecture. He also has extensive experience designing museums in existing monuments and a special interest in the conservation of twentieth-century architecture, particularly concrete structures.

GRETA BRUSCHI is an architect holding degrees in the history and conservation of architectural and environmental heritage, and in architecture, from the IUAV University of Venice, where she was also awarded a PhD. She specializes in conservation and restoration of architecture, particularly historic structural concrete. She is a teaching assistant in architectural conservation at the IUAV and at the University of Trieste.

LAURA N. BUCHNER is a senior conservator and project manager at Building Conservation Associates in New York. She holds undergraduate degrees in English and physics from Concordia College and a graduate degree in historic preservation from Columbia University Graduate School of Architecture, Planning and Preservation.

FRANÇOIS CHATILLON was appointed chief architect for historical monuments in France in 2005. Much of his professional activity is dedicated to conserving outstanding architectural heritage works that are listed monuments, including the Grand Palais, Arc de Triomphe, and École des Beaux-Arts in Paris. He has also been entrusted with several emblematic buildings of twentieth-century heritage, including the Cité de Refuge by Le Corbusier and the Piscine des Amiraux by Henri Sauvage, both in Paris. In 2015, the Halles du Boulingrin restoration project was awarded the EU Prize for Cultural Heritage / Europa Nostra Awards, conservation category.

CATHERINE CROFT is director of the Twentieth Century Society and editor of *C20* magazine. She studied architecture at Cambridge University, and earned a master's degree in material culture and architectural history (and held a fellowship) at the Winterthur Museum in Delaware. She is an alumna of the Architectural Association course. Prior to the Twentieth Century Society, she worked for English Heritage (now Historic England) as a buildings inspector in London and the Midlands. She writes on contemporary as well as historic buildings, authored *Concrete Architecture* (Gibbs Smith, 2004), lectures in the UK and internationally, and teaches a course on concrete for conservation professionals at West Dean College.

PATRICK DILLON is a theater architect, conservationist, writer, and broadcaster. He led the architectural team for the award-winning regeneration of the National Theatre, London, and the regeneration of Snape Maltings, Suffolk, England. He is currently a director at Allies and Morrison architects in London, and sits on the casework committee of the Twentieth Century Society. He has published books on social history, as well as a monograph on Denys Lasdun and the National Theatre.

STEPHEN DOUGLAS is the building and conservation manager at the National Theatre in London. He is a civil engineer with an interest in materials and heritage. In his current role, he has been proactive in developing strategies for concrete conservation at the National Theatre and monitoring their long-term performance. He has published several articles in the technical press and regularly speaks to groups about his work.

PAOLO FACCIO graduated in civil engineering from the University of Padova, and in architecture from the IUAV University of Venice. He has been director and chair of Faccio Engineering since 1986. In 2005, he was appointed associate professor of conservation at the IUAV and consultant for the Italian Ministry of Cultural Heritage and Tourism. In 2016, with a group of IUAV professors, Faccio founded clusterLAB HeModern, an interdisciplinary research cluster focused on the conservation of twentieth-century heritage.

DAVID FARRELL is managing director of Rowan Technologies, a company in the UK that specializes in the development and application of new conservation methods. He earned his master of science degree in maintenance engineering at the University of Manchester in 1982 and went on to complete his PhD in corrosion engineering there in 1984. He has published more than forty technical papers on conservation and corrosion-related issues.

PAUL GAUDETTE is a principal with Wiss, Janney, Elstner Associates in Chicago, focusing on the repair and preservation of historic and contemporary concrete structures. He is a coauthor of the National Park Service's "Preservation Brief 15: Preservation of Historic Concrete," and a chapter on reinforced concrete in *Twentieth-Century Building Materials* (Getty Conservation Institute, 2014). He is a fellow of the American Concrete Institute (ACI) and the Association for Preservation Technology International (APT). He serves as course leader and instructor for numerous concrete repair and conservation courses for Docomomo International, APT, and ACI.

CHRISTOPHER GEMBINSKI is a director of technical services at Building Conservation Associates in New York, and a former adjunct assistant professor of architecture, planning, and preservation at Columbia University. He holds a master of science degree in historic preservation from the University of Pennsylvania. His preservation projects in New York include Saint Patrick's Cathedral, Grand Central Terminal, Moynihan Station, and the Central Park Police Precinct.

TULLIA IORI is a professor at the University of Rome Tor Vergata. Her research includes the history of construction and conservation of modern architecture. Currently she is fully involved with SIXXI research on the history of structural engineering in Italy (www.sixxi.eu). She is author of *Il cemento armato in Italia* (Edilstampa, 2001) and *Pier Luigi Nervi* (Motta Architettura, 2009). She coedited the first three books of the SIXXI series (2014–15) and has curated exhibitions related to SIXXI at MAXXI in Rome.

WESSEL DE JONGE holds an architecture degree from Delft University of Technology. As a practicing architect, his portfolio includes the conservation of the Netherlands Pavilion at the Venice Biennale (1953) and a former sanatorium, Zonnestraal (1928), in Hilversum, the Netherlands, as well as the rehabilitation of the UNESCO-listed Van Nelle Factory (1928) in Rotterdam. He is a partner in the design team for the restoration and adaptation of the 1938 Olympic Stadium in Helsinki. Since 2015, he has been a full professor in heritage and design in the Faculty of Architecture and the Built Environment at Delft University of Technology.

ULISSES VANUCCI LINS earned a master's degree in built heritage and sustainable environment from Minas Gerais Federal University in 2012. Lins has worked with historic urban centers and modernist heritage since 1984 and is currently employed by Brazil's National Institute of Historic and Artistic Heritage (IPHAN).

SUSAN MACDONALD is head of Buildings and Sites at the Getty Conservation Institute in Los Angeles. She graduated in architecture from the University of Sydney and has a master's degree in conservation studies from the University of York. She worked as a conservation architect in private practice and in the government sector in Australia and in London before joining the GCI in 2008. She has a particular interest in twentieth-century heritage conservation, and has authored and edited a number of books and articles on this topic, including on the subject of concrete conservation. She oversees the GCI's Conserving Modern Architecture Initiative.

CLAUDIO MODENA has been a professor of structural engineering at the University of Padova since 1994 and has authored more than five hundred publications. He has experience as a research participant and is responsible for the university's research unit in numerous projects founded and cofounded by the European Union, the Italian Ministries, the National Research Council, the Italian Civil Protection Agency, ReLUIS University Consortium, and private industrial partners. He is a member of national and international research organizations and standard commissions.

GAIL OSTERGREN is a research specialist in the Getty Conservation Institute's Building and Sites department. Focused on publishing and disseminating the department's work, she provides research, writing, and editorial support to a range of projects, including the Conserving Modern Architecture Initiative; the Eames House Conservation Project; and the Heritage Values, Stakeholders, and Consensus Building project. She earned her PhD at the University of California, Los Angeles, where she specialized in urban, architectural, and Southern Californian history. She is a founding board member of Docomomo US/ Southern California chapter and is a historic preservation commissioner for the City of West Hollywood, California.

RICHARD PALMER is a civil engineer experienced in the analysis, diagnosis, and repair of buildings and civil engineering structures. His university studies and training led to membership in the UK Institution of Civil Engineers and registration as a chartered professional. He began his career in the geotechnical field before developing a passion for materials science. His international experience includes the latest diagnostic and renovation techniques. He lives in France, where he manages the design office of Palmer Consulting.

DAVID S. PATTERSON is a senior principal and architect with Wiss, Janney, Elstner Associates in Princeton, New Jersey. He has directed numerous projects involving the repair and conservation of historic structures, and led the firm's work on Eero Saarinen's Morse and Stiles Colleges at Yale University. He is a member of the American Institute of Architects, the Association for Preservation Technology International, the New Jersey Society of Architects, and the American Architectural Manufacturers Association. He coauthors a monthly column on construction technology for *Construction Specifier* magazine.

RAYMOND M. PEPI has been president of Building Conservation Associates, Inc. since 1985. He attended Columbia University Graduate School of Architecture, Planning and Preservation from 1978–79.

GUIDO PIETROPOLI is an architect who graduated from the IUAV University of Venice in 1970, with Carlo Scarpa as his tutor. He worked in the studio of Le Corbusier for the new hospital project in Venice (unbuilt). Pietropoli opened his own studio in 1972 in Monselice, Italy, and collaborated on projects with Scarpa. Between 1972 and 1976, he was an assistant lecturer in Scarpa's architectural planning courses at the IUAV.

SERGIO PORETTI (1944–2017) was a professor at the University of Rome Tor Vergata whose research included the history of construction, the history of structural engineering, and the conservation of modern architecture. He was principal investigator of the research program SIXXI– Twentieth Century Structural Engineering: The Italian Contribution, European Research Council Advanced Grant. He authored *Italian Modernisms: Architecture and Construction in the Twentieth Century* (Gangemi, 2013) and coedited the first three books of the SIXXI series (2014–15).

FRANCESCA DA PORTO has been an associate professor of structural engineering at the University of Padova since 2015. She has won many competitions and three publication awards. She has won and coordinated European projects and is directly responsible for several research projects and research and development contracts with industry. She participates on technical and standardization committees and has authored or coauthored more than two hundred papers, monographs, and book chapters.

MARCO ANTÔNIO PENIDO DE REZENDE is an associate professor in the School of Architecture of Minas Gerais Federal University. He completed postdoctoral studies in the Historic Preservation Program, University of Oregon, then earned a PhD in construction technology at the University of São Paulo. He has twenty-seven years of experience in teaching, research, and consultancy in the fields of conservation of historic structures, traditional and historic construction techniques, and vernacular architecture. He has authored fourteen book chapters and more than fifty articles in journals and conference proceedings.

WOLFGANG H. SALCHER has been an architect at the Federal Monuments Authority Austria in Vienna since 2003. Previously he worked in architectural practices in Austria, Italy, and Germany, and with the Institut français d'architecture in Paris. He has written on concrete conservation and postwar architecture and has given lectures at universities. He is a member of Docomomo International and ICOMOS Austria, and organizes international symposia on postwar modernism.

PAOLA SCARAMUZZA is an architect who graduated from the IUAV University of Venice with degrees in architecture and the history and conservation of architectural and environmental heritage, with studies related to the conservation of the architecture of Carlo Scarpa. She obtained her PhD in 2016 in the preservation of architectural heritage at the Polytechnic University of Milan, with a study on structural concrete in twentieth-century architecture. She is currently a teaching assistant in architectural conservation at the IUAV.

MICHELE SECCO is an assistant professor in the Department of Civil, Environmental and Architectural Engineering of the University of Padova. He obtained his PhD in earth sciences in 2012. His research focuses on the mineral-petrographic, chemical, microstructural, and physical-mechanical characterization of structural and architectural materials in cultural heritage. He is an author and/or coauthor of several peer-reviewed scientific papers. He has spoken at scientific and technical conferences, seminars, and workshops on his fields of expertise.

DEBORAH SLATON is a principal with Wiss, Janney, Elstner Associates in Northbrook, Illinois. She has served as principal investigator for numerous preservation plans, historic structures reports, and cultural landscape reports for historic resources nationwide. She coauthored the National Park Service's "Preservation Brief 15: Preservation of Historic Concrete," and is a fellow of the Association for Preservation Technology International, a director of the Historic Preservation Education Foundation, and a member of the Society of Architectural Historians Heritage Conservation Committee.

ELENA STIEVANIN is a research collaborator at the University of Padova. She holds a PhD in sciences and technologies for archaeological and architectural heritage and is an architectural engineer. She researches historic reinforced concrete buildings with a focus on new techniques for beam and column repair and strengthening interventions with polymer-modified mortars and Fabric-reinforced cementitous matrix composite materials. She has wide experience with experimental tests and in situ investigations on existing reinforced concrete structures, and has collaborated in the drafting of European projects and in teaching several courses.

STUART TAPPIN is a structural engineer and director of Stand Consulting Engineers, based in London. His work on existing buildings covers all periods and includes the Melnikov House in Moscow, Mughal-era structures in India, and many churches from the twelfth century onward, including three English cathedrals. His research studies for a master's degree in art and architecture looked at the structure of Indo-Islamic domes and the early use of reinforced concrete in India. He presented on both topics at the first international conference of the Construction History Society in Madrid in 2003 and was included in the published proceedings.

CHRIS WOOD is head of building conservation and research at Historic England (HE, formerly English Heritage). He is the lead on a number of research projects, including HE's current work assessing the performance of concrete patch repairs using matching materials. He is series editor of the award-winning English Heritage Practical Building Conservation books, as well as an author and/or contributing author to most of its volumes, including *Concrete* (Ashgate, 2012).

INDEX

Page numbers in italics refer to figures; those followed by n refer to notes, with note number.

© 2018 J. Paul Getty Trust

Published by the Getty Conservation Institute, Los Angeles
Getty Publications
1200 Getty Center Drive, Suite 500
Los Angeles, California 90049-1682
www.getty.edu/publications

Ruth Evans Lane and Rachel Barth, *Project Editors*
Lindsey Westbrook, *Manuscript Editor*
Jeffrey Cohen, *Designer*
Michelle Woo Deemer, *Production*

Distributed in the United States and Canada by the University of Chicago Press

Distributed outside the United States and Canada by Yale University Press, London

Printed in China

Library of Congress Cataloging-in-Publication Data
Names: Croft, Catherine, 1964– editor. | Macdonald, Susan, 1961– editor. | Ostergren, Gail, editor.
Title: Concrete : case studies in conservation practice / edited by Catherine Croft and Susan Macdonald with Gail Ostergren.
Other titles: Conserving modern heritage.
Description: Los Angeles : Getty Conservation Institute, [2018] | Series: Conserving modern heritage | Includes bibliographical references.
Identifiers: LCCN 2018010797 | ISBN 9781606065761 (pbk.)
Subjects: LCSH: Concrete construction—Conservation and restoration—Case studies. | Architecture, Modern—20th century—Conservation and restoration—Case studies. | Historic buildings—Conservation and restoration—Case studies. | LCGFT: Case studies.
Classification: LCC TH3311 .C66 2018 | DDC 624.1/834—dc23
LC record available at https://lccn.loc.gov/2018010797

Front cover: National Theatre, London. Photo: © Philip Vile / Haworth Tompkins
Page 6: Unité d'Habitation, Marseille. Le Corbusier's Modulor Man cast into concrete beside the main entrance. Photo: Geoffrey Taunton / Alamy Stock Photo

Page 15 (top to bottom): View of the reinforced concrete dish of the iconic 30-foot diameter Listening Mirror in 2005 (detail, fig. 1.1). Photo: Tony Watson / Alamy Stock Photo; the Magliana Pavilion under construction, 1945 (detail, fig. 6.1). Photo: MAXXII Museo nazionale delle arti del XXI secolo, Rome. MAXXI Architettura Collection, P. L. Nervi Collection
Page 16 (clockwise from top left): The tower and rotating portion of Villa Girasole (detail, fig. 3.1). Photo: Diego Martini; Halles du Boulingrin following conservation, 2012 (detail, fig. 2.15). Photo: © Cyrille Weiner; completed works on the west facade of the Unité d'Habitation, 2012 (detail, fig. 8.16); São Francisco de Assis Church following repair, 2016 (detail, fig. 5.15)
Page 17 (clockwise from top left): The repaired bear ravine at the Dudley Zoological Gardens, 2015 (fig. 4.1); the terrace to the café-restaurant at the Gänsehäufel Swimming Facility, following conservation (detail, fig. 7.5). Photo: Bettina Neubauer-Pregl. Courtesy of Federal Monuments Authority Austria, Vienna; view of the National Theatre following conservation, 2016 (detail, fig. 12.11). Photo: Ana Paula Arato Gonçalves; Morse and Ezra Stiles Colleges, Yale University, 2013 (detail, fig. 10.1). Photo: Michael Doolittle / Alamy Stock Photo
Page 18 (top to bottom): The north end of the First Christian Lower Technical School Patrimonium after conservation works (detail, fig. 9.12). Photo: Raoul Suermondt Architectural Photography; detail view of the New York Hall of Science, 2017 (detail, fig. 11.14). Photo: Mark Goldberg / Courtesy of Wikimedia Commons, CC BY-SA 4.0
Page 190: Morse and Ezra Stiles Colleges, Yale University, New Haven, Connecticut. Photo: Richard Barnes
Page 201: Covered walkway at Strandbad Gänsehäufel, 2010. Photo: Daniel-tbs, Wikimedia Commons, CC BY-SA 4.0
Back cover (left to right): View of the Listening Mirror in 2005 (detail, fig. 1.1). Photo: Tony Watson / Alamy Stock Photo; the repaired bear ravine at the Dudley Zoological Gardens, 2015 (detail, fig. 4.1); the north end of the First Christian Lower Technical School Patrimonium after conservation works (detail, fig. 9.12). Photo: Raoul Suermondt Architectural Photography

Illustration Credits
Every effort has been made to contact the owners and photographers of objects reproduced here whose names do not appear in the captions. Anyone having further information concerning copyright holders is asked to contact Getty Publications so this information can be included in future printings.